GILLRAY OBSERVED
The Earliest Account of his Caricatures in *London und Paris*

One of England's most famous caricaturists, James Gillray, was an immensely successful and popular artist, yet there were no accounts of his work published in England during his lifetime. The single contemporary source on Gillray is a series of commentaries published in the German journal *London und Paris* between 1798 and 1806. Christiane Banerji and Diana Donald have now translated and edited selected commentaries, with accompanying illustrations, to reveal how Gillray's art was understood by his contemporaries.

The edition offers a unique insight into the role of satire in British politics during the Napoleonic era, and the subtle artistry of Gillray's designs. The volume also includes an informative introduction which places Gillray and his work in the context of a fascinating episode in Anglo-German relations at the turn of the eighteenth century.

CHRISTIANE BANERJI is a professional writer and translator, with research interests in eighteenth- and nineteenth-century German history and culture.

DIANA DONALD is Professor of the History of Art at Manchester Metropolitan University. She has written extensively on eighteenth- and nineteenth-century art including *The Age of Caricature: Satirical Prints in the Reign of George III* (1996).

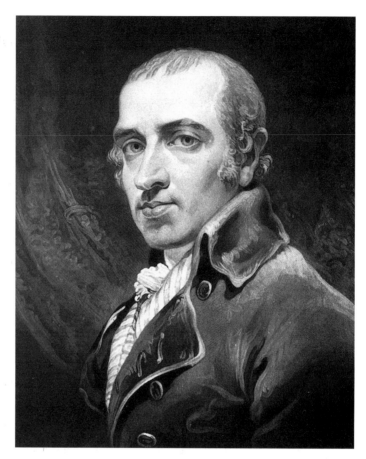

Charles Turner, *Mr James Gillray, From a Miniature painted by Himself*, 1819. Mezzotint.

GILLRAY OBSERVED

The Earliest Account of his
Caricatures in *London und Paris*

Translated and edited by
CHRISTIANE BANERJI
and
DIANA DONALD

PUBLISHED BY THE PRESS SYNDICATE OF THE UNIVERSITY OF CAMBRIDGE
The Pitt Building, Trumpington Street, Cambridge CB2 1RP, United Kingdom

CAMBRIDGE UNIVERSITY PRESS
The Edinburgh Building, Cambridge CB2 2RU, UK http://www.cup.cam.ac.uk
40 West 20th Street, New York, NY 10011-4211, USA http://www.cup.org
10 Stamford Road, Oakleigh, Melbourne 3166, Australia

First published 1999

Printed in the United Kingdom at the University Press, Cambridge

Typeset in Monotype Fournier 11½/15pt in QuarkXPress® [SE]

A catalogue record for this book is available from the British Library

Library of Congress cataloguing in publication data

Gillray observed: the earliest account of his caricatures in *London und Paris* /
 translated and edited by Christiane Banerji and Diana Donald.
 p. cm.
 Includes index.
 ISBN 0 521 58075 7 (hardback)
 1. Gillray, James, 1756–1815 – Criticism and interpretation.
 2. English wit and humor, Pictorial. 3. London und Paris.
 1. Banerji, Christiane. II. Donald, Diana.
 NC 479.G5G56 1999
 769.92–dc21 98-26521 CIP

ISBN 0 521 58075 7 hardback

For Draper Hill

Contents

Plates

Preface

In the last few years, research on the graphic satire of the Georgian period
has advanced dramatically. It owes much to the work of historians of the
1980s and 1990s who have virtually rewritten the history of eighteenth-
century Britain, affording fresh insights into such matters as the widening
of the political world; the growth of popular patriotism and of print culture;
and developments in the public's patronage and consumption of the arts.
Now there is a succession of studies embodying new perspectives on one of
that society's most striking and characteristic products: the caricature print.
The authors of such studies represent several different disciplinary and
political standpoints and come to different conclusions, especially on the
related questions of how far satirical prints had a truly popular appeal; the
social complexion of those who saw them or bought them; and the extent of
their circulation beyond London's elite. This is a stimulating debate, but one
that is hampered still by a dearth of primary research into the sparse records
of the period. One important contemporary source in particular has until
now been largely inaccessible to English readers – the series of com-
mentaries on caricature prints in the German journal *London und Paris*.
Although factual information from the journal was used by Mary Dorothy
George in her volumes of the *British Museum Catalogue of Political and
Personal Satires*, and by Draper Hill in his excellent biography of James
Gillray, there is no previous translation of its extensive articles on particu-
lar caricatures, which provide a unique account of how they were received
and construed by contemporaries. The present edition of some of the art-
icles on Gillray from *London und Paris* is therefore intended as a timely
contribution to the growing body of work on this richly suggestive but
problematic category of visual imagery.

The commentaries on French and English caricatures in *London und
Paris*, which accompanied reduced copies of the prints, span almost the
whole period of the journal's existence, from 1798 to the end of the

Napoleonic wars, but they are most important and prolific in the years down to 1807. Among the English prints, numbering about 145 in all, examples by several artists are featured – Gillray, Isaac Cruikshank, Williams and some anonymous hands. However, the articles devoted to Gillray's contemporaneous production greatly outweigh, both in length and in significance, those on the works of other caricaturists. We therefore decided at an early stage to restrict our collection to Gillray, and to treat the book as a portrayal of this artist, the key figure in the early history of graphic satire. Even so, it has only been possible to include about a quarter of the commentaries on Gillray's caricatures which appeared in the journal. In making our selection, we were influenced not only by the quality and historical interest of the prints in question, but also by the value of the chosen commentaries in throwing light on attitudes to caricature, both as a political instrument and as an art form. Twenty of the commentaries on Gillray's designs are translated and reprinted in their entirety, together with three articles which dealt in more general terms with the trade in satirical prints. The latter tell us much about Gillray's relationship with other producers, and about both the moral and the commercial contexts within which his works appeared.

The commentaries in *London und Paris* are written in a discursive, scholarly and often witty style. We have endeavoured to render this in an unmarked English which avoids anachronistic modernisms, but which makes no attempt to imitate the English idioms or terminology of the period. *London und Paris*'s variable and often erroneous spellings of proper names (including Gillray's) have been corrected. Classics of English literature were often quoted in German translations, and in these cases the original texts have of course been restored; where the works of German poets were quoted in *London und Paris*, the translations are ours, unless otherwise stated. Where *London und Paris* quoted Latin and Greek works in German translation, we have used an existing modern English translation of the passage in question, cited in the relevant footnote, and we are grateful for the copyright permissions involved, notably of Penguin Books Ltd.

The accounts of Gillray's prints in *London und Paris* were extensively footnoted. These footnotes add greatly to the density of meaning elicited from the prints; indeed, many are as important as the main text. They have

therefore been included almost in their entirety, although in a very few cases (e.g. some digressive allusions to ancient literature, or references to German editions of classical or English authors), minor omissions have been made. *London und Paris*'s references to literary sources were generally laconic or inaccurate. We have therefore traced and checked them, and have silently expanded or corrected them as necessary. In those few cases where it proved impossible to identify or find a copy of the work in question, *London und Paris*'s citation has been retained as it stands. A similar approach has been adopted in connection with allusions to works of art.

In order to make this collection of translations as useful as possible to the modern English reader, editorial footnotes have also been provided; these are distinguished by the use of brackets. First, we have added details of the medium and publication date of the chosen Gillray prints. Since all were published by Hannah Humphrey at 27, St James's Street, London, this information has not been repeated. However, the variant forms of Gillray's signature are quoted, since they denote the differing degrees of his responsibility for the design of the prints. The numbers of Gillray's prints in the *British Museum Catalogue of Political and Personal Satires* are given next (the *Catalogue* normally includes *London und Paris*'s copies of Gillray's originals as an annexe to the entries for the latter), together with references to other important works on the prints. We have also explained points in *London und Paris*'s texts and footnotes as necessary, and have provided some references to modern secondary literature.

This book has occupied us both intermittently over a period of several years, and its completion has been reliant on the support of a number of institutions. A Grant-in-Aid from the Swann Foundation for Caricature and Cartoon in 1992 enabled translation to begin. The Paul Mellon Centre for Studies in British Art made a generous grant in 1994 towards the cost of research and translations from *London und Paris* used in Diana Donald's *The Age of Caricature: Satirical Prints in the Reign of George III* (Yale University Press, 1996), and this has of course equally benefited the present work. Manchester Metropolitan University has provided substantial assistance through contributions to the salary costs involved. For all these awards we are extremely grateful.

Many individuals have also given vital assistance to the editors. Nicholas

Penny's early enthusiasm for the *London und Paris* project, and his constructive suggestions as to how the edition should be published, were crucial in bringing it to fruition. Special thanks are due to Justus Fetscher, whose wide knowledge of the period, helpful advice and friendship have proved invaluable in the preparation of the book. Draper Hill provided welcome encouragement, and, in particular, expert comments on the Gillray letters printed in the Appendix. Sarah Richards was kind enough to read a draft of the Introduction, and to make suggestions based on her extensive study of eighteenth-century German journals. The staff of the Handschriftenlesesaal, Staatsbibliothek, Berlin (West), and of the Goethe- und Schillerarchiv, Weimar, were also extremely helpful to us. In pursuing the more abstruse allusions of *London und Paris*'s writers, we have sought the help of a number of scholars; however bizarre the item of information requested, they have all responded with the greatest generosity and good humour. We are here particularly indebted to the erudition of Christa Grössinger; Peter Humfrey; William Hutchings; Roy Turner; and David Womersley. Most of all, we wish to thank Stephen Parker and Trevor Donald for their constant encouragement and support over the long period of the book's gestation; they must be as pleased as we are to see it finished.

Abbreviations

Donald (1996) Diana Donald, *The Age of Caricature: Satirical Prints in the Reign of George III* (New Haven and London: Yale University Press, 1996)

BM (with catalogue numbers) Mary Dorothy George, *Catalogue of Political and Personal Satires . . . in the British Museum*, 11 vols. (London: Trustees of the British Museum, 1870–1954, reprinted 1978), vol. VII for *1793–1800* (1942) and vol. VIII for *1801–10* (1947)

George (1959) Mary Dorothy George, *English Political Caricature: A Study of Opinion and Propaganda*, 2 vols. (Oxford: Clarendon Press, 1959), vol. II, *1793–1832*

Hill (1965) Draper Hill, *Mr. Gillray the Caricaturist* (London: Phaidon Press, 1965)

Hill (1966) Draper Hill, *Fashionable Contrasts: Caricatures by James Gillray* (London: Phaidon Press, 1966)

Hill (1976) Draper Hill, *The Satirical Etchings of James Gillray* (New York: Dover Publications, 1976)

LuP *London und Paris* 1–12 (Weimar: Landes-Industrie-Comptoir, 1798–1803); 13–20 (Halle: Neue Societäts Buch- und Kunsthandlung, 1804–7); 21–4 (Rudolstadt: Hof- Buch- und Kunsthandlung, 1808–10). Thereafter issued by the same publisher in Rudolstadt as a new series, continuously numbered but with variant titles, and with a break in 1814: *Paris, Wien und London* 1–2 (1811); *Paris und Wien* 3–5 (1812–13); *London, Paris und Wien* 6 (1815)

Introduction

The historical importance of *London und Paris*'s articles on caricature and Gillray

In the second half of the eighteenth century, a wide and interesting cultural exchange took place between Britain and Germany. At a time when German thinkers could claim primacy in aesthetic theory and attempts to understand the history of the arts in society, German culture was nevertheless remarkably porous and receptive to influences from abroad. Many works of British literature were transmitted, translated and reviewed, and prints produced in London were similarly imported in large numbers.[1] This growing trade was not restricted to the engravings of historical subjects, mezzotint portraits and genre scenes etc. which had apparently begun to displace French prints in Germany: it also included large numbers of popular English satires. Pastor Wendeborn, a long-time German resident in London, noted in the 1780s that

Caricature prints go likewise in great quantities over to Germany, and from thence to the adjacent countries. This is the more singular and ridiculous, as very few of those who pay dearly for them, know any thing of the characters and transactions which occasioned such caricatures. They laugh at them, and become merry, though they are entirely unacquainted with the persons, the manners, and the customs which are ridiculed. The wit and satire of such prints, being generally both local, are entirely lost upon them.[2]

[1] Albert Ward, *Book Production, Fiction and the German Reading Public 1740–1800* (Oxford: Clarendon Press, 1974), pp. 37, 46, 55, 69–70, 86. Timothy Clayton, 'Reviews of English Prints in German Journals, 1750–1800', *Print Quarterly* 10.2 (June, 1993), 123–37 and *The English Print 1688–1802* (New Haven and London: Yale University Press, 1997), pp. 261–4. Antony Griffiths and Frances Carey, *German Printmaking in the Age of Goethe* (London: British Museum, 1994), pp. 14–16, 18–21.

[2] Frederick A. Wendeborn, *A View of England Towards the Close of the Eighteenth Century*, 2 vols. (London: G. G. J. and J. Robinson, 1791), vol. II, pp. 213–14.

It was perhaps to remedy this situation that the journal *London und Paris*,[3] started in Weimar in 1798, published among its varied contents extensive commentaries on current caricatures, which were sent over from England and France. They did indeed provide accurate and detailed information about the 'characters and transactions' satirised in the prints, so that their humour would be more intelligible to German enthusiasts. But these caricature commentaries, the journal's novel and distinctive feature, were much more than a key for collectors. They fed the hunger of the growing German *Lesepublikum* for accounts of political and social life in the metropoles of London and Paris, in all their aspects – good and bad. The tolerance of caricature in Britain suggested a freedom of opinion, and an indulgence on the part of the authorities, which educated Germans marvelled at, and many readers of *London und Paris* certainly envied. If one could interpret their astonishing imagery, one could better understand the British national character they appeared to express, and instructively set them alongside the cultural products of other countries. Despite the frivolity of the prints themselves, the articles on them reflect that intellectual curiosity and zest for self-improvement so typical of educated Germans at this period. Some rise above the level of jobbing journalism, as essays of lasting historical interest.

In each issue of *London und Paris*, the final section was devoted to caricature, and reproduced a selection of French and English prints, carefully copied in reduced form as etchings (Plates 2 and 16), and bound in as folding

[3] The literature on the history of *London und Paris* is sparse. The main works are Ellen Riggert, 'Die Zeitschrift "London und Paris" als Quelle englischer Zeitverhältnisse um die Wende des 18. und 19. Jahrhunderts. London im Spiegel ausländischer Berichterstattung', inaugural dissertation, Göttingen (1934); Karl Riha, 'Großstadt-Korrespondenz. Anmerkungen zur Zeitschrift *London und Paris*' in *Rom–Paris–London: Erfahrung und Selbsterfahrung deutscher Schriftsteller und Künstler in den fremden Metropolen*, edited by Conrad Wiedemann (Stuttgart: Metzler, 1988), pp. 107–22; Iris Lauterbach, '*London und Paris* in Weimar. Eine Zeitschrift und ihre Karikaturen als kunst- und kulturgeschichtliche Quelle der Zeit um 1800' in *Festschrift für Hartmut Biermann*, edited by Christoph Andreas et al. (Weinheim: Verlag VCH, Acta Humaniora, 1990), pp. 203–18. See also *BM* vol. VII, pp. xv–xvi, xlvi, and vol. VIII, p. xiv; Paul Hocks and Peter Schmidt, *Literarische und politische Zeitschriften, 1789–1805. Von der politischen Revolution zur Literaturrevolution* (Stuttgart: Metzler, 1975), pp. 26–8; David Kunzle, 'Goethe and Caricature: From Hogarth to Töpffer', *Journal of the Warburg and Courtauld Institutes* 48 (1985), 164–88 (172–5).

plates with the accompanying commentaries. The French prints chosen (significantly fewer in number) were mainly mild satires on social affairs, fashion and manners,[4] while the English caricatures were predominantly political.[5] There was, it seems, an intentional contrast between the understated Neoclassical style of the French prints, which were mainly drawn in neat outline and uncoloured, and the licentious exuberance of the richly tonal, hand-coloured English ones, with their exaggerated caricatures of the leading statesmen of the day: 'British liberties' appeared as much in the style of the prints as in their content.

Freedom did not, however, necessarily imply crudity. The best of the English prints evinced a political and artistic sophistication which was unprecedented in the field of caricature. They were the work of James Gillray, described by *London und Paris* as the most famous caricaturist in Europe.[6] So famous was he, indeed, that his name and style were adopted by several continental satirists.[7] The very first issue of the journal carried an article on 'Gillray and Mrs Humphrey', to be followed later in the year by a biographical sketch of the artist. In subsequent numbers Gillray's prints, featured as they appeared in London, occupied by far the largest space in the caricature section of the journal, and their characteristic traits were minutely analysed. One of the last articles sent from London before Napoleon's continental blockade cut off communications between Germany and Britain was entitled 'Caricaturists in London Today', but was in fact a eulogy of Gillray, and a fitting valediction. *London und Paris*'s

[4] In some issues no French caricatures were included, although this imbalance was partly compensated by a larger number of non-satirical French prints. The writers in *LuP* seem to have regarded French satires as inferior to the English ones. See the articles 'Pariser Carricaturen' in 2 (1798) 78f.; 'Betrachtungen über die französischen Karikaturen' in 20 (1807), 127–30; and cf. *French Invasion*, especially footnotes 4 and 5, in our collection, pp. 160–1 below.

[5] A few of the French prints in *LuP* were also political, e.g. *Divers Projets sur la descente en Angleterre* in 1 (1798) and *Situation de l'Angleterre Au Commencement du 19ième Siècle* in 7 (1801).

[6] 'Caricaturists in London Today' in 18 (1806). See p. 245.

[7] Johann Gottfried Schadow signed his anti-Napoleonic satires of 1813–14 'Gilrai', 'Gilrai à Paris' etc., and the Swiss David Hess signed himself 'Gilray Junior'. *BM* vol. VII, p. xv. Hill (1965), p. 73. Kunzle, 'Goethe and Caricature', 175. Griffiths and Carey, *German Printmaking*, p. 170.

writers well understood the instrumentality of satire in the sometimes murky, callous and cynical world of British politics, yet they could at the same time recognise Gillray himself as an original artist in the full sense. To the twentieth-century reader, accustomed to the presentation of caricature history as an apostolic succession of 'great cartoonists', with Gillray standing at their head, *London und Paris*'s approach might seem conventional. However, in the eighteenth century, when the political caricaturist tended to be viewed merely as an executant, a hack labouring at the behest of his political taskmasters, and scarcely known by name, the attention paid by this journal to 'the extraordinary talents united in Gillray's works' was a complete innovation.[8] Contemporary German notions of genius and appreciation of the unique creative gifts of artists could, it seems, rescue even a caricaturist from obscurity. But *London und Paris* did not rely on airy theorising in order to justify Gillray to its readers. The descriptions of his prints were based on first-hand accounts provided by the journal's London correspondents: one of whom, as will appear, had direct contact with Gillray himself. The authority with which they interpreted his intentions and the deeper meanings of the designs cannot be doubted.

None of Gillray's English contemporaries thought fit to give his work this kind of notice in print. Only after his death in 1815, when old controversies lost their heat and the passage of time bred forgetfulness of the people and incidents in the caricatures, did English publishers decide to explain them retrospectively for the benefit of print collectors. *The Caricatures of Gillray; with Historical and Political Illustrations, and Compendious Biographical Anecdotes and Notices*, an anonymous work, was apparently issued in parts between 1818 and the mid 1820s.[9] It contains some valuable comments on the role and reception of Gillray's prints during the Napoleonic Wars, emphasising their patriotic effects, but hardly lives up to the promise of its title. In the later 1820s the printseller Thomas McLean reissued Gillray's plates to subscribers, and supplied a catalogue, the *Illustrative Description of the*

[8] The status of the caricaturist in eighteenth-century Britain and Gillray's critical heritage are dealt with at greater length in Donald (1996), ch. 1.

[9] Published in London by John Miller, Rodwell and Martin, in Edinburgh by William Blackwood; undated. It is illustrated with etched, reduced copies of the prints. Nine parts survive in the British Library's copy. Hill (1976), p. xxvi.

Genuine Works of Mr. James Gillray (1830).[10] The entries often include witty and astute remarks on the artist, his subjects and the practice of caricature in his day; but they are merely thumbnail sketches. Moreover, as McLean's writer complained (p. 57), 'In looking back to these "*by-gone days*" it seems already as though our gray goose-quill were busied in recording the events of a period at least a century back.' The contemporaneous, extended and reflective commentaries on Gillray's prints in *London und Paris*, informed by journalists with an intimate knowledge of passing events, are a prime historical source which has no English counterpart.

The history and general character of *London und Paris*

London und Paris was a characteristic product of Weimar's distinctive political and artistic culture. The ducal court dominated a town of about 6,000 inhabitants, which still preserved much of its feudal and bucolic character.[11] However, Duke Karl August, absolute ruler of Saxe-Weimar-Eisenach, was unusual among German princes in the relative liberality of his social and religious views and (at least until Germany was threatened by Napoleon) his relaxed attitude to the licensing of the press.[12] Goethe, whom the Duke had appointed as an adviser in 1776, was, by the date of *London und Paris*'s launch, the all-powerful director of the arts at the court of Weimar, and round him had gathered many of Germany's leading writers, including Wieland, Herder and Schiller. The high intellectual tone established in Weimar's aristocratic and literary circles seems to have been diffused at a more popular level in many of the journals published in the duchy.[13] It

[10] On p. 233, the date of writing is given as 1828. It was a limited edition of 100 copies, evidently for wealthy collectors. Hill (1976), p. xxvii.

[11] W. H. Bruford, *Culture and Society in Classical Weimar* (Cambridge University Press, 1962), pp. 56–73. Nicholas Boyle, *Goethe: The Poet and the Age*, vol. I, *The Poetry of Desire (1749–1790)* (Oxford: Clarendon Press, 1991), pp. 233f.

[12] He permitted Bertuch's *Oppositionsblatt*, published from 1817 to 1820. Cf. Bruford, *Culture and Society in Classical Weimar*, pp. 77, 81f., 93–6. Friedrich Kapp and Johann Goldfriedrich, *Geschichte des deutschen Buchhandels*, 5 vols. (Börsenverein der Deutschen Buchhändler, 1886–1923, reprinted Leipzig, 1970), vol. IV, p. 76. Ilse-Marie Barth, *Literarisches Weimar* (Stuttgart: Metzler, 1971), p. 102.

[13] Bruford, *Culture and Society in Classical Weimar*, pp. 291, 294.

explains something of the erudition, mental energy and openness to ideas which is evident even in the commentaries on Gillray's caricatures.

The men who conducted *London und Paris* were close to, if not always in perfect harmony with, this literary elite. The proprietor, Friedrich Justin Bertuch (1747–1822),[14] had started as a translator and literary hack, whose business reputation led to an appointment as the Duke's private secretary; he had gone on to make a fortune as a manufacturer, entrepreneur and publisher. His varied enterprises in Weimar turned its cultural productions into saleable commodities, and had done much to enhance the duchy's fame, influence and prosperity. In a country which was still overwhelmingly agricultural, his 'Landesindustriecomptoir', a commercial agency set up in 1790 to promote and channel orders for Weimar's craft wares, and facilitate import of goods from abroad, constituted an early experiment in capitalism. It was particularly important in the field of books and prints.[15] Bertuch was, indeed, strikingly successful in his own publications. The highly respected *Allgemeine Literatur-Zeitung*, founded in 1785, was a broad-ranging international literary review, whose anonymous contributors could conveniently be recruited from the duchy's University of Jena. An illustrated monthly, the *Journal des Luxus und der Moden*, popularly known as the *Modejournal*, followed in 1786, and lasted until 1826.[16] It dealt with fashion and all aspects of domestic design, but also literature, travel and society news. Like the 'Landesindustriecomptoir', it was intended to advertise and foster an international trade in expensive and tastefully designed consumer articles, and had subscribers

[14] See ibid., pp. 297–308 and Barth, *Literarisches Weimar*, pp. 102–4 for a full account of Bertuch's career and publications. See also Wilhelm Feldmann, *Friedrich Justin Bertuch: ein Beitrag zur Geschichte der Goethezeit* (Saarbrücken: Schmidtke in Komm., 1902); Albrecht von Heinemann, *Ein Kaufmann der Goethezeit: F. J. J. Bertuchs Leben und Werk* (Weimar: Böhlau, 1955) and *Friedrich Johann Justin Bertuch: ein Weimarischer Buchhändler der Goethezeit* (Bad Münster: Hempe, 1950).

[15] Griffiths and Carey, *German Printmaking*, p. 20. See also Fritz Fink, *Friedrich Johann Justin Bertuch: der Schöpfer des Weimarer Landes-Industrie-Comptoirs 1747–1822* (Weimar, 1934).

[16] Aileen Ribeiro, *Dress in Eighteenth-century Europe* (London: Batsford, 1984), p. 52. Gerhard Wagner, 'Von der Galanten zur Eleganten Welt: Das Journal des Luxus und der Moden im Einflußfeld der englischen industriellen Revolution und der Französischen Revolution', *Weimarer Beiträge* 35 (1989), 795–811.

in England, France and the Netherlands as well as Germany. *London und Paris* happily complemented these sister publications. As a subscription journal with costly, hand-coloured etched plates, it was evidently aimed at an affluent and discriminating readership.[17] It could be ordered 'from all good post offices in and outside Germany, from all newspaper offices, and from all good German and foreign booksellers',[18] but sales were probably numbered in hundreds rather than thousands.[19] Nevertheless, each copy is likely to have circulated among many readers, and the journal was soon well known and greatly admired.[20] Only Napoleon's invasion of Germany prevented it enjoying the same longevity in Weimar as Bertuch's other publications.

The nature of the Weimar journal which was to make such a significant contribution to our understanding of English satire was explained in an announcement preceding publication in 1798: 'To entertain, to amuse and to recount'; to reproduce faithfully the reports sent back to Weimar by two 'not entirely inexperienced German men', living and observing life in the greatest capital cities of Europe, London and Paris, the 'playgrounds of the

[17] The 'Announcement' to *LuP* gives the annual subscription price of the journal in three of Germany's many currencies: '1 Carolin; 6 Reichsthaler and 8 Groschen; or 11 fl. Reichsgeld', roughly equivalent to 19 shillings in English currency ('Plan und Ankündigung', 1 (1798), 11). See W. H. Bruford, *Germany in the Eighteenth Century: The Social Background of the Literary Revival* (Cambridge University Press, 1965), Appendix 1, 'German Money and its Value, Weights and Measures'. By 1810 the subscription price had dropped slightly to 6 Reichsthaler and 4 Groschen, or 11 Gulden.

[18] *LuP* 23 (1810), 1.

[19] Sales figures of several hundred would have been the norm for journals of this kind. Bruford, *Germany in the Eighteenth Century*, pp. 281–2.

[20] Kunzle, 'Goethe and Caricature', 173, n. 31, summarises some of the evidence for *LuP*'s renown. He quotes Eduard Fuchs, who in *Karikatur der Europäischen Völker* described it as 'probably the most highly regarded periodical of the early nineteenth century'. While this is clearly an exaggeration, the journal was certainly admired by informed contemporaries such as Johann Wilhelm von Archenholz, who referred to it in his *Annalen der Brittischen Geschichte* as 'the well-known journal *London und Paris*'. Riggert, 'Die Zeitschrift "London und Paris"', p. 93. *London und Paris* was sufficiently well known and respected to be used as a source for Johann Dominik Fiorillo's *Geschichte der zeichnenden Künste von der Wiederauflebung bis auf die neuesten Zeiten*, 5 vols. (*Geschichte der Künste und Wissenschaften* Abth. 2) (Göttingen, 1796–1850). See vol. v, pp. 598–600, where Fiorillo reproduces almost word for word Gillray's biographical details from a footnote to the commentary on *Search-Night* (pp. 55–6 in this volume).

fashions which rule the world'.[21] Devoting approximately equal space to each city, *London und Paris* provided full and highly readable accounts of the politics and current affairs, social life, gossip, famous people, customs, arts and institutions characteristic of these two very different nations. A typical Paris section might discuss topics as varied as a recent election, French schools, Parisian parks, and clairvoyants, while the accounts of London life included articles on the theatre, sports, balls and fashions, and scandalous divorces, together with thoughts on the English character and English xeno-phobia. Anxious not to idealise, the contributors dealt also with the dark and dangerous aspects of both cities, in reports on poverty, crime and prostitu-tion. Even the texts of the popular songs of the moment were reprinted, translated and explained. The journal was illustrated with fine engravings, including maps, views, and scenes of public ceremonies. Through this spec-trum of impressions, *London und Paris* conveyed a sense of what it was like to live in a great city, an experience denied to most of its German readers, who must have perused the journal's contents with mingled envy and horrified fascination. In the kaleidoscopic intermingling of aristocratic and demotic culture and the abrupt juxtapositions of reports on the two opposed capital cities, the journal provided a perfect context for understanding the ephemeral satires reproduced in each issue.

Since travel restrictions were frequently imposed on their subjects by the rulers of German states, many educated Germans had become 'armchair travellers', addicted to the exploration of other countries through the medium of books, periodicals and prints. *London und Paris* announced its intention of catering to these 'German newspaper readers and observers of current world conflicts', who hungrily 'devour news from abroad'.[22] It was consciously modelled on the many late eighteenth-century works which represented the dynamic western European world to the German reader, and were often quoted in the journal itself: for example Johann Wilhelm von Archenholz's *Annalen der Brittischen Geschichte des Jahrs 1788–1796*[23] or

[21] 'Plan und Ankündigung', 31 May 1798. *LuP* I (1798), 3–11.

[22] Ibid., 5.

[23] 20 volumes; published in Hamburg, Vienna and Tübingen (1790–1800). The *Annalen* made Archenholz famous throughout the German-speaking world, where he was regarded as an

Louis-Sébastien Mercier's *Tableau de Paris* (1781–8) and its post-revolutionary sequel, *Le Nouveau Paris*.[24] A genre of travel literature had arisen, in which the author adopted the standpoint of a knowledgeable, on-the-spot but non-participant observer, able to communicate a wealth of objective information to the reader,[25] and *London und Paris*'s accounts of Gillray's caricatures shared these characteristics. They assumed that the reader would have not only an extensive knowledge of literature, but also an unlimited appetite for news of the British political world, and for the mass of ephemeral publications associated with it. Lacking a major metropolis which could focus and project their own dawning sense of national identity, German readers looked longingly to the capital cities, London and Paris, which seemed to epitomise all the political, economic and cultural advantages of the modern unitary state. In particular they marvelled at the constitutional protection, voting rights and free press apparently enjoyed by the people of Britain, where, it was frequently said, even commoners were well versed in public affairs: privileges described in idealistic terms by successive German visitors to England such as Karl Philipp Moritz, Georg

expert on English affairs. He also produced an English-language journal, *The British Mercury, or Annals of History, Politics, Manners, Literature, Arts etc. of the British Empire*, 17 vols. (Hamburg: 1787–91). His book *A Picture of England: Containing a Description of the Laws, Customs and Manners of England* was published in English translation, 2 vols. (London: Edward Jeffery, 1789), and later editions (Dublin: P. Byrne, 1791 and London: 1797).

24 *Tableau de Paris*, 4 vols. (Amsterdam: 1782), translated into English as *Paris in Miniature* (London: G. Kearsley, 1782). *Le Nouveau Paris*, 6 vols. (Paris: 1797).

25 E.g. Karl Philipp Moritz, *Reisen eines Deutschen in England im Jahr 1782* (Berlin: Maurer, 1783), translated as *Travels, chiefly on Foot, through several parts of England in 1782, described in Letters to a Friend* (1795) and reprinted (London: Humphrey Milford, 1924); newly translated by Reginald Nettel as *Journeys of a German in England: Carl Philip Moritz. A Walking-tour of England in 1782* (London: Eland Books, 1983). Gebhard Friedrich August Wendeborn, *Beyträge zur Kentniss Großbritanniens vom Jahr 1779* (Lemgo: Meyer, 1780); also *Der Zustand des Staats, der Religion, der Gelehrsamkeit und der Kunst in Großbritannien gegen das Ende des achtzehnten Jahrhunderts*, 4 vols. (Berlin: Haude und Spener, 1785–8), translated by the author and published in London in 1791; cf. note 2 above. Karl Gottlob Küttner, *Beyträge zur Kenntniss vorzüglich des Innern von England und seiner Einwohner* (Leipzig: Dyk, 1791–6). See also Michael Maurer, *Aufklärung und Anglophilie in Deutschland* (Göttingen: Vaudenhoeck und Ruprecht, 1987) and Conrad Wiedemann (ed.), *Rom–Paris–London*.

Christoph Lichtenberg and Archenholz,[26] and echoed by *London und Paris*'s writers. Middle-class readers still confined by the system of rank, hierarchy and rigid protocol prevalent in the Holy Roman Empire must have been astonished by Gillray's brazen but licensed abuse of high-ranking figures in public life; and the relative press freedom which made this possible stood in contrast to the state censorship and self-imposed observance of decorum which was normal in Germany. 'Anglomania' may partly have blinded *London und Paris*'s journalists to the real restrictions on political societies and publications in Britain during the period that followed the French Revolution, or caused its journalists sometimes to underestimate the degree of Gillray's complicity in the workings of the political establishment for which he displayed so little deference or admiration. Not that *London und Paris* was naively disposed to consider press freedom an unmitigated good, or to ignore completely the signs that in Pitt's Britain it was far from absolute. An extensive quotation from Peter Pindar's *Out at Last, or the Fallen Minister*, for example, was followed by comments which were characteristically equivocal:[27] 'It would be hard to overcome the revulsion' aroused by the 'loutish crudity and insolence' of Pindar's satire, were it not a reminder of 'the extent to which liberties can still be taken in England. It shows the ignorance of those people who maintain that the once free Briton has now had a padlock permanently clamped on his muzzle', as in fact he was shown in some contemporary prints.[28]

London und Paris's writers were prone to compare 'British liberties', if only by implication, with the situation in Germany, but they were also well aware of the dangers of straying into such controversial territory. The editor announced he would 'guard against politics, as against a sphinx which daily devours the sons and daughters of the Boeotians'.[29] This was a sensi-

[26] Margaret L. Mare and W. H. Quarrell, *Lichtenberg's Visits to England, as Described in His Letters and Diaries* (Oxford: Clarendon Press, 1938). Hans Ludwig Gumbert (ed.), *Lichtenberg in England: Dokumente einer Begegnung*, 2 vols. (Wiesbaden: Harrassowitz, 1977). Nettel, *Journeys of a German in England*, especially pp. 54–7, 184. Johann Wilhelm von Archenholz, *England und Italien*, second edn, 5 vols. (Carlsruhe: Schmieder, 1791), pp. 1f. Archenholz, *A Picture of England* (1791 edn), chs. 1 and 2. Donald (1996), pp. 109–10.

[27] In the commentary on Gillray's *Integrity retiring from Office!*, see pp. 108–10 below.

[28] George (1959), p. 18 and pl. 7. Cf. *BM* 8710 and 8711, undated prints of c. 1795.

[29] *LuP* I (1798), 7.

ble aim in the highly charged political atmosphere of the time, and one which would prove ever more necessary, given Germany's uncertain and threatened position over the next decade. The 'London' and 'Paris' sections of the journal were kept rigidly separate; and this insulation, an editorial device which strikes the modern reader as increasingly artificial, maintained a position of studied neutrality towards the belligerents. *London und Paris* was in fact performing a perilous balancing act. Plates showing Napoleon's coup d'état, the fête held in 1801 to commemorate 14 July, Napoleon's imperial throne and coins with his profile[30] competed with illustrations of the popular panoramas of British victories exhibited in Leicester Square and a commemorative portrait of Nelson.[31] These reports and celebratory images situated Gillray's caricatures in the midst of the epic events of the time, while acting as a counterpoint to his abusive and cynical art. But London *versus* Paris, the real state of affairs which *London und Paris* inevitably reflected, could no longer provide unproblematic amusement for the thinking German, as many of the poignant comments on Gillray's images reveal.

It was the highly political nature of caricature which posed the greatest difficulties for the journal. In a biography of *London und Paris*'s editor, Karl August Böttiger, his son claimed that the propaganda campaigns between France and England had actually inspired the caricature section of *London und Paris* in the first place: 'a remarkable . . . war of pamphlets and caricatures, to which the French replied in turn with pamphlets and vaudevilles', that 'gave Bertuch the idea for the journal . . . an idea which met with great approval in the . . . intellectual world'.[32] Yet in *L'Insurrection de l'Institut Amphibie* and *French Invasion* such rancour and mutual defamation were condemned in the strongest terms,[33] and in fact the majority of prints selected by *London und Paris* dealt not with international affairs but with domestic politics. This prudent restraint seems to have broken down in 1803, when the resumption of hostilities after the Peace of Amiens and fears of a French invasion produced a spate of ferociously patriotic prints in

[30] *LuP* 5 (1800), pl. III; 8 (1801), pls. XVI–XVII; 13 (1804), fig. 1; 15 (1805), figs. 1–3.

[31] *LuP* 3 (1799), opposite 336; 7 (1801), pl. VI; 16 (1805), opposite 309.

[32] Karl Wilhelm Böttiger, *Karl August Böttiger, eine biographische Skizze* (Leipzig: Brockhaus, 1837), pp. 39–40.

[33] See pp. 81–3, 158–63 below.

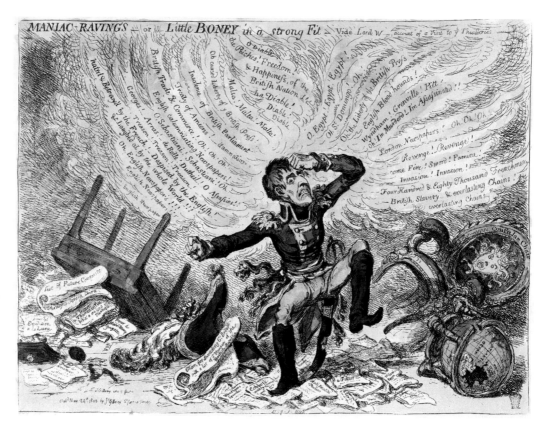

PLATE I
James Gillray, *Maniac-Ravings – or – Little Boney in a strong Fit*, 1803.
Etching, hand coloured.

London.[34] So violent and insulting were Gillray's caricatures of Napoleon
that some of those featured in *London und Paris* had to be toned down by
substituting symbols for the figure of the Emperor (Plates 1 and 2), and it
has even been suggested that these expurgated versions were designed by

[34] *LuP* 11 (1803) and 12 (1803) included Gillray's *Armed-Heroes* (*BM* 9996); *French Invasion* (*BM*
10008); *The King of Brobdingnag and Gulliver* (*BM* 10019); *Maniac-Raving's – or – Little Boney
in a strong Fit* (*BM* 9998); *John Bull and the Alarmist* (*BM* 10088); *Destruction of the French
Gun-Boats* (*BM* 10125); *The Corsican-Pest; – or – Belzebub going to Supper* (*BM* 10107); and *The
King of Brobdingnag and Gulliver (Plate 2d) – Scene – 'Gulliver manoeuvring with his little Boat
in the Cistern'* (*BM* 10227).

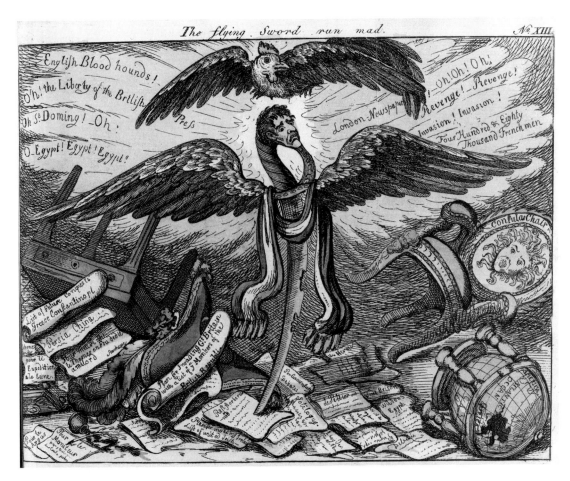

PLATE 2
The flying Sword run mad, in *London und Paris* 12 (1803).
Etching.

Gillray himself.[35] But in vain: even before the French invasion of Germany,
and Weimar's enforced membership of the Confederation of the Rhine in

[35] Surprisingly, some of the most extreme prints, including *The King of Brobdingnag* (both
versions) and *Destruction of the French Gun-Boats* were copied without significant
changes. However, *Maniac-Raving's* was retitled (in English) *The flying Sword run mad*
(*BM* 9999 in *LuP* 12 (1803), 67–82), and the figure of Napoleon was replaced by a
winged sabre with Napoleon's 'raving' head on the handle, and with modified
inscriptions (pl. 2). *The Corsican-Pest* was adapted as *The Kitchen Below or Belzebub going
to Supper* (*BM* 10108 in *LuP* 12, 263–71), the figure of Napoleon on the Devil's

1806, Duke Karl August took measures to avoid antagonising Napoleon.[36] On 9 June 1804, he issued an order: he could no longer allow 'any journal published by the Industrie-Comptoir under the title "London und Paris" to print such illustrations and pictures, with or without an accompanying commentary, in which political transactions and events are ridiculed or in which named persons are mocked'.[37] Thus 'banned by Napoleon' in Bertuch's words, the journal sought 'the protective wing of the Prussian eagle';[38] it decamped to Halle and, as the French advanced in 1808, to Rudolstadt. But by that time its importance as a running commentary on English caricature was already over.

London und Paris's contributors and their working methods

The staff recruited by Bertuch contributed fundamentally to the distinctive character of the journal. The editor, as has been mentioned, was Karl August Böttiger (1760–1835) (Plate 3),[39] a schoolmaster and a good classical scholar, who had been appointed head of educational affairs and director of Weimar's *Gymnasium* in 1791. He quickly joined the town's literary and intellectual circles, and simultaneously developed a productive journalistic career. He edited several publications, including Bertuch's *Modejournal* and Wieland's *Der deutsche Merkur*,[40] and contributed to many more; like Bertuch himself, he was accused by Goethe of exploiting access

Footnote 35 (*cont.*)

toasting fork being transformed into a plucked French cock, and extra devils added. George in her introduction to *BM* vol. VIII, p. xiv and under the relevant catalogue entries, suggests that Gillray himself drew these altered versions for *LuP*. The style and design, of *The flying Sword* in particular, are certainly lively, but drawings could have been commissioned from one of Gillray's many London imitators; mistakes in one or two of the inscriptions indicate that the copies were etched in Germany as usual.

[36] Kunzle, 'Goethe and Caricature', 174.

[37] Stiftung Weimarer Klassik, Goethe- und Schillerarchiv, Weimar (hereafter GSA), 06/5539, folio 85; extract from a protocol of 9 June 1804.

[38] Quoted in Kapp and Goldfriedrich, *Geschichte des deutschen Buchhandels*, vol. III, p. 420, from Ludwig Salomon, *Geschichte des deutschen Zeitungswesens*, second edn (Oldenburg and Leipzig: 1906), vol. II, pp. 32f.

[39] For Böttiger's career, see the biography by his son, note 32 above.

[40] Hocks and Schmidt, *Literarische und politische Zeitschriften*, p. 11.

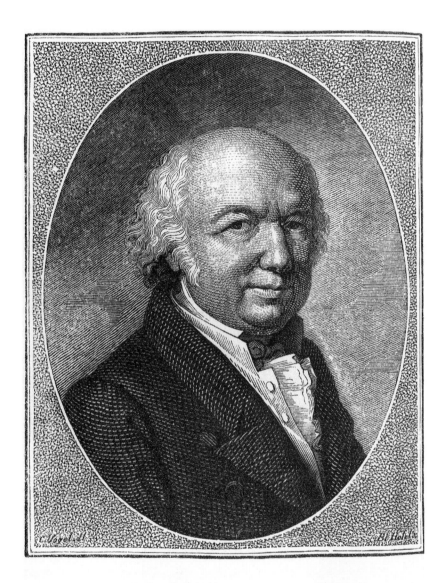

Karl August Böttiger.

PLATE 3
Blasius Höfel after C. Vogel, portrait of Karl August Böttiger; frontispiece to
K. W. Böttiger, *Karl August Böttiger, eine biographische Skizze*, 1837.
Engraving and etching.

to the elite for his own mercenary purposes.[41] One of Böttiger's qualifications for the editorship of *London und Paris* was his knowledge of British affairs,[42] which enabled him to work closely with the journal's London correspondents, and it was these resident observers of the London scene who gave the journal its absorbing topicality. They not only wrote pieces themselves, but also copied out articles and reports from the British press and sent them to Weimar, along with cuttings and prints.

The first and by far the most important of these correspondents was Johann Christian Hüttner (1766–1847).[43] Hüttner had lived in London intermittently since 1790, and his colleague Karl Gottlieb Horstig described him as 'forever fettered' there by his love for the British capital.[44] Bertuch clearly valued Hüttner's extensive knowledge of England, and he was one of *London und Paris*'s highest paid contributors.[45] However, his unique importance in the present context is his long acquaintance with Gillray. In 1805 he reported a conversation about the theatre with 'the famous Gilray' (*sic*),[46] and he supplied *London und Paris* with many biographical details of the artist which would not otherwise be known. It was only when the continental blockade made correspondence between England and Germany impossible that Hüttner ceased to post his regular contributions to the journal;[47] but by this time Gillray himself was nearing the sad end of his course as London's leading political caricaturist. Papers in Bertuch's literary estate, now deposited in the Goethe and

[41] Bruford, *Culture and Society in Classical Weimar*, p. 382.

[42] Böttiger, *Karl August Böttiger*, p. 41.

[43] Hüttner was by far the major contributor to the London section of the journal and was often responsible for every London article in early issues. He settled in London in 1790, following his appointment as tutor to the son of George Staunton, the British diplomat. In 1792–3 he accompanied Staunton on a trade mission to China. He wrote on the subject of England for several other German journals, including Bertuch's *Modejournal*, Wieland's *Der Deutsche Merkur* and his own *Englische Miscellen* (1800–7). Hüttner acted as interpreter for the Ministry of Foreign Affairs from 1809 onwards, and remained in London until his death.

[44] Horstig, 'Merkwürdige teutsche Gelehrte in London', *LuP* 11 (1803), 193–9 (198).

[45] See note 48 below.

[46] 'Schirmers teutsches Kindertheater in London', *LuP* 16 (1805), 3–12 (8). Gillray told Hüttner that, although he understood no German, he could see that the German child actor Schirmer was potentially 'a second Garrick'.

[47] His final contribution was sent on 11 August 1807, arriving in Weimar on 24 August 1807.

Schiller archive at Weimar, provide some fascinating information about the manner in which Hüttner and the journal's other correspondents delivered their material to the editor. They were paid by the line or the sheet,[48] and lists of consignments received in Weimar, together with details of their respective fees, suggest that they drafted most or all of each article (some are in fact signed with an initial), although, as will be shown, Böttiger's editorial role was also very significant. Hüttner wrote to Weimar at least every three to four weeks, and the Bertuch papers contain a list of everything received from him from 1798 onwards. Unfortunately many of these items were described simply as 'contribution to *London und Paris*' etc., and it is not always possible to identify them; but as time went on more exact descriptions were given – 'explanation of caricature X'[49] for example. He also sent over the prints themselves, amounting to some two hundred in all, which fortunately were listed by title on receipt (Plate 4).[50] Reimbursement of his expenses reveals that he sometimes bought as many as twelve or thirteen a month in the London printshops, for which he paid between 1 and 2 shillings each. Transmitted via the postal service, they usually arrived in Weimar within three or four weeks of posting, and sometimes even sooner.[51] Hüttner's efficiency in this respect may be compared with the practice of another London correspondent, Nina von Engelbrunner, who also sent batches of caricatures to Böttiger – occasionally choosing the same ones as Hüttner; in order to save money, she

[48] Hüttner was paid 24 Reichsthaler per sheet for his contributions to *LuP* (the printed sheet was calculated at 464 printed lines). Nina von Engelbrunner (see below) received the same, but Horstig in Heidelberg was paid only 20 Reichsthaler per sheet, Schwabe in London 16, and Carl Bertuch in Paris 10. These details appear in an unsigned and undated note among the Bertuch papers, datable on internal evidence before 1806. GSA 06/5541, i; unnumbered folio in a folder marked 'Paris'. The sum of 24 Reichsthaler was worth approximately £3.12.0 in English currency. For information on fees paid to German journalists at the time, see Bruford, *Germany in the Eighteenth Century*, pp. 278–9 and Ward, *Book Production*, p. 90.

[49] 'Herr Hüttners Lieferungen' from 1798 onwards; GSA 06/5537 (Hüttner), folios 22–30.

[50] GSA 06/5537 (Hüttner), and 06/883. In *Karl August Böttiger*, pp. 40, note and 127–8, Karl Wilhelm Böttiger reports that after his father's death his collection of more than 1,000 lithographs, etchings etc., including the caricatures by Gillray and other British artists used for *LuP*, was to be auctioned.

[51] GSA 06/5537 (Hüttner), folio 22.

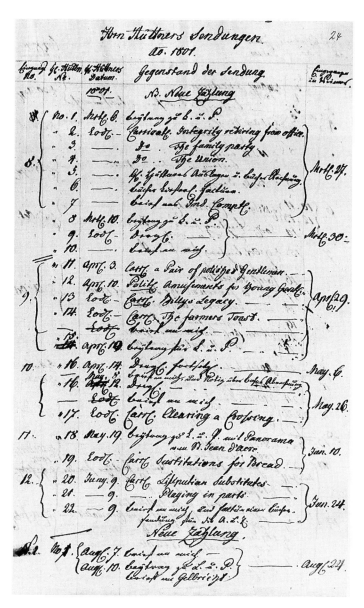

PLATE 4
Page from the listing of prints and contributions to *London und Paris* sent to Weimar by the London correspondent, Johann Christian Hüttner, with dates of posting and receipt.
Goethe- und Schillerarchiv, Weimar.

was in the habit of entrusting them to travellers to Germany, and many did not arrive until several months later – hardly a satisfactory arrangement for the delivery of material which was valued for newsworthiness.[52] Not all the caricatures sent by Hüttner and von Engelbrunner were used; the final selection was evidently made by the editor in Weimar.[53] The prints would then be entrusted to the engraver, and etched copies were produced, which printed in the same direction as the originals. In some cases Carl Starcke signed these copies,[54] which retained the English wording of captions and speech balloons, and attempted to imitate as faithfully as possible the lively drawing, etched and aquatinted shading, and the hand colouring of Gillray's originals. Inevitably, however, there were some errors in transcription, some distortions and deliberate changes, and the copies are uneven in quality. Like the texts of *London und Paris*, the illustrations represent the work of many hands, with the end result at a remove from the source material supplied by the correspondents (Plates 15 and 16).[55]

The records in the Bertuch papers allow one to build up a much fuller picture of these correspondents than has been available until now; they included not only Hüttner and von Engelbrunner but also Schwabe, who was a Lutheran pastor in the east end of London, the peripatetic Horstig, and (in Paris) Théophile-Frédéric Winkler and Carl Bertuch, the proprietor's son,

[52] For example, on 12 June 1805 she dispatched a consignment of material including eleven caricatures, which had cost £1.15.0, sending it via a traveller to save 'three guineas postage'. GSA 06/5537 (Madame Nina d'Aubigny), folio 47.

[53] However, the correspondents were apparently paid for their scripts, whether or not these were used. E.g. Hüttner was paid for an interpretation of Gillray's *The Bear and his Leader* (1806), which was not published in *LuP*. GSA 06/5537 (Hüttner), folio 29.

[54] His name was sometimes spelt Starke or Starck. He also engraved anatomical illustrations and worked on a number of Weimar publications including Schiller's *Musenalmanach*. Ulrich Thieme and Felix Becker, *Allgemeines Lexikon der bildenden Künstler von der Antike bis zur Gegenwart*, 37 vols. (Leipzig: Seemann Verlag, 1907–50), under 'Starke', citing nineteenth-century sources. The *LuP* copies from Gillray signed by Starcke were the largest, most elaborate plates, for which he evidently wanted to take credit, e.g. *Political-Dreamings* and *Dilettanti-Theatricals*, but he may also have executed some of the less ambitious, unsigned ones.

[55] We reproduce *LuP*'s copy of *John Bull taking a Luncheon* (pl. 16, p. 70 below) where the scale of the John Bull figure has become even more monstrous than in Gillray's original.

who was to succeed Böttiger as editor in 1806.[56] However, the extent to which Hüttner was responsible for the final wording of the commentaries on Gillray remains unclear. As we have seen, he was paid for 'explanations' of certain caricatures, particularly of those included in later volumes of the journal; but whether these 'explanations' were just outlines and notes which were substantially expanded by Böttiger, or whether they arrived in Weimar as fully-formed articles which Böttiger simply edited, is not known. In the biography of Böttiger by his son, it was suggested that the editor himself wrote most of the articles in *London und Paris* from mere notes provided by the correspondents:

In Paris and in London (where Böttiger's friend and pupil Hüttner ... proved very useful) diligent colleagues ... were chosen. They sent pictures, pamphlets, vaude-villes with briefly sketched explanations, and whenever these were insufficient for his commentaries Böttiger sought advice from the *Moniteur*, the *Morning Chronicle*, and in particular from the ... English Gore family who lived in Weimar at the time.[57]

Obviously this account may be biased, but some of its details have the ring of authenticity. It is true that *London und Paris*'s commentaries on Gillray very often cite reports in the *Morning Chronicle*, suggesting that it was regularly sent over to Böttiger's office in Weimar. The reference to the Gore family is also revealing: Charles Gore, an English amateur landscape water-colourist of aristocratic birth, had settled in Weimar permanently in 1791,

[56] Little is known of the second major contributor to the London sections of the journal, Nina von Engelbrunner, also known as d'Aubigny (actually Jana Wynandina Gertraud von Engelbronner d'Aubigny). She insisted on anonymity (see letter to Carl Bertuch, 15.1.1805, GSA 06/5537 (Madame Nina d'Aubigny), folio 43) so as to be able to 'write freely'. Although she sent a number of caricatures to Weimar, there is no evidence to suggest that she wrote any of the caricature commentaries in *LuP*. Her contributions focused on theatres, fashion, the royal family and her travels around the country. Although her importance is reflected in the fact that her fee was as high as Hüttner's (see note 48 above), she is rarely mentioned or identified by scholars writing on the journal. Karl Gottlieb Horstig (1763–1835), a clergyman, contributed to both London and Paris sections. Although he is sometimes referred to as a London correspondent, he does not seem ever to have been based in London for a lengthy period. Contributors to the Paris section included not only the young Carl Bertuch (1777–1815) and Winkler (1770–1806), but also Wilhelmina Christiane von Hastfer von Chézy.

[57] Böttiger, *Karl August Böttiger*, p. 40.

and became an intimate of the court circle;[58] he and his daughter Emily are shown, for example, in the famous sketch by G. M. Kraus of an evening gathering at the house of the Dowager Duchess of Weimar, Anna Amalia.[59] It is quite plausible that the Gores would have been consulted on tricky points relative to English politics, national customs and tastes. The balance of likelihood is, therefore, that Böttiger in Weimar worked up or at least polished the texts sent to him by Hüttner and the other correspondents. In fact, the internal evidence of the commentaries themselves frequently suggests such joint authorship; they read as graphic accounts of political affairs and ephemeral news and gossip in London which were given shape, thematic coherence and a range of literary references by a writer of considerable erudition, such as Böttiger was. The many digressions on Greek and Roman archaeology and philology are certainly his, and indeed his contemporaries often accused him of pedantry.[60] However, Böttiger was also best placed to draw on recent German publications, and many of the works cited in the commentaries are by authors in his circle.[61] So far from deadening or confusing the accounts of Gillray and caricature in *London und Paris*, this partnership enriched them immeasurably. Moreover the ambivalences, contradictions even, in attitudes to caricature which the commentaries reveal, while they may represent the interplay between several writers, represent also the gamut of conflicting views held in Germany and Britain at the end of the eighteenth century. We must examine this nexus of enthusiasms and prejudices, for it conditioned all the observations of Gillray's apologists.

Attitudes to caricature

There can be no doubt about the huge popularity of satirical prints at the end of the eighteenth century, for which, indeed, *London und Paris* is one of

[58] Thieme–Becker, *Allgemeines Lexikon*, under Charles Gore.

[59] Bruford, *Culture and Society in Classical Weimar*, pl. 6a.

[60] Cf. p. 212 n. 16 below. Böttiger was satirised by Ludwig Tieck in his play *Der gestiefelte Kater* (1797), where he appears as Bötticher, a connoisseur of the theatre and pedantic scholar, mocked by those around him.

[61] They included Goethe, Herder, Schiller, Wieland, Baggesen and Posselt.

our best sources.[62] Gillray's prints, the first article on him states, are 'very well received by the public . . . You will always see dozens of people standing outside the shops which sell these caricatures' (Plate 5); although, as we later learn, the public 'of high and low birth alike' which 'besieged' caricature shops ranged from discriminating collectors of Gillray's work to those who were easily fobbed off with a poor imitation. Gillray's *Search-Night* entertained 'the entire country . . . for days', while *Political-Dreamings* 'created a sensation even in London, where normally the most remarkable things hardly cause a stir. Indeed, this caricature has been in such demand . . . that Mistress Humphrey . . . had exhausted her entire, very considerable supply after only a few days.'[63] Caricatures carried abroad a peculiar image of Britain as a land, seemingly, of unlimited tolerance, and they were avidly bought by educated Germans for this reason. 'The freedoms which the English allow themselves in this way', wrote Horstig disapprovingly, 'are as well known to their continental cousins, for whom the sight of an English caricature is no longer an oddity, as they are to Londoners.'[64] *London und Paris* reported that even the King of England, George III, laughed at caricatures of himself, and regularly sent over batches of them to the library of the University of Göttingen; presumably as a kind of chronicle of political events, and a proof both of the patriotic spirit of the British people and of the benign liberality of their Hanoverian rulers.[65]

One would expect such widespread – if not universal – appreciation of caricatures in Germany to find expression in print, and there were in fact some favourable precedents for *London und Paris*'s project of interpreting Gillray's designs for the enlightenment of its readers. J. C. Lavater's *Physiognomische Fragmente* (1775–8) impressively set forth the author's

[62] Archenholz in *Annalen der Brittischen Geschichte des Jahrs 1789* 3.8 (1790), 189–90 ('Geschichte der Kunst in England') had also described the milling crowds round the caricature shops, 'where they stare at the latest inventions – of Bunbury perhaps, or Gillray' with 'merriment and pleasure'. Such laughter, Archenholz said, disarmed the critic who came prepared with moral and aesthetic objections to caricature, and reflected 'that happy situation, where every citizen takes a lively interest in political events'.

[63] See pp. 49, 116.

[64] See p. 203.

[65] See p. 192. Lichtenberg had already in 1782 sold his collection of Hogarth prints to the University of Göttingen. Gumbert, *Lichtenberg in England*, vol. II, p. 99.

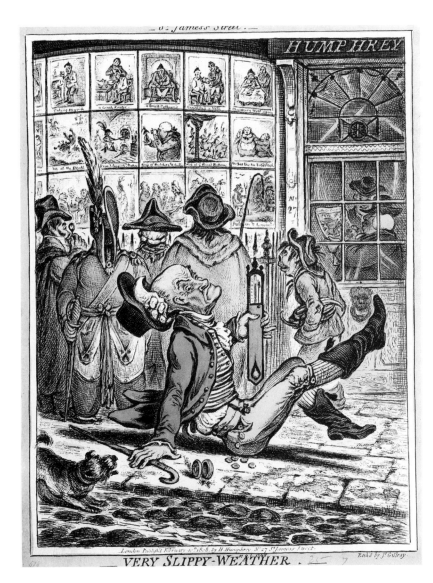

PLATE 5
James Gillray, *Very Slippy-Weather*, 1808.
Etching, hand coloured.

belief in the essential connection between physical features and moral character: Hogarth's expressive physiognomies of the debauched and vicious figured prominently among his illustrations.[66] Translated into English in 1789, the book had enjoyed a great success, and had demonstrably influenced Gillray's powerful caricatures.[67] Of even greater importance for *London und Paris*'s writers, however, were the immensely popular commentaries on Hogarth's prints written by the Göttingen professor Georg Christoph Lichtenberg, which appeared in the *Göttinger Taschenkalender* between 1784 and 1796, and were later compiled as a book, the *Ausführliche Erklärung der Hogarthischen Kupferstiche* (1794–9).[68] From the many laudatory references to this work in *London und Paris*, it is evident that the essays on Gillray's prints were patterned on it, although, as will be discussed, there were some significant differences between them. Even Goethe, who generally disliked caricature, and disapproved of the attention given to Hogarth's

[66] Johann Caspar Lavater, *Physiognomische Fragmente zur Beförderung der Menschenkenntnis und Menschenliebe*, 4 vols. (Leipzig and Winterthur: Weidmann and Steiner, 1775–8). The young Goethe had also contributed to this project. However, Lavater's theories were widely criticised, notably by Lichtenberg. Mare and Quarrell, *Lichtenberg's Visits to England*, pp. 102–3. E. H. Gombrich, 'On Physiognomic Perception', in *Meditations on a Hobby Horse* (London: Phaidon Press, 1963).

[67] There were two such translations. The prime, de luxe version, translated from the French edition of 1781–6, was supervised and partly illustrated by Lavater's friend Henry Fuseli: *Essays on Physiognomy, Designed to Promote the Knowledge and the Love of Mankind. By John Caspar Lavater . . . Illustrated by more than eight hundred engravings . . . Executed by, or under the inspection of, Thomas Holloway. Translated from the French by Henry Hunter D.D.*, 3 vols. (London: John Murray, Henry Hunter, Thomas Holloway, 1789–98). Gillray himself contributed an engraving from a drawing by Fuseli in vol. II (1792), p. 291. A cheaper edition was *Essays on Physiognomy; for the Promotion of the Knowledge and the Love of Mankind . . . Translated into English by Thomas Holcroft*, 3 vols. (London: G. G. J. and J. Robinson, 1789), based on J. M. Armbruster's abridged version of the German text. There were many other popular editions and adaptations of Lavater's text in several languages. John Graham, 'Lavater's Physiognomy: A Checklist' in *Papers of the Bibliographical Society of America* 55 (Jan.–March 1961), 297–308 and 'Lavater's Physiognomy in England', *Journal of the History of Ideas* 22.4 (1961), 561–72. For Lavater's influence on Gillray, see Donald (1996), pp. 171–4, 180–3.

[68] A supplement to *LuP*, *Karrikaturen nach Hogarth und Lichtenberg. Eine nothwendige Beylage zu dem Journal 'London und Paris'*, edited by J. F. E. Albrecht, was published by Vollmer at Hamburg in 1801. *Lichtenberg's Commentaries on Hogarth's Engravings*, translated and introduced by Innes and Gustav Herdan (London: Cresset Press, 1966).

prints through Lichtenberg, acquired a large collection of French political and social satires, and considered publishing commentaries on them in *Propyläen*, a journal he edited with Schiller. He mentioned this 'lichtenberg-ising' project in a letter to Schiller of 1797, just on the eve of *London und Paris*'s inception, but was ultimately deterred, either by doubts over the subject or by the likely cost of reproducing the prints in *Propyläen*.[69] A genre of literary interpretation of graphic imagery[70] was nevertheless well established in Germany before *London und Paris*'s series, not only by Lichtenberg's commentaries on Hogarth, but by the texts which both he and Goethe provided for mildly satirical pocket-book engravings by Chodowiecki and Ramberg.[71] As one of Goethe's fictional characters remarks in *Die guten Weiber* (1800), 'a caricature cannot exist without explanation, and it is only through interpretation that it is animated . . . A caricature without inscription, without interpretation is . . . dumb. Language makes it become something.'[72]

Lichtenberg's analyses of Hogarth's narrative scenes provided a literary model for *London und Paris*'s essays on Gillray, which habitually described him as the most talented British artist since Hogarth, or Hogarth's devoted follower. However, the success of the earlier series could not wholly justify *London und Paris*'s enterprise, for in the eighteenth century a sharp distinction was drawn by both English and German writers between Hogarth's salutary moral satire and the vindictive exaggerations and personalities of the political caricaturist. Georg Forster was typical in this respect when in

[69] 'Recension einer Anzahl von französischer Kupferstiche', in *Goethes Werke, herausgegeben im Auftrage der Großherzogin Sophie von Sachsen*, 55 vols. (Weimar: Böhlau, 1887–1918), vol. XLVII, pp. 350–61. Goethe refers to the collection in a letter to Schiller (24.8.1797) where he suggests that they might be included in the journal *Die Horen*. See *Der Briefwechsel zwischen Schiller und Goethe*, 3 vols. (Munich: C. H. Beck, 1984), vol. I, p. 393.

[70] Cf. also the many German print collectors' handbooks and the practice of reviewing new prints of all kinds in German journals, some years before such reviews were common in England. Clayton, 'Reviews of English Prints in German Journals' and *The English Print*, pp. 262 f. Griffiths and Carey, *German Printmaking*, p. 19.

[71] Alan Marshall, 'Lichtenberg on Chodowiecki and Hogarth', *Publications of the English Goethe Society* n.s. 36 (1966), 83–110. Kunzle, 'Goethe and Caricature', 170–1. Griffiths and Carey, *German Printmaking*, pp. 15–16, 56–62. Anne-Marie Link, 'The Social Practice of Taste in Late Eighteenth-Century Germany: A Case Study', *Oxford Art Journal* 15.2 (1992), 3–14.

[72] Goethe, *Die guten Weiber* in *Goethes Werke*, vol. XVIII, pp. 275–312 (p. 290).

his *Voyage Philosophique et Pittoresque*, based on a visit to Britain in 1790, he condemned the caricaturists for their malice and corruption of taste: 'Combien les modernes dessinateurs en ce genre sont loin d'imiter l'artiste philosophe Hogarth, et de savoir comme lui sonder les profondeurs du cœur humain!'[73] It was this negative strain which surfaced in the clergyman Karl Gottlieb Horstig's brief article in *London und Paris*, entitled 'English Caricatures'. Although it is an interpolation into the series of far more enthusiastic – and better informed – accounts by Hüttner, it is nevertheless in itself quite characteristic of much writing on satire at the period. Caricaturists like Bunbury and Gillray, says Horstig, 'confirm the supposition that those artists who take their tone from the depravity of the common people might well have been moralists on a par with Hogarth, might have acted in the service of virtue, had love of profit not stifled any finer feelings within them, and suppressed all sensitivity to beauty and decorum'.[74]

Horstig's complaints about the obscenity, intrusiveness, disrespect and socially divisive effects of caricature find many parallels in the strictures of British moralists, particularly those influenced by the Tory Evangelical reformers. John Corry in *A Satirical View of London at the Commencement of the Nineteenth Century. By an Observer* (1801) warned that

The caricature and printshops, which are so gratifying to the fancy of the idle and licentious, must necessarily have a powerful influence on the morals and industry of the people. Caricaturists are certainly entitled to the reward which a well-regulated police will ever bestow on the promoters of immorality and profaneness. Their indefatigable study to ridicule oddities of character might be overlooked, and in a few instances their exhibition of vice to derision may be useful, but . . . the greater part . . . are injurious to virtue.[75]

However, when Horstig condemns caricature's affront to beauty, 'the damage that is done to good taste, and the extent to which art – true art – suffers as a result', he strikes a note which is more Germanic.[76] Writers

[73] Georg Forster, *Voyage Philosophique et Pittoresque, sur les Rives du Rhin . . . l'Angleterre . . . etc fait en 1790*, translated by Charles Pougens, second edn, 3 vols. (Paris: F. Buisson, C. Pougens, 1799–1800), vol. III, pp. 243–4.

[74] See p. 204.

[75] (John Corry), *A Satirical View of London at the Commencement of the Nineteenth Century. By an Observer* (London: 1801), pp. 148–9. Cf. Donald (1996), pp. 15–19, 99, 147.

[76] Nevertheless some British proponents of 'high' historical art also deplored the vulgarising

imbued with the idealising spirit of Neoclassicism sometimes invoked caricature as the very antithesis of the purity, harmony and nobility that were the hallmarks of classic art. Lessing in *Laocöon* (1766) criticised the degeneracy of modern painting, where skill in representation was held to justify and redeem any ugly subject. The ancients had rightly relegated artists who chose such low genres to a lower level of esteem. The Thebans had even 'commanded idealisation in art, and threatened digression towards ugliness with punishment'. Their law 'condemned the Greek Ghezzis, that unworthy artistic device through which a likeness is obtained by exaggerating the ugly parts of the original – in a word, the caricature'.[77]

Goethe's attitude to caricature was more equivocal. As we have seen, he collected French satirical prints, and was ready to accept that satires might be worthy of critical attention; but his preoccupation at this time with establishing the principles of an art that was solidly grounded in nature, yet ideal and capable of uniting men in the contemplation of beauty, could only turn him against such a disruptive and disordered art form. Goethe's fictional dialogues on art allowed both the merits and the demerits of caricature to be expressed. The discussion in *Die guten Weiber* seems to have grown out of his experience of writing a text to accompany Ramberg's engraved satires on female vices in the *Taschenbuch für Damen auf das Jahr 1801*, and his more sensitive characters abhor the 'ugly' and the 'hateful' which such illustrations represented. Henriette thinks caricatures are both true to life and 'irresistibly attractive', but Amalia, more virtuously, deplores the way in which caricature distorts the reputation of worthy men: it is now only possible to 'picture Pitt as a broomstick with a turned-up nose, and Fox as a well-stuffed pig' – a clear indication that Goethe was familiar with English political prints.[78] In 'The Collector and his Circle' ('Der Sammler und die Seinigen'), published in *Propyläen* in 1799, Goethe's cultured conversationalists decide to categor-

effect of caricature on public taste. Diana Donald, '"Characters and Caricatures": the Satirical View' in *Reynolds*, edited by Nicholas Penny (London: Royal Academy and Weidenfeld and Nicolson, 1986), p. 360. Donald (1996), pp. 27–30.

[77] Gotthold Ephraim Lessing, *Laocöon: an Essay on the Limits of Painting and Poetry*, translated by Edward Allen McCormick (Baltimore and London: Johns Hopkins University Press, 1984), pp. 12–13. Pierleone Ghezzi was a well known eighteenth-century Italian caricaturist. Cf. Shearer West, 'The De-formed Face of Democracy', in *Culture and Society in Britain, 1660–1800*, edited by Jeremy Black (Manchester University Press, 1997), p. 167.

[78] Goethe, *Die guten Weiber*, pp. 281–2.

ise artists and art lovers into types – each type being one-sided in itself, but valuable when all are balanced out and combined, especially when the opposing qualities of 'Earnest' and 'Play' are united. Among these six categories are the 'imaginers', representing 'Play', who reject true natural appearances, the proper study of the visual artist, in favour of the poet's flights of fancy: imaginers are 'Phantomists . . . attracted to empty ghosts, Phantasmists because they included dream-like distortions and incoherence, Nebulists, because clouds were the most appropriate foundation for their airy imaginings'. The Swiss painter Henry Fuseli, who had settled in England, is cited as the very epitome of an 'imaginer', with his 'strange fairies and spirit shapes . . . moving and interweaving dreams'. However, Julie, the narrator at this point, also counts herself among the derided imaginers: 'they asked me whether I must not admit that satirical caricatures, the greatest destroyers of art, taste and morals, were not the logical development of this tendency. Certainly I could say nothing in defence of them, although I must also confess that these ugly things sometimes amuse me, and that *Schadenfreude*, that original sin of all the tribe of Adam, is, if highly spiced, a not unsavoury dish.'[79] It is fascinating that the 'phantasmic' and the satirical could thus be associated; and indeed the characterisation of the imaginers' excesses sounds like a description of many of Gillray's prints which were featured in *London und Paris*, such as *Effusions of a Pot of Porter* and *Political-Dreamings*. Gillray seems to have known Fuseli, in fact, and many of his designs were free parodies of Fuseli's Shakespearean and Miltonic scenes, the element of eccentric fantasy being pushed to its limit, in what Gillray called a 'Mock Sublime Mad Taste'.[80] Imagination of this kind, when unbridled by reason, led artists astray, but Goethe's characters have to agree with Julie that it is

[79] John Gage, *Goethe on Art* (London: Scolar Press, 1980), pp. 38, 66–8, 71, and cf. 47. Kunzle, 'Goethe and Caricature', 168–70. Werner Hofmann, 'Play and Earnest: Goethe and the Art of His Day', in *The Romantic Spirit in German Art 1790–1990*, edited by Keith Hartley et al. (Edinburgh: Scottish National Gallery of Modern Art and London: Hayward Gallery, 1994), pp. 19–27.

[80] Hill (1965), pp. 35, 45, 90, 147–8. Jonathan Bate, 'Shakespearean Allusion in English Caricature in the Age of Gillray', *Journal of the Warburg and Courtauld Institutes* 49 (1986), 196–210. Donald (1996), p. 73. For Fuseli's and Gillray's joint association with the English edition of Lavater's *Physiognomy*, cf. n. 67.

also the hallmark of genius, and an indispensable constituent of 'the highest art'. Such complex and vacillating judgements form the intellectual ambience within which *London und Paris*'s commentaries on caricature must be situated; but whether Gillray was a great artist *because of* or *in spite of* his gift for satire could never be satisfactorily resolved.

Gillray observed: a portrait of the artist

Such was the disdain for political caricaturists in eighteenth-century Britain that they were accorded few personal memorials. As has been mentioned, there were no contemporary biographical notices of Gillray in the British press, no obituaries and few published posthumous accounts by those who had known him, Henry Angelo's reminiscences being almost the sole exception.[81] This dearth of primary sources gives a unique value to the details of Gillray's life and character provided by *London und Paris*, on the basis of Hüttner's meetings with the artist himself. Gillray may have had some interest in German culture through his family's membership of the Moravian community,[82] and, even if he did not speak German, he can hardly have failed to be aware of *London und Paris*'s project, or to have been gratified by it. The idea of treating him as a second Hogarth, and giving his works such expansive and admiring critical attention, must have been some solace for the slights he felt he had suffered in his own country.

A sense of injury and an urge to self-justification lie not far below the surface in the biographical sketch of Gillray which appeared in volume 1. Having 'studied hard' at the Royal Academy's school, Gillray graduated to the role of an historical engraver, and his print of *The Loss of the Halsewell East Indiaman*, published by Wilkinson in 1787 (Plate 6), was, according to *London und Paris*, among several that were 'very well received' by the public. This pathetic shipwreck scene, from a painting by Northcote, was one of a group of proto-Turneresque depictions of disasters at sea which

[81] Donald (1996), pp. 22, 36f.

[82] Hill (1965), pp. 8–13. In Gillray's *Two-Penny Whist* (1796), apparently showing a quiet domestic card party at Mrs Humphrey's, her partner has been identified as a German friend of the artist and his publisher. Hill (1976), pl. 38 and p. 109. Cf. n. 46.

PLATE 6
James Gillray after James Northcote, *The Loss of the Halsewell East Indiaman*, 1787.
Engraving and etching.

Gillray either designed himself or engraved after Northcote in the 1780s.[83] Its emotional turbulence, swirling compositional rhythms and heightened expressions prefigure the imaginative style of Gillray's later caricatures, but may have been too extreme to recommend him as a serious reproductive engraver. At any rate, Gillray's contribution to the work was not acknowledged in the publication line, and this omission possibly explains his concern to establish authorship in the pages of *London und Paris*. A greater dis-

[83] Hill (1965), pp. 26–7, 28–9, pl. 25. Clayton, *The English Print*, p. 223.

appointment was to follow in his rejection by the print publisher Boydell as one of the team of engravers working on the prestigious Shakespeare Gallery project.[84] *London und Paris* provides intriguing information that Gillray's revenge was not restricted to satires like *Shakespeare – Sacrificed; – or – The Offering to Avarice* (1789), but took the form of a 'brilliant and biting letter' to Boydell in the press, presumably anonymous. This was apparently one of a number of excursions into newspaper journalism or correspondence in the early 1790s, but their subjects are not revealed.

Gillray's feeling of having been exploited by the publishers, yet ultimately written off as a serious artist, is especially evident in the account he gave the journal of his portrait engraving of Pitt. Several competing portraits of the Prime Minister were commissioned in the spring of 1789, to commemorate his political triumph in the outcome of the regency crisis;[85] but because Gillray 'captured his features exactly, reproducing the cold darkness of his features, a more flattering portrait was demanded'. Both this engraving for Samuel Fores and another portrait of Pitt, which Gillray seems to have published on his own account (Plates 7 and 8), do indeed have an unflattering physical exactness in their definition of the long tilted nose pulling at the upper lip, the receding chin and flabby jaw, which complements the extreme tension, arrogance and disquieting directness of Pitt's stare. It is a world away from the patrician grace and aplomb of Sherwin's engraving of Pitt from a portrait by Gainsborough (Plate 9), and reveals once again both Gillray's inaptitude for the requirements of successful 'high' art practice, and, at the same time, what *London und Paris* called his 'pronounced gift' for caricature.

There are some surviving letters to Fores about the Pitt portrait, which are printed for the first time here (Appendix, pp. 260–5 below); they confirm the commercial competition with Sherwin, and the fact that the proof of

[84] See *Search-Night*, n. 22, p. 56 below.

[85] Hill (1965), pp. 31–3, pl. 24. Marcia Pointon, *Hanging the Head: Portraiture and Social Formation in Eighteenth-Century England* (New Haven and London: Yale University Press, 1993), p. 99. Donald (1996), pp. 31, 165. Edward Gibson, Lord Ashbourne, in *Pitt: Some Chapters of his Life and Times*, second edn (London: Longmans, 1898), has an appendix by G. Scharf, 'A Catalogue of all known portraits . . . of William Pitt'. A. D. Harvey, *William Pitt the Younger, a Bibliography* (Manchester University Press, 1989), section XI.

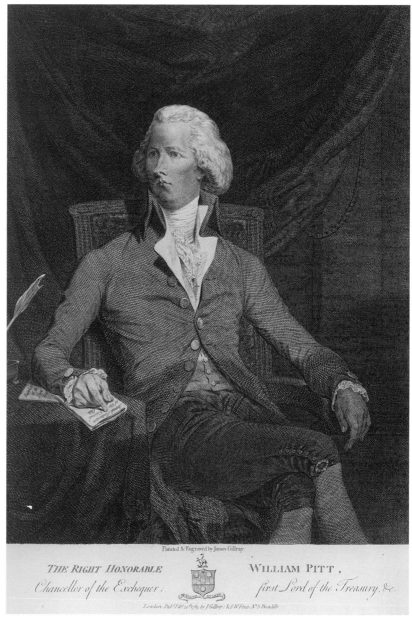

PLATE 7
James Gillray, *The Right Honorable William Pitt*, 1789.
Engraving and etching.

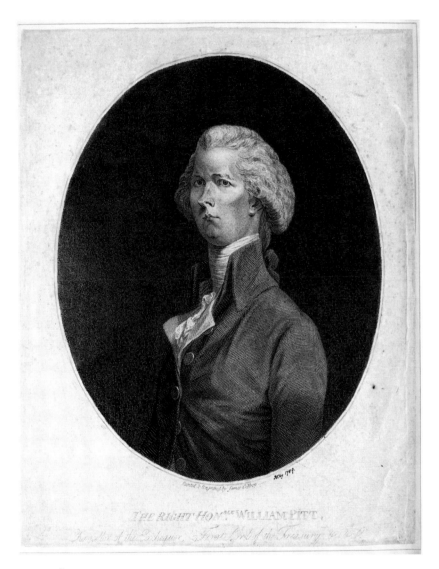

PLATE 8
James Gillray, *The Right Honble. William Pitt*, 1789.
Engraving and etching.

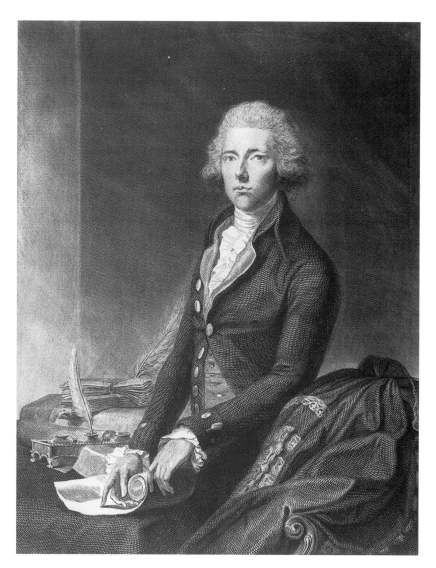

PLATE 9
John Keyes Sherwin after Thomas Gainsborough, *William Pitt*, 1789.
Engraving and etching.

Gillray's print was cruelly criticised by his publisher. In these letters Gillray's habitual sense of humiliation, his anxiety and wounded sensibilities are painfully exposed. The cynical and depressive side of the artist's personality, which Angelo was later to describe most convincingly,[86] was not, however, mentioned in *London und Paris*. Instead, Hüttner's articles emphasised Gillray's kindness to his family, and represented him as a simple man of principle, attributing his faithful service of Pitt after 1797 to patriotism and political conviction, and rejecting suggestions of any mercenary motive.[87] These were, after all, current reports on the activities of an artist who was well placed to feed *London und Paris*'s journalist with inside information on satire and politics, perhaps even to give him a sight of suppressed prints: too much offensive candour would have been inadvisable. Conceivably Hüttner was not aware of the darker aspects of Gillray's character, for the artist's notorious reticence stood in the way of a genuine intimacy. For whatever reason, the portrayal of him in *London und Paris* gave the German readers an impression which corresponded more closely to the satires they admired than to the vulnerable Gillray revealed by the letters. 'Witty' or 'mischievous' or 'mocking' Gillray, as he is often characterised in the commentaries, is supposedly a gleeful and uninhibited observer of the passing scene, the effortlessly inventive and 'merciless scourge' of powerful politicians. In the first biographical sketch he is described as an 'extremely well-informed and widely-read man, pleasant in company, with an effervescent wit'. Later Hüttner conveys what was probably a truer perception of Gillray: 'no one would guess this gaunt, bespectacled figure, this dry man, was a great artist'.[88] It was as a 'great artist', however, that *London und Paris* intended Gillray to be known and remembered.

His extensive literary knowledge of every kind; his extremely accurate drawing; his ability to capture the features of any man . . . his profound study of allegory; the novelty of his ideas and his unswerving, constant regard for the true essence of caricature: these things make him the foremost living artist in his genre, not only amongst Englishmen, but amongst all European nations.[89]

[86] Donald (1996), pp. 31, 41, and cf. pp. 42–3.
[87] See pp. 56, 247.
[88] See pp. 56, 246–7.
[89] See p. 245.

These qualities were amply illustrated in the commentaries on individual prints; the ability of Hüttner and Böttiger to illuminate what it was that contemporaries saw in Gillray's *art*, however little could be learnt from talking to the artist, constituted the enduring value of their enterprise.

The interpretation of Gillray's work in *London und Paris*

The articles on caricature in *London und Paris* – a continuous series starting in the first issue, working up to a high point of richness and complexity, and then tailing off under the pressures of war – aimed at far more than a collector's catalogue or gossip column. Their model, as has been noted, was the widely read series of essays on Hogarth's prints by Lichtenberg. In the preface to these commentaries Lichtenberg discusses two possible methods for interpreting such satires: the 'prosaic' and the 'poetic'. The 'prosaic' would simply explain 'the meaning of things', and would be restricted to factual description. It was the 'poetic', however, which Lichtenberg adopted in his response to the imagery of Hogarth; he explains the facts of each satire, but employs 'a language . . . which brings to life a certain mood, which is as similar to the mood of the artist as possible . . . What the artist has *drawn* must now be *said* as he himself might have *said* it, had he been able to guide a pen as well as he could guide the burin.'[90] Thus Lichtenberg offers an imaginative interpretation of characters, actions and expressions, in which every detail, even of inanimate objects, played its part in the chain of speculative ideas and allusions. The reader is engaged in an enjoyable conversation with the author, and the playfully digressive style has something of Sterne, whom *London und Paris*'s writers also frequently bring to mind. Evidently Lichtenberg's 'poetic' method was fundamental to their whole approach. This is apparent in the very first commentary on a Gillray print, *Search-Night*, which cites Lichtenberg's 'unsurpassed' account of Hogarth's *The Rake's Progress*. In the description of *Search-Night*, much attention is given to the facial expressions of the participants, and to the significance of the scattered objects – emblems of the varied characters, or

[90] Lichtenberg, *Gesammelte Werke*, 2 vols. (Frankfurt am Main: Holle Verlag, 1949), vol. II, pp. 671–81 (p. 672).

incriminating evidence of their supposed fealty to the ideals of the French Revolution. Gillray has 'inherited much of Hogarth's spirit'; and the appended biographical sketch of the artist was clearly designed to confirm his status as a natural successor to Hogarth, and hence a legitimate subject for *London und Paris* to bring before the German reading public.

It was inevitable, however, that there should be differences between Lichtenberg's approach to Hogarth and *London und Paris*'s treatment of Gillray. Lichtenberg was describing dramatic fictions, and copious information on the social mores they depicted was available to him in the many existing English commentaries on Hogarth's prints;[91] Hüttner and his colleagues were dealing with the raw stuff of actual politics, and with designs that, in the usual manner of political satires, were crammed with overt symbolism and literary references. Gillray's vivid physiognomies, his 'ability to capture the features of any man', certainly continued to interest *London und Paris*'s writers, but they may have been disinclined to concentrate on this aspect of his work in the long run, through a consciousness of the inevitable loss of subtlety entailed in the process of copying the faces in the prints. The virtue of their commentaries is rather the combination of accurate knowledge of the events Gillray represented with an astonishing range of references to European art, literature and folklore; the aptness and suggestive power of many of these allusions succeed in creating an ambience for Gillray's subjects analogous to Lichtenberg's more personal play of reflections inspired by the imagery of Hogarth. For the twentieth-century historian, *London und Paris*'s articles on Gillray have the additional value of affording at least some insights into the mental world of those who first laughed at his prints. A modern English reader may sometimes feel that the references to Greek and Roman authors are overdone; but precisely these witty analogies could have occurred also to classically-educated Britons, explaining why, as Hüttner reported, 'it is only in Mrs. Humphrey's shop, where Gillray's works are sold, that you will find people of high rank, good taste and intelligence'.[92]

[91] Lichtenberg refers specifically to the writings on Hogarth by André Rouquet, John Trusler, Horace Walpole, William Gilpin, John Nichols and John Ireland.

[92] See p. 246.

All these allusions – encompassing the works of Homer, Horace and Shakespeare, antique and Renaissance artists, but also Reformation propaganda, popular songs and the crude woodcuts on ballad sheets – explain or expand the dense intertextuality of the prints themselves, and are integrated by the writers' apprehension of what the prints mean. Gillray's caricatures work at many levels, and *London und Paris*'s effortless transitions from 'high' to 'low' culture are in sympathy with his own methods. In the mordant humour of *L'Insurrection de l'Institut Amphibie* Gillray had projected the grim *realpolitik* of imperialism underlying Napoleon's cultural programmes in Egypt; and at the same time, like another Edmund Burke, the artist satirised the utopian plans of French rationalists for universal reform of human society. *London und Paris*'s tongue-in-cheek commentary heightens the satire with its tales of ambitious projects for 'l'éducation du crocodile' in the ancient world, solemnly citing Aristotle, Pliny, Dio Cassius, Strabo, Seneca and several other authorities. Through this absurd recital one becomes more aware of the constant element of parody in Gillray, and more inclined to join the game of source-hunting. The agonised Frenchman seized by the crocodile, for example, seems to be a comic version of the ancient statue of Laocoon killed by serpents, which Winckelmann, Lessing and Goethe had discussed as an exemplar of noble and restrained expression of suffering in Greek art. Goethe had only recently reminded his readers of how Laocoon grips a snake which 'being now irritated, bites him in the haunch'.[93] None of this learned badinage prevented the spectator from enjoying Gillray's idea as pure slapstick, and most people looking in Mrs Humphrey's window probably saw nothing more than a patriotic joke on the follies and disasters of Frenchmen. *The Plumb-pudding in danger* was another print which, in the words of *The Athenaeum*'s article on Gillray many years later, was 'adapted to all comprehensions'.[94] By analogy, *London und Paris*'s description begins with joky but perceptive remarks on English caricaturists' obsession with eating, referring this to the popular stereotype of 'Jack Roast Beef' in novels and poetry; and leads on

[93] Goethe, 'Über Laokoon' in *Propyläen* 1.1 (1798), 1–19 and *Goethes Werke*, vol. XLVII, pp. 96–118; Gage in *Goethe on Art*, pp. 78–88, reprints an English translation which appeared in the *Monthly Magazine* 7 (1799), 349–52, 399–401. See Gage, p. 82.

[94] 'James Gillray, and His Caricatures', *The Athenaeum* 205 (1 Oct. 1831), 632–4 (634).

to the shockingly physical image of the world-pudding with Pitt and Napoleon as monstrous diners. But the inspired quotation from Schiller's *Am Antritt des neuen Jahrhunderts*, which offered a remarkable precedent for Gillray's choice of symbols, changes the mood from black humour to anger and tragedy. Real events in the whole of Europe thus dominate the conclusion, and *London und Paris*, recently forced to move from Weimar to Halle by fear of Napoleon, makes an unusually open and impassioned appeal to the enlightened German public to resist censorship and tyranny.

Reading essays of this kind, one is bound to speculate on how far Gillray himself knew or comprehended the many references which enrich *London und Paris*'s interpretations of his prints; and it is worth remembering the 'extensive literary knowledge of every kind' and 'profound study of allegory' with which the journal itself credited him. Hüttner and his colleagues may not have known the full extent of the secret traffic of politicians and political agents up and down Mrs Humphrey's back stairs, or of the secret correspondence which conveyed sponsors' ideas and instructions to the artist:[95] collaborations which the variant forms of his signature denoted.[96] It is likely that the germ of many of Gillray's graphic inventions came from these patrician patrons. However, *London und Paris*'s commentaries demonstrate the acute insight with which he applied quotations from the classics, Shakespeare or Milton to the political situation of the day, and the imagination with which he transformed them into pictorial images: qualities which can only have come from the artist himself. Gillray's great gift, as *London und Paris* proves, was for clothing political messages in visual forms, in which 'not a single line is drawn in vain', and all this restless elaboration

[95] For covert political sponsorship of Gillray, see Josceline Bagot, *George Canning and His Friends, Containing Hitherto Unpublished Letters, Jeux d'Esprit etc.*, 2 vols. (London: John Murray, 1909), vol. 1, pp. 54f., 135f.; Hill (1965), especially chs. 6 and 10; Donald (1996), pp. 26, 165–6. British Library Additional MS. 27337, 'Correspondence of James Gillray . . . 1796–1820', contains a number of letters sent to the artist with ideas and sketches for caricatures.

[96] 'Invt. & fect.' indicated Gillray's own conception, while 'des. & fect.' denoted a contributed idea. Plates which were closely based on someone else's drawing were signed simply 'fect.' Those that the artist considered as merely popular pot-boilers were sometimes unsigned. Hill (1965), pp. 58–9, 64 n. 1. *LuP* did not attempt to retain these distinctions when the prints were copied.

gave the journalists plenty to work on. The essays were written at a time when the incisive linear detail of early German prints was beginning to be admired,[97] and when claustrophobic and hallucinatory effects interested many German artists,[98] so that these aspects of Gillray's etchings may have appealed to *London und Paris*'s readers. However, the writers were also at pains to show how even in the most complex prints the plethora of discordant motifs resolves itself into a unified composition, and how the masses and rhythms of *the whole* are informed by political meaning. In *L'Assemblée Nationale*, for example, a 'broad-bottomed' administration in process of formation is punningly embodied in the grotesque bulk of Sheridan, Buckingham and Fox; and through ingenious superimpositions – thin people above fat ones producing pear-shaped configurations – 'everything in this colourful national assembly is broad-bottomed in every sense of the word'. Similarly, the idea of a transfer of allegiance from the declining King to the Prince Regent-in-waiting is expressed by the whole movement of the composition: the 'active' and 'passive' forces in each group, the waxing and waning lights symbolising political illumination or eclipse, the flux of the transient crowd – 'those who have already arrived and those who are arriving' – even the wine flowing into and, by figurative implication, out of bodies. All this reminds *London und Paris*'s writers of Schiller's description of the dance – ever forming and dissolving, yet ever composed – but it could also be described as a kind of political physiognomy, in which each shape manifests the urges of the protagonists. As Fuseli had written in the *Advertisement* for Lavater's *Essays on Physiognomy* in the English translation of 1789, which Gillray certainly knew: '*The immediate effect of form* on every eye, the latent principle which is the basis of that effect . . . the influence derived from this impression on conduct and action . . . are self-

[97] Many collectors, including Goethe, were interested in fifteenth- and sixteenth-century German and Netherlandish prints, although Goethe disliked the archaising tendencies they gave rise to in contemporary art. Bruford, *Culture and Society in Classical Weimar*, p. 151. Gage, *Goethe on Art*, pp. xi, xv. Griffiths and Carey, *German Printmaking*, pp. 11, 24.

[98] See e.g. William Vaughan, *German Romantic Painting* (New Haven and London: Yale University Press, 1980), pp. 32–3, on the work of Karl Wilhelm Kolbe. The etched versions of Philip Otto Runge's visionary *Times of Day*, with their intricate linear detailing, date from 1805.

evident truths, and need as little to be proved as the existence of smell or taste.'[99]

It was Gillray's ability to organise the dramatic actions of disparate groups into the effect of 'a single whole' which most impressed *London und Paris*'s writer, and entitled him 'to the highest regard as an artist'. 'Materiam superabat opus'; the achievement of the artist had transcended his contemptible subject matter.[100] *London und Paris* frequently reiterated this compliment. Despite the malice and partisanship of Gillray's sponsors, of which the writers were increasingly aware, the genius of his embodiments could still be admired. In *Political-Dreamings!* Gillray's fantastic visualisation of the mental obsessions of the loyalists proved that he 'is in fact destined for something quite different from the slavish service of a political faction through his caricatures'.[101] Discussing *End of the Irish Farce of Catholic-Emancipation*, the writer invites the reader to

ignore for the moment all the mockery and sarcasm, inspired by party-political rage, which no reasonable Protestant would ever condone. What deserves our respect in this caricature is the splendidly conceived composition and poses of the figures, which would be worthy of a nobler subject. Look at the energy with which the violent movement of the four principal figures is conceived and executed! Despite the bold placing, everything is in perfect order . . .

The powers of comprehension with which an artist interpreted a complex narrative, and the pictorial lucidity of his exposition, were indeed recognised as the key qualities of history painting in the grand style, and *London und Paris* did not hesitate to compare Gillray's satire favourably in this respect with Raphael's fresco of *The Repulse of Attila* in the Vatican (Plate 34). There, too, the composition involved an expressive contrast of figure groups, with an advancing barbarian horde suddenly repelled by divine intervention. To appreciate to the full Gillray's invention in the spirit of the most admired of old masters, it was only 'necessary . . . to ignore the inten-

[99] *Essays on Physiognomy* translated by Hunter (see n. 67 above), opening of vol. 1. Marcia Allentuck, 'Fuseli and Lavater: Physiognomical Theory and the Enlightenment', *Studies on Voltaire and the Eighteenth Century* 55 (1967), 89–112, especially 106.

[100] See p. 185.

[101] See p. 122.

tional exaggeration which is a law of caricature'.[102] But how could it be ignored? Gillray may have proved himself to be one of the most attentive and intelligent pupils of the Royal Academy, but his adaptations of classic prototypes were never innocent. Even here, there must be an intentional irony in the transformation of Raphael's allegory of papal supremacy into a scene which celebrated the defeat of a Catholic challenge to the Protestant ascendancy in Ireland. The work of art may again have 'surpassed its subject matter', but Gillray's mastery was *inseparable from* his intention of creating an appropriate and witty visual symbol for political opinions, or what *London und Paris* itself described as his 'unswerving, constant regard for the true essence of caricature'.

It was this paradox which lay behind many of *London und Paris*'s comments on Gillray's prints, and which explains some of its confused polemic on the status of caricature as an art form. In *Integrity retiring from Office*, the 'calm, sedate grandeur' of Pitt's group, strikingly opposed to the 'frenzied, raging violence' of the Foxites, 'genuinely fulfils the demands of high art', even if haughty critics refuse to acknowledge that a caricature can have such aesthetic qualities. Here the provocative and perhaps mischievous echo of Winckelmann's definition of the supreme qualities of Greek art reminds us that Böttiger was once accused of publishing a satirical spoof, which mimicked the solemn judgements on works submitted to Goethe's art competitions in Weimar with their Homeric themes.[103] The Neoclassical ideal of 'calm grandeur' and beauty properly excluded the grotesque 'phantasms' which Goethe had reprimanded in 'The Collector and his Circle', and which were so prominent in Gillray's satires.

However, *London und Paris*'s quarrel with the champions of classicism ran deeper than arguments over the admissibility of the ugly and the base into the sphere of high art. According to Lessing in *Laocöon*, great paintings are ideal and necessarily static images of visible appearances, in which the artist rejects any misguided ambition to simulate the temporal nature of poetic narrative, or to emulate its powers of suggestion.[104] Gillray flouted

[102] See p. 242.

[103] Bruford, *Culture and Society in Classical Weimar*, p. 361, referring to a notice in the Leipzig *Zeitung für die elegante Welt* in 1802.

[104] Cf. Goethe's complaint that 'In the work of Fuseli poetry and painting are always in conflict.'

such classical purism in every possible way: in his wayward parodies of epic literature; in his emphasis on motion and impermanence, epitomised in *L'Assemblée Nationale*, which ran counter to the academic requirement of simultaneity; and in his evocation of fleeting phenomena which lie beyond, but continually invade, the material world – dreams, apparitions and arbitrary but vividly embodied metaphors. For Lessing, the highest art is the voluntary production of autonomous genius, art for beauty's sake which has freed itself from 'external constraints', such as the requirements of royal or priestly patrons; for in his eyes it is the political which contaminates the aesthetic, leading the artist astray by its imperious demands for 'every sort of flattering allusion' and overt symbolism alien to the proper character of painting. No such 'stimulus lying outside the domain of art' can, in Lessing's view, inspire a great work: as we have seen, Gillray's art was wholly contingent on such extraneous stimuli.[105]

In a footnote to *French Invasion*,[106] *London und Paris* cautiously challenged Lessing's theories on the mutual incompatibility of literature and the visual arts, for the flow of ideas between them, as this commentary in particular revealed, was fundamental to its view of satire. But in the discussion of 'caricature allegory', admittedly a 'bastard foundling' of the great European art traditions,[107] illustrations of the promiscuous interchange between word and image were not the only way in which the tenets of high art might be challenged; for *London und Paris*'s writers do not acknowledge a difference in kind between the most revered masterpieces and the despised works of the caricaturist. *French Invasion*, which Gillray himself disowned as a crude product of the propaganda war with France, is given a context that embraces Homer, Virgil, Poussin and Le Brun. Moreover, the history painters of the day such as Van Brée, author of a mediocre allegory of Napoleonic triumph, only 'delude themselves that they are on a far higher plane' for they 'actually vie with the lowest caricaturists in their aggrandise-

'No true work of art should seek to play on imagination: that is the concern of poetry'. Gage, *Goethe on Art*, p. 220. The association between Fuseli and caricature in Goethe's mental system has already been noted.

[105] Lessing, *Laocöon*, pp. 55–6, 96.

[106] See p. 165, n. 15.

[107] See p. 172.

ment of the French and disparagement of the British';[108] Gillray used the same symbols as they did, to better effect. The service of politics was therefore not peculiar to caricature, nor was it restricted to present-day artists: in the description of Gillray's *Confederated-Coalition*, *London und Paris*'s writer traces its lineage from the court allegories of the sixteenth century and even from one of Rubens's most admired mythologies, originally forming part of the decorations for the triumphal route of a Cardinal Infante of Spain. In his madness poor Gillray apparently believed he was Rubens,[109] and one can imagine the pleasure which he would have derived from this comparison with the energetic, boldly conceived fantasies of the Baroque. In the pages of *London und Paris*, if not in the wider art world, cultural hierarchy was dissolved, and Gillray's 'endlessly fertile imagination' for once received a worthy tribute.

[108] See p. 162.
[109] Hill (1965), p. 146.

I *Gillray and Mrs Humphrey: The Latest Caricature*[1]

I (1798), 23–5 8 March

I see that Gillray the artist is still producing his caricatures. They are very
well received by the public; not one of his imitators comes even close to his
achievements. This man has studied the human form so assiduously and
successfully that each line he draws, though it may be distorted, is never out
of proportion to the whole, or more exaggerated than the idea requires. He
always stops just where the intelligent observer would wish him to. I was sur-
prised to see that his publisher Mrs Humphrey has now moved to St James's
Street, which leads directly to the Palace and which is frequented by courti-
ers, aristocrats, guards, spies and informers at all times of day.[2] You will
always see dozens of people standing outside the shops which sell these cari-
catures. Recently Gillray issued a series of prints on the French invasion.[3]
One shows the French just after they have landed, wearing shapeless hats and
enormous jackboots. They have long pigtails, gaunt faces, thin bodies, their
frock-coats are torn and ragged, and they carry huge hunting whips. Standing
behind the English, they are teaching them how to till the fields. These
English people are clergymen, farmers and husbandmen; men, women and
children, all standing in a row and harnessed to the plough, wearing, you'll
note, the wooden shoes commonly found in Picardy and elsewhere in France
(sabots), which the English loathe.[4] Another print shows Parliament, its

[1] [In both title and text, Gillray is misspelt as 'Gilroy' or 'Gillroy', and Mrs Humphrey as
 'Humphreys', while St James's Street is called 'St Jame's Street'. Such inexactitude with names
 is typical of *LuP* and common at the period.]

[2] [Hannah Humphrey moved from New Bond Street to 27, St James's Street in April 1797. Hill
 (1965), p. 86 n. 4. Donald (1996), p. 166.]

[3] [*Consequences of a Successfull French Invasion* (*BM* 9180–3) was commissioned by Sir John
 Dalrymple as loyalist propaganda, but the series was never completed. George (1959),
 pp. 35–6. Hill (1965), pp. 73–80, pls. 69–72. Donald (1996), pp. 174–5.]

[4] [*Me teach de English Republicans to work – Scene. A Ploughed Field* (*BM* 9182).]

45

The Storm rising ;— or —— the Republican

PLATE 10
James Gillray, *The Storm rising; – or – the Republican Flotilla in danger*, 1798.
Etching, hand coloured.

insignia broken and a guillotine erected on the table. At the side of the table
the members stand chained to one another, their heads shaved.[5] The Speaker,
still wearing his periwig, is the most amusing figure. A large padlock has been
clamped across his mouth and his face is contorted with rage as a sansculotte
places handcuffs on him. But I think the best print shows the approach of what
is supposed to be a large raft, containing windmills, castles and all the murder-

[5] [*We come to recover your long lost Liberties. – Scene. The House of Commons* (*BM* 9180). The
guillotine actually figures in the scene set in the House of Lords (*BM* 9181).]

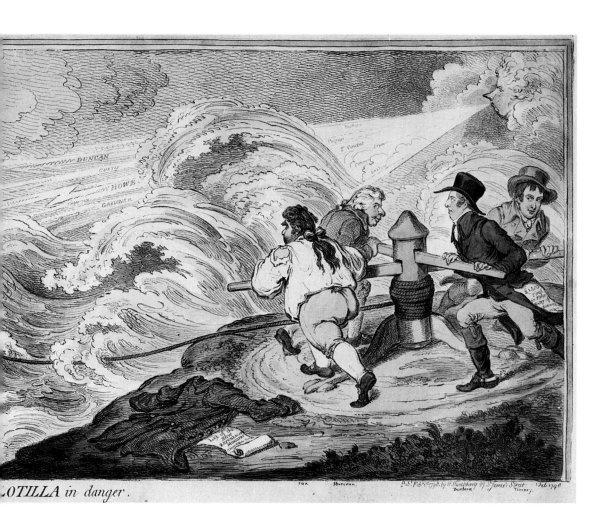

LOTILLA in danger.

ous instruments with which the French are threatening the English. On the shore we see a capstan or ship's winch with a rope, which is being turned by fat Fox (looking for all the world like a thresher), mean, 'cropped' Bedford, Erskine baring his teeth, and a fourth member of the Opposition; all puffing and panting, their exertion clearly visible. A rope leads from the capstan through the water to the ship, hauling it in. The fat-cheeked winds, whose gusts bear the names of the great saviours of the nation – Howe, St Vincent, Duncan, Bridport, Onslow, Pellew, Sidney Smith etc. – are trying as hard as they can to blow the terrifying machine away.[6] I cannot begin to describe the

6 [*The Storm rising; – or – the Republican Flotilla in danger* (BM 9167) (Plate 10). George (1959), p. 35. The Whig 'collaborators' featured here are in fact Fox, Sheridan, Tierney and Bedford,

impression which this characteristic print makes on all who see it. The four figures pushing the levers are the spitting images of the people in question.

Footnote 6 (*cont.*)

and *LuP*'s description of the wind and its inscriptions is also inaccurate. The writer may be remembering some details of Isaac Cruikshank's similar design, *The Raft In Danger or the Republican Crew Disappointed* (*BM* 9160). Here there are three 'winds' – Dundas, the King and Pitt – whereas Gillray shows only Pitt; and Cruikshank also includes Erskine as a winged head flying alongside the French raft.]

2 *Search-Night; — or — State-Watchmen, mistaking Honest-Men for Conspirators*[1]

1 (1798), 195–204, pl. IV

Witty Gillray[2] published the print we have copied here early last spring, at a time when the numbers of 'state arrests' were mounting steadily. The entire country was entertained for days by this piquant offering, which attacks the most distinguished members of the Opposition. These gentlemen have gathered at midnight to plot against their country; but Pitt and Dundas have successfully sniffed them out at their nocturnal meeting in one of the most disreputable houses in St Giles. The ministers appear at the tightly bolted door, barricaded with planks of wood from the inside. They have just forced open the upper half of the door, splintering its planks with a terrible crack. Pitt, the night-watchman, triumphantly shines his lantern into the room, his pointed greyhound's nose growing even longer at the sight of the game he has successfully tracked down. War Minister Dundas, immediately recognisable by the Scottish plaid thrown over his shoulder, plays the part of a state messenger, as we see by the crown embroidered on his sleeve. Thanks to his official 'state warrant', he is legally permitted to break into a private house: an act allowed in England only in the event of a felony. His stick serves as a battering-ram, and he brandishes it wildly. At the sight of his successful catch, a self-satisfied smile spreads across his plump face; and the eight members of the Opposition, who have been caught unawares, grow ever more dismayed by their predicament. All are gripped by the same panic and shock, but it is expressed in various ways, according to their different temperaments. The two most cunning and nimble – curiously agile despite their corpulence – are in the process of

[1] [Etching published 20 March 1798. 'Js. Gy. invt. & fect'. *BM* 9189. George (1959), p. 37. Hill (1966), pl. 33, pp. 150–1. Donald (1996), pp. 40, 179.]

[2] [*LuP*'s footnote here, an important biographical sketch of Gillray, is given in full below, after the main text on *Search-Night*.]

49

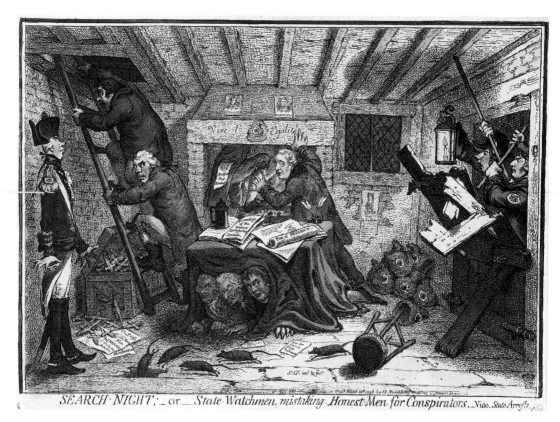

SEARCH-NIGHT; – or – State-Watchmen, mistaking Honest-Men for Conspirators. Vide. State Arrests.

PLATE II
James Gillray, *Search-Night; – or – State-Watchmen, mistaking Honest-Men for Conspirators*, 1798.
Etching, hand coloured.

climbing up a ladder leading to a trap-door. At a glance we recognise Fox, cowering on the top rung, and on the lowest rung is Sheridan, sneaking a look back out of the corner of his eye. They have chosen the best way; for the two timid deer attempting an escape through the chimney certainly face a far more difficult ascent to heaven. And even if they were blessed with all the skills of the famous Lord Montagu, who, we know, loved as a child to play the part of a sweep's climbing boy, they could only survive their ordeal in the still-burning hearth if they were as fire-resistant as salamanders. But fear will make you do anything! Fear gives the quick-footed deer the sharp instinct of the cat, who, as the astonished Egyptians observed long ago in

their own sacred cats, will even jump into a fire if it thinks it is in danger.[3] Fortunately Franklin's or Rumford's stoves have not yet strayed into *this* part of town! If they had, even the thought of such an escape through the fireplace would be utterly impossible.[4] The gentlemen themselves are immediately recognisable. The stocky gentleman in the slate-coloured jacket with the black collar and stockings, an expression of dismay on his face, is the Duke of Norfolk, whose usual attire is reminiscent of that of an honest farmer. He was the president or 'chairman', as the English would say, of this holy circle. This is shown by the fact that the *only* chair in the room has fallen over beside him. Being merely a 'joint stool', as one might expect in a meeting room of this kind, it is hardly suitable for such an illustrious president, or indeed any chairman in an armchair. But who is the other gentleman whose face is hidden from us by the jealous chimney hood? The identity of the scoundrel is betrayed not by his face, but by the object peeping from his pocket. The owner of this pocket is a passionate architect. We see from his plan for a splendid dog kennel, labelled 'Bedford Dog Kennel', that it is the Duke of Bedford, who is as great a friend of the Opposition as he is a devotee of hunting. This is why Burke wrote to him in his famous letter of 1795:[5] 'The sect of the cannibal philosophers of France . . . are a misallied and disparaged branch of the house of Nimrod. They are the Duke of Bedford's natural hunters; and he is their natural game.'[6] Bedford also owns countless country estates, summer retreats and

[3] Lovers of natural history will find this instinct . . . laboriously investigated by the father of history, Herodotus, Book II, ch. 66.

[4] [Sir Benjamin Thompson, Count of Rumford, invented an 'improved' fireplace design with a narrowed chimney throat to prevent smoking, which became fashionable for the London houses of the aristocracy. Thompson, *Essays, Political, Economical and Philosophical*, 4 vols. (London: T. Cadell and W. Davies, 1796–1812), vol. I, 'Essay IV, of Chimney Fire-Places', pp. 303–87. Gillray had satirised this device in *The Comforts of a Rumford Stove* (1800). *BM* 9565. Hill (1976), pl. 75, pp. 122–3.]

[5] [Actually 1796.]

[6] [*A Letter from the Right Hon. Edmund Burke to a Noble Lord, on the Attacks Made Upon Him and His Pension in the House of Lords, by the Duke of Bedford and the Earl of Lauderdale* (London: 1796). R. B. McDowell (ed.), *The Writings and Speeches of Edmund Burke*, vol. IX (Oxford: Clarendon Press, 1991), p. 174. *LuP* quotes from Friedrich Gentz's translation, *Edmund Burke's Rechtfertigung seines Politischen Lebens Gegen einen Angriff des Herzogs von Bedford und des Grafen Lauderdale* (Berlin: Vieweg, 1796), pp. 90–1.]

parks at Tavistock and Woburn Abbey. Recently he had a wall built around
his Woburn estate which will cost 300,000 pounds sterling by the time it is
completed. It is also said that he has commissioned the great architect Wyatt
to design a splendid dog kennel at Woburn for his many pairs of hunting
dogs.[7] For it is well known that the stables and kennels on the estates of the
English nobility embody a genre of rural architecture all of their own. Even
the diligent Stieglitz thought it unnecessary to supply poor Germans with
much information on the subject in his *Encyclopädie der bürgerlichen
Baukunst*, for there is a book of copper-engravings in English, devoted
solely to the architecture of these splendid 'dog kennels'.[8] But why should
the inventor of this caricature show the plan of a new, still more splendid
dog kennel peeping from the Duke's pocket, as he tries to escape through
the hot and narrow flue? Perhaps he is trying to suggest that the Duke is a
new breed of that species of animal which is man's companion the world
over? We defer to the opinion of the observer on this matter, as is only right
and proper.

It is plain that the three members of the club who have taken up their
uncomfortable positions under the green tablecloth (serving as a somewhat
defective curtain) have been so overcome by fear that they have confused
the upper regions, to which men direct their heavenly thoughts, with the
lower regions, where common people usually throw bones for their domes-
tic animals. The portraits are strikingly accurate. The one right at the back
closest to the ladder is Horne Tooke, the famous philologist and political
writer, orator and martyr to democracy. The man in the middle is Nicholls,
and the one at the front is Tierney. As with almost all the figures in this
group, their sidelong glances reveal the direction of the attack. Poor
Nicholls is only able to look with one eye, for a very good reason; this time

[7] [Presumably a reference to either James or Samuel Wyatt. Neither the literature on the Wyatt
dynasty of architects nor surviving records at Woburn offer any evidence to support this
rumour of a Wyatt commission. We are grateful to Ann Mitchell, the archivist at Woburn
Abbey, for the search she undertook. However, as early as 1789 the Hon. John Byng saw at
Woburn 'the new kennell' where 'his Graces fox hounds . . . are established in a pompous stile'.
The Torrington Diaries, Containing the Tours . . . of the Hon. John Byng, edited by C. Bruyn
Andrews, 3 vols. (London: Eyre and Spottiswoode, 1935), vol. II, p. 125.]

[8] [Christian Ludwig Stieglitz's *Encyclopädie* appeared in five volumes (Leipzig: Fritsch, 1792–8).]

he has not even had a chance to don the eyeglass which usually identifies him in such portrayals.[9]

There is one last figure who has been affected by terror in the manner which the perceptive ancients ascribed to the sight of the terrible Medusa's head: he has been struck dumb, he is rooted to the spot, *petrified* with fear. We see from his uniform that he is a Guards Officer of the highest rank; honour therefore prevents him from fleeing. But he is nevertheless gripped by a breath-stopping, finger-splaying terror. Even if the papers at his feet could not speak, his physiognomy would not go unrecognised. It is the Irish Earl Moira, who has here been made an honourable member of the same club to which the other leaders of the Opposition belong. Every newspaper reader will know that this man is a fervent advocate of Irish rights.[10] Given the aristocratic standpoint of the caricature, Moira's role is alluded to by the inclusion of the disreputable Dublin newspaper, *The Press*, edited by Arthur O'Connor, who has been the subject of much attention following a recent state prosecution at Maidstone.[11] The newspaper was soon banned because of its customary candour, or what the government called its inflammatory views. 'Bloody news from Ireland! Bloody news' not only gives a clearer indication of the contents of this sheet, but also describes a speech made at the beginning of last winter that will be remembered forever in the annals of the British Parliament and the House of Lords, in which Moira graph-ically described the atrocities committed by the rampaging English troops in Ireland.[12] Naturally, the ministerial party declared these descriptions to be mere rhetoric and spiteful exaggeration. The name Herr von

[9] [John Nicholls, MP for Tregony, had lost an eye. Gillray was spotted observing him from the gallery of the Commons, and always represented him as grotesquely ugly. Josceline Bagot (ed.), *George Canning and His Friends*, 2 vols. (London: John Murray, 1909), vol. I, pp. 143–4.]

[10] [The second Earl of Moira was a member of both the English and the Irish peerages and a lieutenant-general in the British army. Owing to his public protests against the treatment of the Irish Catholics, the loyalists of the *Anti-Jacobin* sought to discredit him as the dupe of the United Irish rebels. Donald (1996), pp. 178–9.]

[11] [Marianne Elliott, *Partners in Revolution: the United Irishmen and France* (New Haven and London: Yale University Press, 1982), pp. 182–5.]

[12] [*Speech of Earl Moira, on the Present Alarming and Dreadful State of Ireland, in the House of Lords . . . Nov. 22, 1797* (London: undated); *The Parliamentary History of England*, vol. XXXIII (London: Longman, Hurst et al., 1818), cols. 1058f.]

Münchhausen, written on a sheet below it, alludes to this. The comical adventures and boasts widely known by this title are extraordinarily popular, particularly in England. The travels of Herr von Münchhausen have become the common people's favourite reading, following the publication of a whole series of editions of the work.[13] In 1795 the adventures of this new Aistolfo were performed in a pantomime at the Sadler's Wells Theatre. Nothing was left out, not even scenes set in other parts of the world, nor even a journey to visit the Emperor in the moon. The splendid decorations and scenes were received with indescribable applause and cries of encore from the crowds who frequent this theatre.

But let us return to the conference interrupted so unpleasantly. The pile of Jacobin bonnets with the tricolour cockade, to the side of the guillotine fixed to the wall beneath the window; the portraits of Bonaparte and Robespierre hung like household gods above the fireplace; the words of allegiance framing the Jacobin bonnet; the 'proceedings' of the infamous London Corresponding Society on the table; the plan for the invasion of Ireland, from which the name O'Connor peeps; the 'Assignats' and 'Plan for Raising United Irishmen' thrown to the floor; and finally the half-opened chest with the sharpened daggers – all these leave no one in doubt for a moment as to the true purpose of this midnight meeting, which could only be lit by a conspirator's dark lantern.

Hogarth established the rule that in a caricature human actions should have a counterpart in the domestic animals surrounding them. Who could forget, for example, the charming pair of dogs in the third print of *The Rake's Progress*,[14] or indeed Lichtenberg's unsurpassed commentary on it?[15] Gillray, who has inherited much of Hogarth's spirit, uses the fleeing vermin to show us once more what we have already seen. This, at any rate, is how I choose to interpret these fleeing rats, although I know that they reminded

[13] [Jeanne K. Welcher and George E. Bush (eds.) in *Gulliveriana IV* (New York: Scholars' Facsimiles and Reprints, 1973) reprint an early version of these tall stories by Rudolf Erich Raspe. Donald (1996), p. 179.]

[14] [In fact in plate 5, the Rake's marriage.]

[15] [Lichtenberg's commentaries on Hogarth's prints are referred to in the Introduction, pp. 24, 36–7 above. Cf. G. C. Lichtenberg, *Gesammelte Werke*, edited by Wilhelm Grenzmann, 2 vols. (Frankfurt am Main: Holle, 1949), vol. II, pp. 1061–2.]

many people in England of the Opposition's secession from Parliament. 'I smell a rat', says the Englishman, to express the fact that something seems to be not quite right.[16] The pointed nose sniffing in at the smashed door also thought it could smell a rat, and the artist's caption below – 'State watchmen' (this might also have read 'rat-catchers') 'mistaking honest men for conspirators' – was intended as bitter irony.

FOOTNOTE

Gillray, the famous caricaturist, whose talents are recognised, and often feared, by every Londoner, is the son of an invalid who is still alive.[17] Gillray was apprenticed to a text engraver (who engraves text onto finished copper plates).[18] He did not really enjoy this work, however, and together with a number of other apprentices decided to join a company of strolling players. When he had travelled around the country for some time, his love of art began to stir once more. He returned to London, where he studied hard at the Academy of Art at Somerset House.[19] Many of his engravings, etchings and paintings were very well received. One of his excellent prints shows the East India ship Halsewell running aground.[20] He has also engraved Prime Minister Pitt. But because he captured his features exactly, reproducing the cold darkness of his features, a more flattering portrait was demanded. However, the artist employed to do this first made sure he bought Gillray's plate at a high price, since it portrayed the man far more accurately.[21] Gillray's pronounced gift for caricature soon emerged, and the unanimous approval of the public inspired him to develop his talent. He is

[16] We are reminded of the verse in Samuel Butler's *Hudibras* (1663), Book 1, Canto 1, lines 821–2: 'Quoth Hudibras, – "I smell a rat; / Ralpho, thou dost prevaricate."'

[17] [The artist's father, also James Gillray, a veteran who had lost an arm in battle, served as sexton to the Moravian community in London. Hill (1965), pp. 7–9.]

[18] [Harry Ashby of Holborn Hill. Hill (1965), pp. 14–15. Hill (1976), pp. xviii–xix.]

[19] [Gillray was admitted to the Royal Academy schools in 1778. Hill (1965), pp. 19–21.]

[20] [See the Introduction, pp. 29–30 above. Gillray's engraving from Northcote's *The Loss of the Halsewell East Indiaman* was published by Robert Wilkinson in 1787. Hill (1965), p. 29.]

[21] [Gillray was one of several engravers who produced portraits of the Prime Minister in 1789. The incident mentioned by *LuP* is discussed in the Introduction, pp. 31–5 above, and some letters in which Gillray refers to his portrait of Pitt and its problems are printed for the first time in the Appendix, pp. 260–5 below.]

an extremely well-informed and widely read man, pleasant in company, with an effervescent wit. If only lesser artists were able to exploit the indescribable superfluity of his original ideas, they too would be able to shine. He wrote a great deal in the newspapers in '91 and '92. I have seen a brilliant and biting letter to Alderman Boydell, as black as the deeply etched lines of a copper engraver.[22] His caricatures are the merciless scourges of both political parties. At first he worked only against the ministers. 'But now', he says, 'it is the Opposition's turn. They do not buy my prints, so I must trade them on the stock exchange of the great parties.'[23] It is impossible to look at his works without admiring his original, uncommonly clever inventiveness and the consistent accuracy in his depictions of individual people. To all this should be added that Gillray is a simple, fundamentally honest man and a wonderful son who supports his aged father in every way he can.

[22] [In 1788 Gillray had sought employment as a serious reproductive engraver on the ambitious Shakespeare Gallery project, and bitterly resented Boydell's rejection of his services. He revenged himself by several satires on Boydell, notably *BM* 7584 and 7976. Hill (1965), p. 35. Winifred H. Friedman, *Boydell's Shakespeare Gallery* (New York and London: Garland, 1976), pp. 76–8, quoting Gillray's letter to Boydell. Diana Donald, '"Characters and Caricatures": the Satirical View' in *Reynolds*, edited by Nicholas Penny (London: Royal Academy and Weidenfeld and Nicolson, 1986), pp. 361, 369–70. Donald (1996), p. 73.]

[23] [Gillray's changing allegiances are discussed by Hill (1965), pp. 47–8; Donald (1996), pp. 26, 42–3, 166, 168. Cf. also *LuP*'s comments in 'Caricaturists in London Today', pp. 246–7 below.]

3 *The Tree of Liberty, – with, the Devil tempting John Bull*[1]

1 (1798), 204–9, pl. v

The real tree of liberty, Herr von Archenholz informs us,[2] is an ancient British tradition; it is in fact 'the may-pole', around which the Anglo-Saxons danced in their springtime village festivals. But the French certainly did not borrow this custom from the British. Like the cap of liberty, it was originally taken from the true inventors of such insignia of freedom, the *Carmagnolas* or the people of Marseilles.[3] This is why no loyal Briton has ever wanted so much as a graft or shoot of this foreign tree to be planted on his happy island. Mr Taylor composed a British ballad called 'The True British Tree of Liberty', which could still be heard recently at festivals and gatherings of song-lovers all over England. What, then, could be more natural than to contrast these two trees, the French and the British, and to portray them for the edification and pleasure of the English nation, *vulgo* John Bull? This is exactly what Mr Gillray did a few weeks ago in his characteristic style, in the caricature we have before us.

In England, every respectable paterfamilias has Milton and Shakespeare on his shelves beside the Bible. Milton's *Paradise Lost* is like a sacred national poem in the hearts and on the lips of everyone. You can buy editions costing anything from a shilling to 20 guineas. Now the key passage, the true focus of the entire epic, is the famous bite of the apple, with which Satan, disguised in his slippery snakeskin, tempted and seduced our dear

[1] [Etching published 23 May 1798. 'Js. Gy. inv. & ft.' *BM* 9214. Hill (1976), pl. 56, pp. 115–16. Ronald Paulson, *Representations of Revolution (1789–1820)* (New Haven and London: Yale University Press, 1983), p. 190. Donald (1996), p. 170.]

[2] 'Sittengeschichte', *Annalen der Brittischen Geschichte des Jahrs 1794* 13 (1796), 356–429 (427–9).

[3] [On the liberty trees of the Revolution and their connection with the maypole: E. H. Gombrich, 'The Dream of Reason: Symbolism in the French Revolution', *British Journal for Eighteenth-century Studies* 2.3 (1979), 199–200; Lynn Hunt, *Politics, Culture, and Class in the French Revolution* (London: Methuen, 1986), pp. 59–60; Donald (1996), pp. 156–7.]

PLATE 12

James Gillray, *The Tree of Liberty, — with, the Devil tempting John Bull*, 1798. Etching, hand coloured.

first parents. Gillray has found the clearest and most eloquent point of comparison with this scene, which every Briton will comprehend; for the clever artist portrays all the advantages of the English constitution and the disadvantages of the French, using the true and false trees of liberty: the tree of life and the tree of the knowledge of good and evil. The latter is the more important here. Its name is Opposition, and the Tempter, the serpent of hell,

> towered
> Fold above fold, a surging maze; his head
> Crested aloft, and carbuncle his eyes;
> With burnished neck of verdant gold, erect
> Amidst his circling spires.[4]

It is obvious at first sight that this serpent is the Leader of the Opposition – Fox himself, as he lives and breathes. The fruit he offers as a temptation is called Reform: total reform of Parliament and the constitution. But the tree itself is also a tree of knowledge: from its roots right up to every single fruit, it bears a genealogical inscription of heraldic accuracy that would do credit to the most experienced court herald compiling a family tree. Let us take a closer look at this wonderful tree. Its knotty, dry and leafless trunk is founded upon a great three-fold root, named Envy, Ambition and Disappointment. At the top it divides like a fork into two main branches. The first branch, like Paine's famous book, is called 'Rights of Man'. Unfortunately it ends only in a rotten, hollow stump. But even in this condition it has been able to grow two smaller branches. On one, displayed in its full red splendour, is the Jacobin bonnet with the tricolour cockade. Centrally positioned, it forms the crown of the tree in more than one sense of the word. Next to it hangs the fruit of the Whig Club, and below, that of the London Corresponding Society. On the other secondary branch in ascending order we find Conspiracy, Revolution, Murder, Plunder, Treason and Democracy, and, at the very summit, the culmination of all: Slavery. The second main branch is called Profligacy. Directly beneath it emerges another secondary branch –

[4] Milton's *Paradise Lost* Book IX, lines 498–502.

 [*LuP* quotes these lines from *Johann Milton's verlornes Paradies*, translated by Samuel Gottlieb Bürde, 2 parts (Berlin: Viehweg, 1793), part II, p. 107.]

the notorious 'Age of Reason', under which title, as we all know, Thomas Paine published a strong two-part attack on the Bible and on revealed religion in general, which for years inspired many English and North American writers, theologians and non-theologians alike, to take up their pens.[5] Then follows Deism, above it Impiety, Blasphemy and Atheism. No one will fail to grasp the point which the artist is trying to make in his depiction of the fruits' two sides. On one side they appear tempting, with beautifully reddened skin which promises sweetness. Yet their other side is rotten and worm-eaten.

'Nice apple, Johnny, nice apple', calls the friendly Tempter, while offering the deceptive side of the apple of parliamentary reform. But fat, well-fed Johnny is not hungry at all. The Tempter is too late! For Johnny has already stuffed his coat and waistcoat pockets with beautiful golden apples from the other tree in the background. His pockets are so full that he has no difficulty whatsoever in refusing the wily deceiver. 'Very nice apple indeed', he replies, 'but my pockets are full of pippins from the other tree. And besides I hate medlars, they're so damned rotten that I fear they will give me stomach ache for all their fine looks.'[6] Do we need to say that this Adam – a clever rogue, despite all his rusticity (who reminds Germans of Hans Sachs's famous farce and those hulking great children of Adam, destined by God to be farmers[7]) – is none other than the English people in its famous personification as John Bull? Finally, let us glance at the true English Tree of Liberty in the background, whose fruit John has plundered. How

[5] The German translation, which appeared in 1794, was banned in Leipzig, on pain of a fine of 20 Thaler. See *Allgemeiner Litterarischer Anzeiger* 101 (28 June 1798), 1018.

[The banned publication was Thomas Paine's *Untersuchungen über wahre und fabelhafte Theologie. Aus dem Englischen übersetzt und mit Anmerkungen und Zusätzen des Uebersetzers begleitet*, translated by Heinrich Christoph Albrecht (Lübeck: Bohn, 1794). Later editions of the translation were published under the title *Das Zeitalter der Vernunft.*]

[6] The words of the original are intentionally written in the dialect of the lower classes . . . The pippin is also called 'Goldpippin' in German, and is the commonest apple in England. It is used to make excellent 'cyder'.

[7] [Cf. Hans Sachs, *Wie Gott der Herr Adam unnd Eua ihre Kinder segnet* (1553), in which God blesses Adam and Eve's children and pronounces that the four roughest and least intelligent will become a cobbler, a weaver, a shepherd and a farmer. Hans Sachs, *Fastnachtspiele*, edited by Theo Schumacher (Tübingen: Max Niemeyer, 1957), pp. 103–19.]

very different it is from its half-brother! The trunk, Justice, stands on three principal roots: Lords, Commons and King, with the latter properly at the centre. Laws and Religion are the two main branches. Instead of the wicked Jacobin cap, the King's crown is also the crown of this tree. Freedom, Happiness and Security are the beautiful triplet fruits which accompany the crown. But the other fruits which adorn this lush, green and shady Tree of Life are nameless and numberless. At the sight of them, who would not happily parody the famous verse from the first of Virgil's *Eclogues*: O Meliboeus, a god has made this tree yours![8]

[8] [Virgil, *The Eclogues*, translated by Guy Lee (Harmondsworth: Penguin, 1984), p. 31. The phrase parodied here is, 'Oh, Meliboeus, a god has made this leisure ours.']

4 *United Irishmen in Training*[1]

1 (1798), 213–14, pl. 1

A horde of savage Irishmen, the green cockade of liberty on their caps, are practising on a straw man, which they have dressed in the uniform of the English Guard and impaled upon a pike. The pile of weapons, the tattered dress of the rabble-rousers, the assistance of the women and the wild firing are all characteristic features of these rebellions, as they are described by the dozen in every newspaper. Particularly significant is the lad right in the foreground, sharpening his murderous sword on a grindstone, which is turned by a sniggering woman. The scene takes place in front of a shebeen with the Tree of Liberty on its sign. The innkeeper, a female Caliban, is pouring her deadly brew into bulbous glasses, straight from a small barrel which she clutches to her breast with one hand. Someone else has opened a full bottle. Yet another raises his glass in celebration. The inscription above the door is perfectly in keeping with the tone of the caricature. It says 'True French Spirits', which in English can refer to genuine French brandy, as well as to the true French way of thinking. In the background we see the ruins of a burned-out castle in the wood.[2] At the sight of the female furies at work here we are reminded of a tale recently recounted in several English newspapers: that at the battle of Ballynahinch two Amazons remained on the battle-field, carrying the green flag before their heroes. One of them had given herself the title 'Goddess of Freedom'; the other 'Goddess of Reason'.[3]

[1] [Etching and aquatint, published 13 June 1798. 'Js. Gy. inv. & ft.' *BM* 9229. Hill (1976), pl. 57, p. 116. Donald (1996), pp. 179–80.]

[2] [This seems to be a mistaken reference to the broken paling.]

[3] [Ballynahinch in Ulster, Lord Moira's estate, was the site of an important defeat of United Irish rebels on 13 June 1798, the same day as the publication of Gillray's print. For the 'goddesses', see Thomas Pakenham, *The Year of Liberty: The History of the Great Irish Rebellion of 1798* (London: Orion Books, 1992), p. 231.]

PLATE 13
James Gillray, *United Irishmen in Training*, 1798.
Etching and aquatint, hand coloured.

5 *United Irishmen upon Duty*[1]

1 (1798), 382–7, pl. XII

A scene taken from nature, the like of which has been repeated all too often over the last four months in the unfortunate Irish counties of Wexford and Wicklow. Once again the artist is Gillray, whose praises we have sung on a number of previous occasions. This time he was inspired not so much by the mischievous spirit of satire, as by vengeful Nemesis, who does not record in vain horrific scenes like the one shown here. For it was not mocking laughter that Gillray was trying to provoke, but outrage and deep pain at the sight of the violation and suffering of these poor people. And he did not fail in his intention, if it is true (as we are assured by a traveller very recently returned from England) that the publication of this copperplate engraving coincided with the great crisis, when the volunteer corps in most English counties were offering their services against the Irish insurgents. In fact, to some extent they were only moved to volunteer for service across the sea by vivid portrayals of the heinous deeds being perpetrated in the sister kingdom, such as those depicted in our print.

Morning approaches; the moon in its final quarter shows the time quite clearly. The villainous rebels, or as they themselves like to be called, the United Irishmen, all of them experienced in the *free* arts of the roughest soldier's life, have stolen up on the peaceful cottage of a fellow countryman, who is honest, and therefore not united with them. They smash down his doors and, brandishing their swords, they begin destroying everything in sight and setting fire to the cottage. A scene of the most terrible confusion opens, filled with murder and horror. The leader of this murderous band of arsonists is recognisable by his single good riding boot, for almost all his subordinates are closer to a state of nature in their footwear. He has dragged

[1] [Etching and aquatint, published 12 June 1798. 'Js. Gy. inv. & ft.' *BM* 9228. Hill (1976), pl. 57, p. 116. Donald (1996), pp. 179–80.]

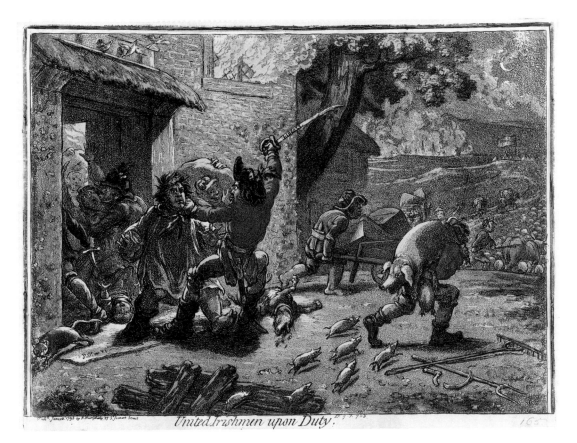

United Irishmen upon Duty.

PLATE 14
James Gillray, *United Irishmen upon Duty*, 1798.
Etching and aquatint, hand coloured.

out the father of the house, dressed in nothing but a nightshirt, and is in the
process of beating a confession out of him as to where he has hidden his
money. Meanwhile his adjutant, the fellow in the red jerkin, is attacking the
mother of the house, intent on satisfying his animal urges. Every line of the
portrait is powerfully drawn. Look at the trunk-like mouth elongated to a
kiss! Never has such a kiss been conceived of or described; not by gentle
Janus Secundus in his famous kissing poems,[2] or even by the learned Martin

[2] Janus or Johannes Secundus, from The Hague in Holland, wrote, amongst other things,
 nineteen songs which he entitled *basia*, or kisses: some of them have been translated into

Kempe in his twenty-five treatises on kisses![3] The bloody dagger of a third accomplice, of whom we can see only the hind quarters, appears to be making violent contact with the child, which lies screaming on the ground as it is trodden underfoot. In addition to this trio, there are also four other thieves and murderers in the foreground. Grinning with malice, two are carrying off large bales of goods from the burning house. A third is pushing a wheelbarrow filled with chests and boxes. Like Hercules carrying the Erymanthian boar in ancient sculptures, a fourth man hauls away a fertile, fat sow on his shoulders.

These beasts in human form are accompanied by a number of real animals. In the middle of the print we see the incorruptible guard, the faithful family dog, rewarded for fulfilling his duties in the way of the world. Of all the mortals here, he alone died on the field of honour. The path into the farmyard led first over him, and then to the tenant farmer's stack-yard, where they stole the sheep and oxen from the byres. We can still see one of the thieves using a stave to drive some of them away. The sow has been taken from the dilapidated stack-yard. The little piglets run behind their mother, following her screams of lamentation; a well-captured scene which brings a smile to our lips, even in the midst of sadness. And not even the domestic fowl were spared, as we see from the goose hanging from the belt of the pig-carrier in place of a sword. Finally, we cannot overlook the cat's escape on the ground, or the flight of the doves. Everything is in a state of alarm and uproar.

Once again the inventive artist has produced a work in which every last detail provides matter for observation. How touching and horrific is the plight of the child right *under* its mother, how telling the broken sickle next to the other scattered farm tools. In these parts the sickle is always used for

Footnote 2 (*cont.*)

German by our best poets. He kissed himself to death when he was only in the twenty-sixth year of his life.

[Johannes Secundus was the pseudonym of Jan Nicolaas Everaerts. His nineteen love poems, known as *basia*, were first published in 1539.]

[3] This thoroughly scholarly work, on a subject which could be killed by pedantry, appeared in Frankfurt in 1680 in a strong quarto volume.

[I.e. Martin Kempe, *Opus Polyhistoricum, Dissertationibus XXV de Osculis.*]

cutting. Never again will these people hear Iris singing her song, inviting them to rest:

You sun-burn'd sicklemen, of August weary
Come hither from the furrow, and be merry,
Make holy-day! Your rye-straw hats put on,
And these fresh nymphs encounter every one.[4]

Sickles of a very different kind are being used here! We need only look at the Captain's sabre with its sneering motto: 'Liberty!', and its telltale marks of blood.

Even the fact that the poor sow on the thief's shoulder plays such a significant role amongst the booty is highly characteristic of a scene set in Ireland. For Ireland is the main source of fresh and salted pork in Great Britain, and pig-rearing competes with potato-growing there. That is why during the present rebellion, when the pork market was closed to England, requests were made in various ministerial newspapers to spare sucking-pigs and to continue to rear them for future use.

Finally, we cannot overlook the masterly distribution of light in this night piece. What an illumination! The crescent moon, half covered and broken up by smoke, would give off only a poor light. But the robber hordes have lit brighter torches themselves. In the background is a burning town, where the small taste of arson we are given here in the farmer's house is enacted again on a larger scale. A fire of this size even lights up the bloody tricolour flag of the rebels' camp, and the inscription 'Equality' is clearly visible. And now in the foreground the flames shooting from the window light up the scene like day; a scene where so many works of darkness are carried out in such a small space!

[4] In Shakespeare's *Tempest*, Act IV, scene I.

6 *John Bull taking a Luncheon: — or — British Cooks, cramming Old Grumble-Gizzard, with Bonne-Chére*[1]

2 (1798), 286–93, pl. XXIV

Readers will doubtless recall several Opposition caricatures from earlier times, which are always reissued with a number of additions whenever the Minister opens his Pandora's box with a new tax. They show the English people, symbolised by the popular image of John Bull, burdened and oppressed in every possible way by the terrible weight of new and old taxes.[2] This good-natured, phlegmatic old soul was bound to grow sick of being persecuted in the end, get sour and ill-tempered and begin to grumble and moan. Fortunately for Pitt, however, he had a friendly guardian angel who came up with an excellent sop to silence the old grumble-gizzard once and for all before Parliament was reconvened. A decisive and glorious naval victory came just when he needed it most; and in a trice it calmed all the huffing and puffing of the ever-more-heavily-burdened Briton, who was now taxed from head to toe.

This is what happened recently, when the entire country found itself in transports of the sweetest joy following Nelson's supreme victory. And now Pitt is in a position to demand millions more, and can even levy the hated tax on all income over a hundred pounds without a qualm, despite its similarity to the infamous *Emprunts forcés*.[3] In comes Nelson with nine conquered warships and all the glory of his victory at Aboukir, which he now

[1] [Etching published 24 October 1798. 'Js Gillray invt. & fect.' *BM* 9257. John Ashton, *English Caricature and Satire on Napoleon I* (1888, reissued New York and London: Blom, 1968), pp. 58–9 and cf. p. 40. Hill (1965), p. 84. Hill (1976), pl. 58, p. 116. Ronald Paulson, *Representations of Revolution 1789–1820* (New Haven and London: Yale University Press, 1983), p. 200. Donald (1996), p. 162.]

[2] [On the John Bull symbol, see Donald (1996), pp. 157–62 and p. 236 n. 117, listing previous literature. For John Bull as a taxpayer, see especially Miles Taylor, 'John Bull and the Iconography of Public Opinion in England c. 1712–1929', *Past and Present* 134 (1992), 93–128.]

[3] [On these obligatory loans to the French government, see Georges Lefebvre, *La France sous le Directoire* (Paris: Editions sociales, 1977), pp. 498–9.]

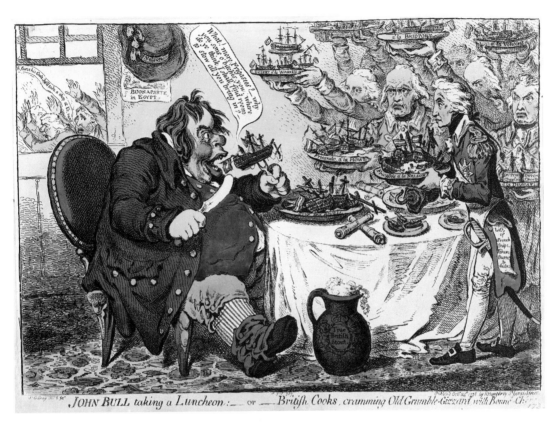

PLATE 15
James Gillray, *John Bull taking a Luncheon: – or – British Cooks cramming Old Grumble-Gizzard with Bonne Chére*, 1798.
Etching, hand coloured.

serves up under the greedy gaze of a ravenous nation. Warren supplies the dessert: the captured invasion fleet. And John Bull tucks in hungrily; he would be only too happy to pay the bill, even if it were double the price. This is how Gillray saw the event in the new caricature we have here. It is one of his most successful and clever inventions. Anyone who has counted the witty demons who once danced around La Casa's inkwell[4] will appreciate the true value of this witty rocket fired from Gillray's burin.

4 [Apparently a reference to Giovanni della Casa, author of *Il Galateo* (1558), who, as 'John de la Casse', figures in Laurence Sterne's *Tristram Shandy* (1759–67), vol. v, ch. xvi: 'he

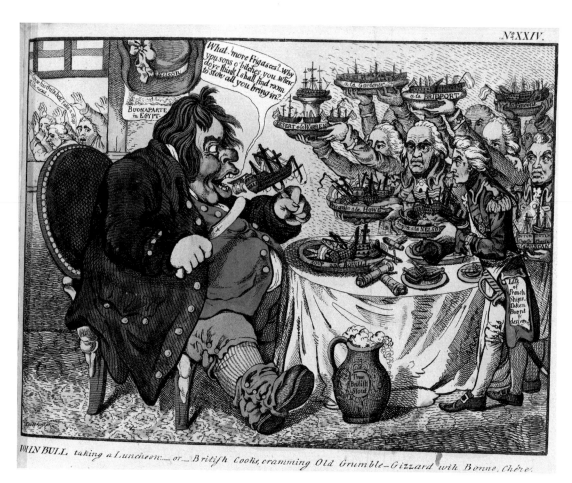

PLATE 16
John Bull taking a Luncheon – or – British Cooks, cramming Old Grumble-Gizzard
with Bonne Chére, copy after Gillray in *London und Paris* 2 (1798).
Etching, hand coloured.

Dressed in his 'drab-coloured' coat and knee-breeches, John Bull is por-
trayed here as a respectable farmer who has just come up to town from the
country. Seeking to assuage his rumbling stomach with a hearty snack, he
has found his way into a chop-house, which, we may imagine, is not too far

Footnote 4 (*cont.*)
maintained, that from the very moment he took pen in hand – all the devils in hell broke out of
their holes to cajole him.']

from the Treasury. Between breakfast and the main meal of the day, which is virtually an evening meal ('dinner'), the Englishman with a healthy digestion often eats an additional midday meal called a 'luncheon'. It is this, as the caption suggests, that we see here. But, good Heavens, what an appetite he has! And just look at the dishes and their cooks! These are no 'sticky, dirty, oafish cooks and ragged kitchen boys' as Fischart called the tavern cooks with their flapping sleeves in his *Rabelais*.[5] These are admirals in fine kitchen aprons, serving as many enormous dishes of ship's pastries and ship's fricassees as the hungry fellow can eat. Cannon barrels lie on the table, crossed like knives and forks, alongside gunboats, laid out like slices of bread. In front of all the others Mylord Nile, commonly known as Nelson, approaches John Bull. With the hook on the stump of his arm, which he usually attaches to a button hole, he is serving up a dish of 'Soup and bouilli', made of minced warships. In his left hand he is still holding a second dish with similar ingredients called 'Fricassée à la Nelson'. While he was cooking, some splinters wounded his forehead above his left eye. But this doesn't seem to have affected his enthusiasm at all as he dishes up a cornucopia of delicacies to his hungry guest. Indeed, he still has another tempting 'bill of fare' peeping from his pocket: 'List of French ships – Taken, Burnt and destroyed'. Lord Howe comes next. He holds a Spanish *fricando*, prepared from a fine recipe. Next to him, brave Warren serves John Bull's favourite dessert – the invasion squadron recently defeated in Irish waters. The *Hoche* in particular, raised on its own stand on the splendid triple-decker in the middle, would make an excellent fortifying morsel to fatten up this gourmand and round off his repast.[6] Brave Lord Camperdown can be distinguished just behind Nelson, holding two fat 'Dutch cheeses' and other delicacies 'à la Duncan'. Lord Bridport's and Gardner's dishes are held high in the background. Bridport needs both hands to lift his dish, despite the fact that it is hardly

5 [Johannes Fischart's free adaptation of Rabelais's *Gargantua* was published under the pseudonym J. Fisch, *Affenteurliche und Ungeheurliche Geschichtschrift von Leben rhaten und Thaten der for langen weilen Vollenwolbeschraiten Helden und Herrn Grandgusier, Gargantoa und Pantagruel* (Strasbourg: B. Jobin, 1575). Cf. Fischart, *Geschichtklitterung (Gargantua)*, edited by Ute Nyssen (Düsseldorf: Karl Rauch Verlag, 1963), ch 3, p. 64.]

6 [On 12 October 1798 Sir John Warren defeated the Brest fleet off the coast of Ireland, and captured the *Hoche* with Wolfe Tone on board.]

garnished at all. The latter's prizes cannot be made out clearly. Those who are familiar with the history of British naval power will easily grasp malicious Gillray's joke in this depiction. Neither Bridport, who is in charge of the Channel between France and England, including the French coast, nor Sir Alan Gardner, who is in charge of the sea between England and Ireland, have as yet distinguished themselves by their vigilance or operational successes. Nor should we overlook St Vincent, shown last of all.

Rabelais's *Gargantua* has been ridiculed on the grounds that the famous account of his swallowing seven pilgrims in a salad is somewhat implausible.[7] Having seen this English 'Grandgurgler', as Fischart would put it, open his omnivorous jaws just once, it would never again occur to anyone to dismiss Rabelais's quaint old tale as a tall story. Our John Bull is a match for Prince Gargantua in physical proportions and, like Pantagruel's, his tongue could shelter any advancing army from the rain.[8] Nothing could surpass the greed in his ravenous eyes as he regards the ever-growing piles of ship's pastries and frigate fricassees. But finally it is all too much, even for him: 'What!', he exclaims, 'More Frigasees? – why you sons o' bitches you! Where do ye think I shall find room to stow all you bring in?' But to judge by the fat forkful he is holding now, he has the capacity to polish them off as if they were mere dumplings. Indeed, it is as if good old Fischart's teachings had been written specially for him: 'How can you thrive if you do not chew well, spit and chew again, and eat like pigs? There is no shame in acting like pigs in matters relating to the inner workings of the body. For there humans and pigs are alike. So shake yourselves valiantly, stand up straight, stuff yourselves and ladle it in, huff and puff, etc, etc.'[9]

Every good meal needs a good drink to go with it. The full meaning of the word 'superfluous' is depicted here. 'True British Stout' foams from the jug, engraved with the English shield-bearers. A print on the wall showing Bonaparte's deeds in Egypt is almost entirely covered by our farmer's large hat with the resplendent blue sailor's ribbon. It also bears the magic name 'Nelson', the catchword of the day, which can be seen everywhere; on

[7] See François Rabelais's *Gargantua* or Book I, ch. 38.
 [This was frequently illustrated in popular prints, which may well have influenced Gillray.]
[8] Rabelais, *Pantagruel* or Book II, ch. 32.
[9] [Fischart, *Geschichtklitterung*, ch. 3, p. 56.]

ladies' and gentlemen's hats, on houses and church spires, illuminated by torch and sunlight. It kept the steel- and other metal-workers in Sheffield and Birmingham from getting to their beds for many a long night.[10] But look, there are people in England who trail John Bull closely in order to goad and incite him whenever his mood darkens. These men have even followed honest John to the chop-house, and are peeping in and eavesdropping at the window as he is served. But as John starts to grind the millstones in his mouth, they are seized with panic. With a scream of terror, their hands raised high, Fox and Sheridan (we recognise them immediately) shout as they run away: 'Oh Curse his Guts, he'll take a chop at Us, next'.

Great minds, as the saying goes, think alike. More than two thousand years ago the most witty and mischievous of all comedy writers, Aristophanes, wrote a dramatic caricature, called *The Demagogues or the Knights*, which still survives today. In this play the John Bull of the Athenians, whom they called 'Demos' or the people, was personified in the same way, banqueting and feasting on delicacies which his good friends had served him. This Athenian Demos is also 'a moody old grumble-gizzard'. He is not fat, however, but rather a thin, old, almost childish, drivelling little man, tied to the apron-strings of his lord and master. In Act IV[11] Paphlagon, a tanner, and a sausage-seller compete to serve their old customer with anything he might like, just as the British admirals do here:

PAPHLAGON Here's some pea soup.

. . .

SAUSAGE SELLER – This delicious
Beef broth the Nobly-Begotten
Has boiled and a prime portion
Of innards and tripe . . .

. . .

[10] English newspapers report that labourers in the English manufacturing towns where haberdashery and steel goods are made worked at top speed, night and day, to satisfy the huge orders for tobacco tins, etuis, etc., bearing Nelson's name and other mottoes referring to him.

[11] Wieland's masterly translation of this piece in *Attisches Museum* 2.i (1797), 1–144, really transports us to Athens.

[Aristophanes, *Plays 1.*, translated by Patric Dickinson (Oxford University Press, 1970), pp. 94–5, 96.]

DEMOS What on earth shall I do with pig's guts?
SAUSAGE SELLER — For the bellies of our ships.
 Clearly the goddess favours our fleet.
 . . .
PAPHLAGON Have a cut of this succulent cake . . .

And so it goes on until old Demos is advised to examine the food baskets of
these generous benefactors. He finds the tanner's basket full to busting with
large cakes and this finally forces the miserable old wretch to exclaim:

You greedy deceiving swine!
And 'I stuffed you wi' duff' . . .

It goes without saying that English John Bull, who of course is served by
the most honest and selfless people under the sun, bears no resemblance
whatsoever to his older Athenian brother in this respect. This is why he has
grown quite disproportionately fat.

7 *Stealing off; – or – prudent Seces[s]ion*[1]

3 (1799), 65–74, pl. 1

There is an old English saying that someone who is forced to retract a rash speech in disgrace must 'eat up his words'. This traditional saying is found in several works, including Butler's *Hudibras*.[2] Comic parody and its sister caricature have always found an inexhaustible source of amusement in the literal rendering of simple imagery and figurative expressions in common speech, or in the realistic depiction of metaphors. The ancient Athenians, for example, used to say that a sophist who had lost himself in hair-splitting and subtleties was 'walking in the clouds'. Aristophanes, the most witty and imaginative of all ancient writers of comedy, took this image and, in one of the most edifying scenes in his *Clouds*, showed us the sophist Socrates actually suspended in a cheese basket, quite literally floating in the clouds.[3] There can be no doubt that the English caricaturist Gillray is akin to this ancient comedian, both in imagination and in the work he produces. In a similar way he uses the English metaphor described above to aim a sharp and poisoned arrow at the Opposition party he hates so much, as is abundantly clear in the caricature before us.

But in order to appreciate the full wit of this caricature, the following facts must be generally understood. Since the last prorogation of Parliament, England has enjoyed a period of great good fortune. Green, the colour of the Irish rebels, has now become the symbol of union, and the

[1] [Etching and aquatint, published 6 November 1798. 'Js. Gillray invt. & fect.' *BM* 9263. George (1959), p. 42. Hill (1976), pl. 60, p. 117.]

[2] Thus, in 'The Lady's Answer to the Knight' in Book III, canto 3, lines 176–7, she says . . . 'a brave knight-errant of the post, / That eats perfidiously his word' . . .

 [*LuP* also quotes these lines from the German translation, *Butlers Hudibras frey übersetzt von Dietrich Wilhelm Soltau* (Königsberg: Nicolovius, 1798).]

[3] See Wieland's translation of the *Clouds* in *Attisches Museum*, 2.ii (1798), 67–174 and 2.iii (1798), 1–35 (2.ii 90f.).

75

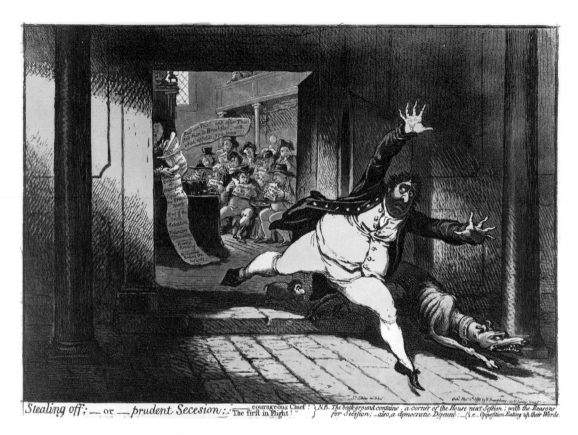

Stealing off; — or — prudent Secesion:— courageous Chief! The first in Flight! N.B. The background contains, a corner of the House next Session; with the Reasons for Secesion; — also, a democratic Dejeuné: — (i.e. Opposition Eating up their Words.

PLATE 17
James Gillray, *Stealing off; – or – prudent Seces[s]ion*, 1798.
Etching and aquatint, hand coloured.

bloodiest uprisings have been almost completely quelled. Abroad, enemies have been conquered everywhere; at home, trade is flourishing as never before, and several European courts have once again been drawn into the theatre of war. It was, therefore, not hard to predict that when Parliament re-convened at the beginning of December the Minister would vent his jubilation, and would leave the Opposition in no doubt as to how short-sighted, erroneous and groundless their objections to his measures had been. Gillray has now established a memorial to this triumph over the rival party. This print was issued the day before the re-convening of Parliament, and contained an apocalyptic vision of what would be seen the following day in the House of Commons.

In the background we see the House of Commons, with an excellent view of the right-hand side where the Opposition sits. Facing them is the ministerial side, known appropriately as the Treasury Bench, since it contains the seats not only of the Treasurer (Pitt), but also of the hungry crows whom he feeds from this treasure. The arms of the Minister, clad in the Windsor uniform, appear from behind the wall on this side, writing a *Mene, Mene, Tekel* . . ., as in the banqueting hall of Belshazzar, and holding out two unfurled parchment scrolls of the kind used for bills. Certainly, nothing more painful could be held before the eyes of the Opposition than the unequivocal message of these two scrolls. The one in the left hand bears the inscription: 'O'Connor's list of secret traitors', and alludes to the Irishman's statement before the secret committee in Dublin, in which he compromised terribly all the patrons and friends who had kindly supported him in Maidstone.[4] In the right hand we read a list of all the recent events which have made the heart of every Briton swell with pride; albeit with a degree of rhetorical licence, as we see in the first line, 'Destruction of Buonaparte'. But even if this great butterfly (or 'farfallone', as the Italians call such a figure of speech) has taken flight somewhat prematurely, the lines that follow contain clear, indisputable truths: 'Capture of the French Navy – End of the Irish Rebellion – Voluntary Associations – Europe Arming – Britannia Ruling the Waves'. And then there is the thunderous voice booming: 'Read o'er This! and after This! And then to Breakfast, with what appetite you may!!!'[5]

And what a breakfast the gentlemen opposite are consuming! They have cooked it themselves, and now they must eat it, for the sake of their health. Their meal consists of their own words and threats. For it is here that the subtitle of the piece is literally portrayed: the Opposition 'eating up their words'. Some of the gentlemen are immediately recognisable. Sheridan at the front has often praised the loyalty of the Irish. That particular mouthful will be hard to swallow – but swallowed it must be! Tierney is next to him, his hat

[4] [Thomas Pakenham, *The Year of Liberty: The History of the Great Irish Rebellion of 1798* (London: Orion Books, 1992), pp. 289–91; Marianne Elliott, *Partners in Revolution: the United Irishmen and France* (New Haven and London: Yale University Press, 1982), pp. 209–12.]

[5] [A quotation from Shakespeare's *King Henry the Eighth*, Act III, scene 2, where the King confronts Wolsey with incriminating papers.]

pulled down over his wild eyes. He once said 'that we should be obliged to do homage to the French convention'. Homage to the French convention isn't quite a bread-and-honey breakfast! Next to him, the egotistical Erskine in legal robes always has the words 'my own Loyalty' on his lips. But now they stick in his teeth. Next to him another man, said to be Colonel Tarleton, has a mouthful of 'French Liberty'.[6] Our readers will recognise Nicholls, the one-eyed man with the spectacles on the second bench. He is now consuming his great 'Letter to William Pitt', which appeared two years ago.[7] The gentleman with the quiff – we know him well enough – Sir Francis Burdett, is enjoying French 'Equality'. The other gentlemen are also nibbling their paper breakfasts. Courtenay, Jefferys, Jekyll, not forgetting Sir John Sinclair at the back who, it is true, joined this party very late, and who has said on several occasions 'that we must make peace, or ruin would ensue'.

Between Sheridan and Tierney is a hat, symbolising an empty place. Even if the name were not written inside, it wouldn't take us long to find the pan which fits this lid. The gentleman in the foreground, leaping away from the contents of the two scrolls in horror and mortification, has characteristically left his hat in the lurch. The action represents his secession, extending into next year; in other words, he is refusing to attend any parliamentary meetings.[8] In his speeches at the Whig Club, of course, he gives a quite different explanation for his behaviour. But here, Gillray proclaims, is the true reason for his stealing off, or prudent secession, as it is described in the caption. The somewhat hasty manner of his retreat requires no commentary for those who have eyes to see. But for Germans who are not as familiar with Milton as the British are, a brief glance at the quotation in the caption might be appropriate at this point. In applying the quotation to the fugitive Fox, Gillray has dipped his etching needle in something stronger than mere caustic. In *Paradise Lost*, when Satan is forced out of his toadish

[6] [George in *BM* identifies this figure as Shuckburgh.]

[7] [Probably a reference to 'A letter from John Nicholls Esq. M.P. to the Rt. Hon. William Pitt', *Morning Chronicle* (14 November 1797), which accused Pitt of bad faith in the conduct of relations with France. Lord Granville Leveson Gower, *Private Correspondence 1781 to 1821*, edited by Castalia Countess Granville, 2 vols. (London: John Murray, 1917), vol. I, p. 182.]

[8] [Fox and his associates first withdrew from Parliament in May 1797, and decided to secede formally in October, frustrated by their impotence in the Commons.]

disguise to the furthest limits of his hellish kingdom, Gabriel mockingly asks him at the end (Book IV, 917–23):

But wherefore thou alone? Wherefore with thee
Came not all hell broke loose? Is pain to them
Less pain, less to be fled? or thou than they
Less hardy to endure? Courageous chief,
The first in flight from pain, hadst thou alleged
To thy deserted host this cause of flight,
Thou surely hadst not come sole fugitive.[9]

A Briton would only have to read the central words 'Courageous Chief' under the print to grasp the whole situation immediately, as it applies to Fox and his colleagues. Now that the verse has been completed, our German readers can do this too. Furthermore, we can safely assume that the witty caricaturist, who always likes to kill two birds with one stone, also intended another, deeper meaning with the abandonment of that hat on the bench of the Lower House; for 'The hat alone makes a free man', as one of our great tragedians says. Every Member of Parliament has the right to keep his hat on if he so desires. There was talk of contesting Fox's right to his parliamentary seat, and the rights of his fellow-seceders, if their absences continued. This prompted Belsham, one of the best writers in the Opposition party, to write his own account of a previous secession under Robert Walpole, citing precedents in order to justify the present Leader of the Opposition in his use of this procedure.[10]

When the young Telemachos enters the national assembly, Homer tells us that he came 'not alone, two swift-footed hounds attended him' (*Odyssey* II, line 11). Fox is similarly accompanied at his exit. Barking and with teeth bared, a massive greyhound runs alongside him, its collar bearing an intentional spelling error which reveals the artist's true meaning.[11] It is Mr Gray,

[9] [*LuP* also quotes the passage from Samuel Gottlieb Bürde's German translation, *Johann Miltons verlornes Paradies*, 2 parts (Berlin: Viehweg, 1793), Part I, pp. 214–15.]

[10] [This work does not appear among William Belsham's essays, and was presumably published anonymously.]

[11] 'Opposition Gray-hound' should be spelled 'greyhound'. But Gray is the name meant here.
[In fact *LuP* is mistaken as to the spelling of Grey's name; Gillray had used the archaic alternative spelling for the dog.]

the greatest Opposition speaker after Fox, who is now transformed into his namesake the greyhound, and is seceding with Fox. Behind him wriggles a lapdog – or is it a piglet? The artist is deliberately ambiguous. It is little Michael Angelo Taylor, whom our readers have already encountered in a similar metamorphosis in another caricature.[12]

In the *Notabene* below the artist informs us that the background contains a corner of the House of Commons at the next session; and for those who have never been to London and have not had an opportunity to visit the gallery in the Chamber, this glance into the Lower House is particularly interesting, if only for Gillray's faithful representation of the setting. Above Pitt's outstretched hands we see the Speaker enthroned in his robes. Between Pitt and the Opposition is the table, with a kind of brass railing. On this table lies the mace, a type of large gilded sceptre, the symbol of honour in the House of Commons. It remains on the table at all formal debates. But as soon as the House decides to form a committee, to engage in less formal discussion, without being obliged to follow parliamentary procedure, one of the clerks takes the mace and hides it under the covered table.

[12] [*Pigs Meat; – or – The Swine flogg'd out of the Farm Yard*, 22 June 1798. *BM* 9230. *LuP* 2 (1798), 80–91, pl. XVI.]

8 'L'Insurrection de l'Institut Amphibie' — The Pursuit of Knowledge[1]

3 (1799), 350–8, pl. XI

Even Nelson's glorious conquest at Aboukir has been unable to dispel the nightmare vision of Bonaparte's Egyptian campaign in the minds of many Britons; and even those still drunk with victory regard him as a grinning death's head. As a result, they do everything possible to brand his enterprises as wicked, or even foolish.[2] Countless hymns praising Nelson's victory have been published in verse and prose, hymns which an English reviewer greeted indulgently with the words: "'Aaron stretched out his hand over the waters of Egypt, and the frogs came up and covered the land of Egypt.' Scarcely less numerous and scarcely more musical are the poets who have swarmed in England since Nelson exercised his power on the Egyptian waters.'[3] The great majority of these eulogies curse Bonaparte and call forth all the plagues of Egypt on his head. Eyles Irwin, famous for his oriental *Eclogues* and his voyages across the Red Sea, was one of only very few who recognised the enemy as a great general, and who were able to distinguish Bonaparte's personal merits from the cause he is fighting for.[4] William Sotheby, the only genuinely gifted triumphalist poet, went

[1] [Etching published 12 March 1799, in the series of six *Egyptian Sketches*. 'Etched by Js. Gillray, from the Original Intercepted Drawing'. *BM* 9356. John Ashton, *English Caricature and Satire on Napoleon I* (1888, reissued New York and London: Blom, 1968), p. 67. George (1959), p. 47. Hill (1966), pl. 27, p. 149. Ronald Paulson, *Representations of Revolution (1789–1820)* (New Haven and London: Yale University Press, 1983), p. 198.]

[2] One of the strangest works is the monstrous invention of a Cambridge scholar, who parodies Aeschylus' *Persae* in a poem he calls *The Battle of the Nile, a Dramatic Poem, on the Model of the Greek Tragedy* (London: Faulder, 1799).

 [*LuP* summarises the plot, in which the French Directory is confounded by news of defeat at Aboukir and other reverses.]

[3] *Critical Review* (March 1799), 355.

[4] See his elegy entitled *Nilus*, which stands out from many other ephemera. In memory of conquered Bonaparte, he concludes with the wish that the lotus and papyrus, both of which

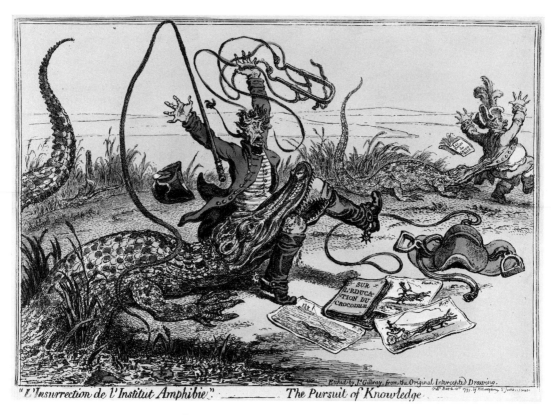

"*L'Insurrection de l'Institut Amphibie*". *The Pursuit of Knowledge*

PLATE 18
James Gillray, *'L'Insurrection de l'Institut Amphibie' – The Pursuit
of Knowledge*, 1799.
Etching, hand coloured.

badly wrong, as I think even fair-minded Britons would agree, when he
composed a poem trumpeting forth his premature rejoicing over a rumour,
circulating some months ago, that Bonaparte had been murdered in Cairo.[5]

Footnote 4 (*cont.*)
grow by the Nile, should shade the grave of the hero. *Nilus; an Elegy. Occasioned by the Victory
of Admiral Nelson over the French Fleet* (London: Bulmer and Nicol, 1798), p. 15.

[5] Sotheby published his song of triumph under the title *The Battle of the Nile, A Poem* (London:
Hatchard, Rivington et al., 1799). He believes the rumour that Bonaparte was attacked and
killed by the murderous Mamelukes: 'Hark, the loud voice of rumour loads the gale, / And
Europe spreads from realm to realm the tale: / He rests in death, the dream of Glory o'er, / He
rests untimely on a barbarous shore.' Cf. *Monthly Review* (February 1799), 227.

One of the most malicious ways in which Bonaparte's conquest was denigrated in the eyes of the British public was the publication of the letters intercepted from French ships, a measure which was authorized by the government.[6] It goes without saying that the editor first removed anything to the advantage of the French enterprise. His selection is peppered throughout with the strongest invectives against Bonaparte, in the introduction as well as in footnotes to the letters themselves, and the most bloodthirsty and abhorrent intentions are attributed to him. Certainly, nothing good could ever be gained by these passionate outpourings of bile. Yet merely the tone of such comments on the Egyptian enterprise appeals to the great majority of readers in England, and that, of course, is exactly what was intended. The first part of the collection, which appeared at the end of last year in London, rapidly went through eight editions, and was greedily consumed by the public. The French Directory had the letters reprinted in France, repaying the English editor's additions in the same coin – i.e with further libellous and insulting counter-accusations.[7]

It is well known that one of Bonaparte's first enterprises on taking Cairo was to organise the scholars in his retinue and the learned gentlemen of his general staff to form an Egyptian National Institute. Its meetings were first announced in the Cairo *Décade Egyptienne*, and then in the French journals.[8] Whatever the motives of the valiant conqueror of the Mamelukes in

[6] *Copies of Original Letters from the Army of General Bonaparte in Egypt, Intercepted by the Fleet under the Command of Admiral Nelson*, part 1 . . . (London: Wright, 1798). The second part was not published until a few months ago (1799). The *Anti-Jacobin Review* (December 1798), 647, emphatically states: 'We know, however, that it comes from the highest authority' (this is why, even in the French edition, it says 'avec une introduction et des notes de la Chancellerie anglaise'), and praises the elegant style of the editor. Nevertheless, the *Analytical Review* . . . (February 1799), 149, maintains that publication of these papers goes against the tradition hitherto observed amongst civilised nations. (The French Directory, however, had already done the same thing, and even made up some letters.) . . . 'A plain, unadorned publication of the correspondence would have made a deeper impression on the public mind. The editor takes away much of the effect by an overstrained anxiety to abuse, vilify and condemn Bonaparte and his army.'

[7] Even the editors of the equally official *La Décade philosophique, litteraire et politique* (Paris, l'an 7), No. 13, 232, voice their disapproval of the insulting ripostes of the French editors.
 [In a review of *Correspondance de l'Armée française en Égypte* . . ., signed J.-B. S.]

[8] The establishment of the institute . . . and the minutes of the first meetings, are given in the

creating this Institute, it cannot be denied that news of its establishment was very favourably received throughout Europe. Scholars of all nationalities and tongues, who prefer scientific conquests to military victories and conquered provinces, hailed it as a new dawn in a region which has until now been cloaked in impenetrable darkness.

We can only welcome the fact that Gillray, who keeps pace with every important event of our time, saw fit to erect a memorial of his own design to this Egyptian Institute. The caricature in question plays on British contempt for the Institute, which is otherwise highly praised. At the same time it creates a joke at the Institute's expense. The note in the corner of the print, where the artist usually puts his name, saying that this is only a copy 'from the original intercepted drawing' is very amusing.[9] For even if it is true that Gillray only offers his services to the ministerial party for the sake of profit, as is often alleged, he is still capable of the wicked little suggestion that many of the 'intercepted' letters published in England are about as authentic as his faithful copy of 'the original drawing'.

One of the learned scientists in Bonaparte's retinue is the well-known zoologist Geoffroy, who gave a lecture on the ostrich at one of the very first meetings of the Institute in Cairo.[10] He even ended his talk with suggestions on how these 'camel sparrows' (as they were so picturesquely called in antiquity) might be tamed and domesticated for the use of man, the lord of creation. Gillray's satirical muse has now devised a similar suggestion, said to come from the Egyptian Institute, on the subject of taming and domesti-

Footnote 8 (*cont.*)

tenth review of French literature in *Intelligenzblatt der Allgemeinen Literatur-Zeitung* 8 (23 January 1799), 58f. The latest minutes, from 1–26 Frimaire, can be found in *La Décade philosophique*, l'an 7. No. 23, 262f.

[The Institut d'Egypte was established in Cairo in August 1798.]

[9] [According to the frontispiece (*BM* 9355), Gillray's *Egyptian Sketches* were 'extracted from the Portfolio of an ingenious young Artist, attached to the Institut National at Cairo, which was found on board a Tartane intercepted on its Voyage to Marseilles–The Situations in which the Artist occasionally represents his Countrymen are a sufficient proof of an Impartiality and Fidelity, which cannot be too much commended . . .']

[10] [Etienne Geoffroy St-Hilaire's 'Observations sur l'aile de l'Autruche', 1799, was published in *La Décade Egyptienne, Journal Littéraire et d'Economie Politique* (Cairo: l'Imprimerie Nationale, An. VII), vol. I, pp. 46–51. This published version of Geoffroy's paper does not mention taming the ostrich, which may be wishful thinking on *LuP*'s part.]

cating the crocodile! Indeed, in the caption below he decides to entitle the Institute itself Amphibian ('l'Institut Amphibie'). A portfolio thrown to the ground bears the inscription, 'On the Education of the Crocodile'. In addition to the *Procès verbaux* of discussions in the Cairo Institute, it contains a number of pictures – the three carefully numbered drawings scattered around it provide further details. For if these Nile monsters are to be made useful to the inhabitants, three stages of instruction must be followed, starting with the easiest and ending with the most difficult. First they must be used as riding horses; then as coach horses; and finally as tow horses on the Nile barges. Palaephatus, who explained miracles, used to say, 'what was once true, may still be true today'. If this maxim itself remains true today, then the first step, the riding of the crocodile, should not be impossible. For the Tentyrites of ancient Egypt were accomplished crocodile-riders,[11] as we read in Strabo's true and wonderful eye-witness account. He describes, for example, how millennia before this French inspiration, priests learned how to tame them and make them compliant.[12] But the French are not Tentyrites, and indeed most of the Tentyrites were killed anyway during these neck-breaking experiments, as Seneca assures us.[13] At any rate, the crocodile-rider in Gillray's print is not enjoying himself at all. All he wanted was to saddle the disobliging animal so that he could ride it – the first step in the taming process – but alas! he set about the affair rather incompetently, as the unused saddle and bridle in his hand testify. The entire depiction of the terrible creature is accurate and masterly, although scientists might quibble

[11] 'The Tentyrites', says Pliny (*Natural History*, Book VIII, ch. 38) 'can easily tame crocodiles. They sit on their backs like riders, and when the beasts turn their heads and try to snap at them, they poke a stick between their jaws and use it as if it were a bridle, to drag them along like prisoners.' Crocodiles on ropes are often seen on coins from Nîmes. When Augustus once entertained the Romans with thirty-six crocodiles in his naumachia (Cassius Dio's *Roman History*, Book LV, ch. 10), the Tentyrites played with them like lap-dogs. See Strabo, *Geography*, Book XVII, part 1, ch. 44.

[12] The priests in the crocodile city, later known as Arsinöe, fed the crocodiles as follows: one man held their jaws open, while another stuffed meat and cake into their mouths. Strabo, *Geography*, Book XVII, part 1, ch. 38. Benoît de Maillet in his *Description de l'Egypte*, 2 vols. (Paris: Genneau and Rollin, 1735), vol. 1, p. 298, clearly doubts poor Strabo's reliability, but forgot how cunning the priests were in unbelievably civilised ancient Egypt.

[13] Seneca, *Naturales Quaestiones*, Book IV A, ch. II. 15.

about the movable upper jaw and the tongue of the crocodile seen protesting in the reed bed.[14] However, the comb-like interlocking teeth, about whose number there were so many stories in antiquity, are more faithfully represented,[15] as is the powerful beating of the tail.

Another group in the background deserves a fleeting glance. A recent arrival in this *Nouvelle France* has been trying to preach the new Gospel of the Seine to the hulking brute, and is portrayed as a legislator. His legal tables are inscribed 'Les Droits du Crocodile'. But here too crocodile law is the law of 'might is right', which is all too clearly reminiscent of the enforcement of certain highly praised 'rights of man' in Europe. Our apostle will be lucky if he can save his skin with the sacrifice of a single ham and certain adjacent parts:

— imitatus castora, qui se
Eunuchum ipse facit, cupiens evadere damno
Testiculi adeo medicatum intellegit inguen.[16]

Who knows, maybe the clever Nile lizards will let the fellow go for their own safety, when they begin to suspect that 'blessed trouble' is afoot.[17]

[14] It is well known that the ancients always attribute a movable upper jaw to the crocodile, and dispute the use of the tongue, but modern scientists' views on the matter differ. The most frequently used sources are to be found in a scholarly commentary on Aristotle's *Natural History of Animals*, Book II, ch. 10, by the French national archivist Camus.
[*Histoire des Animaux d'Aristote, avec la traduction françoise. Par M. Camus*, 2 vols. (Paris: Desaint, 1783), vol. I, p. 75; vol. II, pp. 263–4.]

[15] Already in antiquity the tradition was that the crocodile had only 60 teeth; because for the ancients the number 60 was ominous. But hieratic legends gave the crocodile as many teeth as there are days in the year. See Achilles Tatius of Alexandria, *Leucippe and Clitophon*, Book IV, ch. 19.

[16] Juvenal, *Satires*, XII, lines 34–6. This passage is untranslatable.
[Presumably *LuP* sought to protect the delicacy of its readers through quoting in Latin. Gillray's Frenchman may imitate the beaver, which, being hunted for a valuable drug secreted in its groin, 'castrates itself when cornered, sacrificing its balls for the chance of freedom'.]

[17] Readers of Volney know what is meant by *mal béni* in Egypt. See Count Constantin François de Volney, *Voyage en Syrie et en Egypte pendant les Années 1783, 1784 et 1785*, 2 vols. (Paris: Volland and Desenne, 1787), vol. I, p. 224.
[I.e. the crocodile might contract venereal disease by eating the Frenchman's genitals.]

9 *Effusions of a Pot of Porter, — or — Ministerial*
 Conjurations for Supporting the War[1]

5 (1800), 71–84, pl. 1

Everyone knows that there are various types of second or double sight in the great realm of visions, encountered both inside and outside the madhouse. We have all experienced the horror of quite respectable, though somewhat depressed people suffering from disorders of the digestion and the brain, when they see themselves outside their own bodies, and receive quite a shock because it is not themselves that they see. Yet this affliction has arisen merely from ignorance of the claims of modern philosophy. For since we have learned to distinguish clearly between the pure self and the non-self, this emotional disorder has been consigned to the lumber room of Grun's *Antiquitates medicae*. The second sight experienced by the honest Highland Scots, in so far as they undergo a visionary self-deception of this kind, has long been explained beyond all possible doubt. Indeed, the cause has recently been confirmed yet again by Dr Garnett in his detailed report of his travels through the Highlands.[2]

Yet of all optical illusions, none comes as close to the 'delightful madness' which the ancient lyric poet so frequently and emphatically recommends to the Romans, as the second sight experienced by the drunken man, and the rapturous effusions of carousers under the inspiration of Bacchus:

Why, now! I seem to see two suns; a double Thebes;
Our city's wall with seven gates appears double.
You are a bull I see leading me forward now . . .[3]

[1] [Etching and aquatint, published 29 November 1799. 'Js. Gillray invt. & fect.' *BM* 9430. Donald (1996), p. 40.]

[2] This travelogue has just appeared in London in two large quarto volumes with many engravings, maps etc., and is one of the best works to come from England this winter. The author is now a 'lecturer' at Rumford's newly established institute.
 [I.e. the Royal Institution. Thomas Garnett in *Observations on a Tour through the Highlands*, 2 vols. (London: T. Cadell and W. Davies, 1800) refers often to excessive whisky drinking.]

[3] Euripides in the tragedy *Bacchae*, v, 906.

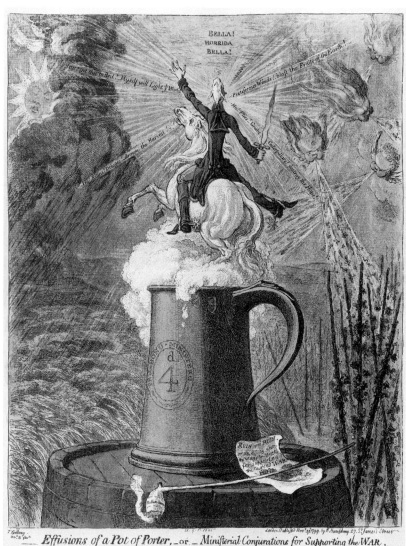

PLATE 19
James Gillray, *Effusions of a Pot of Porter*, 1799.
Etching and aquatint, hand coloured.

Many a Pentheus has uttered these words under the influence of the intox-
icating gifts of the god. Indeed, the inspiration sometimes goes even further,
allowing its enthusiasts to see forms which have no original, either in heaven
or on earth.

When he devised the caricature in front of us, Gillray had in mind a case
of this kind; only with a small variation in the nature of the divine drink by
which the miracle is usually wrought. Dr Parr is one of the most learned, but
also one of the most fervent and bold Whigs and Opposition writers in
London. Schooled and nourished by the spirit of the republican writers of
antiquity, he makes no secret of his convictions as to the form of government
which he would prefer.[4] And although these views rule out any prospect of a
pension from the court, or a treasury note from Pitt, he is nevertheless
admired by a large and respectable part of the public as a fearless and honest
man, and by scholars as a shining example of an English man of letters. In his
habits he has remained true to his former way of life; he retains an affection
for old English traditions, including a full and foaming tankard of good
brown beer or porter. And after a meal with a few good friends, when spirits
grow warm and cheerful, he likes nothing better than to puff away at a pipe
to aid digestion, and indulge in hearty discussions of politics and literature.

Since the last harvest, or rather since the total failure of the last harvest
due to the unusually damp, cold, rainy weather (which meant that many of
the fruits of the earth never even ripened, and most of the few that did
rotted in the fields), rising prices and a failed harvest are words dreaded by
every rich Briton. For even if he owns all the gold in both the Indies, he

Footnote 3 (*cont.*)

[*The Bacchae and other Plays*, translated by Philip Vellacott (Harmondsworth: Penguin,
1986), pp. 224–5. *LuP* also quotes these lines from *Euripidis tragoediae quatuor: Hecuba,
Phoenissae, Hippolytus et Bacchae*, edited by R. F. P. Brunck (Strasbourg: J. H. Heitz, 1780).]

[4] In a pamphlet . . . which Samuel Parr published under the title *Remarks on the Statement of Dr.
Charles Combe* (London: J. Bell, 1795) . . . and in which he defends himself against an attack by
Dr Combe . . . he expressly states on p. 71: 'Of my politics I shall scarcely give any other
explanation than that they are chiefly drawn from Plato, Aristotle, Polybius, Livy, Sallust,
Cicero and Tacitus among the ancients.' Compare in the same work his respectful testimonial
to Fox, p. 9, and his opinions on the revolution and its sworn enemies, the Tories, in various
passages. In the second volume of the *Public Characters of 1799–1800* (London: R. Phillips,
1799), pp. 89–104, there is also an excellent, meritorious account of our Doctor Parr.

cannot buy a morsel of freshly baked bread anywhere in the kingdom, unless the baker is willing to risk a fine of 5 pounds sterling.[5] According to the last Lenten sermon given by the Bishop of London on Ash Wednesday, nothing would please God more than if Britons were to eat as little bread and as many potatoes as possible. Of course this blight also affects the noble barley juice, the nourishing porter which strengthens the marrow, the Burgundy of Old England. This is what the Britons themselves call porter, with a proud, self-satisfied glance at the full, frothing tankard; they usually prefer it to all foreign drinks and artificial mixtures of fermented and distilled juices, regarding it as the one and only medicine for the stomach.[6] For many years, despite rises in the price of other foods, this true English national beverage continued to be sold at threepence-halfpenny (approximately 2 Groschen) per tankard or 'pot', because the common man believes he cannot live without it, and it would have seemed dangerous to raise the price of this product, which could more justifiably be called 'John Bull's last comfort' than an operation at the opposite end.[7] But finally, towards the end of last year, when our caricature was published, the price of barley and oats had risen so much, owing to genuine shortages and to the speculation of rich farmers, that even the pot of porter had to be sold at a halfpenny more, and the price was raised to fourpence.

[5] [Roger Wells, *Wretched Faces: Famine in Wartime England 1763–1803* (Gloucester: Alan Sutton and New York: St Martin's Press, 1988), pp. 37–8, 214–18.]

[6] There is evidence enough in the work of Hogarth, the father of English caricature. Connoisseurs who are familiar with the whole series of his caricatures need only remember *Beer Street*, and the 'sinewy strength' which he gives to his hefty porter drinkers in their various poses. They are modelled on those of his idol, Breughel, in the picture entitled *La grasse cuisine*. See John Ireland, *Hogarth Illustrated*, 3 vols. (London: J. Boydell, 1791–8), vol. II, pp. 56f.

 [The popular prints after Pieter Breughel's designs, *The Fat Kitchen* and *The Lean Kitchen*, date from 1563.]

[7] Amongst the anti-Pitt caricatures which appeared last year, commendable neither for their invention nor for their execution, one stands out for its exceptional vulgarity. It shows John Bull on a commode, divesting himself of a certain burden which no one else could do for him. Pitt comes up, and, happy to see this new evidence of superfluity, immediately places a new tax upon it. Underneath we read: *John Bull's last Comfort*.

 [Apparently not in *BM*, but related to the anonymous *John Bull Caught at his Last Luxury!!!* (16 December 1797), *BM* 9050.]

Measures such as these seize every devout porter drinker by the throat as well as by the purse! Someone like Dr Parr is least able to tolerate it. For, like the other members of the Opposition, he maintains that all these trials and tribulations are to be attributed solely to the mistaken measures taken by the Minister, and to his obstinacy in continuing the war with France. All sorts of violent exclamations are vented after dinner, and phantoms appear too – made, if not of air, then of fumes and porter froth. The former are encapsulated in a lengthy caption which appeared under the original engraving with the following quick prayer: 'Four Pence a Pot for Porter! – mercy upon us! – it's all owing to the War and the cursed Ministry! have not They ruin'd the Harvest? – have not They Blighted all the Hops? – have not They brought on the destructive Rains that we might be Ruin'd in order to support the War? – And brib'd the Sun not to Shine that they may Plunder us in the Dark?'[8] And now there's this phantom too!

We all know the famous apocalyptic emblem in which war, starvation and pestilence are portrayed as three armed riders on a red, a black and a pale horse, who emerge after the holy seals have been opened: 'And I looked, and behold a pale horse: and his name that sat on him was Death, and Hell followed with him. And power was given unto them over the fourth part of the earth, to kill with sword, and with hunger, and with death, and with the beasts of the earth.'[9] This vision from the revelations of the holy seer on Patmos has long formed part of the metaphorical language of English politics. There is a famous caricature by Gillray from the period when he was still employed – more lucratively – by the Opposition, at the outbreak of the war, where Pitt appears, wasted away to a hideous,

[8] Underneath we read the citation: 'Vide the Doctor's Reveries, every Day after Dinner'. We need hardly point out that the reasoning is very much of an Irish bull: they are ruining us in order that we will support the war. The final idea, that they have bribed the sun that they might plunder us in the dark, reminds us of the amusing passage in Aristophanes' *Clouds*: 'When that man was elected . . . you know, / Old pain-in-the-neck, old cursed-of-the-gods . . . / The general, the tanner! . . . / . . . the Moon went on strike, and the Sun / Turned his wick down and sulked.'

[Aristophanes, *Clouds, Women in Power, Knights,* translated by Kenneth McLeish (Cambridge University Press, 1979), p. 27. *LuP* quotes from Christoph Martin Wieland's translation in *Attisches Museum* 2.ii (1798), 67–174 and 2.iii (1798), 1–35 (II.ii, 124).]

[9] Revelation, 6:8.

shrunken skeleton, galloping in on a grey steed, portrayed as Death and brandishing his scythe menacingly.[10] So he rises from this beer mug, but this time he is a free spirit of the air, or perhaps of the vapour from the porter froth, surrounded by the sulphurous and blood-red rays of hell: a second Joshua, commanding the sun and the elements; a truly terrible sight. At the centre of the hellish transfiguration we read the slogan: War, Terrible War.[11] In his right hand he holds the flaming sword of destruction; and the Medusa-haired brood of Aeolus, obedient to the commandments of this archangel from pandemonium, spits thousandfold destruction on the ground, which is covered with green seed beds, and on the hop fields with their staves. He has two orders for this cheerful bunch. To one pair he shouts, 'Ho, Flies, Grubs, Caterpillars destroy the Hops!' whereupon flies, grubs and caterpillars are emitted from the fat-cheeked monsters. To the other pair the call rings out: 'Pestiferous Winds, blast the Fruits of the Earth!' and scorching, glowing arrows pour from the full mouths of these willing sylphs. Raising his left hand, he has another order for the fat-bellied clouds with their cavernous jaws: 'Ho! Rains, Deluges, drown the Harvest!' And the clouds pour forth their water, at the same time throwing a black, impenetrable veil around the sun. The omnipotent monster also has an order for the sun: 'Sun! Get thee to Bed, Myself will light y^e World'. And indeed, the half-extinguished and darkened sun is already in a deep midnight sleep. One can almost hear the flattened negro face snoring.

What a terrible vision, what horror and fear it arouses! Quite right, says mischievous Gillray, but only in the spray and fumes of a porter tankard, and only in the foggy, second-sighted brain of a blaspheming democrat!

And now to the pot itself and its very solid base, the beautiful round, fat porter barrel! Winckelmann's book[12] includes a famous old relief at the Villa Albani, where Diogenes is shown half rising from the famous barrel, like a mermaid from the fishy depths. Already in antiquity this comical idea gave

[10] [*Presages of the Millen[n]ium* (1795). *BM* 8655. Donald (1996), pp. 164–5, 192.]

[11] 'Bella, horrida bella!' We are all reminded here of the opening of Lucan's *Pharsalia* (*Civil War*). And as all men on earth are duty bound, in the name of Christ, to think of themselves as one great family, are not all wars therefore civil wars, brother against brother?

[12] Giovanni (i.e. Johann) Winckelmann, *Monumenti antichi inediti spiegati ed illustrati*, 2 vols. (Rome: for the author, 1767–79), vol. I, no. 174.

rise to various witty applications.[13] Here the idea is turned around. The barking anti-ministerial dog remains in the barrel, or, if you like, stuck behind the barrel; but out of the barrel rises the new Alexander. The idea itself is not new. There is an older allegorical picture which, if I am not mistaken, features as a woodcut on a Scottish ballad against whisky, where the ugly, knock-kneed figure of Death rises from a whisky bottle trailing a comet-tail of pestilence and disease. With little effort, similar phantasmagoria could also be made to rise from the vapours of coffee cups and apothecaries' jars.

Readers who have been kind enough to glance at earlier issues of this journal will find in this pewter porter pot the pictorial testimony to information our London correspondent has previously given us.[14] These pots belong to the publican and are sent out daily to all the customers in the district. But here our artist has allowed himself a little mischief. Usually the name, the street and the publican's house are engraved on every pot, to avoid dishonesty and confusion wherever possible. But this pot bears not only a stamp with the price – 4d or four pence – but also the inscription: PRO BONO MINISTERO, for the good Minister. As innocent as this porter pot legend appears to be, it hides a double hit. On the one hand it is a sign of the great loyalty of the honest publican, who, in order to please the *good* minister, is happy to charge a halfpenny more for his pot of porter. On the other hand the good Doctor Parr, whenever he sees this inscription, must feel as angry as many fervently royalist souls do to this day, both inside and outside the disputed borders of the Great Nation, whenever they see the terrible new French republican calendar; 'l'an VIII de la liberté' etc.[15] For Parr would

[13] The scene is often shown on cameos and monuments, where, indeed, it is often misinterpreted . . . See Winckelmann, *Cabinet de Stosch*, p. 422, no. 84.

[I.e. Jean Winckelmann, *Dactyliotheca Stoschiana, ou Collection de Toutes les Pierres gravées qui appartenaient autrefois Baron de Stosch et qui se trouve maintenant dans le Cabinet du Roi de Prusse*, edited by F. Schlichtegroll, 2 vols. (Nuremberg: Frauenholz, 1805), first published in German in 1797.]

[14] 'London' in *London und Paris*, 4 (1799), 14–18 (17f.)

[The correspondent describes how tankards of beer are sent out to private addresses and collected again later.]

[15] Compare all the mathematical reviews in a certain widely read and learned newspaper, in praising which we appear the more disinterested, since it will never stoop to advertise this frivolous journal.

rather spend his last penny on a subscription to a portrait of his arch-enemy Dr Combe than approve this *kalokagathia* to the no-less-hated minister, which the patriotic pewterer has engraved for him. And then that semantically barbarous 'Ministero', a touch of spite. What an abhorrent sound! What a torture to the tender ears of a correct Latin scholar, as the entire kingdom believes Dr Parr to be.

Not for nothing is the name 'Bellendenus' written on the burning pipe which has been placed down there on the barrel. This refers to the famous preface which our Dr Parr added to a collection of unpublished tracts by the famous Scottish author Bellenden, edited by Parr's friend, the preacher Homer.[16] The exquisite Latin style of this preface is admired in England, and it is regarded as a masterpiece of its kind. But Gillray certainly did not place the name Bellenden on the bowl of the pipe for this reason alone. The preface penned by this brave do-or-die staunch Whig also includes some very free opinions on the country's royal family, and a powerful declaration of beliefs. And it is for this very reason that the cunning artist gives the pipe its fiery glow. Not even a lenient constable would allow tobacco smokers to go around in public with burning and uncovered pipes.[17] And shouldn't Parr, too, be looked on as an incendiary of some kind? Everyone knows that a match or something similar is required to light a pipe. The paper on which the pipe stem is resting would serve the purpose very well. But look at the scrap of paper about to be condemned

[16] William Bellenden, a learned Scot who lived at the beginning of the last century, was already known to scholars for his classic work, *De tribus luminibus Romanorum* (Paris: Apud Tussanum du Bray, 1634). The circumstances in which Parr's friend Homer issued three previously unpublished tracts by the same author, and how Parr came to write such a splendid preface, are described in detail by the latter himself, in the pamphlet against Dr Combe referred to above, pp. 42f.

[See n. 4 above. Cf. *A Free Translation of the Preface to Bellendenus; Containing Animated Strictures on the Great Political Characters of the Present Time* (London: T. Payne et al., 1788).]

[17] I have just encountered the latest evidence for this in . . . Wilhelm Ferdinand Müller's *Meine Streifereyen in den Harz und in einige seiner umliegenden Gegenden*, 2 vols. (Weimar: Gädike, 1800), vol. I, pp. 103–4.

[Müller condemns the posting of a sign at the entrance of the Brühl promenade in Quedlinburg, banning various activities including the smoking of tobacco.]

to a terrible death by fire in this summary fashion. We know it *is* scrap or waste paper by the mass of beer froth which has sprayed onto it. 'Ruin upon ruin, or an Essay upon the Ways and Means for supporting the cursed War' can be read clearly on the half-title page. It is the title of a new pamphlet against the ministers and their taxes which can only have been written by Dr Parr himself! And now, despite all his tender feelings for this nestling barely hatched from the egg, the author must sacrifice it to Vulcan! What a cruel penance the wicked caricaturist exacts from the Doctor, who is already discredited enough by this whole smoking apparatus.[18] On a lighter note, it reminds us of the comic derivation of the name of such scraps of paper, the etymology of *fidibus*.[19]

Here then is an interpretation of the caricaturist's meaning. As with so many other things in the political world, everything rests on the pedestal and the inscription on the monument. Try imagining, for example, that Pitt's splendid pillar of honour and *statua equester*, with all its glorious surroundings and bold rhetoric, had been placed upon a finely hewn block with the inscription beneath: *Genio Britanniae*, the tutelary genius of Britannia. In order to make it easier to imagine, we would only need to cut the caricature under the horse's hind hoof and throw away the bottom half.[20] Then we would have the most forceful expression the Opposition ever uttered on the subject of Pitt's measures and their dire consequences, displayed in

[18] Only the lowest class of people in England, or at least those gentlemen who have long since relinquished the fashionable world, would these days allow themselves to be seen either at home or in public smoking a pipe. Fielding used this trait in his novel *Joseph Andrews* to characterise Parson Adams, a minister who was kind and learned, but quite inexperienced in the ways of the world. Now the thing has an even worse reputation . . . Cf. *London und Paris* 4 (1799), 16.

 [*Joseph Andrews* (1742), Book 1, ch. 16.]

[19] One of the etymologies which Johann Christoph Adelung regards as ridiculous and refuses to cite . . . (*Grammatisch-kritisches Wörterbuch der Hochdeutschen Mundart*, second edition, 4 vols. (Leipzig: Breitkopf, 1793–1801), vol. II, p. 145) is that an author was once given a *fidibus* of this kind to light his pipe. Out of curiosity he unrolled the burned stub and to his shock recognised a fragment of his own latest work, whereupon, overcome with remorse, he exclaimed: 'Fy die Buße.'

 ['repentance'.]

[20] The beer froth would then be the dust which an Irishman once famously ordered from a sculptor.

word and image.[21] We should not find ourselves confused or embarrassed by the substance used for the pedestal. We would only need to place a fine block of Portland stone under Pitt's feet, and the base would be fully worthy of its statue from a political point of view.[22] Who knows, perhaps Gillray has once again imitated his great idol Hogarth; on several occasions that artist too, following a change in circumstances, reworked a caricature of a certain person, so as to express quite different convictions about him.[23] How easy it would be for Gillray to give the minister his just deserts, as the Opposition would see them, in exactly the same way!

[21] At the end of the day, it all comes down to the question, whether the present price rises can be attributed solely to the failure of the harvest, or whether they are a direct result of the war. In a remarkable speech in the House of Lords on 27 February, Lord Darnley, who is by no means a member of the Opposition, showed that there was enough corn, and 'that the distresses felt by the Poor at present were not as consequence of real scarcity, but of high prices', *Morning Chronicle*, 28 February 1800. The same view was maintained in the remarkable petition presented to the King in the name of the citizens of London by the present estimable Lord Mayor. Against this, the 1,500 liverymen mustered by the ministerialist Kemble, who submitted a counter-petition, could say very little. If this were to be proved, then the blame for the present enormous price rises would fall on the continuation of the war, now in its seventh year, and on those who stubbornly insist on its continuation, even after the most recent offers from France. The consequences are self-evident.

[Cf. *The Parliamentary History of England*, vol. XXXIV (London: Longman, Hurst et al., 1819), cols. 1497–9, 1503–4. The *Morning Chronicle* reported the speeches of Lord Clifton, Earl of Darnley, on 21 and 28 February, but they do not include the words here attributed to him.]

[22] The most popular type of building stone in England is Portland. I need not remind you that Pitt's omnipotence in the Commons is based primarily on the fact that the Duke of Portland and the whole of his Whig group went over to Pitt's party. As early as 1797 an emblematic picture appeared in London, where Pitt, with a budget full of taxes under his arm, stands on a pedestal of 'Portland stone', and, speaking through a voice trumpet, promises the people peace, trade, comfort, freedom and property. The caption reads: *The hopes of Britain blown away thro' a Speaking trum-Pitt.*

[By Robert Dighton. *BM* 9047.]

[23] [Apparently a reference principally to Hogarth's *The Times, Plate I* (1762), where the elder Pitt, originally symbolised by Henry VIII, was transformed in the third state of the print into his own caricatured likeness. Ronald Paulson, *Hogarth's Graphic Works*, 2 vols. (New Haven and London: Yale University Press, 1970), vol. I, pp. 249–50. By this allusion to Hogarth's satirical indictment of William Pitt the Elder as a warmonger, *LuP*'s writer discreetly underlines his comments on the ambiguity of Gillray's attitude to Pitt the Younger.]

10 *Lilliputian-Substitutes, Equip[p]ing for Public Service*[1]

7 (1801), 248–62, pl. VII

The recent change of ministers in England inevitably involved many out-breaks of friction and party spirit. Sparks flew on all sides and of course there was plenty of kindling in which these hostile sparks could catch fire, amongst those who had long been the bitterest opponents. On the whole, the nation seemed, and still seems, to be convinced that the new ministers will be just 'pantins'[2] and puppets of the old, and that only if their great predecessors are still pulling the invisible strings of government 'behind the screen', can this fresh administration be regarded as acceptable and beneficial. There is not a single eminent talent amongst the new ministers. This is another important reason for the suspicion that the old state actors intend the new to be simply their temporary understudies, and that they have no desire to give up the roles which they once so famously played themselves. The news-papers, too, confirm these suspicions in everything they report regarding the behaviour of the King towards the ministers who have resigned. We need only consider the King's visit to Dundas in Wimbledon, and the toast pro-posed to his good health at parting! You will recall that Pitt wished to visit his great friend Dundas in Scotland, but had to remain near England because no one wanted to go searching for this much-consulted political Pythia on the other side of the Tweed. It explains why even the most loyal supporters of the ministerial party do not take offence at the many jokes and attacks on this whole political puppet show. It also explains how our friend Gillray, an enthusiastic supporter of the great Pitt, could unashamedly make an ass of

[1] [Etching published 28 May 1801. 'Js. Gillray fect. & delt.' *BM* 9722. George (1959), pp. 54–5. Hill (1965), pp. 104–5. Hill (1976), pl. 72, pp. 121–2.]

[2] [Pantins were little dancing manikins which had been fashionable as a toy in the eighteenth century. George Paston, *Social Caricature in the Eighteenth Century* (London: Methuen, 1905), p. 13.]

PLATE 20
James Gillray, *Lilliputian-Substitutes, Equip[p]ing for Public Service*, 1801.
Etching, hand coloured.

his deputy in the caricature before us, yet could nevertheless be assured in advance of the applause of all parties.[3]

The tireless Gillray scorns no contribution for his pencil, from either friend or foe. This time he seems to have in mind Socrates' old motto: a wise man knows how to use his enemy.[4] His lamp was lit from one of Fox's witty

[3] [Both George and Hill surmise that the idea came from Canning. The form of Gillray's signature indicates a contributed suggestion, since he claims credit only for the execution of the print, and (apparently as an afterthought) for the drawing.]

[4] In Xenophon's *Oeconomicus*, ch. 1, section 15 . . . Shakespeare's famous lines, 'There is some soul of goodness in things evil' etc. provide further commentary.
 [*Henry V*, Act IV, scene 1.]

ideas, and he has simply taken it a little further in the present caricature. In the remarkable Whig Club meeting of 5 May, Fox described the new ministers in the following way: 'We may come to a situation in which the King may not only rule us by his Jack-boot, but we may be governed by his Jack-boot's Jack-boot.' On hearing this witticism, those present nearly split their sides laughing.[5] Indeed, it was almost as if the entire Whig Club had been transported to Homer's Olympus, when 'irrepressible laughter rang out from the immortal gods' at the sight of the limping cup-bearer.[6]

At the time all the newspapers reported that their laughter continued for some three minutes and their applause for five. Make what you like of this, and good luck to you! Let us now see how Gillray chose to understand this *bon mot*, and how he developed it to create one of his wittiest caricatures.

I have often heard tell of a pair of pet monkeys who found their way into their master's closets, and, following their innate ape-natures, immediately fell upon the clothes, dressing up in them to marvellous effect.[7] Then there was the tale of Franz the lackey and Suzette the little chambermaid playing masquerade, who presumed to the most ludicrous elevation in status by donning the contents of their master's wardrobe. Gillray has given us free tickets to a masquerade of this sort. We enter the 'robing room'[8] of the gentlemen of St James's. The former ministers have left behind their state wigs, their clothing and their gowns. Their successors, this riff-raff of dwarfish Lilliputians, have been quick to take possession of the spoils, and

[5] The English cavalry and postillions, like ours, wear large stiff boots or foot casings which can easily be shaken off in an emergency. These are called 'jack-boots'. They must be able to withstand blows which would otherwise lead to the foot being crushed, or worse. According to the English constitution, it is not the King but the minister who is answerable to the nation. The minister is therefore the King's jack-boot, whom he can put on and take off as he pleases, and can expose to any kick or blow. Thus, Pitt was the King's jack-boot; but this jack-boot itself has got a new jack-boot in the form of Mr Addington. Pitt still controls everything, but as an unseen and unaccountable middleman, and Addington is the jack-boot's jack-boot.

[Fox's listeners would have been reminded of the 'jack-boot' as a nickname and graphic symbol formerly applied to the King's hated minister and favourite, Bute. Donald (1996), pp. 50–5.]

[6] [Homer, *Iliad*, Book 1, lines 584f. The cup-bearer is Hera's son, Hephaistos or Vulcan.]

[7] See, for example, *Die Eumeniden* (Zurich: 1801).

[8] This is the room next to the chamber of the House of Lords, where each Lord keeps his state robes locked in his own wardrobe, and dons them on solemn occasions.

are now swaggering and strutting around in their robes like proud peacocks; but they are half a world too big and fit them as badly as the lion's skin and Hercules' cudgel fitted Bacchus in the old comedy.[9]

The most remarkable aspect of this print is the huge jack-boot which stands on the Chancellor's bench, with a small head on top, dressed in Pitt's coat, bag-wig and enormous hat. It is here that Fox's *jeu d'esprit* is literally reproduced, and every Englishman will immediately grasp its true meaning. Addington, the former Speaker and now Prime Minister, is but a poor stop-gap, and the entire masquerade more or less means that Pitt's boot has been placed on the seat of the Chancellor of the Exchequer. The caricaturist therefore hardly needed to add the words coming from the mouth of this boot-like bust: 'Well! to be sure these here Cloaths do fit me to a inch! – and now that I've got upon this Bench, I think I may pass muster for a fine tall Fellow, and do as well for a Corporal as my old Master Billy himself!!!' The intentional crassness and vulgarity in the words of the original are carefully calculated, and this soliloquy also contains many other allusions. Addington is as skinny as a bean-pole, and is at best 'to an inch' smaller than Pitt, who is himself as thin as a rush-light. Partly for this reason and partly because of his strict discipline, Pitt is compared here to a sprightly corporal. Yet the reference to stature is, by implication, just as much intellectual as physical. In this respect Addington has to be placed on a pedestal if he is not to be overlooked entirely. But again, isn't this base still far too high for him? Surely everyone is reminded here of our noble Pfeffel's Mikromegas.[10]

The figure on the red woolsack is the silhouette of the Lord Chancellor; of course he is to the House of Lords what the Speaker is to the Commons. At the change in ministry the place of Lord Loughborough (Wedderburn) was taken by the former Attorney General, Sir John Scott, now Lord Eldon, just as Loughborough himself was once promoted to this position from Attorney General, when he became Lord Chancellor in place of the noble Thurlow. As Attorney Lord Eldon was already a powerful defender and

[9] [In Aristophanes' *Frogs*.]

[10] [A poem by Gottlieb Konrad Pfeffel, entitled 'Mikromegas' (1773), about a tiny monkey which took to walking on stilts to impress its companions. All went well until it fell from the stilts and became a dwarf once more. See Pfeffel's *Poetische Versuche*, 5th edition, 10 vols. (Tübingen: Cotta, 1816–1821), vol. 1 (1816), pp. 130–1.]

champion of the royal prerogative, acting for the Crown,[11] lending the minister every possible assistance in legal matters. The monstrosity of a wig which parades as the very essence of the Chancellor's honour will almost certainly figure in a new edition of Nicolai's book on wigs, and looks worthy of the title page.[12] It is the perfect example of what the English call 'a large, full bottomed wig'. The exclamation emanating from this strange wig at the point where the mouth should be, 'O such a Day as This, so renown'd, so victorious. Such a Day as This, was never seen', refers to a remark made by the new Lord Chancellor on a previous occasion; at the same time it gives a taste of his rhetorical strength in the use of *epiphonema* and the figure of ancient rhetoric described by the scholarly term *epizeuxis*.[13] We dare not identify for certain the two figures shown only in vague outline between Loughborough's wig and Pitt's hat. Gillray must have had good reason to fear the *Scandalum magnatum* which normally fails to frighten him.[14] Was it perhaps his intention to show Admiral St Vincent, successor to Earl Spencer as the First Lord of the Admiralty, in the head with the tall-brimmed military hat right at the end? The functionary seen from the back

[11] 'He prosecuted', we read in the *Public Characters of 1798*, p. 434, 'more men for libels, than ever fell to the lot of any two of his predecessors! It is during his time too, that secret imprisonment has crept into practice.' He delivered up many a victim to Aris, the infamous chief jailer at Coldbath Fields. Anyone who wishes to turn eulogy on its head should be sure to read a letter sent to Eldon by the famous philologist Gilbert Wakefield: he languished in prison for two years for writing it, which gave him time to write his *Noctes Carcerariae* (London: S. Hamilton for the author, 1801).

 [*A Letter to Sir John Scott, His Majesty's Attorney-General, on the Subject of a Late Trial in Guildhall. By Gilbert Wakefield* (Sold by the author, 1798).]

[12] [Friedrich Nicolai, *Über den Gebrauch der falschen Haare und Perücken in alten und neueren Zeiten. Eine historische Untersuchung* (Berlin and Stettin: 1801).]

[13] E.g. 'nunc, nunc insurgite remis!'

[14] As is well known, this law protects a peer's character from libel. But as Gebhard Friedrich August Wendeborn points out in *Der Zustand des Staats, der Religion, der Gelehrsamkeit und der Kunst in Grossbritannien gegen das Ende des achtzehnten Jahrhunderts*, 4 vols. (Berlin: Haude und Spener, 1785–88) vol. I, p. 31, the nobles rarely make use of it, 'because in many cases their characters bear out what would be scandal and lampoon if it were reported of an honest man'.

 [Cf. Wendeborn, *A View of England Towards the Close of the Eighteenth Century*, 2 vols. (London: Robinson, 1791), vol. I, pp. 14–15. Herbert Atherton, *Political Prints in the Age of Hogarth* (Oxford: Clarendon Press, 1974), p. 69. C. R. Kropf, 'Libel and Satire in the Eighteenth Century', *Eighteenth-Century Studies* 8.2 (1974/5), 153–68.]

with the 'Calotte' wig and black robe, signifies a lawyer of high office, what in England is called a 'Serjeant at Law' in the hierarchy of the goddess Themis.[15] But a certain degree of inspiration is required to guess what is hidden by this back view. *A posteriori* may be the safest and quickest method in all empirical enquiries, but in physiognomy by far the best approach is to look your subject in the face, and it is this front view which proves its undoubted truth.[16]

Poor Lord Hawkesbury cuts a truly wretched figure. He is Lord Grenville's successor as Secretary of State for Foreign Affairs. He has put on his noble predecessor's breeches, and finds them, to borrow Shakespeare's description of old men's breeches, a world too wide.[17] One could call the whole man a walking pair of braces. The way he holds the considerable excess of his breeches in his right hand might foster the suspicion that this troubled gentleman's heart had sunk to his nether regions. The suspicion is reinforced by the words issuing from his mouth: 'Mercy upon me! What a Deficiency is here!!! ah, poor Hawkee! – what will be the consequence, if these d—d Breeches should fall off in thy "March to Paris" and thou should be found out a Sans-Culotte?' For several years this 'march to Paris' has been the butt of all the jokes made at Lord Hawkesbury's expense. Robert Banks Jenkinson, as he was called before his elevation to the peerage, revealed himself as one of the keenest bloodhounds of the English administration from the very start of the revolution. He was even in Paris during the storming of the Bastille, and, when events in the Netherlands in 1794 earned the allies such a great reputation, he announced in the initial euphoria that a direct march to Paris would be the easiest thing in the world. Caricaturists and satirists have made him pay heavily ever since for this premature triumphalism,[18] and wicked Gillray therefore puts Grenville's enor-

[15] [Themis was the goddess of justice.]

[16] [Physiognomy, the art of determining a person's character from the facial features, had become extremely popular, following the publication of Johann Caspar Lavater's *Physiognomische Fragmente*, 4 vols. (Leipzig and Winterthur: Weidmann and Steiner, 1775–8). See Introduction, pp. 22–4 above.]

[17] [*As You Like It*, Act II, scene 7.]

[18] In the account of this Lord in the *Public Characters of 1799–1800* (London: R. Phillips, 1799), pp. 128–9, we read: '"*The march to Paris*", uttered in the intoxicating moment of success, dwindled into ridicule, when its impracticability was established by defeat and disappointment.

mous trousers on him, so that he may lose them on the march to Paris.[19] Thus the sprightly anti-Jacobin enters the category of the breeches-less, or 'sans-culottes'.

As an interlude between the jack-boot and the braces, Minister Windham's successor, Mr Charles Yorke, peeps out, wearing a huge busby. He has 'Wyndham's Cap and Feather' on his head, as the inscription confirms.

The next principal figure, and at the same time the focus of the whole piece, is Dundas's successor in the War Office, Lord Hobart. The little dwarf with the valiant face and the threatening stance is quite ridiculously dressed in his predecessor's costume: that of a Scottish Highlander. This includes the fillibeg, or woman's skirt, and the Scotch bonnet;[20] even the 'broad-sword', complete with its huge pommel, which the Highland Scots were able to use with uncommon ease, and which they have stubbornly continued to use for many years, even in defiance of the government. This Lilliputian swashbuckler talks and behaves rather like the Goliath who appears in Goethe's *Roman Carnival* under the name 'il gran Capitano'.[21]

It was repeated with all the force of ironical invective by the Opposition-bench, and reiterated by the anti-ministerial writers. It soon found its way, with many ludicrous comments, into coffee-houses and places of amusement, and will probably be preserved in the tablet of public memory, while his Lordship shall retain an official situation under government.'

[Cf. e.g. Gillray's *Preliminaries of Peace! – or – John Bull and his Little Friends 'Marching to Paris'* (6 October 1801). *BM* 9726.]

[19] Perhaps it is also an allusion to the figurative expression, used particularly of domineering women, 'to wear the breeches'.

[20] In *Voyage en Angleterre, et en Ecosse et aux Iles Hébrides*, 2 vols. (Paris: H. J. Jansen, 1797), vol. I, p. 307, Barthélemi Faujas Saint-Fond describes the Highlanders' dress as follows: 'leur tête est couverte d'un bonnet bleu, avec une petite bordure autour de couleur rouge, bleue et verte'. This is faithfully reproduced in the print. But then the travel writer adds 'une seule plume longue et flottante le décore'. Instead of this feather, Hobart is wearing the military symbol of Ireland, the green shamrock. For Lord Hobart earned himself a great reputation in Ireland under the Viceroys Buckingham and Westmorland, through certain privileges granted to the Catholics. See *Public Characters of 1800–1801* (London: R. Phillips, 1801), pp. 236f.

[21] [See Johann Wolfgang von Goethe, 'Das Römische Karneval', *Italienische Reise II* in *Goethes Werke*, edited by Erich Trunz et al., 14 vols. (Munich: C. H. Beck, 1973–77), vol. XI (1974), pp. 484–515 (p. 502). Goethe refers to the '*Capitano* of the Italian theatre' whom he witnessed during a visit to a Roman carnival. Dressed in Spanish costume, and boasting loudly of his exploits on land and at sea, the captain was joined by a Pulcinella whose interjections and remarks made him look ridiculous.]

Blood runs in streams from the murderous sword, and announcements of his own great achievements pour from his mouth; for other storytellers have had the audacity to attribute them to quite different heroes. Note the emphatic use of 'we' and 'us' in the whole tenor of this fanfaronade. 'Ay! Ay! leave *Us* to settle them all! here's my little Andrew Ferrara!!!²² Was it not *Us* that tip'd 'em the broad-side in the Baltic? – was it not *Us* that gave yᵉ crocodiles a breakfast in Egypt? I'm a Rogue if it is not *Us* that is to save little England from being swallow'd up in the Red Sea!!!' Thus he suggests that the last encounter at Copenhagen,²³ like that at Aboukir and the succour sent from India across the Red Sea, can be attributed to the new Secretary at War, who has hardly had time to read through the political will of his great testator, let alone carry it out! Lord Hobart is, of course, regarded as the founder of the nation's militia. Yet the militia has never had a direct influence on foreign affairs. In the strange incongruity of such valiant boasting, the figure appeals irresistibly to a well-developed sense of humour; he brings to mind unbidden those words of the Countess of Auvergne in Shakespeare's *Henry VI Part I* (Act II, sc. 3):

– is this the scourge of France? . . .
I see report is fabulous and false.
I thought I should have seen some Hercules,
A second Hector for his grim aspect,
And large proportion of his strong-knit limbs.
Alas! this is a child, a silly dwarf. It cannot be this . . . shrimp
Should strike such terror to his enemies.²⁴

It is said that Lord Hobart earned his military reputation as secretary to two viceroys in troubled Ireland and as Governor of Madras, and that he is truly a man who has his heart in the right place. Perhaps he will say of this caricature, as Lord Talbot said, 'No, no, I am but shadow of myself.'²⁵

²² The Catholic Highland Scot used to call his sword 'little Andrew' after the national patron saint, and 'Ferrara' is the name of a good Spanish sword blade.
 [Andrew (Andrea da) Ferrara was a famous sixteenth-century swordsmith.]
²³ [Nelson defeated the Danish fleet in Copenhagen harbour on 2 April 1801.]
²⁴ [*LuP* quotes August Wilhelm Schlegel's translation, *Shakspeare's dramatische Werke*, 9 vols. (Berlin: Unger, 1797–1810), vol. VII (1801), p. 242.]
²⁵ [In the same scene from *Henry VI Part I*.]

We are left with two secretaries to the Treasury who took the places of Messrs Rose and Long. Gillray portrays them as Treasury inkstands, thereby proving himself to be a descendant of Vulcan the sorcerer. Just as, in Homer, Vulcan fashioned animated, walking tripods,[26] so too does Gillray create living inkstands who shoulder their pens like rifles, and march in time like the Volunteers in Hyde Park. The one with the spectacles is Vansittart, the other Hiley Addington. You are only inkstands, says Gillray, at best only useful as writing machines.

Lord Liverpool recommended Mr Canning (whose slippers his successor is vainly trying to don) to the almighty Pitt, on account of his excellent brain.[27] Finally he was appointed to the very important position of Paymaster and Quartermaster General. Canning is a slim man, always the height of elegance, right down to his dainty little slippers. His bare-bottomed successor, Lord Glenbervie, well-padded from top to toe, is in the depths of despair because his shoes are too tight. 'Ah Damn his narrow Pumps! I shall never be able to bear them long on my Corns! – zounds! are these Shoes fit for a Man in present-pay Free Quarters?' The main sting, as everyone will see, lies in the words, which mean: 'I am so little suited to my new post that I can't even wear my predecessor's slippers for long.' Only time will tell whether these gentlemen can act out anything more than a masquerade together. Otherwise such rulers may remind Germans of Pfeffel's epigram entitled 'The Regent':

A court jester once stretched out and yawned
On his Prince's cushioned throne.
Just then the Prince arrived,
Preceded, as always, by his vizier.
'Hey boy', said he, 'What are you doing?'
'Oh, nothing!', said Niklas, 'Just ruling!'[28]

[26] [Homer, *Iliad*, Book XVIII, lines 373f. Cf. Pope, 'The Rape of the Lock', canto IV, line 51.]

[27] Canning excelled in wit and poetry in ancient and modern languages while still at Eton. This is why Peter Pindar, in his recently published satirical and defamatory ode on Pitt, calls him 'lame-Latin Canning'. See *Out At Last! or the Fallen Minister* (London: West and Hughes, 1801), p. 9, note. Through Canning's enterprise, he and some other Eton scholars used to edit a weekly sheet called *The Microcosm*, which attracted general attention. In the last few years Canning himself edited the *Anti-Jacobin* and appeared to be one of the keenest defenders of ministerial measures.

[28] [Pfeffel, *Poetische Versuche*, vol. V (1817), p. 187.]

11 *Integrity retiring from Office!*[1]

7 (1801), 333–48, pl. x

It's easy to kick a man when he's down. The truth of this old saying was proved ten times over at the last change of ministry in England. One could as soon alter the course of the sun as deflect the much-feared, almighty Pitt from the pursuit of his principles. Hardly had his resignation been accepted by the royal authority, than the most malicious satirists appeared on all sides. They dipped their arrows in bile, whetted their molars and incisors on bitter desire for vengeance, then fell upon him and his government colleagues. Our readers have already been given ample opportunity to judge the Opposition caricatures from a single example published in an earlier issue of this journal.[2] The damned crew of satirical writers is harsher still; and the famous Wolcot, or Peter Pindar, as he is more commonly known, is the harshest of them all. He used to be respected by the public, and his works were generally regarded as entertaining. Recently, however, it has seemed as if only the filthiest scum remains in the Muse's cup of this political joker, and his writings have plumbed new depths. It is said that over the last three years threats have intimidated him into silence; what many believed was the effect of a golden mouth-stop, *vulgo* a pension, was actually only the result of fear, the lowest of all the emotions.

Whatever the truth may be, it is certain that as soon as Pitt and his colleagues had resigned, Pindar produced a long satirical poem; we have the sixth edition before us – if this numbering is not itself a bookseller's 'puff'! Entitled *Out At Last!*, *or, the Fallen Minister*, it contains the most biting and acerbic invectives against poor Pitt.[3] From start to finish, the outburst is a

[1] [Etching and aquatint, published 24 February 1801. 'Js. Gillray invt. & ft.' *BM* 9710. George (1959), p. 54. Hill (1965), p. 103. Donald (1996), p. 37.]

[2] Isaac Cruikshank's *Billy's Legacy* in *LuP* 7 (1801), 171–8, pl. iv. [*BM* 9712.]

[3] The title of this satire, already referred to in the last issue of our journal, is *Out At Last! or, the Fallen Minister. By Peter Pindar, Esq.* The motto is 'Procumbit humi Bos' (London: West and

106

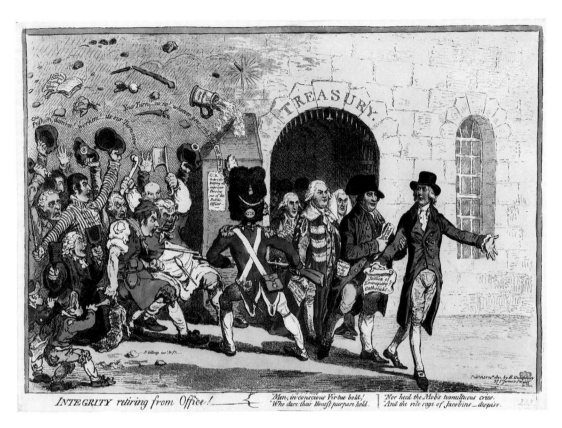

PLATE 21
James Gillray, *Integrity retiring from Office!*, 1801.
Etching and aquatint, hand coloured.

veritable 'Sarcasm', in the old and true sense of the word.[4] That is to say, it is a derisive speech, mocking the fallen enemy. It is divided into several

Hughes, 1801). Since it appeared, the poet's fertile Muse has burst forth in another poem, 'Odes to Ins and Outs'. This, and a few previous effusions, comprise a little volume of their own, under the general title *Tears and Smiles: a Miscellaneous Collection of Poems* (London: West and Hughes, 1801).

[4] As everybody knows, the word 'sarcasm', according to its original Greek derivation, denotes derisive jubilation: as when Homer's heroes stamp upon their slaughtered enemies. There was also sarcasm of this kind in the Pythic hymns to victory. Here the singers expressed the mocking tone in which Apollo heaped scorn on the dragon Python he had slain. In the philological dictionary of modern literature, a sarcasm of this kind is called an 'Ehrenpforte' (triumphal arch).

parts. First comes a prologue, in which the poet, drunk with joy, compares himself to Isaiah, who sang of the fall of the Babylonian King; then the song of triumph itself; and finally various epilogues and acclamations. To give our readers an idea of the whole work, we quote the following passage – a charming example of the poet's urbanity and sophistication, in which this 'genius of Old England' expresses his delight over Pitt's fall (p. 6):

But hark! OLD ENGLAND'S GENIUS sings!
(Sounds that will pierce the ears of Kings)
'Harpoon'd art thou at last, thou flound'ring porpoise –
 'Thou who hast swallow'd all my rights
 'Gobbling the *mightiest* just like mites –
'Devouring like a sprat my *Habeas Corpus*.'

 'Thou, who didst bind my sons in chains,
 'And nearly beatedst out their brains,
'For fear their wrath might kindle riot;
 'And, after binding them in chains,
 'And nearly beating out their brains,
'Didst cry – "How tame they lie, poor things! how quiet!"

 'Thou who didst groaning Prisoners keep
 'In Cold-bath Fields, like hapless sheep
'Whom horrid butchers mean to slay;
 'Where ARIS[5] with his iron rod,
 'The PLUTO of the dark abode,
'Roasted and broil'd in cook-like way
 'The victims of his pow'r and pride,
'And damn'd them all before they *died*.

Readers who are familiar with the works of classical antiquity will recall at this point the famous passage in Juvenal's Tenth Satire on the fall of Sejanus. This, Peter Pindar wishes us to believe, is how happy the English people were when they received the news of Pitt's fall (p. 23) . . .

[5] Readers will recall that Aris was the governor or head jailer at Coldbath Fields prison, which was assiduously used by the former ministers. His severity was often painted in shocking colours – particularly by the famous Sir Francis Burdett – both inside and outside the House of Commons.

Lo! thou art sprawling in the dirt!
The *Mob* their wanton jokes will spirt! –
Behold a sable CHIMNEY-SWEEP appear!
And hark! a SCAVENGER, with eyes
Sparkling with rapture and surprise,
Exclaims 'Ah, MASTER BILLY, are you *there*?'
Then, anxious to reward thee, on they rush,
One with his *broom*, and t'other with his *brush*!

Hark! AUTHORS braying round thee crowd,
And AUTHORESSES cry aloud –
'Villain! to wage a war with all the Muses!'
And lo, the PRINTERS' Devils appear!
With ink thy visage they besmear,
While each in turn indignantly abuses;
And more their pris'ner to disgrace,
They empt the pelt-pot in thy face!
Roaring, around thee as they caper,
'Take that, my boy, for Tax on Paper!'

And lo! with anger HARDY[6] glows!
The Man of Leather, with delight,
Runneth his *awl* into thy nose
And stirrups thee with all his might.
'He wants *much mending*, d—n my eyes!'
The punning Son of Crispin cries – (. . .)

And, see! the GIRLS around thee throng –
'Art *thou* the Wight[7], thus stretch'd along,
'An enemy well known to Wives and Misses?
'Art *thou* the man who dost not care
'For oglings, squeezes of the FAIR?
Nay, makest up *wry mouths* at woman's kisses?' –
Then shall the NYMPHS apply their birchen rods,
And baste thee worse than PETER PINDAR's odes.

[6] Hardy, Thelwall and Horne Tooke were, of course, accused of high treason, but acquitted.
[In 1794. Thomas Hardy was by trade a shoemaker.]

[7] Pitt is the most stubborn confirmed bachelor in the whole of Britain, and our Achilles has often had to put up with taunts in the Commons about this lack of susceptibility.

But enough, more than enough, indeed, of this disgusting morsel, whose only attractive quality, the piquancy of its rhymes, cannot even be reproduced in German. It would be hard to overcome the revulsion which our quotation inevitably arouses, were it not for the fact that the poem, in all its loutish crudity and insolence, is evidence of the extent to which liberties can still be taken in England. It shows the ignorance of those people who maintain that the once-free Briton has now had a padlock permanently clamped on his muzzle.

Be that as it may: it is extremely probable that witty Gillray was provoked by Pindar, and by similar attacks on Pitt and his friends, to publish the caricature before us, which is designed to protect and rescue the honour of the departed ministers. The scene takes place in front of the Treasury. Pitt and his colleagues have just emerged from the gates of the building. Each of them holds a piece of paper or a scroll, describing the deed which earned him the greatest honour in the eyes of the unprejudiced public. Wearing the Windsor uniform, Pitt leads the dignified procession. His scroll bears only the most recent of his achievements – if we were to write out all the others, we should require all the pens of the 'short-hands' or speed-writers in the galleries of the House of Commons, and all the paper supplies of the largest stationer's shop in Paternoster Row. His scroll reads 'Justice of Emancipating the Catholicks'. We know from both private and public sources that the King – who is well-meaning, but too much taken in by Clare's ideas[8] – would not negotiate this stumbling block, and that it was for this reason alone that Pitt's resignation was accepted.[9]

Pitt is followed by his faithful helper, the Scot Dundas, whose undeniable contribution to the flourishing state of the vast territories in East India is

[8] [John Fitzgibbon, Earl of Clare, Lord Chancellor of Ireland, was violently hostile to Catholic emancipation.]

[9] Many times under similar circumstances Pitt had used the threat of resignation on the King, who always hated the minister's inflexible mentality. As a result, Pitt had always got his own way. But this time the King felt more than usually insulted by the minister's stiff-necked obduracy. The Irish Protestants had the unique distinction of having always defended the cause of the Hanoverian dynasty. And now *these* men were to be levelled with the Catholics! The King's conscience could not allow it. Once again Pitt used scare tactics; but this time he failed to scare.

revealed in the paper peeping from his pocket: 'Successes in the East'. It is widely accepted that he has a profound knowledge of the rule of the merchant princes in India, and that his choice of skilful state administrators and fiscal managers in those regions has been excellent. Following his appointment as President of the Board of Control of the East India Company, Dundas not only rescued the Company, which twelve years ago seemed to be on the verge of bankruptcy, but also increased and consolidated its wealth to an extraordinary degree. It is on this wealth that the core of England's power is based.[10] His resignation from the presidency followed his departure from the ministry. But even after this, a wise measure which he had expressly recommended became the subject of intense discussion amongst the Directors of the East India Company. It concerned the granting of permission to British ships not equipped by the East India Company to carry return freight from India. If the directors had managed to resist the temptation of self-interest based on short-term profit alone, and had accepted Dundas's proposals, it would have been to their advantage.[11] 'Successes in the East' is therefore the pleasing motto with which Henry Dundas retires to private life.

The rather plump man in peer's robes is Lord Grenville, Pitt's voice in the Upper House. On the paper he holds in his right hand we read the glorious martial achievements of the British: 'Acquisitions from ye War. Malta, Cape of Good Hope, Dutch Islands' etc., etc. Every English sailor boy would punch the air at the sound of these names! The ceremonial wig between Grenville and Dundas is the departing Lord Chancellor Loughborough, who is, we hope, still familiar to our readers from a caricature we featured recently.[12] The Scot Alexander Wedderburn, the future Lord

[10] Dundas was 'President of the Board of the Controul of the East India Company in the management of their affairs'. See *British Characters*, vol. I, pp. 339–42, on his undeniably great services in this capacity. Of course, the verse from Virgil's *Aeneid* Book I, line 289, 'spoliis Orientis onustum' ('laden with the spoils of the East') has also been applied to him. But although this verse well describes many arrogant nabobs, it does not fit Dundas. All his wealth belongs to his wife. He is, so the well-informed say, not rich.

[11] But they did not resist; and when Dundas, the gallant Scot, was unable to force through the measures which he had originated and bravely defended, he resigned his presidency with lofty displeasure. So the door is left wide open to the contraband of foreign ships!

[12] [Loughborough's wig featured in Gillray's *Lilliputian-Substitutes, Equiping for Public Service* in *LuP* 7 (1801), 248–62, pl. VII. *BM* 9722.]

Loughborough, was always a strong advocate of strict measures against high treason and meetings liable to incite riots. No one can deny that the imposition of these measures sometimes led to mistakes being made, and compromised the constitutional liberties of the English nation. But in the fight against malignant growths, drastic treatment often brings merciful relief to the whole body. One need only read the detailed account by Mr Herbert Marsh, a well-informed Englishman, of those seditious persons who preach revolution in the Corresponding Societies throughout England, to be convinced that powerful influences must be met with even more powerful counter-influences.[13]

The last clearly visible figure at the back is the First Lord of the Admiralty, Earl Spencer, who was replaced by St Vincent. Most of Britain's magnificent naval victories may be attributed directly to his intelligent policies and calm persuasion (because passionate rows often broke out between the admirals and their immediate subordinates). But Earl Spencer is equally known as a great advocate of all useful and patriotic endeavours,[14] and he has always been very actively supported by his wife, who shares his views. He is therefore right to point to the paper inscribed with words which indicate his claim to the thanks of the nation: 'Enemies Ships taken and Des(troyed)'.

It is men such as these, Gillray calls to us from his print, who are leaving the highest positions in the state. And it is men such as *those over there*, he adds, who would like to get in. The long-bolted gates of the Treasury have been forced open, and a thieving rabble is there, ready to take advantage when the happy moment comes. Amidst cheers and all sorts of unruly and boisterous ejaculations, they storm in. A heavily built butcher with 'marrowbone and cleaver' (remember this butcher's harmonica from earlier car-

[13] *Historische Uebersicht der Politik Englands und Frankreichs* (Leipzig: Dyk, 1799), section x, pp. 184f.

[Herbert Marsh, *The History of the Politicks of Great Britain and France, from the Time of the Conference at Pillnitz, to the Declaration of War Against Great Britain*, 2 vols. (London: John Stockdale, 1800). In the Preface, p. xv, Marsh explained that the work had been written and first published in German, as detailed above.]

[14] For example, he was a powerful supporter of the vaccination of the British navy, and therefore received special mention on the coin commemorating Dr Jenner, dedicated by the ships' doctors (*Spencero duce*). See *Allgemeine Zeitung* 285 (1801).

icatures) and a cobbler lead the gang. At first glance it is clear beyond the shadow of a doubt that the butcher with the ruby carbuncles on his nose is the powerful opposition speaker, Sheridan, whose eloquence is likened here to a marrowbone concert. The cobbler is financing Tierney. Since he is unable to plunder the homeland of the tiger as a minister or ministerial aide, he has vented his wrath on a poor tabby cat instead. The trio behind Tierney consists of the Duke of Bedford (in the middle), who is dressed as a jockey and waves a riding crop and cap; to his right little Jekyll, wearing lawyer's robes and carrying a chimney-sweep's brush and shovel to tone in with them; and to his left one-eyed Nicholls. Fierce Tyrwhitt Jones peeps out from behind Sheridan right at the top. At the rear we spy the Duke of Norfolk with his emblem, an overflowing claret bottle, and Sir Francis Burdett, recognisable by his shock of hair. A murderous war cry is raised from behind: 'Push on, dam'me – work 'em! – its our Turn now!' In an attempt to fill them with warlike courage, two trumpeters sound the attack, blowing with all their might. One wears on his cap the name of the most violently partisan Opposition newspaper, the *Morning Chronicle*. For they are news-boys, who, as readers will know from earlier accounts, blow their trumpets to announce their newspapers in the London streets. And if ever the old poet's adage *Furor arma ministrat*, or 'a furious man never lacks for weapons',[15] proved true, it certainly does here. Look at everything flying, crackling and whizzing overhead! Paving stones, broken cudgels, turnips, Irish cabbages, exploding fireworks and tankards filled with frothing porter. The words 'Whitbread's Entire' are written on the pewter jug. This is 'entire' beer from the largest of all the London breweries, Whitbread's beer factory. And of course, since the younger Whitbread is a staunch and combative member of the Opposition, this beer bomb also represents the man himself. The wittiest part of the whole composition is the trajectory of the live jumping-jack firework, which is set to collide with the beer jug and its foaming contents. This terrible spray of fire could be extinguished by a single jug of beer! At the back, the gang's book of rules and rituals, entitled as we see, 'Jacobin Charges, Speeches and Essays', performs an aerostatic somersault.

[15] [Virgil, *Aeneid*, Book 1, line 150.]

These ardent passions and these prodigious contests
A little handful of dust will lay to rest
(Virgil's *Georgics*, IV, 86–7)[16]

For *pulveris exigui iactu* read a single bayonet and an enormous grenadier's cap, and this wild attempt to storm the Treasury will be foiled in a trice. The man in the guard's uniform and the huge busby, which we recall from the previous caricature,[17] can be none other than the War Minister Windham, who continues the grim fight even after his resignation. 'Your Turn? – no, no! whoever goes out, You'll not come in!' he shouts, valiantly beating back those trying to force an entry, ignoring the butcher's steel on poor Sheridan's stomach. There is a royal notice, evidently super-fluous, posted at the entrance to the Treasury. A placard with the venerable *Georgius Rex* as heading, it contains, as its title says, 'Orders for keeping all improper Persons out of the Public Offices'. This worthless bunch of robbers should be told!

Many art critics turn up their noses and become quite annoyed when people talk about the composition or the poses of the figures in a mere caricature. Gillray's caricatures, however, genuinely fulfil the demands of high art. Looking at this caricature with an objective eye, no one can deny that the calm, sedate grandeur[18] with which Pitt and his faithful companions leave their glorious empire is superbly composed and set against the effervescent, frenzied, raging violence of the attacking mob. How amusingly apt is the unification of these two contrasting groups by eager

16 [*The Georgics*, translated by L. P. Wilkinson (Harmondsworth: Penguin, 1982), p. 127. *LuP* quotes from J. H. Voss's German translation, *Georgicon libri 4 – Landbau, Vier Gesänge* (Hamburg: Bohn, 1789).]

17 [In *Lilliputian-Substitutes* (see note 12 above) Charles Yorke, the new Secretary for War, was shown wearing a busby inscribed 'Windham's Cap & Feather'. This seems to confirm *LuP*'s identification of the 'guard' here as Windham, although George suggests he symbolises the King.]

18 [This phrase, 'stille ruhige Größe', appears to be a conscious echo of Winckelmann's description (in *Gedanken über die Nachahmung der griechischen Werke*, 1755) of the defining qualities of ancient Greek art, 'edle Einfalt und stille Größe' ('noble simplicity and calm grandeur'). See H. B. Nisbet (ed.), *German Aesthetic and Literary Criticism: Winckelmann, Lessing, Hamann, Herder, Schiller, Goethe* (Cambridge University Press, 1985), p. 4 and pp. 31–54 (p. 42). Pitt's pose is in fact close to that of the Apollo Belvedere.]

Windham. How noble is Pitt's proud, imperious stance, with Dundas fondly clasping his arm. Spectators familiar with the intimate relationship of these two statesmen will be reminded of a common description of their political friendship, whereby the Scot Dundas is called the 'moderating Minerva' of the unyielding, frequently stubborn Pitt.[19]

[19] The four lines below the print contain a free, semi-parodied translation of the famous passage from Horace: 'Iustum et tenacem propositi virum, / Non civium ardor prava jubentium, / Non vultus instantis tyranni, / Mente quatit solida' which the seventy-two-year-old Oldenbarnevelt is said to have spoken on the scaffold.

> Men, in conscious Virtue bold!
> Who dare their Honest purpose hold
> Nor heed the Mob's tumultuous cries,
> And the vile rage of Jacobins – despise.

[Although this is indeed a free version of Horace, *Odes*, Book III, Ode iii, lines 1–4, the first line also quotes Pope's prologue to Addison's *Cato* (1713), line 3 – 'To make mankind in conscious virtue bold'. Jan van Oldenbarnevelt (1547–1619), the Dutch statesman and adviser to Prince Maurice, was condemned as a traitor and beheaded after he concluded a truce with Spain.]

12 *Political-Dreamings! – Visions of Peace! – Perspective Horrors!*[1]

8 (1801), 312–26, pls. XXII–XXIII

Not since Don Francisco Quevedo Villegas dreamed his world-famous *sueños*, or visions of the Last Judgement, hell and death,[2] has there been a more terrible and ridiculous fairy apparition than this – not even in the realm of Morpheus, that master of illusion and deceit. It represents the vision of ex-minister Windham,[3] and created a sensation even in London, where normally the most remarkable things hardly cause a stir. Indeed, this caricature has been in such demand and so many copies have been sold under the title *Windham's Dream*, that Mistress Humphrey, the sole vendor of Gillray's satires, had exhausted her entire, very considerable supply after only a few days. It closes this year's gallery of political satires from England just as fittingly as the first part opened with the famous *Union-Club* print by the very same satirist.[4]

William Windham, Secretary of State for War in Pitt's administration, distinguished himself in all his actions and parliamentary speeches as the most bitter adversary of the revolution, and the most vehement opponent

[1] [Etching published 9 November 1801. 'Js. Gillray invt. & fect.' *BM* 9735. John Ashton, *English Caricature and Satire on Napoleon I* (1888, reissued New York and London: Blom, 1968), p. 116. A. M. Broadley, *Napoleon in Caricature, 1795–1821*, 2 vols. (London and New York: John Lane, 1911), vol. I, pp. 148f. George (1959), pp. 57–8. Hill (1965), pp. 105, 126.]

[2] [The satiric *Sueños y Discursos de Verdades* of Francisco Gómez de Quevedo y Villegas (Zaragoza: 1627) was translated as *Visions, or, Hels Kingdome and the World's Follies and Abuses* by Richard Croshawe (London: Simon Burton, 1640). Quevedo may have influenced Goya's print series *Caprichos*, published in 1799, and there is an interesting affinity between 'The Sleep of Reason Produces Monsters' and Gillray's design of two years later. However, it is likely that Goya knew, and drew on, earlier English caricatures that used a dream or nightmare as a satirical vehicle, such as Gillray's *Tom Paine's Nightly Pest* (1792). Reva Wolf, *Goya and the Satirical Print in England and on the Continent, 1730 to 1850* (Boston College Museum of Art, 1991).]

[3] [*LuP* spells his name 'Wyndham' throughout.]

[4] [*LuP* 7 (1801), 61–87. *BM* 9699.]

116

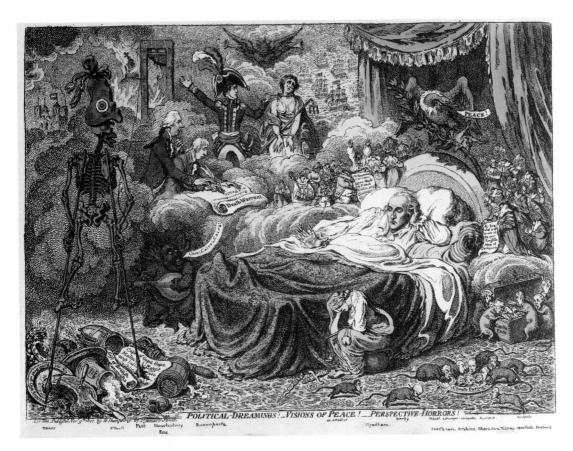

PLATE 22
James Gillray, *Political-Dreamings! – Visions of Peace! – Perspective Horrors!*
1801.
Etching, hand coloured.

of any measures which seemed even remotely to be aimed at Burke's 'regicide peace'.[5] Those who are familiar with the events of the day will clearly remember the rhetorical thunderbolts which he hurled even at Lord Malmesbury's putative peace negotiations, despite the fact that he was utterly convinced that the whole thing was just a political charade. Thus, the

5 [Burke's three *Letters on a Regicide Peace* were published in 1796–7. R. B. McDowell (ed.), *The Writings and Speeches of Edmund Burke* (Oxford: Clarendon Press, 1991), vol. IX, pp. 187–386.]

actual signing of the Peace Preliminaries was for him like the glance of the mythic Gorgon. The anger he had reined in for a full month burst out in the remarkable parliamentary debate of 3 and 4 November 1801.[6] Our prophet of doom is just like Virgil's Cassandra, whose 'lips utter once again the truth of what destiny has in store'.[7]

This time Windham's audacious use of imagery and metaphor, always a characteristic of his parliamentary speeches, was more striking than ever. Britons take a particular pleasure in such language, being accustomed to it from their reading of Shakespeare. Certain expressions from Windham's earlier speeches have acquired general currency in national parlance; and on this occasion, too, it wasn't long before many of his bold turns of phrase (on the funeral he attended after Bonaparte's unexpected death, for example,[8] and on the dangers of French sirens) were repeated and discussed in every society and every pamphlet: either in mockery or in hearty agreement, according to whether one was peaceable or warlike in inclination. His opponents flatly accused him of being a mad visionary. Ah yes, exclaims his advocate Gillray in the print before us, the noble patriot has indeed been granted a vision: all hell has broken loose! Now you can see for yourselves the atrocities and horrors of this fine Peace, which have gathered around the deeply-troubled patriot's bed in the eerie witching hour!

So as not to be overwhelmed by the sheer mass of objects which the satirist shows pressing in on the brooding head of the sleeper, we must, first of all, separate out his images and explain them in sequence. We should regard the whole vision as a phantasmagoric apparition to be presented in the following order.

The spirits appear swathed in fog and smoke. This is traditional. Schröpfer and Cagliostro, remembered as miracle-workers, also had their apparitions shrouded in mist.[9] A new sort of column of fire and smoke,

[6] [*The Parliamentary History of England* vol. XXXVI (London: Longman, Hurst et al., 1820), cols. 86f.]

[7] *Aeneid*, Book II, lines 246–7.

[8] See *Allgemeine Zeitung* 324 and 330 (1801).

[9] [Schröpfer, a notorious swindler and spiritualist, committed suicide in Leipzig in 1774. Count Alessandro di Cagliostro (1743–95) travelled Europe selling an 'elixir of immortal youth' and persuading people to invest in 'Egyptian freemasonry'. He died in prison in Rome.]

a *Shekinah*, floats down over our political dreamer's bed, although in Windham's brain it might only be the vapours of the claret to which he is rather partial. In the confusion of misty figures twirling to and fro within it, the first we see is a feathered messenger of peace above the sleeper's pillow. It announces the whole drama: 'Peace', it calls from its hooked beak! But this is not the noble servant of Zeus, the eagle, which Pindar represents slumbering with arched back on the god's sceptre: this is the thieving vulture, and the characteristic feature of all vultures, the naked head and neck, is made to look as revolting as possible. It is interesting to note that natural history books describe this bird as the Egyptian vulture.[10] It takes on the role of gravedigger after one of nature's beneficent operations, the flooding of the Nile, and its name in the language of the nomadic Arabs translates as 'father of the air'. We cannot help but see a sinister premonition in the fact that it is this very vulture from this very country which is now announcing the Peace! And how can we reconcile the hare, which it has gripped in its talons and torn limb from limb, with the gentle messenger of peace? In short, if all Egyptian hieroglyphs were as easy to interpret as this one, Athanasius Kircher would never have needed to write his *Oedipus*, nor the learned Zoega his *Obelisk*.[11] One sees immediately that this herald of peace is Bonaparte himself, to whom history once somewhat prematurely gave the surname *Aegyptiacus*. And would we be wide of the mark if we were to interpret the poor little hare, torn by the rapacious feathered monarch, as one of the little republics which have recently begun to realise that the guardianship of the great nation isn't exactly a bed of roses? At any rate, this is how Gillray wishes the apparition to be understood. We await correction from the highest authorities in Amsterdam, Berne, Milan, Genoa – and Lucca.

The vulture's cry and his olive-branch announcement are then acted out

[10] It is the *vultur percnopterus*, a clear illustration of which may be found in Friedrich Justin Bertuch's *Bilderbuch für Kinder*, 12 vols. (Weimar: Verlag der Industrie-Comptoir, 1798–1807), vol. III (1798), 'Vögel' XLV, no. 91, plate 2. Benoît de Maillet gives the Arabic name in his *Description de l'Egypte*, 2 parts (Paris: Genneau and Rollin, 1735), part II, p. 22.

[11] [I.e. Athanasius Kircher, *Oedipus Aegyptiacus*, 3 vols. (Rome: 1652–4 (1655)); Georg Zoega, *De origine et usu Obeliscorum* (Rome: 1797).]

before the inner eye of the seer. We witness the young twenty-six-year-old State Secretary Hawkesbury signing the Preliminaries of Peace, with Pitt guiding his pen. 'Hush!' says the political master scribe, his finger on his lips, like Harpocrates.[12] 'Death Warrant', we read in Gothic letters on the side turned towards the sleeping man. And for whom is this 'launch into Eternity' decreed?

Third vision: Bonaparte drags fettered Britannia by a hangman's noose to the guillotine, the blood still dripping from the blade, where soon we shall see the blood of thousands. The trident, with which this Empress once ruled the islands of the world, is broken. Great tears course down the cheeks of the sorrowing woman. Behind the instrument of murder we witness the collapse of British religion and monarchy, as St Paul's Cathedral bursts into flames and the tricolour flies on top of the royal palace.[13]

Fourth vision: thronging to the right and left are crowds of guillotined men and women, now receiving a second death blow in the form of these Peace Preliminaries. Except on the occasion of the landing at Quiberon, which he arranged,[14] Windham has always been the most vocal funeral orator of the victims of the revolution. This was why his old schoolfriend Professor Robison of Edinburgh dedicated to him a noisy royalist fanfare, his book on the plots of the *Illuminati* and freemasons,[15] and applied Lucretius' weighty words to these unholy times:

Then Kings were killed; the ancient majesty
And pride of sceptre and throne fell, overturned;
The bright ensign of royalty lay bloodied
Under the feet of the mob, mourning lost glory:
Men lustily trampled what they had vastly feared.

[12] [Harpocrates was the Greek name for the god Horus, who was often represented in this pose: another supposed Egyptian connection.]

[13] [George identifies this building as the Tower of London, not St James's Palace.]

[14] [Windham supported the landing of a corps of French royalist émigrés at Quiberon in Brittany in 1795. They suffered heavy casualties, were quickly defeated by the republican army, and 748 of those taken prisoner were executed. Jacques Godechot, *The Counter-Revolution Doctrine and Action 1789–1804* (Princeton University Press, 1971), pp. 257–9.]

[15] [John Robison, *Proofs of a Conspiracy Against All the Religions and Governments of Europe, Carried On in the Secret Meetings of Free Masons, Illuminati and Reading Societies* (Edinburgh: W. Creech and London: T. Cadell and W. Davies, 1797).]

Life sank to the depths, the dregs,
 back to confusion.[16]

At the very first glance it is clear that the headless crowd on the sleeper's right is French. Poor Louis XVI holds high his petition: 'Oh! Remember our Cause! poor Ghosts of French Ladies and Gentlemen'. The practised eye will easily identify the Queen, with the magnanimous Elizabeth, the bishops, and many other illustrious victims of slaughter who share her predicament. The naked beauty to the crozier's left is a sarcastic image which could only have hatched out of Gillray's deep-seated hatred of the French, a coarse legacy which he has inherited from his ancestor Hogarth. It is the dreamer's privilege to see the future as if it had already occurred. This Peace will soon permanently establish the guillotine in England too, and therefore a beheaded Lord Chancellor, together with several peers from the lay and ecclesiastical benches, presents troubled Windham with this reminder: 'Ah! See what is to become of Us poor English Men of Consequence'. 'Brute, tu dormis!' might also be an appropriate exclamation here. Oh, Windham, you've heard these corpses – do you still intend to be silent in Parliament tomorrow?

Fifth vision: the old King of Terror, Death himself, grins in triumph as he enters. He wears the Jacobin bonnet with a dainty ribbon on his skull. His normally bleached white bones are blood red. They have not been dyed by the Gobelins, but by that other infamous dyer, Sanson.[17] In order to be sure of seizing his booty, the monster strides in on stilts. When he sees apparitions of this kind the Briton is always reminded of the imagery of his favourite Milton, and it would not be inappropriate here to quote a passage from the second book of *Paradise Lost*:

[16] *De rerum natura*, Book v, 1136–41.
 [Quoted by Robison, following his dedication to Windham. Lucretius, *The Nature of Things*, translated by Frank O. Copley (New York: Norton, 1977), p. 139.]

[17] Readers of Louis Sébastien Mercier's *Le Nouveau Paris*, 6 vols. (Paris: Fuchs et al., 1797) will be familiar with this virtuoso amongst executioners. In the same book, which is full of anecdotes, we also find (vol. II, p. 43) the information that a special channel was being made to carry off the streams of blood of victims of the guillotine. 'Déjà l'on parloit d'établir un puisard en pierre sous l'échafaud, et d'y ménager des couloirs pour le sang humain; déjà l'architecte avoit tracé le plan de cette bâtisse.'

> Death
> Grinn'd horrible a ghastly smile, to hear
> His famine should be fill'd and blest his maw
> Destin'd to that good hour . . .[18]

Oh deluded fools, who hope this Peace will yield an abundance of cheap roast beef and better porter for them to savour! Death is the ally of the Peace, and how destructive his footsteps are! The stilts end in two lance tips, one of which is stabbing the most grievous wounds into the stomach of the nation, the other into its honour. Readers will recall the popular folk song: 'Oh the Roast Beef of Old England!' from earlier caricatures. The tip of one stilt is piercing the edge of the bowl in which this blessing of old England was enthroned. It is then overturned and its tasty entrails spill out onto the carpet underfoot. This fall also drags the porter jug,[19] and the pudding bowl with it. The other lance tip is piercing the list of British military victories, which this Peace will nullify. There's the Cape of Good Hope, and Malta, Egypt, the West Indies etc. Buried in the rubble of British prosperity, straddled by the terrible apparition of Death, is the sceptre which usually lies before the Speaker of the House of Commons as a symbol of sovereignty (the mace). There is also a bishop's mitre and a small barrel containing 'True British Spirits'. The insatiable monster is trampling and destroying it all! The originality of this idea, with the skewer-like stilts and the ruin they are causing, would be an honour to their inventor, had this image not already been frequently found in old English masques. But its use here proves that Gillray is a true master of motivation and is in fact destined for something quite different from the slavish service of a political faction through his caricatures.

Sixth vision: the Goddess of Justice, who, in the general collapse of all things, has scarcely been able to retain enough to cover her nakedness, is lamenting in a manner which would melt a heart of stone. Her scales are full of holes, her sword lies broken at her feet. This is a perfectly natural consequence of all the preceding events. For wherever the guillotine is used, no

[18] Lines 845–8.

[*LuP* quotes from Bürde's translation, *Johann Milton's verlornes Paradies*, 2 parts (Berlin: Viehweg, 1793), part I, p. 104.]

[19] The jug bears the inscription 'John Bull's Old Stout' . . . which is called porter, because in its own way it is as strong as a muscular porter or carrier.

honourable Lord Chief Justice presides, and no jurors sit on the bench. There are only revolutionary tribunals with the likes of Fouquier-Tinville or Carrier raging at their head, like a vision of Hell.[20] The pure virgin Justitia's seat has been overturned; and so she is enthroned, not on the chair which the poet Blumauer once memorialised for all time (to the astonishment of the muses and graces),[21] but on the even more infamous chamber pot, whose balsamic essences brave Xanthippe employed to subject wise Socrates to trial by water, after he had courageously resisted the trial by fire of her eloquence.[22]

You have to cloud the water to catch eels! This is abundantly clear to the Opposition party. And, while everything is in disarray, they are now greedily commandeering the cheese parings and candle ends. Our friend Windham once famously used this expression to describe the rewards the Treasury gives to its loyal servants.[23] The rats with the stolen human physiognomies, frolicking at the bottom of the picture, are the leading members of the former Opposition, as anyone familiar with our portrait gallery will instantly recognise. The richer pickings, the candle ends in the casket covered with red velvet, are divided amongst the most respected members of the Opposition. At first glance we recognise Erskine, who is gilded by Themis; Sheridan, the hungriest of the rats and probably also the one who needs the food most; Tierney, who always aimed for a position in the Treasury; and the Dukes of Norfolk and Bedford. At the bowl with the cheese parings we notice half-blind Nicholls, the Baronet Burdett, Earl

[20] [Antoine Quentin Fouquier-Tinville was prosecutor for the revolutionary tribunal in Paris during the Terror. Jean-Baptiste Carrier ordered that thousands of royalists should be drowned in the Loire at Nantes during the Vendée uprising of 1794. Godechot, *The Counter-Revolution*, p. 224.]

[21] [Aloys Blumauer wrote an ode to a commode ('Ode an den Leibstuhl'). *Sämmtliche Werke*, 4 vols. (Königsberg: Universitäts-Buchhandlung, 1827), vol. II, pp. 223–5.]

[22] [Legend made Xanthippe, Socrates' wife, a shrew given to domestic violence.]

[23] Cf. *London und Paris* 7 (1801), p. 176, where this metaphor was explained. In Peter Pindar's last emotional outburst . . . *Odes to Ins and Outs* (London: West and Hughes, 1801), there is a political fable called 'The Hedge-Hogs'. Here Pindar says that Pitt's much-praised integrity isn't up to much, since, for example, he established the profitable sinecure of the Cinque Ports (p. 39):

> The Cinque Ports, with a few *remunerations*,
> Prove to JOHN BULL some *trifling* obligations,
> Which WYNDHAM *cheese-parings* might call. –

Stanhope and Earl Grey, the well-known orator. The nobler rats at the casket will not be satisfied with anything less than 'places' and ministerial posts: the pretensions at the cheese platter are less grand. These *minorum gentium* rats, as the Romans would have called them, would be content with a pension and a sinecure. Some have only just heard the news and are arriving at the gallop. These include Fox the Seceder, who, in his solitude at St Anne's Hill, can think only of his great historical work and of documents that can only be found in Parisian libraries, and who therefore does not get to hear about what is happening in Downing Street.[24]

Everything we have seen so far was only a vision in the real sense of the word; floating, shadowy figures which the silently observing imagination can see but not hear. But a wild, hellish army such as this must also reveal itself to the inner ear. And this too is taken care of. We need only glance at the little dark brown devil with the pandaemonic smile at the sleeper's feet, accompanying its 'Ça ira!' on the guitar:[25] a poisonous stab at the federation festivals staged at the beginning of the revolution, which are still remembered with respect. Incidentally, in colloquial English 'Ça ira!' is pronounced something like the capital of Egypt: 'Cairah!' Our Satanic virtuoso's skin is as dark as that of the lowest class in Egypt. The allusion is now easier to interpret. A hellish cherub in the clouds announces this Last Judgement on a double trumpet, since all is now performed in the ancient manner. We were involuntarily reminded here of the small Savoyard who, at the destruction of the Tuileries on that famous day, 10 August 1792, played his pipe from the top of the organ in the court chapel.[26]

[24] [George identifies this figure as M. A. Taylor, but points out that the 'little devil' described below has Fox's features. Fox's historical research was for a book on James II. See L. G. Mitchell, *Charles James Fox* (Oxford University Press, 1992), pp. 188–93.]

[25] It is well known that this was one of Franklin's favourite expressions when he lived at Passy, and he often had occasion to fortify and comfort himself with a 'Ça ira'. At the beginning of the revolution the phrase was used in a famous folk song, and rang out from many thousands of throats during the construction of the huge amphitheatre for the Fête de la Fédération on the Champ de Mars on 19 July 1790.

[Actually 14 July. The refrain of the revolutionary song known as the *Ça ira* was 'Ah ça ira, ça ira, ça ira, les aristocrates à la lanterne.']

[26] 'Un jeune savoyard debout au sommet de l'orgue de l'église, soufffloit dans un tuyau le *Dies irae*: on eût dit de l'ange trompette du jugement', Mercier, *Le Nouveau Paris*, vol. I, pp. 213–14.

And what sort of impression does this Witches' Sabbath make upon the tense fibres of poor Windham's brain? Oh, that has to be seen in the picture itself! This dreamer is an exquisite figure, and every twitch of his face speaks volumes! His philippic is to be delivered in the House of Commons the very day after he suffers a dream like this! Perhaps there are other small details which could be discovered in the picture as a whole, for one may be certain that Gillray never draws a single line in vain.[27] But a more detailed examination would only weaken the impression of the whole. It is better that we close our phantasmagoria with those powerful words from *Julius Caesar*, Act II, scene 1:

Between the acting of a dreadful thing,
And the first motion, all the interim is
Like a phantasma, or a hideous dream;
The Genius and the mortal instruments
Are then in council; and the state of man,
Like to a little kingdom, suffers then
The nature of an insurrection.

and, for the views of an observant English statesman on this Peace, we refer to the reassuring statement of a highly esteemed diplomat.[28]

[27] Thus, for example, the position of the knife and fork on the fallen joint of beef was intended to signify the exact moment of cutting, thereby suggesting an interrupted sacrificial feast . . . Here a cruel and sudden death, which in the Christian litany we pray to be spared, suddenly intervenes. If we look carefully, we see lions' heads, dragons and monsters embroidered or printed . . . on the red coverlet of the bed. On the subject of imagination Muratori remarked that, though our soul itself remains unconscious, mere external impressions of this kind can conjure up wondrous phantoms within us. Another bit of wickedness on the caricaturist's part forbids us to affront decency by an explanation.

[28] The well-known statesman Sir Frederick Morton Eden makes the following observation in a recently published pamphlet: 'We . . . find . . . [no precedent] to prove that a Peace' . . . like the present, 'has been the forerunner of ruin. Ill-omened birds, vain foretellers of tempests, may perch on our masts; but the vessel of the state will hold on her course' . . . We should be vigilant: we ought not to be fearful. Our navigators still plough the sea and grow rich by commerce, 'amidst all the dangers of climates, storms, rocks, and quicksands'.
 [Sir Frederick Morton Eden, *Eight Letters on the Peace; and on the Commerce and Manufactures of Great Britain and Ireland*, second edition (London: J. White and J. Stockdale, 1802), pp. 6–7.]

13 *Metallic-Tractors*[1]

9 (1802), 264–75, pl. VIII

It is the duty of the true caricaturist, as of the true satirical writer, to scourge the follies and quackeries of his age. Both vocations were devised by Apollo, President of the High Council on Parnassus, albeit at an extremely unpropitious hour: just as he had finished flaying poor Marsyas. Yet the validity of the god's own patent and autograph cannot be denied. There is no doubt that Gillray in London has also received this calling – and he is always a credit to his vocation.

This plate refers to a medical hocus-pocus, not entirely unknown in Germany; the so-called Perkins's needles, or 'Metallic Tractors'. In this caricature Gillray has both dug its grave and written its epitaph.[2] The funeral oration has already been delivered by the famous Chester doctor, John Haygarth, who is well known for his plans to eliminate smallpox.[3] In brief, the whole thing concerns the following:

About six years ago Samuel Perkins, a doctor from Plainfield, North America, invented a new method of healing a long list of internal and external ailments from Pandora's hospital box, ranging from inflammations, burns and attacks of gout, to diseases of the skin and nerves.[4] He did this by

[1] [Etching and aquatint, published 11 November 1801. 'Js. Gillray invt. & fect.' *BM* 9761. Hill (1965), pp. 140–1. M. Dorothy George, *Hogarth to Cruikshank: Social Change in Graphic Satire* (London: Penguin and New York: Viking Penguin, 1967), p. 96. Kate Arnold-Forster and Nigel Tallis, *The Bruising Apothecary: Images of Pharmacy and Medicine in Caricature* (London: Pharmaceutical Press, 1989), p. 45.]

[2] [Despite *LuP*'s assumption that the caricature was hostile and damaging to Perkins, Hill presents astonishing evidence that it was possibly commissioned, certainly approved by Perkins 'with great satisfaction' in a secret correspondence with Gillray.]

[3] [See note 11 below.]

[4] [Elisha (not Samuel) Perkins, a physician of Plainfield, Connecticut, invented the metallic tractors and patented them in America in 1796–7. Martin Kaufman et al. (eds.), *Dictionary of American Medical Biography* (Westport, Conn.: Greenwood Press, 1984), vol. II, pp. 590–1.]

METALLIC-TRACTORS.

PLATE 23
James Gillray, *Metallic-Tractors*, 1801.
Etching and aquatint, hand coloured.

stroking the patient's afflicted limbs and parts with two metal needles; one
of brass, the other of iron. Both are club-shaped at one end and pointed at
the other (just like the Roman writing implements displayed in collections
of antiquities, such as that in the Brunswick Museum). Since each is flat on
one side and therefore only hemispherical, they form a single needle when
placed together. This American doctor's son, Benjamin Douglas Perkins,
was granted a fourteen-year patent for these tractors in England.[5] He moved

[5] [He had arrived in England in 1795.]

into the house of John Hunter, once a very famous surgeon, in Leicester Square, and soon had all the newspapers and journals blowing their trumpets, announcing this new saviour to the astonished and joyful crowd, both within the new Jerusalem and outside it. As we all know, the English John Bull, whether he is of high or low birth, is three times more susceptible to the medical tricks of charlatans and quacks than his cousins on the mainland. His good-natured gullibility for all that is shouted in the market-place, and for all miracle cures, knows no bounds. Anyone who is brazen enough to fill column after column of the most widely read newspapers with fabricated and bought testimonies of cures, or who is in a position to pay people to beat the drum for him, will find huge crowds of miracle-loving spectators and potential customers streaming towards his flag. He will then be able to capture and fleece these ninnies in their dozens. It was with great delight that the noble Asclepiades Perkins discovered this for himself, when he came to live amongst a nation whose kings have for three centuries been able to rid people of the most stubborn goitres merely by touching them. He was able to sell his miraculous needles, despite the fact that they were nothing more nor less than two quite ordinary metal sticks; just like the Parisian miracle doctor who sold bottles of pure Seine water for 25 Thaler a pair. In order to recommend them even more highly, Perkins had charming little caskets of red morocco leather made for them, and the happy inventor then had the gall to charge 5 guineas for his device. Every friend of humanity, good Dr Trotter is supposed to have said, and in particular every clergyman, should keep a set of these needles about his person as a vademecum, so that he can provide immediate aid to afflicted persons.[6] In his first major work on the subject, Perkins assures us that the effect of his metal tractors has nothing whatsoever in common with magnetism.[7] The idea then travelled from England to other countries. Some Danish physicians – Abilgard,

[6] This is what it says in a splendid announcement we have before us, closely printed on four octavo pages, padded out with all sorts of 'cases'.

[Dr Thomas Trotter, a former naval surgeon, published works on diseases afflicting sailors, such as scurvy, etc.]

[7] [Benjamin Douglas Perkins, *The Influence of Metallic Tractors on the Human Body* (London: J. Johnson, 1798), p. 19. Cf. Charles C. Langworthy, *A View of the Perkinean Electricity, or an Inquiry into the Influence of Metallic Tractors* (Bristol: for the author, 1798).]

Bang, Divisional Surgeon Herholdt and Assessor Rafn – published their findings on the subject in Danish, together with Perkins's own piece. This was then translated from the Danish into German by the Court Physician, Professor Tode.[8]

In a footnote Tode remarks that, to all appearances, any sewing or brass needle would have the same effect as Perkins's needles are alleged to have. Herr Kotzand in Copenhagen copies the whole miserable contraption for 32 Lübschilling (18 Groschen), and so the miracle needles can now be bought everywhere. Experience in North America, England and Germany has shown that when these needles are stroked over the afflicted parts, there is undeniably a certain mechanical stimulus. 'But one does not need expensive, newly invented needles for this purpose', says Hufeland, one of the most competent judges of the matter, 'and even less does this phenomenon, which has long been recognised, deserve the honour of the new word; Perkinism.'[9] The clever metal brush invented by Herr Molwitz from Stuttgart is far more effective and sensible. This consists of tufts of metal fibres fixed to a wheel which turns gently[10] and is a far better and stronger method of stimulation. In England all this charlatanism soon got its come-uppance. Particularly painful and damaging to Perkins's whole band of street criers was a work by Haygarth, the declared enemy of all medical hoaxes, in which he showed that painted wooden needles made to look like Perkins's needles were often even more effective than their metal

[8] *Von dem Perkinismus oder den Metallnadeln des D. Perkins in Nordamerika*, edited by Johan Daniel Herholdt and Carl Gottlob Rafn, translated by Johann Clemens Tode (Copenhagen: Brummer, 1798). See the review of this work in the *Medicinisch-chirurgische Zeitung* 1.viii (1799), 129, and in J. C. Loder's expert *Journal für die Chirurgie, Geburtshilfe und gerichtliche Arzneykunde* 2.i, 201f. The experiments promised there have been carried out and have completely confirmed the charlatanism of the whole sorry business.

[9] C. W. Hufeland, 'Ein Paar Worte über den sogenannten Perkinismus und seine Anwendung' in *Journal der practischen Arzneykunde und Wundarzneykunst* 6.ii (Berlin, 1811), 130–5.

[10] For a description and illustration, see 'Einige Beobachtungen über die Wirkungen der Metallbürste, nebst der Abbildung, von Fr. Molwitz in Stutgart' (*sic*), in *Journal der practischen Arzneykunde und Wundarzneykunst*, 10.i (Jena, 1800), 95–9. What a wonderful thing English patent law is! If this clever invention had been hatched in an English brain and prettily packaged in the English way as 'patent wheel brushes', it would have become a wheel of fortune for the inventor, and a new watchword for German anglophiles.

counterparts, and that therefore almost all their effects should be put down to deception and imagination.[11] The venerable Mr Perkins then arose once more in a work full of invective and vituperation.[12] But the death knell had begun to sound, and whatever deadly earnestness had left undone, Gillray's mockery completed in this caricature. Incidentally, the most recent applications of galvanism, whose all-encompassing principles would easily explain the phenomena observed here, have long since put the whole thing in its proper place.

Let us imagine that the figure of the patient we have before us is some plump landlord or citizen of the old City of London. Here is a man who, even in the cradle, loved to hear the sweet lullaby 'When all's said and done, let me die by the beer tap', penned by his fellow countryman, the immortal Canon of York. The lifelike portrait of his god hangs on the wall at the back of the room. In defiance of every dyed-in-the-wool archaeologist or icon-ologist, the god is shown riding not on his original compatriot, the East Indian tiger, but on a West Indian rum barrel. The patient has offered up a pleasing libation and smoke sacrifice to this god. The censers and *infundibula* of these most ardent morning devotions are still steaming on the lavish sacrificial altar. The holy sacrifice has just been mixed and poured into the goblet with due reverence. The ingredients of the punch from which this genuine nepenthes has been brewed – lemons, sugar, tea, and brandy – lie in appropriate disorder on the altar. The manner in which they have been mixed and filled testifies to the fact that this is no mere table for shewbread. In fact we are dealing with a thorough course in 'methyology', the techni-cal terms for which Lichtenberg has provided in an excellent collection in

[11] The title of Dr John Haygarth's work is *Of the Imagination, as a Cause and as a Cure of Disorders of the Body; Exemplified by Fictitious Tractors, and Epidemical Convulsions* (Bath: R. Cruttwell, 1800). See Kurt P. J. Sprengel's *Kritische Uebersicht des Zustandes der Arzneykunde in dem letzten Jahrzehend* (Halle: Gebauer, 1801), pp. 466–7 . . . Tode attributes most of it to imagination, as does Professor v. Hildebrand in Lemberg. See *Medicinisch-chirurgische Zeitung* III (1799), 311f.

[12] This riposte is entitled *The Efficacy of Perkins's Patent Metallic Tractors, in Topical Diseases, on the Human Body and Animals* (thus far it is merely the same old story, but now comes the heavy artillery), with a *Discourse in which, the fallacious Attempts of Dr. Haygarth to Detract from the Merits of the Tractors, are . . . Fully Confuted. By B. D. Perkins* (London: J. Johnson, 1800). The medical reviews in Germany have quite rightly ignored this damp squib.

High and Low German.[13] The burning tobacco pipe here replaces the strong ferula or herb stalk with which Prometheus stole the first fire from heaven, and with which he lit the flame of the first sacrifice on the altar. There's even a morning hymn, for we must not forget that the newspaper lying open here is worshipped by politically minded Britons from early morning onwards, rather as the Halle Holy Brethren revered Bogatzky's *Treasury*, or the Herrnhuters their little book of mottoes, in the pious decades of the last century.[14] But just as the fate of a cherry tree already lies sealed in the cherry stone, so the entire course of an eventful morning lies in this morning benediction. Bacchus, whom this votary worships day and night, has touched his loyal servant on the forehead and the nose with the wondrous stave of Thyrsus, which he uses to transform men into beasts, and fools into geniuses. Now he is illuminated inside and out, and has been decorated with a halo of rubies, which in all modesty he would probably prefer to decline. Then, right on cue, along comes *The True Briton* newspaper, puffing the miracle cures which Perkins's metallic tractors are said to have effected, even in the case of red noses. The surgeon is called at once, and in a trice conducts the bold experiment, whose results are now plain to behold.

The action, as we see, has reached a climax. As soon as the surgical prospector begins to use his divining rod on this rich copper mine, a powerful tremor shakes the whole mountain of flesh and fat like an earthquake. Bright sparks crackle and spray out in electrical showers from all parts of

[13] Georg Christoph Lichtenberg, *Vermischte Schriften, nach dessen Tode aus den hinterlassenen Papieren gesammelt*, edited by L. C. Lichtenberg and F. Kries, 9 vols. (Göttingen: J. C. Dieterich, 1800–6), vol. III (1801), pp. 34–42.

 [An ironic article in which the term 'Methyologie' is coined to describe a new science: the systematic treatment of the art of drinking. Lichtenberg lists some 150 ways of describing inebriation in different parts of Germany.]

[14] [Karl Heinrich Bogatzky was the author of many religious works, the most famous of which was *Güldenes Schatz-Kästlein der Kinder Gottes, deren Schatz im Himmel ist*, 2 vols. (Halle: Waisenhaus, 1761–2), translated into English as the *Golden Treasury* (1775). The Herrnhuter were members of a Silesian pietist sect (named after their colony at Herrnhut), also known as the Moravian Brethren. The sect was founded in the early eighteenth century by Count Nicolaus Ludwig Zinzendorf (1700–60), who was exiled from 1736 to 1748 for his religious beliefs. James Gillray's family belonged to the Moravian Brethren in London.]

the nose and nostrils. His teeth grind, his eyes stare like those of a stuck calf, his hands clench in the excess of prickly, tickly pain; every nerve jumps. There are no hairs on his bald head to stand on end, but his wig jumps from his palpitating scalp. It is well known that the most extreme tickling is closely related to the most extreme pain. The fact that Harlequin, having rejected every other form of death, finally desires to be tickled to death testifies to his extraordinary courage and heroism. But just look at this Perkinised illuminary![15] Look at the tension between movement and counter-movement in every muscle and limb! The only companion of our swilling hero – for this dumpling would never be able to befriend another human being – the faithful hound, howls loudly at the sight of such raptures. Watching these events perhaps he fears that the dreadful needle might later be applied to his own muzzle.[16]

The Perkins surgeon's sweet calm and complacent indifference – we might call it 'Imperturbabilité', after a word born during the terrifying birth-throes of the French state – is indescribably charming and refreshing. Only if this tail-wagging greyhound forgets to come to heel will the other dog opposite him stop barking for good. In this virtuoso's face we see the fog which always rises during a state of ecstasy, when one believes that one has been elevated above the common, humdrum people into the clouds. And at the same time look at the foolish frown of pure smugness,[17] and that snout which is ready for anything! Try to imagine these pincer lips returned to a state of repose. There are people, says a perceptive physiognomist, whose lips are of the same thickness all the way round, which makes their mouth look like a flint steel! These types are usually fairly useless. I suppose if nothing else were available to light the pipe, he could be used! In short,

[15] Instead of saying 'he is inebriated', a drunken man is actually described in some regions as having a holy glow.

[16] Perkinism attributes a large part of its present success to its alleged efficacy in the treatment of horses' external injuries. Indeed, Perkins cites almost as many 'cases' of cured horses as cured people. What applies to horses must also apply to dogs.

[17] See G. C. Lichtenberg's 'Physiognomische und Pathognomische Beobachtungen und Bemerkungen', *Vermischte Schriften*, vol. II (1801), pp. 176–7, where he says, 'I once saw a secret smile of contentment on the face of a lad who had successfully brought his pigs to the watering hole, where they were usually reluctant to go . . . Contentment such as this I never saw again.' Here we have its counterpart in action and expression.

nothing could be conceived which is more strikingly true than this Poda-lirius.[18] Anyone looking at him would swear that he had already seen his double, perhaps with a barber's bowl under his coat, in the parlour of a post-house or staging inn. He is an old friend; even a child in petticoats would be able to point him out.

Here, too, Gillray's wit does not fail to provide us with motivation and a number of subtle touches which bind the scattered details into a whole. The bloated and passive plum-pudding physiognomy contrasts with the skinny and active surgeon! Everything is linked in a long chain of cause and effect. The inspirational icon on the wall can be seen as the highest link, and the electrified tuft on the queue of the wig as the lowest. Clearly the caricatur-ist had this idea in mind, and took the liberty of depicting the spraying effect of the metallic tractors in far more extreme terms than observation itself would allow. In fact, frequent stroking provides a stimulation which at most brings out a redness in the skin.

A whole nest of stinging wasps swarms in the open page of the *True Briton*,[19] one of the most widely read ministerial newspapers, which the car-icaturist probably chose on account of its title. This, he is saying, is how we can recognise the true British character: a good feed, a good drink, and good-natured gullibility; though tweaked by the nose one hundred times, he will still give himself up trustingly for a one-hundred-and-first time to any medical quack – or, indeed, to any political quack too!

[18] [Podalirius, son of Asclepius, is a warrior physician mentioned in Homer's *Iliad*, Book II, lines 731–2; Book XI, line 836.]

[19] One must be familiar with the layout of an English newspaper to appreciate the witty parody in Gillray's sequence of words. The first column of several newspapers, including the *Morning Chronicle*, contains announcements of the current plays and other shows. Here, too, the first column begins with a theatrical notice. The play in question is called *Dead Alive*. This is followed by 'Grand Exhibition in Leicester Square'. It was there that the great surgeon Hunter once had his anatomical theatre and his world-famous collections: now Perkins the mountebank has rented these lodgings as a good omen. A veritable sparrow's instinct! But swallows have been known to wall in such unwelcome guests. Now comes the list of the latest importations into the Port of London. We read here that the true 'Rod of Aesculapius' has just arrived. The entire second column is given over to Perkinism's miracle cures. It helps disorders such as gout, and gets rid of red noses, wind and humps on backs. In the third column the miracle is raised by the power of three – to the *grand œuvre* and the true *lapis philosophorum*; and amazingly enough, this miracle is the most natural and most comprehensible of them all!

The wittiest aspect of the caricature remains the double meaning in the title *Metallic Tractors*. These needles are metallic attractors![20] By using them, as we read in the last column of the newspaper, the true philosopher's stone, the art of turning all metals into gold, will undoubtedly be discovered. A bit of iron and a bit of brass which can be had for 18 Groschen cost 4 to 5 guineas! And all this for the common good, *pro bono publico*. We should surely look for evidence of similar ruses by patriotic adepts in our own homeland!

[20] See Lichtenberg's comment on galvanism, 'Lustige und satyrische Einfälle und Bemerkungen', *Vermischte Schriften*, vol. II (1801), pp. 351–85 (p. 372).

[Lichtenberg ironically suggests that galvanism might explain why 'people love to stretch out their hands when they see gold': human hands are like divining rods which seek out metal.]

14 *Dilettanti-Theatricals; — or — a Peep at the Green Room*[1]

11 (1803), 158–88, pls. IV–V

Poor beleaguered English nobility! Like Milton's lightning flash striking the fallen angels, the curse of publicity is always at its heels. Even the most personal kind of satire is not restricted to dialogues between Pasquino and Marforio,[2] but paints a picture of the greatest in the land as they live and breathe; a portrait far more lifelike than Apelles' charcoal sketch of his enemy on the wall of King Ptolemaeus Lagi.[3] No matter how serious, boring or innocently entertaining their occupations and diversions may be, Gillray the tormentor pursues them every step of the way. Like the ghost of Hamlet's father, he is everywhere! He is there when they devote their own noble time to the sciences. He is there when they donate their guineas to learning instead, using the charm of metal to tempt forth the spark of profit, and found an orphanage or foundling hospital for scientific experiments whose fathers have starved. (In fact this latter practice usually does more for scientific knowledge!) Others simply pretend to practise the sciences (and this has its uses too; for even hypocrisy has its beneficial aspects!); but here again the merciless caricaturist slips into the Royal Institution to make fun of their favourite diversion. Poor Sir John Hippisley will never get over the explosion, a *levis notae macula*, which had a far worse effect than the one which made lecherous Yorick burst his trouser button![4]

[1] [Etching published 18 February 1803. 'Js. Gillray inv. & fect.' *BM* 10169. Hill (1976), pl. 78, pp. 124–5. Donald (1996), pp. 107–8.]

[2] [A reference to the 'talking statues', two fragmentary ancient sculptures in Rome to which anonymous literary 'pasquinades', or lampoons on individuals, were attached. Those on the statue nicknamed 'Marforio' were replies to those on 'Pasquino' or vice versa. Francis Haskell and Nicholas Penny, *Taste and the Antique* (New Haven and London: Yale University Press, 1981), pp. 258–9, 291–6.]

[3] [Pliny, *Natural History*, Book XXXV, 89. E. Sellers (ed.), *The Elder Pliny's Chapters on the History of Art*, translated by K. Jex-Blake (London: Macmillan, 1896), p. 127.]

DILETTANTI-THEATRICALS ; — or — a Peep at the Green Room. - Vide Pic-Nic Orgies -

PLATE 24
James Gillray, *Dilettanti-Theatricals*, 1803.
Etching, hand coloured.

And if, in an unguarded moment, a great personage of the United
Kingdom yields to temptation and invites the great Billington, the first
nightingale of the British Isles, to his estate at Bulstrode, to trill forth a
bravura air in the snug privacy of his closet: within a fortnight a wicked
satire appears on the subject of this *faux pas*, which was really only
impelled by the purest love of heavenly music.[5] So if a circle of fashion-

[4] [Gillray's *Scientific Researches! – New Discoveries in Pneumaticks! – or – an Experimental
 Lecture on the Powers of Air* (1802) ridiculed the fashion for lectures at the recently-opened
 Royal Institution. Gas administered to Hippisley, manager of the Institution, by the
 demonstrators, Young and Davy, causes a huge fart. *LuP* 10 (1802), 60–90, pl. XIII. *BM* 9923.
 Hill (1966), pl. 93, pp. 173–4. The reference to the 'slight stain' which caused Yorick to burst
 his trouser button is puzzling, but may be a confused recollection of the incident in Sterne's
 Tristram Shandy, vol. IV, ch XXVII.]
[5] At the beginning of April this year a caricature by Gillray referring to the Duke of Portland

able people from the noblest families were to unite for innocent games with Thalia and Terpsichore, gathering for a weekly sacrificial feast or merry picnic dedicated to the God Comus, it would be almost too much to bear. There would be a veritable hail of satires, sarcastic letters and epigrams on the subject in the journals and morning newspapers. And every few months mischievous Gillray would mix the most garish colours on his palette, and expose the blue-blooded dilettantes to the laughter of the public in his usual infamous manner. The depiction of the dilettante society we see here, which takes place backstage, behind the scenes, is the clearest proof of how far the foul fiend is prepared to take his malice. And what a swarm of hornets and stable flies buzzes out towards us as we approach! Taking aim from afar, the artist has emptied an entire quiverful of satirical arrows into his target. But who sharpened and feathered them for him? Which man-servant or little chambermaid was bribed to allow our cheeky peeping Tom[6] to witness so many dressing-room secrets? Certainly he would never dare to show himself. He is outlawed here, just as Peter Pindar is at St James's.[7] But no subject escapes gossip and exposure in London! Every detail of Virgil's description of Fama applies to the forty newspaper offices

caused general amusement. Entitled *The Bulstrode Siren*, it was based on the gossip of the day: an anecdote was in circulation, about how the Duke of Portland, no spring chicken, spent some days with the siren Billington at his estate at Bulstrode and put her virtuosity to the test in every imaginable way. Billington, who is superfluously endowed with fullness of figure, sits on a sociable sofa beside the rapturous Duke. Whilst the most exquisite 'ha's' and 'ho's' pour forth from Billington's mouth, the soulful Corydon clasps his hands in devotion. In an open music book at his feet we read: 'Epithalamium pour l'Hereux Nuit' (*sic*!) and underneath is this verse from Prior's famous song:

> Blest as th'immortal Gods is he
> The Youth who fondly sits by thee,
> And sees and hears thee all the while
> Softly sing and sweetly smile.

[*BM* 10168.]

6 We have all heard of 'peeping Tom' of Coventry, whose eyes nearly popped out of his head when, unable to control his disgraceful curiosity, he saw the beautiful Lady Godiva riding naked through the town. See K. G. Küttner's *Beiträge zur Kenntniss vorzüglich des Innern von England und seiner Einwohner*, edited by J. G. Dyk, 3 vols. (Leipzig: Dyk, 1791–6), vol. III, p. 58.

7 [Peter Pindar (John Wolcot) was notorious for his verse satires on the royal family.]

of the great capital on the Thames. Indeed, most of the people shown here are used to being gossiped about whenever they appear in public. For they are, as the Briton would say, 'public characters'.

Before we introduce you to the many apparitions and phantasms in this noble society of merrymaking, song and dance, we must first ask you to recall the details given in the last annual volume of our gallery of manners, which included a print and commentary on the subject of this amateur theatre, and the dancing, games and amusements associated with it.[8] It was founded by Colonel Greville at Tottenham Court in London, and has been maintained with uncommon single-mindedness for three years by the leading aristocratic families. The general public, whose sentiments Gillray echoed in the first print, continued to express its disapproval of these antics until last spring. It was this disapproval which, at the beginning of May, inspired the clever caricaturist to publish the extremely detailed print now before us.

Those who are familiar with Hogarth's caricatures will have noticed that our friend Gillray had in mind two famous prints by his master and predecessor when he was devising this caricature. The meetings of the picnicking dilettantes, as our readers will recall from earlier accounts, had a twofold purpose: to stage short French plays, and now and again a longer English drama, at their theatre in Tottenham Court;[9] and then to while away the long nights with music, dancing and games. Of course Ceres and Bacchus and their gifts would not be forgotten either. We have two prints by Hogarth, well known in Germany from Riepenhausen's engraved copy and Lichtenberg's superb commentary.[10] One is filled with extremely lifelike portraits. It shows a society of night owls and lusty votaries of Bacchus at a steaming punch table, running through the entire sequence of nocturnal conviviality, with a final collapse into senseless intoxication. Hogarth calls this *A Midnight Modern Conversation*. There is no doubt that Gillray is alluding to that riotous

[8] See *London und Paris* 9 (1802), 102–11, 166f., pl. IV.
 [*The New and Elegant St. Giles Cage* (1802). *BM* 9918. Cf. Gillray's *The Pic-Nic Orchestra* (1802). *BM* 9921. Hill (1966), pl. 97, p. 174.]

[9] [Sybil Rosenfeld, *Temples of Thespis: Some Private Theatres and Theatricals in England and Wales, 1700–1820* (London: The Society for Theatre Research, 1978), pp. 12, 170.]

[10] [Lichtenberg's commentaries on Hogarth's prints are discussed in the Introduction, pp. 24, 36–7 above.]

punch orgy in some of the features of our caricature.[11] Hogarth's *Strolling Actresses Dressing in a Barn* is even more famous (Plate 25).[12] The vulgarity of this sorry group of common actresses in a draughty barn, which can barely conceal the glaring poverty of its temporary occupants, is now elevated by Gillray to the heavenly realms and the highest social rank: to a green room or dressing room of the grandest fashionable circle in London. In both prints the actresses are dressing and making themselves beautiful for the glory of their art. In the former they are dressed in rags, here they are dressed in royal purple and velvet. The perceptive observer will be able to trace similar parallels through every single aspect of this print. One could therefore describe our print as a travesty travestied. We cannot emphasise enough that the art-loving connoisseur with a penchant for tit-bits of this kind should take a look at Lichtenberg's bill of fare[13] before partaking of this little dish, which was made from a recipe in Hogarth's cookery book.

So let us peep, as the caption says, into the Green Room[14] of the society theatre at Tottenham Court and spy on the preparations. We can see from the scripts in the hands of the main actors which play is going to be performed. It is the famous old tragedy by Nathaniel Lee; *Alexander the Great*

[11] [Published in 1733. Ronald Paulson, *Hogarth's Graphic Works*, 2 vols. (New Haven and London: Yale University Press, 1970), vol. I, pp. 150–2. Paulson, *Hogarth: His Life, Art and Times*, 2 vols. (New Haven and London: Yale University Press, 1971), vol. I, pp. 230–4, 305–7. Paulson, *Hogarth*, vol. II, *High Art and Low* (Cambridge: Lutterworth Press, 1991), pp. 4–7.]

[12] [Published in 1738. Paulson, *Hogarth's Graphic Works*, vol. I, pp. 182–3. Paulson, *Hogarth: His Life*, vol. I, pp. 395–8. Paulson, *Hogarth*, vol. II, pp. 128–31. Christina H. Kiaer, 'Professional Femininity in Hogarth's *Strolling Actresses Dressing in a Barn*', *Art History* 16.2 (1993), 239–65.]

[13] See Lichtenberg's *Ausführliche Erklärung der Hogarthischen Kupferstiche*.
 [G. C. Lichtenberg, *Gesammelte Werke*, edited by Wilhelm Grenzmann, 2 vols. (Frankfurt am Main: Holle, 1949), vol. II, pp. 788–813.]

[14] It is well known that in the older of the two major London theatres, Drury Lane, the room where the actors gathered before the performance to practise their lines or rehearse was painted green. For this reason every similar backstage room for dressing, reciting, or merely gossiping and bantering was given the name Green Room. A famous scandalous chronicle of the actors and actresses on the great London stages is reprinted virtually every year. It is called *The Secret History of the Green Rooms*, 2 vols. (London: J. Ridgway, J. Forbes and H. D. Symmonds, 1790), and later editions. We also recommend the famous Mrs Mary Robinson's life history, which she wrote herself.
 [*Memoirs of the late Mrs. Robinson, Written by Herself*, 4 vols. (London: R. Phillips, 1801).]

PLATE 25
William Hogarth, *Strolling Actresses Dressing in a Barn*, 1738.
Engraving and etching.

or the Rival Queens. This play need not have been performed by the Pic Nic
Society in reality, although it is still part of the repertoire of the two London
theatres as a popular old folk play, and is revived from time to time.[15] It

[15] Of the eleven tragedies written by Nathaniel Lee, a man whose excess of imagination finally
transported him to the madhouse, only two are still performed on the English stage. The
Companion to the Play-House, 2 vols. (London: T. Becket, P. A. Dehondt et al., 1764), vol. II
under Lee states that 'His *Theodosius* and *Alexander the Great* are Stock-Plays, and to this Day
are often acted with great Applause.'
 [*The Rival Queens, or the Death of Alexander the Great* dates from 1677.]

would therefore be entirely plausible for the play to have been chosen by the amateur society on account of some of the famous leading roles. It is more probable, however, that Gillray chose the play for his print simply for the amusing connotations which the assignment of roles offered him, and even for the *double entendre* in the title.[16] Those who are curious should go to London and ask the malicious joker in person. We shall content ourselves with examining the splendid actors and actresses in greater detail.

All the characters have their sights on the same target – the target of pleasure – and all are aiming for a bull's eye, though their missiles vary. On closer observation they can be divided into several different, clearly defined groups; these are also alluded to by the emblems on the folding screen, where four muses are receiving their chaste sacrifices. First we have the genuine servants of the tragic muse, devotees of Melpomene; then there are the comic actors, Thalia's favourites; next we find the musical dilettantes in vocal and instrumental concert, Euterpe's priests and priestesses; and then come the dancers, worshippers of Terpsichore, who enlivens every occasion. The encore is provided by the audience behind the folding screen. It is by no means passive or idle, but actively demonstrates its membership of the famous dilettante theatre in a number of brief intermezzos.

Let us first examine the worshippers of the tragic muse, sublime Melpomene. The three main figures at the front, the great Alexander and the two rival Queens, are most definitely members of this group. Of course the angry and terrible heroic figure of Alexander the Great – for this is what the script in his hand says – armoured from head to toe, hardly accords with the stature of the Lilliputian dwarf who is putting on such airs in his role. And that is exactly the point which Gillray was making! Alexander the Great is being played here by the tiny Lord Mount Edgcumbe, who is a mere *monticulus*, a pimple on the face of the earth, an

[16] A scarcely noticeable change in pronunciation could make 'Rival Queens' into 'Rival Queans', or jealous whores. In 1729 the poet laureate and playwright Colley Cibber published a famous parody of Lee's *Rival Queens*, which had already been in performance for many years, and called it *The Rival Queans. With the Humours of Alexander the Great*. In this burlesque, Statira and Roxana are both priestesses of Venus Vulgivaga and Alexander the Great is a London fop of the period. We may be quite sure that our malicious caricaturist had both the title and plot of this parody in mind when he devised his caricature.

insignificant molehill, but who likes to pretend he is the Schreckhorn or Wetterhorn. There is nothing more amusing than a Mikromegas of this kind, who rears his head, stands on tiptoe as he postures and gesticulates, every muscle on the stretch, and who seems to be shouting 'Look at me!' This little lord, who in fact takes his very ominous name from one of the most interesting promontories in the world,[17] struts and boasts like Alexander himself, and the poet who wrote the role for him has served him very well. For in strained histrionic passages it would be hard for any tragic poet to outdo ranting mad Lee.[18] Now that our pocket-sized Alexander has such a splendid tirade to declaim, the huge heroic soul in his little nutshell of a body will be crushed until it bursts from its bonds and fetters. When Le Kain made his famous remark,[19] he was probably speaking for Mount Edgcumbe; and who knows what kind of miracles the wonderful muse, who can give a mute fish the voice of a singing swan, may work this time? Perhaps she will change our little wren into a golden eagle. Costume and ornamental devices are appropriately chosen to arouse fear and horror. On the helmet is a snorting basilisk or dragon with bat's wings, spitting out death and ruin. Gillray has doubtless placed it here to heighten the travesty. It represents that fire-spitting chimaera on the helmet of Virgil's Turnus: 'His tall helmet was crowned by a triple plume and supported a Chimaera breathing Etna's fires from its jaws; and ever louder it roared, and madder grew the menace of its flames as grimmer grew the battle amid streaming blood' (*Aeneid*, VII, lines 784ff.).[20]

[17] [Mount Edgcumbe in Cornwall.]

[18] Addison in his *Spectator* 39 and 40 (1711) already commented on what the English call 'a rant', taking the poet Lee as an example.

[19] Le Kain was far too small for his heroic roles, being barely five feet tall. People often felt they had to say something nice about this, and would swear that on the stage he seemed to be six feet tall. To such remarks he often replied, 'Ce n'est point par notre corps que nous sommes grands, c'est par notre âme.' See Karl August Böttiger, *Entwickelungen des Ifflandischen Spiels in 14 Darstellungen auf dem Weimarer Hoftheater* (Leipzig: Göschen, 1796), p. 52. The great Barry, known to cultivated readers from Churchill's *Rosciad*, was built like an ox, and played the role of Alexander on the London stage for many years to great applause, taking advantage of his giant stature.

 [Spranger Barry is mentioned in *The Rosciad* (1761), lines 891f.]

[20] [*The Aeneid*, translated by W. F. Jackson Knight (Harmondsworth: Penguin, 1982), p. 199.]

Our stage emperor's unmistakable coronation regalia is made up of his flowing red robe (the *syrma* of ancient tragedy), the petrifying Gorgon or Medusa's head on his breast-plate, the huge gloves and spurs, and finally the mighty sabre. The latter will immediately remind the educated observer of a familiar *bon mot* of Cicero's on the subject of his diminutive son-in-law, Lentulus.[21] D'Alembert recounts that Baron, the father of the French school of acting, often remarked that an actor should have been brought up in the lap of queens: ('un comédien devroit avoir été nourri sur les genoux des reines'). What a fine picture it would make if we were to see our Alexander being rocked to and fro on the laps of these two theatre queens, one of whom is donning her footwear, the other painting her face. Queen Statira, who is looking up sweetly, and pulling on her boots, is none other than Lady Salisbury, well known as the bravest Amazon and fox-hunter in the whole of England.[22] This is why, in addition to the other regalia and symbols of royal dignity, her chaste breast is covered with what is called a Belcher cloth, which of course alludes strongly to pugilism and boxing. Her clothing suggests a high tragic role. We see this, for example, in the particular type of boot which she is putting on in place of her dainty pointed slippers. These red-laced half-length buskins are doubtless supposed to remind us of the *cothurnus* of ancient times, which, as we gather from many old monuments, was laced downwards at the front.[23] But perhaps, in the pose he gives the

[21] 'Cum Lentulum exiguae staturae hominem longo gladio accinctum vidisset. Quis, inquit, generum meum ad gladium alligavit?' This joke, refreshed in a hundred more recent vade-mecum stories, is told by Macrobius in *Saturnalia*, Book II.

[Macrobius, *The Saturnalia*, translated by Percival Vaughan Davies (New York and London: Columbia University Press, 1969), p. 166. 'Seeing his son-in-law Lentulus (who was a very short man) wearing a long sword, he said: "Who has buckled my son-in-law to that sword?"']

[22] [In Gillray's *Diana return'd from the Chace* (1802) she was shown wild and dishevelled, holding up a fox's brush. *BM* 9908.]

[23] The Cothurnite furies, for example, appeared in laced boots of this kind on an old vase painting. See K. A. Böttiger, *Die Furienmaske im Trauerspiele und auf Bildwerken der alten Griechen* (Weimar: Hoffmann, 1801), p. 41. Diana is also often depicted wearing laced boots of this type. 'Puniceo stabis suras evincta coturno', says Virgil in *Eclogues*, VII, 32. Perhaps Princess Statira should appear here in the costume of Diana. This would then remind us very clearly of the chaste Diana in Hogarth's *Strolling Actresses*.

[Virgil, 'wearing crimson boots'.]

Lady, the cunning artist was concerned less with the tragic half-length boots themselves than with the ribbon she is using to tie them. Suppose this were as significant as the garter of one of her predecessors, half a millennium ago? King Edward III's beautiful inamorata, another Lady Salisbury, occasioned the founding of the Order of the Garter when her own garter slipped down.[24] 'Hony soit qui mal y pense' is Gillray's quip in this contemporary Salisbury's not entirely decent pose. Whether her beauty could compete with that of her famous namesake from those chivalrous times is, at first glance, somewhat doubtful. Physiognomists of the female profile place this shape of face, this turned-up nose, in a class of its own. If only the nose-measurers which died out all too prematurely with the demise of pious Lavater were to return to their former glory, in place of the skull measurement so popular today (for everything comes round again in the cycle of fashionable theories), then justice would once again be done to this nose.[25] If only those articles of contraband were not lying on the floor at her feet! The item of male clothing, with which the Highland Scots and our great compatriot Faust only recently made a pact of eternal peace (according to the old laws no Parisian opera dancer can be without it, and according to the latest cult of all things Greek, no female promenader can either[26]), is lying on an open script. On this we read: 'the Part of Squire Groom to be performed by —y'. Certainly this buckskin substitute for the fig leaf of Paradise barely conceals my lady's amorous antics behind the curtain, especially if it is associated with the dubious objects to which the other laced boot has quite unexpectedly married itself. This much is clear: it is a

[24] This, at any rate, is what is commonly said, although others explain that the story is apocryphal. However, it is so much in keeping with the gallant spirit of the time, that even the critical Hume did not dare to refute it entirely: *The History of England, from the Invasion of Julius Caesar to the Accession of Henry VII*, 2 vols. (London: A. Millar, 1762), vol. II, pp. 206–7.

[25] [Johann Caspar Lavater's theories on the relationship between the shapes of facial features and moral traits in *Physiognomische Fragmente* (Leipzig and Winterthur: 1775–8) were followed by the fashion for phrenology or craniology, derived from the works of Johann Kaspar Spurzheim and Franz Josef Gall. Gillray was certainly aware of Lavater's ideas. Donald (1996), pp. 171–4, 180–3 and cf. Introduction, pp. 22–4 above.]

[26] [On the 'Greek' fashion in dress, see Aileen Ribeiro, *Fashion in the French Revolution* (London: Batsford, 1988), pp. 124f. Prostitutes (nicknamed 'Cyprians') may be indicated here.]

breeches role. And no lady of the theatre was ever indifferent to a role of this kind.[27]

The second Queen betrays quite different desires. She is playing big-hearted Roxana (according to the script in her hand), and is just loading the final howitzer onto the huge battery with which she is about to bombard the hearts of all those present. That is to say, she is applying her last beauty patch as she stands before her dressing table. We have met Lady Buckinghamshire before. She is uncommonly well endowed in physique (almost to a fault!). In a previous caricature she found herself in a rather uncomfortable position.[28] Her toilette may be regarded as a response to and reflection of Hogarth's print, and it is only after comparing the two that this caricature can be fully understood.[29] But the bottle of spirits peeping from under the dressing table is very mischievous. We all remember how Ariadne fell into the arms of Bacchus when she was abandoned by Theseus, who had forgotten both his duty and his oath. This allegory is still being played out here in various places behind the scenes and curtains.[30]

Comedy lives in close and friendly proximity to her sister Tragedy here, contrary to her usual habit. She is introduced to us by two representatives of the comic genre, two characters from Italian farces, commonly called *Zanni*.[31] Arlecchino is Skeffington, whom readers will recognise from

[27] Since we entirely lacked the necessary knowledge, we were forced to seek the help of another . . . 'Breeches roles', came the reply, '*rôles travestis* . . . a character part for ladies. A lady's entire worldly fortune has often been indebted to a role of this kind. Therefore actresses prefer such roles and clothing.' Johann Friedrich Schütze, *Satyrisch-ästhetisches Hand- und Taschen-Wörterbuch für Schauspieler und Theaterfreunde beides Geschlechts* (Hamburg: Buchhandlung der Verlagsgesellschaft, 1800), p. 20.

[Pat Rogers, 'The Breeches Part' in *Sexuality in Eighteenth-century Britain*, edited by Paul-Gabriel Boucé (Manchester University Press, 1982), pp. 244–58.]

[28] In the stocks or pillory, *LuP* 9 (1802), 170.

[*The New and Elegant St. Giles Cage*; see note 8 above.]

[29] Hogarth's Flora is making her toilette, albeit in rather humbler circumstances. There, too, the comb is not lacking. See Lichtenberg's *Ausführliche Erklärung der Hogarthischen Kupferstiche*.

[*Gesammelte Werke*, vol. II, pp. 796–7.]

[30] The label on the bottle tells us that Bacchus, drowner of sorrows, has undergone an Irish metamorphosis. Usquebaugh (pronounced uskebak) is the strongest Irish whisky, often flavoured with saffron.

[31] Pantalone is the Venetian merchant, the Doctor is from Bologna and the two servants are from

earlier caricatures in our gallery.[32] He reminds us of Carl Ruf, who is currently causing quite a stir in the city of London with his chess machine.[33] Skeffington is also a clever and talented man, an aesthete and a playwright. Opposite him the ugliest of all theatrical dilettantes, the hunchbacked Scotsman Lord Kirkcudbright, gesticulates as he plays Brighella or Scapin: a true *lusus naturae*. Like many other 'laughter-makers',[34] he suffers from the misfortune of imagining that people are laughing at his jests, when in fact they are laughing at him. It is impossible to overlook the little fool's amusing attempt to imitate the taller man, or the artistic zig-zags they make as they dance their *pas de deux*.[35] Both of these things are typical of the dilettantes of this city.

But you cannot have a *bande joyeuse* of this kind without music! In our print this is provided by a number of wind and percussion instruments. The orchestra consists of a bassoonist (Lord Carlisle, who plays as great a role in the scandal sheets as he does in the learned world and in the supplements

Footnote 31 (*cont.*)

Bergamo. Both the latter, Brighella and Arlecchino, are also called *ʒanni*. See the *Mémoires de M. Goldoni*, 3 vols. (Paris: Duchesne, 1787), vol. II, pp. 195f. It is particularly appropriate to draw attention to this passage, especially since the issue has been raised anew by the revival of *Turandot*. Goldoni was opposed to it: 'On veut aujourd'hui', he says, 'que l'Acteur ait de l'âme, et l'âme sous le masque est comme le feu sous les cendres' (p. 196).

[32] [E.g. Gillray's *The Union-Club* (1801). *LuP* 7 (1801), 61–87. BM 9699. Sir Lumley Skeffington was also the subject of *So Skiffy-Skipt=on, with his wonted grace* (1800). BM 9557. Hill (1966), pls. 32 and 72, pp. 151, 168.]

[33] [Possibly a reference to a trick machine, of a kind invented by Wolfgang von Kempelen. Members of the public were challenged to a game of chess with a mechanical puppet, dressed as a Turk. In fact inside the machine (called *der Türke*), a small chess master was concealed. Cf. *Der Spiegel* 41. 25 (15.6.1987), 3.]

[34] Wieland coined the term 'laughter-maker' after the Greek, and its assimilation into our language is very apt. See *Attisches Museum* 4.i (1802), 84.

[35] Both dancers are forming a 'z'. Thus, Gillray is saying, they are *ʒanni*, fools. For amongst all the etymologies of this word . . . Latin 'sanna' or 'Giovanni', 'Jean' (see Gilles Ménage, *Le Origini della Lingua Italiana* (Paris: Sebastiano Marbre-Cramoisi, 1669), p. 498), the derivation from the letter 'z' is the most natural.

[It is likely that Gillray also remembered Hogarth's demonstration, in an engraved dancing scene and in allusions to Harlequin, Punchinello etc., that such angular forms and abrupt movements epitomised comic ugliness. William Hogarth, *The Analysis of Beauty* (1753) edited by Joseph Burke (Oxford: Clarendon Press, 1955), pp. 146–7, 158–9 and pl. II.]

of Horace Walpole's *Noble Authors*),[36] a triangle player (the Marquis of Abercorn),[37] a violinist (Lord Salisbury, the lawful wedded husband of the booted Amazon we have already met, and the King's Lord Chamberlain) and a horn player. The latter is immediately recognisable as the fat-cheeked little Lord Derby, who seduced the famous comic actress, Abington's rival, Miss Farren, from the theatre into the marriage bed. One might almost suspect that the entire orchestra is only there for the sake of this little Lord, and that he is only welcome in the society as a *horn* player. For although the character of the present Lady Derby has always been pure and unsullied, both when she was an actress before her marriage[38] and afterwards under the earl's coronet, the hidebound English nobility can never forget this mistake, and is always whispering things it would never dare say aloud. The dissipation of his first wife, Miss Farren's predecessor, plays a large part in this gossip, and is said to have contributed to the lengthening of the troublesome outgrowth on the brow of her husband. In short, Gillray takes every opportunity to laugh at him, and is clever enough to make the bulging brow of the virtuoso touch his instrument as suggestively as the horns of the milked cow once appeared to grow on the head of Hogarth's London blue dyer.[39]

[36] [Horace Walpole, *A Catalogue of the Royal and Noble Authors of England, with Lists of their Works* (Strawberry Hill: 1758). There were several later amplified editions and volumes of illustrations. *LuP* misprints the author's name as 'Robert Molpole'.]

[37] [George indicates that Lord Holland identified this figure as Col. Greville, but 'There is internal evidence suggesting that the writer of the articles in *London und Paris* got his information from Gillray.']

[38] Because of her irreproachable behaviour and modesty, two ladies of the highest rank, Lady Dorothea Thomson and Lady Cecilia Johnston, constantly honoured the Drury Lane actress with their company. In this way Lord Derby became acquainted with her charms, and found her as irresistible as she was invincible. 'The breath of calumny', we read in the account of her life in *Public Characters of 1799–1800* (London: R. Phillips, 1799), p. 471, 'could never find occasion to whisper a single remark on' . . . 'the regularity of her deportment, and the modesty of her disposition'.

[Lord Derby's affair with Elizabeth Farren featured in several caricatures of 1796–7.]

[39] In his *Four Times of Day*, see Lichtenberg's *Ausführliche Erklärungen der Hogarthischen Kupferstiche.*

[*Gesammelte Werke*, vol. ii, p. 853. In Hogarth's *Evening* (1738) a cow was positioned behind this henpecked City dyer, so that a cuckold's horns appeared to grow out of his head, as happens with Derby's French horn. Sean Shesgreen, *Hogarth and the Times-of-the-Day Tradition* (Ithaca and London: Cornell University Press, 1983), p. 113.]

Alongside this instrumental concert, whose devotees probably still have a number of things they wish to whisper to each other, things which the uninitiated need not know about, we see two ladies singing a duet which would melt your very heart. Anyone who claims to be fashionable, or who seeks to be 'dashing', to borrow a London expression, must emulate the greatest siren of the day, the highly-praised Billington, when they sing. Miss Anguish and Miss Carpenter – for those are the names of the two nightingales – are trilling (or killing) a bravura air à la Billington, entirely surpassing the celebrated queen of song herself, if not in their actual singing, then in the gape of the orifices from which the singing emanates. Thus did Lucian's ignoramus at least write with Epictetus' pen.[40]

Terpsichore does not go away empty-handed here, where all the muses link arms in sisterly fashion. In the middle distance people are dancing away merrily. The heir to the British throne himself is a member of the party, or rather is leading the round dance. Or is it a ballet showing Paris, still undecided as to which goddess should receive the apple? At least something of this indecision can be clearly read on the face of the dancer, standing between his two Ninons, for he places his right hand around his former grandmotherly lover, Lady Jersey, but holds Mistress Fitzherbert's hand in his left. We dare not attempt to fathom the source of this strange love of antiquity. Experts assure us that it has not only afflicted the Prince of Wales, but many other young men too. Nor can we judge whether Herr von Ramdohr's explanation of this phenomenon as the attraction of greater tenderness to malleable strength has hit the nail on the head.[41] For these secrets are entirely unknown to us. We shall be content with remarking that the double meaning of the title of tonight's play probably refers to this part of the caricature.[42] On one occasion a few years ago, when news of the Prince's more than strong attraction to the more than elderly Lady Jersey had

[40] [Mrs Billington figures in *Blowing up the Pic Nic's* (see n. 64) as one of the professionals attacking the Pic Nic amateurs.]

[41] 'The ageing woman . . . prefers a youth, whom she judges to be more tender, complementing her malleable strength. The female tendency to lust aroused by these favourable conditions is often violent.' See Friedrich Wilhelm Basilius von Ramdohr's *Venus Urania. Ueber die Natur der Liebe, über ihre Veredlung und Verschönerung*, 3 vols. (Leipzig: Göschen, 1798), vol. I, p. 151.

[42] *The Rival Queans*, the jealous whores.

recently broken, Sheridan said in Parliament: 'Today only youths are worth anything in politics (Pitt and Bonaparte) and old women in love!' The whole of London understood the allusion. With tongue-in-cheek discretion Gillray has hidden the face of the fourth dancer – but only to the extent that those who know the facts can decipher it immediately. It is Colonel Greville, the impresario and director of all the joys of the Pic Nic. Nothing could be more appropriate than that the general should stand at his post of honour, here of all places.

All this action is taking place behind the scenes. But these scenes have their own backdrop. What a view we have of the *postscenia* behind the folding screen! We see the spectators whiling away the time with all sorts of funny and serious business until everything at the front has been organised and arranged. 'Haussez les mains, Monsieur l'abbé', Yorick once heard someone shout in a French theatre.[43] We are allowed a surreptitious glimpse of this lively entertainment. The foreground is given over to serenading swains, but behind them the caricaturist gleefully shows us two more infamous old goats of the great metropolis, unutterably sordid, and in the throes of the most shameless propositioning. The excessively lecherous faun physiognomy at the front belongs to the eighty-year-old 'Q', as he is usually called in anecdotes in the newspapers. It is the Duke of Queensberry, the English Richelieu, although for him, as for other Englishmen of this type, the most riotous *crapule* always counted for gallantry. Since this caricature appeared, the old sinner has been forced to put his house in order and make his exit from the great theatre of life itself. It is said that a burdock plant has grown among crowfoots and thorn-apples on his grave.[44] Behind him we see another noble rake; his organs of touch in fine fettle. This man with the long nose and the cropped hair is Colonel Hanger, who served with the Hessian Chasseurs in the American War, and who is one of the most

[43] [Laurence Sterne, *A Sentimental Journey through France and Italy* (London: Becket and de Hondt, 1768), vol. I: 'The Rose, Paris'.]

[44] [The burdock's prickly burs catch at passing objects, and its stalks were supposed, when eaten, to arouse lust. Thorn-apple is a narcotic, poisonous weed. Geoffrey Grigson, *The Englishman's Flora* (London: Hart-Davis, MacGibbon, 1975), pp. 316, 414–15. The German word for burdock, 'Klette', also means 'nuisance' or 'pest'. All these attributes evidently allude to Queensberry's reputation.]

disreputable madcaps or philanderers ('bucks') in London. A few years ago, he had the audacity to 'dissect himself whilst still alive', as he put it in the foreword to his book. In this autobiography he recounted all his foolish escapades and bagnio adventures, making the public blush for him.[45] Since Hanger was honoured for a time with the closest friendship of the Prince of Wales, Gillray made sure he placed him in the Prince's vicinity. In reality, he would not be regarded very favourably in this dilettante society. The caricaturist has given him some dainty morsels, some unknown wenches who are playing minor roles in the Pic Nic. 'Similes labris lactucae', as an ancient Roman would say![46]

How wide and varied is the *loving* which goes on in this theatre-lovers' society! But which God is it who animates and enlivens the orgies? It is that rogue Amor, and he is actually physically present amongst them. Up to now we have regarded all this only as a green room, a dressing-room and lounge for conversation behind the scenes. How blind we were! For in fact it is a temple, and all those present are engaged in the most awe-inspiring of temple rites: the worship of the immanent God! Of course this kind of divine service would scarcely be expected nowadays in pious Christian Great Britain. It was more at home in ancient Babylon and the Orient more than 3,000 years ago, where both girls and married women gave themselves up to public embraces in the service of Venus Mylitta.[47] But there it is before

[45] 'The adventures of a fair Cyprian' and the most raffish escapades make up more than two thirds of his *Life and Opinions*, which was even translated into German last year. Hüttner reviewed it in his *Englische Miscellen* 3 (1803), 151–70. Instead of the usual frontispiece engraved portrait, the Colonel had himself depicted in silhouette, hanging from the gallows (vol. 1, p. 2). That really is love of the truth! He once studied in Göttingen; but the people there didn't want to advertise his work as the production of an alumnus and former citizen.

[*The Life, Adventures, and Opinions of Colonel George Hanger. Written by Himself*, 2 vols. (London: J. Debrett, 1801) challenges the moral censoriousness of the time. It was translated into German as *Das Leben, die Abentheuer und die Meynungen des Obristen Georg Hanger*.]

[46] ['Like the lips of a lettuce'.]

[47] Herodotus, *History*, Book 1, 199, vouches for the immorality of the beautiful Babylonian women, an account which Voltaire found tasteless and incredible. Pierre Henri Larcher defended it, however, for good reason, notably what was written by the prophet Jeremiah (see *Histoire d'Hérodote*, nouvelle édition, 9 vols., Paris: Debure and Barrois, an XI, 1802, vol. 1, pp. 522f.). The real evidence is supplied by the images on the stones of the pagodas at Salsette and Elephantina. They represent the rites of the ancient oriental *lingam* cult. This 'theopornia' (a

our eyes. No one can deny what is plain for all to see! Is not the large gilded statue in the left foreground a God of Love as he lives and breathes? It is for his sake that all the preparations, declamations, music, dancing and kissing are taking place. Everyone is facing him. He is the sun in this planetary system, the all-powerful, all-inspiring divinity of this festival. The Muses are merely his chambermaids, and this is why they are only roughly sketched on the screen at the back. Only now does the whole picture gain its correct perspective and focus. Of course his colossal dimensions have little in common with our usual image of the beloved and charming little Cypripor. But this Amor too has all kinds of nightingales to feed, all kinds of hearts to pierce with his honey-dipped arrows. The entire gathering is physically real – so why shouldn't Amor, the reigning God, be real too? But what if everything turns out to be mere masquerade? What if the colossal Amor, whom everyone is worshipping, were only a member of the dilet-tante theatre in disguise? In Hogarth's *Strolling Actresses* a small girl played the part of the winged child of the Gods, and was shown standing on a ladder, inspecting the stockings hung out to dry. Here a Lord plays the role of the God. But he has grown suddenly and has expanded in all directions so that, like the immortal Butterbrod, he could exhibit himself for money, simply on account of his physique. In short, the Amor *à la grenadiere* is Lord Cholmondeley (pronounced Chumley), one of the finest, most decent and most lovable mortals in England, or so he is reputed to be. Certainly, he seems to have been abused here beyond the normal limits of caricature. But who knows what exactly the malicious caricaturist has against him? Perhaps the tricolour sash will give us a clue. Lord Cholmondeley spent last winter in Paris and was terribly extravagant, in keeping with his typically British love of splendour. This probably attracted the wrath of the anti-Gallican Gillray. But there may also be another reason: an anecdote circulating in the gallant world in England. At least it should not escape our attention that a horn is sprouting from the fertile field of Lord Derby's brow at the very point where Amor's magic arrow is touching it! Look at the blessed

word first coined by Georg Forster, or so he says) has also caused terrible errors in recent times. Father Achatius of Düren is only the latest sad example of this.

[Jeremiah's report is in the Apocryphal book of Baruch, 6:43. *LuP* alludes by implication to the phallic effect of the arrow gripped by Gillray's 'Cupid'.]

profusion of blazing hearts, burning torches and kissing doves which deco-
rate the golden robes of our God of Love! Oh come and see this, Hamburg
wedding poets and Berlin sonneteers! There is an inexhaustible treasure-
chest for you in Amor's toy box![48] But beware of using the flaming or
pierced hearts too liberally in your poetry. For they are nothing but modern
trash: the venerable Greeks knew nothing of them.[49] To finish with, we have
a question to put to all those keen butterfly hunters and *papillon* mounters
amongst you: which night flier owns the Psyche wings which our Amor has
exchanged for his own golden wings? (Look closely at the scale pattern on
the wing, and it becomes a portentous death's-head hieroglyph.)[50] Oh
Rösel, Schiffermüller, Esper and Sepp, please help us solve this entomolog-
ical puzzle! Could it be the *phalaena atlas* of Surinam, which can grow as
large as a German bat?[51]

 After all this, Gillray's quiver is still not empty.[52] Like the Parthians, he
continues to fire his deadly arrows, even in retreat. But we are tired of
explaining, and our readers must be tired of looking. Only the medallions
on the linen screen warrant a parting glance. Just like the actors treading the

[48] Some idler (probably related to the man who, according to the newspapers, recently counted
 all the letters in the Bible) has just calculated that three Berlin sonnets are composed for every
 one Hamburg wedding poem, but that one could nevertheless count on at least 200 wedding
 poems for every civil year in Hamburg.

[49] As is well known, Monge gave a lecture at the National Institute last winter, in which he
 showed that the symbol of modern art and of our erotic poets, the heart, was not found in
 antiquity. Since then Parisian women have felt that it's not their hearts which are on fire, but
 only their livers!

[50] It seems not to be generally known that the psyche wings which we see in ancient art, in stone
 carvings and reliefs, belong to moths and *phalaenae*. All such moths are attracted to fire and
 flame. For this reason the Greeks first used the image of psyche (in Greek the word means
 literally a night flier) in connexion with Amor's flame of love.

[51] See *Merianae Surinamum*, plate 32.
 [I.e. Maria Sibylla Merian, *Dissertatio de generatione et metamorphosibus insectorum
 Surinamensium* (Amsterdam: J. Oosterwyk, 1719). This German entomologist travelled to
 Surinam in the early eighteenth century, and recorded her observations. August Johann Roesel
 von Rosenhof, Ignatius Schiffermüller, Eugen J. C. Esper and Christiaan Sepp were
 entomologists of the mid to late eighteenth century.]

[52] Note, for example, what would be called *capita iugata* (coupled heads) in ancient numismatics,
 linking Lady Salisbury and Lord Derby; and Lady Jersey's horned-owl decoration with the
 two wing feathers etc.

boards, everyone on the picturesque panelled screen is married up in pairs. Unfortunately the binding mortar has long since crumbled. Has not angry Handel turned his back on this St Cecilia? But she cannot be the fair inventor of the organ and of heavenly music whom we gaze upon in rapture at the Dresden Gallery, or in Bologna.[53] This cannot be the Cecilia who was painted by Raphael's magic brush, or for whom Herder erected such a beautiful memorial.[54] It cannot be she to whom Dryden dedicated the famous 'Ode on St Cecilia's Day', set to music by Handel with his unsurpassed, sublimely simple musical skills. On the contrary: that formidable composer would have used his great periwig to stop the mouth of the screeching St Cecilia here, for she can only open her mouth à la Billington and squeeze out senseless, agonising bravura airs, her brain turned as well as her head.[55] It would be hard to reconcile the little winged head above her with the angels whom the real Cecilia summoned for quite different purposes.[56] Shakespeare, too, has turned his back on Melpomene, who, as the picture shows, has torn all passion to shreds in her Bacchanalian frenzy and 'outherods Herod'.[57] A jury of actors should decide whether she holds Sophonisba's poisoned chalice (on the right, opposite the dagger) or the contents of the whisky bottle peeping out further down. At any rate it would

[53] [The work in the Gemäldegalerie, Dresden, is presumably Carlo Dolci's *St Cecilia* (1671). Raphael's *St Cecilia with SS Paul, John the Evangelist, Augustine and Mary Magdalene* (c. 1514–15) is in the Pinacoteca, Bologna. Luitpold Dussler, *Raphael, a Critical Catalogue of his Pictures, Wall-Paintings and Tapestries* (London and New York: Phaidon, 1971), pp. 39–40, pl. 88.]

[54] J. G. Herder, 'Cäcilia' in *Zerstreute Blätter* 5 (1793), 289f.

[Reproduced in *Herders Sämmtliche Werke*, edited by Bernhard Suphan, 32 vols. (Berlin: Weidmann, 1877–99), vol. XVI (1887), pp. 253–72.]

[55] It appears from his portraits that Handel, following the custom of the time, wore a huge periwig. See for example the lifelike portrait on the title page of the *Allgemeine Musikalische Zeitung* 4 (1801). Once during a concert he became so incensed with the first violin that he tore his wig from his head and hurled it straight at the violinist's instrument.

[56] 'Invitabat angelos precibus, ut immaculatum suum corpus et pudicitiam Deo commendarent'. *Acta Sanctorum*, under Caecilia.

[The angels were to vouch for her virginity.]

[57] 'den Tyrannen selbst übertyrannt'. Thus Herr Schlegel strikingly translated this famous phrase, in *Shakspeare's dramatische Werke*, 9 vols. (Berlin: Unger, 1797–1810), vol. III (1798), p. 240.

[*Hamlet*, Act III, scene 2.]

not be unknown for the divine spark of inspiration, dampened by such libations, to dissolve in steam and smoke. Garrick, too, wants nothing to do with the Thalia with whom he has been so insultingly and mockingly paired. Which street-walker from *The Beggar's Opera* has disguised herself as the Muse of Comedy? Or is it a ballad singer who merely snatched up the mask in an emergency? This seems likely, given the dirty little chimney-sweep standing so loyally by his Mamma.[58]

But there are two sides to every coin. And the so-called dilettantes' theatres are no exception to this rule. In bright, one might even say caustic and acid colours, Gillray has pictured the bad side of this grandest of London amateur theatres. 'For if they do these things in a green tree, what shall be done in the dry?'[59] If this is what happens in the Pic Nic society, what goes on in the 'Spouting clubs'?[60] Our highly praised German amateur theatres could learn a lesson from all this. Fathers, mothers and guardians, tutors and governesses, look in the mirror! It shows what amateur theatres *can* lead to. The serpent lurks not in the play, or in the performance itself; for everything is performed with the greatest modesty and decorum on stage. But look to the green rooms, the rehearsals, the dressing-rooms, behind the scenes! Hippel describes a man who included in his wedding vows: no actors and no poets! Perhaps he was not so wrong after all. Thus it is that this foreign scandal has found a place in our German journal, for happy is he who learns from the mistakes of others![61]

The London amateur society, whose respectable front was recently portrayed in such a good light in a two-volume work,[62] can offer a great many excuses for its behaviour, which would not be the case in our small towns.

[58] Like the ballad singer in the eleventh plate of Hogarth's *Industry and Idleness*.
 [In *The Idle 'Prentice Executed at Tyburn* (1747).]
[59] [St Luke's Gospel, 23:31.]
[60] 'Spouting clubs', says Wendeborn in his *Der Zustand des Staats, der Religion, der Gelehrsamkeit und der Kunst in Grosbritannien*, vol. IV, p. 359, 'are a kind of private society where artisans, apprentices (in some places Jews, too) meet to perform plays among themselves, as well as they can, and to practise their acting'.
[61] 'Felix quem faciunt aliena pericula cautum!'
[62] Some dilettantes and devil's advocates will want to know the title: *The Pic-nic, being a Collection of Essays in Prose and Verse. To Which is Annexed a Narrative Which Gave Birth to the Society called the Pic Nic*, 2 vols. (London: Richardson, 1803).

To finish with, let us listen to an Englishman who, when we asked him about this Pic Nic society, answered as follows: 'In Paris there are at least twelve important theatres; in the whole of London there are only two. The directors of Drury Lane and Covent Garden have thus become monopolists and despots. If a play is rejected by a director in Germany, the author can try his luck elsewhere. Not so in England! Only the London theatres pay, and no play is put on in a provincial theatre unless it has first passed the test of being produced in one of the two main theatres. Thus, one might say that the fate of all dramatic talent in England depends on just two people. You need as much influence to get a new play on the stage as you need to bring a new law before Parliament. In addition, Drury Lane is always in debt, and playwrights find it extremely difficult to get payment from that wretch, Sheridan. Lewis, for example, sent his translation of *Rolla's Death* to Sheridan, asking his opinion of it. Sheridan kept the play for a long time, and then returned it saying that it was unsuitable for the English stage. Shortly afterwards he staged a performance of his own 'translation' (although he does not understand a word of German) entitled *Piʒarro*. This was Lewis's translation word for word, although some political speeches had been added and it was finished off with an act which destroyed the unity of the characters and the plot.[63] What is even worse is that an author is forced to court the prima donnas amongst the actors and actresses. People of standing and dignity find it hard to come to terms with this. It is these combined reasons which occasioned the founding of the Pic Nic society, which includes many highly talented as well as high-ranking members. They rent a small theatre where they perform published and unpublished plays. Naturally the enterprise was initially condemned – firstly by all those who have an interest in the public theatres (both pay off

[63] [Matthew Gregory ('Monk') Lewis complained to Byron that Sheridan had stolen his manuscript translation of August Friedrich Ferdinand von Kotzebue's *Die Spanier in Peru, oder Rolla's Tod* for the very successful *Piʒarro* (1799). The latter was in fact a free adaptation of Kotzebue, with speeches inserted by Sheridan; he used several translations, one of them Lewis's. Thomas Moore, *Memoirs of the Life of the Rt. Hon. Richard Brinsley Sheridan*, 5th edition, 2 vols. (London: Longman, Rees et al., 1827), vol. II, pp. 286–92. F. W. Stokoe, *German Influence in the English Romantic Period* (Cambridge University Press, 1926), pp. 48–9, 69, 184.]

a number of newspapers),[64] and secondly by all those John Bulls of the old school who always look for signs of moral corruption in any novelty. But if we consider that no society in the entire world can exist without gaming, and how high the stakes are in England, where a man's misfortune can destroy an entire family overnight, and with what currency honourable ladies are often forced to pay their debts of honour: then we must admit that there is no more innocent, no more elegant entertainment than dramomania. Incidentally, the Pic Nic furnishings are very good. The room is pretty and gay. After the performance a cold meal is provided and the evening ends with song and with an unforced sprightliness which seems almost exotic in London, and which can be attributed to some émigrées who often perform French plays and are the real soul of the society'.

[64] [Sheridan was among those who attacked the Pic Nic through the press. See Gillray's *Blowing up the Pic Nic's: – or – Harlequin Quixotte attacking the Puppets* (1802). *BM* 9916. George, *Hogarth to Cruikshank*, pp. 110–11, pl. 95.]

15 *French Invasion. – or Buonaparte Landing in Great-Britain*[1]

11 (1803), 353–69, pls. x–xi

As Mirabeau once memorably said, 'Il y a une guerre à mort entre l'imprimerie et l'artillerie'; his words will certainly never lose their relevance in our time. This pernicious war can only end when the cannons are clever enough to befriend the printing presses, making them their allies and steadfast comrades-in-arms, instead of using brute force to silence them. For whenever pyrotechny attempts to intimidate typography using compulsion and censorship, the ancient fable of the battle of the gods and giants is destined to be acted out over and over again. The barbarous giants with their hundred arms stormed and bombarded the palace of heaven, using the most powerful artillery that ever came from a foundry. In comparison, even the ill-famed stone mortars of the Dardanelles are mere toys. Yet Minerva, who sprang from the head of the eternal father, had only to brandish her shield of wisdom once, and lo and behold the hulking great earth-bound ruffians immediately took flight, even before Silenus' famous ass had stopped his terrible braying.[2]

Chalcography, or the art of copper engraving, is the younger half-sister of typography or book printing. In recent times engravers, too, have understood the importance of serving the government now and then, alongside

[1] [Etching published 10 June 1803. Unsigned. *BM* 10008. A. M. Broadley, *Napoleon in Caricature 1795–1821*, 2 vols. (London and New York: John Lane, 1911), vol. i, p. 176. John Ashton, *English Caricature and Satire on Napoleon I* (1888, reissued New York and London: Blom, 1968), p. 141. Hill (1965), pp. 127–8. In *LuP*'s copy of the print the words 'or Buonaparte' were omitted from the title to make it less controversial.]

[2] Myths survive from the oldest Greek *gigantomachia*. We know, therefore, that those storming heaven were already dismayed, when the unexpected braying of Silenus' ass put them in full flight. This is the earliest instance of the so-called 'panicking terror', which an ancient poet had already evoked in his description of the battle of the giants. The latest instance of it can be found in the tactics of some literary journals, although the ass has often put on a lion's skin for greater security.

157

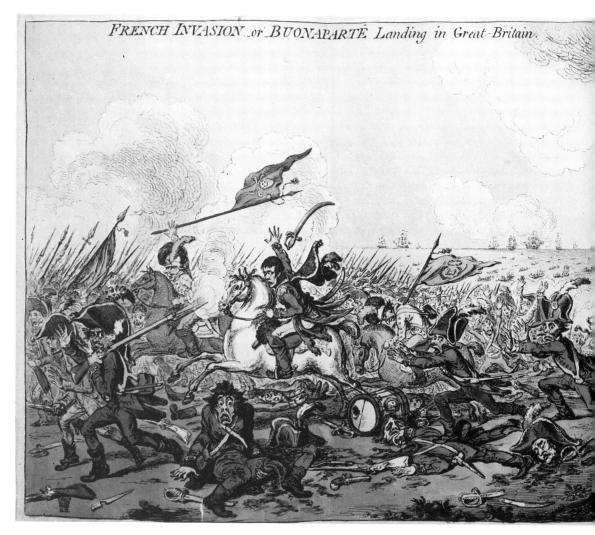

PLATE 26
James Gillray, *French Invasion. – or Buonaparte Landing in Great-Britain*, 1803.
Etching, hand coloured.

cannons and bayonets. Indeed, as we write, the battle being waged between
the caricaturists and engravers in London and Paris, with their witty, highly
explosive missiles, has become as bitter and hateful as the real fight between
the two nations: a war which is fought with a thousand menacing, fire-
spitting cannons. Since the fresh outbreak of this wretched war (so often

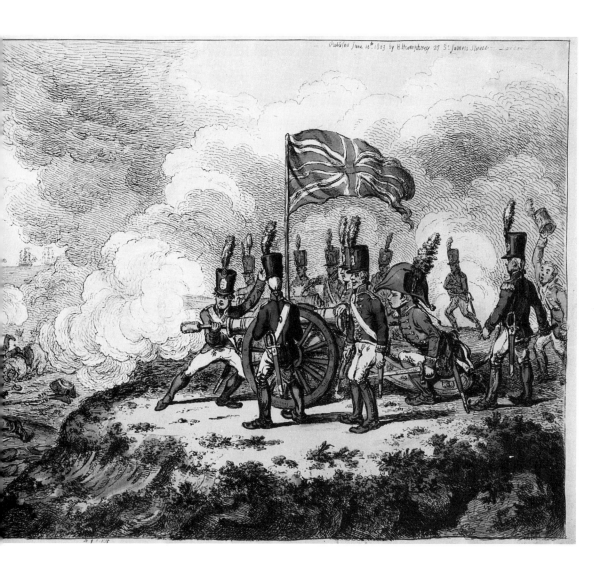

reminiscent of the fabled bull-fight at which certain neighbouring marsh-dwellers made such edifying comments), one cannot deny that the French, too, have summoned up all their wit, so as not to be outdone by the English satires. New examples of the latter appear daily in Humphrey's and Fores's caricature shops in St James's Street.[3] One has to admit that the French

[3] [On this propaganda campaign, see George (1959), pp. 66f. Fores's shop was actually in Piccadilly.]

probably surpass the English prints, if not in the sharpness and polish of their satire, then in sheer vulgarity and outright exaggeration. Following the return of the Duke of Cambridge, for example, a retreat which was by no means shameful, but was occasioned simply by the pressure of the situation, more than eight caricatures could be found on sale in Paris, each more vulgar and clumsy than the last. Indeed, we could not find a single one which was even remotely suitable in terms of invention or execution for our gallery of contemporary history and manners.[4] Even more absurd and foolish are several caricatures on the cowardice of the English soldiers, who drop everything the moment the French set foot on English soil, turn tail and run. One of these monstrosities is particularly inane and uninspired. It shows the English being beaten by invading Frenchmen, and goes by the title *Valeur Anglaise*.[5] Even sensible Parisians remarked that it was unbe-

[4] Even the one which seems to have been judged favourably in Paris, entitled *Démission forcée du Duc de Cambridge*, contains not a trace of satirical wit, for all its malice. The Duke of Cambridge catches sight of a little French drummer boy, beating a drum roll at the double, with a huge cloud of dust behind him. The Duke becomes so terrified that he throws himself upon his horse pell-mell, hardly leaving enough time to write a demission on the back of a crouching, anxious and weeping grenadier. He has lost his hat, and tramples a soiled paper, on which we read the words: 'Je jure de mourir à mon poste.' The French cock flies cheekily above. Beneath all criticism is another caricature entitled: *Arrivée du Duc de Cambridge à la cour de son père*, which has a popular song printed below it. The scene is set in the private drawing room at Windsor. The Duke of Cambridge bursts in breathlessly, and breaks the bad news from Hanover to his royal parents. His mother wipes the sweat from his brow with her handkerchief. Two princesses, his sisters, are getting his nightclothes and bed ready for him. Above, scared by the French cockerel, we see Fear itself, a terrible monster, hovering over the head of the fugitive. But enough of these misbegotten freaks. Even the first announcement of the so-called flight of the Duke of Cambridge by the colporteurs of Paris was ominous. They proclaimed the treaty which Mortier had signed with the Hanoverian government. On the first page was printed the now ubiquitous *prétendu portrait* of the First Consul, with a repulsive grimace. The news now spread that the Duke of Cambridge himself had been taken prisoner. Soon Bonaparte was transformed into the imprisoned prince, and the lads shouted cheekily: 'voilà le fils du fameux roi d'Angleterre qui a été fait prisonnier avec toutes les troupes. Il arrivera demain!!'

[The first print mentioned by *LuP* appears to be a version of *BM* 10026, *Plan, de Campagne du Duc de Cambridge*, published in Paris by Martinet (n.d.); illustrated here as pl. 27. Despite the intention of representing movement, it is a frozen and still emblematic image, in striking contrast to Gillray's vividly depicted scene. Broadley, *Napoleon in Caricature*, vol. I, p. 179; vol. II, pp. 26–7, 39–41, 359.]

[5] Here, for example, we see some French grenadiers hunting down the English troops with

PLAN, de Campagne du Duc de Cambridge.
Chez Martinet.
Déposée à la Bibliothèque Nationale

June 1803

PLATE 27
Anon., *Plan, de Campagne du Duc de Cambridge*, undated (1803).
Etching, hand coloured.

coming to scorn the enemy in advance. When they saw this abortive effort
they grew quite angry and indignant at the foul and filthy notion which the
caricaturist was peddling as wit. But when it comes to scorning the enemy,

whips! Another Frenchman is showing them his bare behind!! A third is tearing open a
cartridge-bag which has been abandoned by one of the Englishmen. Instead of powder
and lead, he finds a well-lined purse inside it. The English government is personified as a
man striding in on stilts. A Frenchman is sawing them in two. In the distance the Duke
of Cambridge is fleeing in a curricle, to which a hare and another long-ears are
harnessed. If French wit cannot produce anything better than that, it deserves the wooden
spoon!

and the great nation's arrogance towards its neighbours and antagonists, there are plenty of other works of art whose creators delude themselves that they are on a far higher plane, but who actually vie with the lowest caricaturists in their aggrandisement of the French and disparagement of the British.[6]

Yet we can hardly think any better of the English, when they too use all the pictures and songs at their disposal to pay back, with interest, their zealous friends on this side of the Channel. This caricature is irrefutable evidence that the proud Britons, whose heartfelt desire is to conquer or to die for their country and constitution as free men,[7] can only visualise the arrival

[6] One thinks here of the allegorical picture which has recently been cried up in all the newspapers. The artist Van Brée, a pupil of Vincent, had been commissioned to paint a large work, glorifying the First Consul's entry into Antwerp. He presented Mme Bonaparte with an allegorical painting which showed the First Consul sitting on the sea, leaning his hand on the earthly sphere (at this point our readers will doubtless recall the caricature by Gillray, no. XVIII from last year, in which Bonaparte has granted Fox an audience and is shown resting his hands on two globes). In the painting Bonaparte is portrayed with the three Fates above him, spinning his destiny in a radiance of light (the third Fate with the dreaded shears has fallen asleep, and a passing genius is bringing a whole basket-load of opium!!). But opposite him it is night-time, with the English coast blackened by storm clouds. See *Journal de Paris* Year XII, no. 49 (11 November 1803), 297.

[*The Arrival of the First Consul Napoleon Bonaparte at Antwerp, 18 June 1803*, commissioned by Josephine and painted by Mathieu Ignace Van Brée, is at Versailles. Gillray's *Introduction of Citizen Volpone & his Suite, at Paris* was in *LuP* 10 (1802), 244–73, pl. XVIII. *BM* 9892. Hill (1976), pl. 77, pp. 123–4.]

[7] Whether one's political convictions incline one more towards the English or the French ways of thinking (and why not simply the *German?*), one cannot help but admire the enthusiasm which at present animates all Britons, whatever their social rank or persuasion. The following remarks in one of the most widely read newspapers are from the pen of a patriotic London tradesman and deserve to be quoted here: 'We have been contemptuously styled by the French "a nation of shop-keepers" by which they would insinuate, that the love of money was our passion. But the love of our country is paramount to every consideration of private interest. Men of trade unite with gentlemen of landed properties to volunteer at their own expense . . . All party-differences are absorbed in the ardour of patriotism. Burdens and privations are submitted to with cheerfulness, and 500,000 men in arms, taken from the most respectable classes of the community, speak a language to Bonaparte, which he had not heard from any other part of the world. Will he now dare to assert: England cannot meet France single-handed? We are rich and free! We have a King that we love, and a constitution that we revere. Should the Corsican land, he would find every City a Sparta, every pass a Thermopylae and I trust every field of battle a Marathon!'

of the enemy in the most insulting and disparaging terms. Here, again, one may take up a far loftier vantage-point, and see their conduct as an infringement of the harsh, immutable laws of Nemesis. Complacency goes before a fall! We all know what kind of marble Agoracritus' statue of Nemesis Rhamnusia was made of.[8] And you will remember from early history the fate which befell that arrogant and bold Duke of Burgundy, when he thought he already had the Swiss in the bag![9] All men could learn a lesson, if their minds were not shut fast against it, from the beginning of the fateful revolutionary war, which proved the theory that severe Nemesis Rhamnusia will not tolerate arrogant scorn of the enemy. Indeed, if we credit the opinions and assertions which Herr von Bülow recently put forward in one of the most widely read journals,[10] we could claim that when the English laugh at the French invasion in sneering caricatures (and this one is sneering with a vengeance), the old saying about the 'sardonic' laughter which comes from eating poisonous buttercups is almost literally borne out.[11] But we really should not treat the matter so tragically and earnestly. For our friend Gillray intends these painted attacks to be mere fleeting entertainment in the minds of his public. His bold anticipation of the future is no Macbethian magical prophecy. He is merely concerned that another contribution should be

[8] Johann Gottfried Herder's 'Nemesis' in *Zerstreute Blätter* 2 (1786), 219–72.

[See also *Herders Sämmtliche Werke*, ed. Bernhard Suphan, 32 vols. (Berlin: Weidmann, 1877–99), vol. XV (1888), pp. 395–428. Pliny, *Natural History*, Book XXXVI, section 17. *The Elder Pliny's Chapters on the History of Art*, edited by E. Sellers, translated by K. Jex-Blake (London: Macmillan, 1896), pp. 190–1.]

[9] [Charles the Bold, Duke of Burgundy, invaded Switzerland but was decisively defeated near Granson in 1476.]

[10] See von Bülow, 'Ueber die Landung in England' in Posselt's *Europäische Annalen* 1803 (iv), 82–99, where even the accommodation of an English government in exile in East India is discussed! If only they had already caught the bear, whose skin they distribute with such largesse! The English would do well to recirculate Lloyd's fair-minded work on the terrors of a French invasion which he published during the Seven Years War. It has been translated in Hamburg and sells for a few Groschen.

[Presumably Charles Lloyd; the pamphlet, perhaps published anonymously, has not been identified.]

[11] It is known that this saying described the grinning spasms of those who had eaten the poisonous swamp weed *ranunculus cocleratus*. Modern botanists identify it as the *herba sardoa* of Dioscorides and Sallust, although muscular convulsions are caused by several poisonous plants. See Murray, *Apparat. Medica*, vol. III, p. 85.

forthcoming from *this* side, to ensure that the flame of patriotism is re-kindled. He knows all too well what is the best wood to use, to keep the fire burning. Fig-tree wood would not serve his purpose at all, for it gives off an acrid smoke which stings the eyes of the person lighting it.[12]

We certainly don't need the usual guide or *cicerone*, however, to throw light on this caricature. A single glance explains everything as clearly as can be. Gillray assumes that the French have *partly* succeeded in their reckless invasion. For there are others still out to sea, in the middle distance there, just arriving in their flat boats. We should imagine a promontory in Sussex or Kent, undoubtedly the two counties which are most exposed to invasion. But hardly have these daredevils overcome the myriad dangers which face them: being swallowed up by the rolling waves and smashed on the cliffs by the foaming breakers; being overrun by the English two- and three-deckers; shot at by the hosts of smaller war squadrons; rendered quite defenceless by seasickness (the tribute which every landlubber must pay to old Ocean and his silver-haired mermaids on his maiden voyage); hardly have they recovered from this and all the other bloody and salty adventures; hardly have they waded up to their armpits in sea water and finally leaped onto *terra firma*, when the batteries hidden on a neighbouring hill open hellish fire on them from all sides, greeting the unwelcome guests a thousand times over with terrible case-shot. Surely we cannot criticise the French if, taken unawares by a reception of this kind, they are so impolite that they do not even take time to respond. Every man who still has feet on his legs and a head on his shoulders is trying to find salvation in flight. But of course salvation is itself the yawning jaws of Death. For behind these dunes, new-sown with mounds of corpses, Thetis holds open her wet apron to catch the refugees and throw them to the greedy sharks and the rest of Neptune's shoals in that yawning abyss,

where salamanders and newts and dragons
writhe in the terrible jaws of hell.[13]

[12] Aristophanes, *Wasps*, 137. Cf. Bode von Stapel on Theophrastus, p. 584.

 [i.e. Johannes Bodaeus à Stapel, *Theophrasti Eresii de Historia Plantarum libr. decem, Graecae et Latine* (Amsterdam: 1644).]

[13] In Schiller's unsurpassed *Taucher* ('The Diver'), which, according to Zelter and Kanne, ranks

Gillray could easily have chosen to depict this terrible scene of drowning, a counterpart to Poussin's *Death of Pharaoh's Armies in the Red Sea*, or Le Brun's *Battle of the Granicus*.[14] But an experienced archer does not shoot all his arrows at once. Like a careful housekeeper, he has kept this one in his quiver so that he can fire it another time to greater effect.

Indeed, we need no heightening of the hyperbole of terror to make this murderous scene more dreadful and shocking. Virgil's famous 'Plurima mortis imago'[15] has been applied so significantly and appropriately to the famous Schlüter masks of dying warriors in the Berlin Arsenal;[16] and now Gillray embodies it with great imaginative power in this masterly picture. It would be highly estimable just as a battle piece, without its contingent meaning.[17] Of course, the artist was concerned with depicting not only the concept of terror, but also the characteristic *effect* of that terror; the suffering in the faces and movements of the fleeing men inevitably verges

with the works of our best musical composers, there is a portrayal of Charybdis writhing with sea monsters. It is scarcely exaggerated, as anyone will discover for himself who feels inclined to compare that terrifying image with the account in Pausanias' *Description of Greece*, Book v, *Elis*, part 1, ch. xxv.

['Der Taucher' in *Schillers Werke. Nationalausgabe*, edited by J. Petersen, G. Fricke et al., 42 vols. (Weimar: Böhlau, 1943–93), vol. 1 (1943), pp. 372–76 (p. 375).]

14 [Nicolas Poussin's *Crossing of the Red Sea* (1634), now in the National Gallery of Victoria, Melbourne, was then in England. Christopher Wright, *Poussin Paintings: A Catalogue Raisonné* (London: Harlequin, 1985), pp. 58, 180, 265. Charles le Brun's *Battle of the Granicus*, from his series of paintings *The History of Alexander* (c. 1665), is in the Louvre. Michel Gareau, *Charles Le Brun, First Painter to King Louis XIV* (New York: Abrams, 1992), pp. 208f.]

15 Without going into the musings of Spence in his *Polymetis* (1747), or dismissing Lessing's criticisms as invalid, I do think that in this passage (*Aeneid* II, 369) and in various other personifications of the war (particularly VII, 607), Virgil really had before his eyes the painting of War and Triumph which Augustus put on display in the most frequented part of his forum, with a companion piece representing Victory: 'posuit in foro suo celeberrima in parte duas tabulas, quae Belli pictam faciem habent et Triumphum', Pliny, *Natural History*, Book XXXV, 27. Then the expression 'plurima mortis imago' really would refer more to the different ways of being killed and wounded, not merely to the piles of corpses. Silius' imitation in *Punica* IV, 591, 'mille leti facies', also points to this.

16 [The inner courtyard of the Berlin Arsenal (now the Museum of German History) is decorated with reliefs showing twenty-two heads of dying warriors (c. 1696), an allegory of death on the battlefield, by the sculptor and architect Andreas Schlüter (c. 1660–1714).]

17 [Despite *LuP*'s high praise, there is evidence that Gillray looked on his propagandist prints of this time as discreditable pot-boilers; hence the absence of signature. Hill (1965), p. 127.]

on the burlesque in some cases. Only when Homer's wounded Mars shouts as loud as ten thousand men, or when fleeing men are compared to starlings and those who are falling over to acrobats etc., does the poet very nearly verge on comedy. But this does not detract from the impression of the whole in any way. Similarly, horror at the bloody massacre in Gillray's print will not prevent the spectator from smiling at the runaways as they stride along, dropping everything, escaping on horseback and on foot, cowering, terrified and wretched. This has to be seen, it cannot be described. There is little doubt that the artist wished us to focus our attention on the comman-der-in-chief galloping off on his white horse, and on the fellow with the shaggy Medusa head, whose left foot has been shot off. Just when every-thing depends on the number of feet you have, what a bitter misfortune it must be to draw such a hopeless blank! – to be knee-capped, like a living commentary on that famous verse from Horace:[18]

> Run, and death will seize
> You no less surely. The young coward, flying,
> Gets his quietus in the back and knees.

The shameful flight of the commander-in-chief is clearly emphasised, and his immediate surroundings are also very significant. He is riding over a corpse, still in the throes of death, an illustration of the words which the brave cuirassier utters in *Wallensteins Lager*:[19]

> Whoever lies across my path,
> Be he my brother or my own son,
> Even if his screams should tear my very soul,
> I must ride across his body,
> I cannot gently carry him aside.

[18] 'Mors et fugacem persequitur virum, / Nec parcit imbellis iuventae / poplitibus', *Odes*, Book III, Ode 2. Of course this does not refer to a mutilation where the stump of the foot remains, but to chopping the knee at the hamstring . . . which was very common in antiquity . . . But at that time there were no cannon-balls, just sabres, which were particularly well suited to slicing, called *gladii falcati*.
[*The Odes of Horace*, translated by James Michie (Harmondsworth: Penguin, 1964), p. 145.]

[19] [Friedrich von Schiller, *Wallensteins Lager*, in *Schillers Werke. Nationalausgabe*, vol. VIII (1949), pp. 1–54 (48–9).]

The artist might easily be referring to the ruthlessness of this general, seeking to refresh English memories of Egypt and Syria;[20] we Germans, however, are reminded of the harsh accusation made against Frederick II, who, it is said, sought to relieve the suffering of the wounded, and those who couldn't be saved, in the quickest way possible.[21] In front of him a despairing standard-bearer hurls away his flag. It has been stamped with very ominous symbols to make a *memento mori*. Near the hind hoof of the fleeing commander's horse is a drum with a perforated skin. So the French alarm drum, as this would be called in good German, has had an ugly hole punched in it. The black list of atrocities of which even modern tyrants stand accused includes the tormenting of prisoners into a state of sleepless despair by the constant beating of a drum outside their cells. Indeed, the English felt they always had a Corybant drum of this kind[22] sounding in their ears, due to the alarm system adopted by their good friends and neighbours on this side of the Channel. But now, says the patriotic artist in his wrath, we've put an end to the drumming once and for all. Finally, you will note the misfired or ricocheted shot from the smoking rifle of the soldier in the foreground, who is fleeing with such an eloquent gesture of capitulation. So the invading army did not even stay to fire the first shot! Yet it was on account of this army that the bishops of the English Church announced a prayer on the last Day of Prayer and Repentance, in which they beseeched: Oh Lord, save us from being

[20] [A guarded reference to reports of Napoleon's massacres of civilians and prisoners, abandonment of the wounded, poisoning of his plague-stricken men at Jaffa, and desertion of the army in Egypt in 1799. These were exploited in British propaganda prints and literature, especially when invasion threatened in 1803. Ashton, *English Caricature and Satire on Napoleon I*, pp. 67–90. J. Christopher Herold, *Bonaparte in Egypt* (London: Hamish Hamilton, 1962), p. 330. E. H. Gombrich, *Meditations on a Hobby Horse* (London and New York: Phaidon, 1963), pp. 124–5.]

[21] [The Emperor Frederick II (1194–1250) was vilified by a hostile papacy.]

[22] It is well known that amongst the conjurers and shamans who have roamed Asia Minor since the earliest times, there was a type of mendicant order whose members were called Corybants, and whose convulsions caused fear and amazement in the people who encountered them. They claimed that they could hear the sound of a tambourine constantly ringing in their ears, which caused them to go mad. This was called Corybant-madness. Plato discussed very seriously how it could be cured through music: *Laws* Book VII, 790.

swallowed up![23] The firing of the fuse is certainly mistimed: we dare not ascertain the direction this dangerous backfire might take if the angle of the musket were to assume a westerly declination. But this much is certain: these are no Parthians who used to fire their man-sized bows behind them as they fled, posing the greatest threat to the enemy pursuing them when they themselves were in retreat.[24] This shot will never hit an English mother's son, or wound anyone who eats roast beef and drinks porter. We shall leave the interpretation of the other figures, where many a witty shaft lies concealed, to the observer armed with English spectacles; we will just draw attention to the way in which the clever artist contrasts the French soldiers with the group of his victorious compatriots operating the battery. This gives the battle piece a fine, balanced composition which makes the caricature very striking. The front gunner in particular, the one holding the fuse, really is sarcasm personified.[25]

So, according to the apocalyptic vision of the English, this is how the French enjoy their 'trip to old England'. Of course the blue jackets in the camp at Boulogne have their own visions of the future. The question is: whose side is the true prophet on? At Nestler's in Hamburg, 6 Groschen will buy you *Die bevorstehende Landung in England, eine Prophezeiung aus dem Englischen*.[26] If only prophets had always been so honoured in their own countries!

[23] Psalm 124 was taken as a text, and the words of verse 3, 'they will swallow us living' applied specifically to Bonaparte and his armies.

[The passage (verses 2–3) actually reads: 'If it had not been the Lord who was on our side, when men rose up against us: then they had swallowed us up quick, when their wrath was kindled against us.']

[24] Everyone knows about the 'Parthos fuga feroces' from Horace and Virgil.

[25] One knows that the word sarcasm, which is found in every modern language, actually refers to the taunts uttered by the victor over the corpse of his slaughtered enemy in the brutal ardour of his triumph.

[26] ['The imminent landing in England, a prophecy from the English'.]

16 *Confederated-Coalition; – or – The Giants storming Heaven*[1]

13 (1804), 53–76, pl. 1

The ancient Greek legend of a pack of giants storming heaven, and their plot to overthrow the abode of the gods on Olympus, has frequently been depicted on canvas and in verse.[2] Yet the subject is truly unique. For in this ancient Greek fable all the powerful giants described in the Scandinavian *Edda* and the Indian *Veda* join together to form one terrible throng:

> Earth
> With monstrous parturition spawned the giants,
> Coeus, Iapetus and grim Typhoeus
> And the brothers who conspired to pull down heaven
> (Thrice they endeavoured – think of it – to heave
> Mount Ossa on Mount Pelion, and then roll,
> Forests and all, Olympus onto Ossa.
> Thrice with his bolt the Father razed that pile.)
> (Virgil, *Georgics*, 1, 278–83)[3]

The theme of the original fable was physical, and alluded to the powerful revolutions of the earth. It was already a common artistic motif in antiquity.[4] Several memorials to the fable still exist, in which Jupiter is shown

[1] [Etching published 1 May 1804. 'Js. Gillray inv. & ft.' *BM* 10240. George (1959), pp. 73–4. Hill (1965), p. 110. Ronald Paulson, *Representations of Revolution 1789–1820* (New Haven and London: Yale University Press, 1983), pp. 210–11. Donald (1996), p. 37.]

[2] It has been shown that the 'gigantomachia' was originally a local Thracian-Thessalian fairy tale. It arose from an obscure tradition about earthquakes and volcanoes, which split the mountains of the region and created new islands in the surrounding seas. The outlines of this myth still reflect the primitive character of its Thessalian origins. We are all familiar with the felicitous and sublime elaborations of it by later poets.

[3] [*The Georgics*, translated by L. P. Wilkinson (Harmondsworth: Penguin, 1982), pp. 65–6.]

[4] This fable entered the repertory of Greek art at an early stage, via the Panathenaea and the embroidered robe or peplos of Minerva (Athene), on which the battle of the giants was

PLATE 28

James Gillray, *Confederated-Coalition; – or – The Giants storming Heaven*, 1804.
Etching, hand coloured.

hurling lightning flashes from his thunder-chariot. They show the dreadful moment, just as he has thrown down the earthlings, the brood of audacious giants, and is aiming his thunderbolts at their heels. Of course the idea was also treated at a very early stage as a moral fable. Pindar saw in it a symbol of the unbridled rebellion of irrationality against the rational and just,[5] and the Roman lyricist follows this Greek example in his interpretation. In modern times Greek mythology has often been used in what Herder refers to as 'Hofallegorie', or 'court allegory'.[6] When the imperious League of Cambrai dissolved, bringing humiliation to the allies and glory to the island queen in the lagoons, Venetian artists flattered their secure republic by portraying the allied powers as hundred-armed giants, being repelled by St Mark, his lion at his side.[7] When Emperor Charles V so quickly vanquished the Schmalkaldian Alliance he despised, an Antwerp artist painted his triumph, again using the allegory of the storming of Heaven. The unfortunate leaders of the Alliance, the scorned and deposed Elector and the outwitted Landgrave, had to suffer being depicted with disgusting serpents' tails and with imperial thunderbolts piercing them.[8]

Footnote 4 (*cont.*)

traditionally represented. See Wilhelm Gottlieb Becker's *Augusteum Dresdens antike Denkmähler*, 13 vols. (Dresden, 1804–12), vol. I, pl. 10. Pheidias himself depicted it on several occasions. The principal group of storming giants has been preserved for us in a famous marble relief in the Vatican collection. See Ennio Quirino Visconti, *Il Museo Pio-Clementino*, 7 vols. (Rome: Mirri, 1788), vol. IV, pl. X. Fulminating Zeus is shown in several stone carvings. One of the greatest excellence has been illustrated by L'Abbé Joseph Hilarius von Eckhel in his *Choix des Pierres Gravées du Cabinet Impérial des Antiques* (Vienna: Joseph Noble de Kurzbeck, 1788), pp. 32–4, pl. XIII. It is well worth taking the trouble to compare the errors of modern artists who have attempted this subject with these highly imaginative creations of antiquity, in so far as they have been handed down to us in fragmentary form. See, for example, Johann Heinrich Schönfeld's *Battle of the Giants* in the Dresden Gallery.

[This painting of c. 1660 was destroyed in the Second World War, but its composition is apparently recorded in Schönfeld's *Musical Entertainment at the Spinet* (c. 1670) in the Gemäldegalerie, where a picture of the battle of the giants is shown on the wall of the room.]

[5] [Pindar, *Pythian Odes* VIII.]

[6] See 'Allegorie der Kunst' in *Adrastea*, 2.iv (1801–2), 232–41, also in *Herders Sämmtliche Werke*, ed. B. Suphan, vol. XXIII (1885), pp. 314–20.

[7] [This image cannot be identified among surviving Venetian paintings. It was perhaps a temporary work like the triumphal decorations referred to in notes 8 and 21 below.]

[8] [This work is not certainly identifiable. However, a scene of the giants storming heaven

Court allegory is joined here by caricature allegory (although the latter is not always welcome, of course, for it is only a bastard foundling, conceived outside lawful matrimony). This caricature, born of Gillray's endlessly fertile imagination, provides us with a new, highly illuminating example of the genre.

Everyone remembers the events of the beginning of May, when Minister Addington was forced to leave the Treasury Bench with some of the King's 'confidential servants', to the bitter disappointment of ailing, good King George. This resignation once again left a place for Pitt on the driving-box of the great British state coach: for the experienced coachman of old had wisely vacated the seat before the Peace of Amiens. No one would deny the private virtues and incorruptible honesty of Addington, the former Chancellor of the Exchequer. But the British Empire was in the throes of an 'awful crisis'. It was threatened internally by the physical weakness of the King, and by an extremely questionable regency, and externally by a brand-new Gallic Emperor and all his deplorable deeds. Even Addington's loyal supporters recognised that, for all his good qualities, he would never win a game in which almost everything was at stake. At the same time, Addington was behaving so indecisively and equivocally in various half-measures relative to the Volunteer system and to defence policy, that finally his suitability for government was doubted even by the nation itself. (One cannot say 'common man' here, for in matters of domestic politics, the lowest man of the people is still far better educated than many German scholars!)[9] The powerful class of rich state creditors, bankers and suppliers had long been

Footnote 8 (*cont.*)

featured among the decorations for the triumphal entry of Charles V into Naples in 1536, and of the future King Philip II into Antwerp in 1549. This latter painting by Frans Floris is lost, but was engraved by Balthasar Bos in 1558, and adapted in a drawing by Anthonie Blockhardt of c. 1570–5. In Bos's print the giants try to mount a ladder, an interesting parallel to Gillray's rope ladder. J. P. Filedt Kok et al. (eds.), *Kunst voor de beelden storm* (Amsterdam: Rijksmuseum, 1986), pp. 420–1.]

[9] 'Indeed', we read in the *Morning Chronicle* of 14 April 1804, 'When we see some folks hugging and caressing the Doctor' (this is the common nickname for Addington), 'we cannot help thinking they must be in the case of *Titania* in the *Midsummer's Night's Dream*, where she doats and drivels upon *Bottom*, the weaver, metamorphosed into the likeness of an ass.' Things must have gone very far, if people dare to make such comparisons.

incensed by an intelligent system of economies in loans and in the navy, quite unheard of under Pitt. Then there was the unpleasant affair concerning the involvement of Drake and Spencer Smith in the plot in Paris. Even if one takes the most favourable view of this episode, and assumes that Addington had not actually been initiated into the details of the plan,[10] it laid him open to whispered criticism for his lack of political vigilance. Storms, thunder and lightning were unleashed upon the anxious minister. He was subjected to such incredible and mounting opposition in four consecutive parliamentary debates,[11] that the steadily growing minority seemed to be irrevocably signing his political death-warrant. The Opposition consisted of three very different groups, which formed a coalition for the sole purpose of bringing about the downfall of the old ministry. These were: the genuine old Whig Club Opposition, with Fox at its head; the Grenville–Buckingham party, led effectively by the clever Windham; and Pitt with his comrade-in-arms, Dundas, now Lord Melville, together with his shield-bearer, Canning, and a number of other loyal satellites and cronies. Immediately after his resignation from the ministry, Pitt had distanced himself from Grenville's party by speaking out in favour of the Peace of Amiens. But now, suddenly, everyone grew closer again: Pilate and Herod were made friends;[12] and all the great statesmen from opposing political

[10] Herr von Archenholz discusses this supposition in a perceptive essay, well worth reading: 'Ueber die Theilnahme Englands an der Verschwörung in Frankreich und die französische Kayserwahl' in *Minerva* 2 (May 1804), 362–73 (363).

 [Francis Drake, the British minister plenipotentiary in Bavaria, and Spencer Smith, the minister at Stuttgart, headed intelligence operations against the French government. Napoleon countered these by employing agents to pass false information, which was duly transmitted to London. When exposed in the French press, it wholly discredited Blake and Smith, who were ridiculed in French satire. Jacques Godechot, *The Counter-Revolution Doctrine and Action (1789–1804)* (Princeton University Press, 1971), pp. 369–72. A. M. Broadley, *Napoleon in Caricature 1795–1821*, 2 vols. (London and New York: John Lane, 1911), vol. I, p. 211; vol. II, pp. 27, 42.]

[11] Cf. the *Morning Chronicle* for 9 April 1804, which printed lists, with initials, of the voting members in all four debates. The strongest opposition was encountered on 15 March, against Lord St Vincent's administration of the navy.

 [*Cobbett's Parliamentary Debates*, vol. I for 1803–4 (London: R. Bagshaw, 1804), cols. 872–928.]

[12] [St Luke's Gospel, 23:12.]

faiths – Fox and Pitt, Grey and Dundas, Windham and Sheridan, Grenville and Norfolk – joined together on a broad basis, to form an all-encompassing 'broad-bottomed administration'. Their rallying cry was: all-out attack on Addington and St Vincent! A thousand dissonances have now come together in one concerted war-cry! Each hopes to win a share of the booty for *himself*. But only one man knows where it will all end. For one man alone will win everything: and that man is Pitt!

It is this moment, when the general coalition and confederation has joined forces to mount the attack, that Gillray places before our eyes in an allegory of the ancient giants storming heaven. His inspiration for this mythological charade was taken directly from an expression in the Lord Chancellor's strongly worded speech in the House of Lords on 24 April, which is also included in the caption to the print.[13] Everyone in England knows that the Chancellor was the political matchmaker in this strange mis-alliance of disparate parties. He is intimate with the most secret workings of the Royal Cabinet, and had made all the arrangements for Pitt's reinstate-ment. Speaking of Pitt and Lord Melville, he had used a figurative expres-sion, saying that 'they (namely Pitt and Dundas) never complain'd of Fatigue, but like Giants refreshed, were ready to raise themselves again from the earth and enter immediately upon the attack!'[14] The Nestor of the

[13] [Lord Eldon's comparison of the ministers (not Pitt and Melville, as *LuP* says below) to 'giants refreshed' actually occurred in a speech of 20 April, after Lord Grenville had sought to adjourn debate on the militia on the grounds of the fatigue of those attacking the government's proposals; quoted ironically in Cobbett's *Weekly Political Register* (28 April), col. 632, and (5 May), heading. *Cobbett's Parliamentary Debates*, vol. II for 1804 (1812), col. 169. Gillray knowingly misappropriates Eldon's simile: here the giants are the Opposition, not the ministers. The relationship of his political satire both to the source quotation and to the original Greek myth is thus characteristically paradoxical.]

[14] 'Like Giants refreshed' – clearly this alludes to that legendary battle between Hercules and the Libyan giant, Antaeus, who, as often as he was thrown to the ground, was given new strength by his mother, the earth, and rose again with renewed vigour. It is a telling image, which Horace had already used to describe the inexhaustible strength of the Romans in the second Punic war.

 [However, Eldon may also have been echoing *The Book of Common Prayer*, Psalm 78:66–7: 'So the Lord awaked as one out of sleep: and like a giant refreshed with wine. He smote his enemies . . .']

House of Lords called them giants, and it is as giants storming heaven that we see them in this print. But their aim is not to destroy the gods above – no! not to kill them, merely to root them out of that blessed heavenly citadel,[15] as we read in the verse below the caption, taken from Milton's *Paradise Lost*: 'Not to destroy! but root them out of Heaven'.

Mirroring the famous battle of the gods in the *Iliad*,[16] our print shows heaven and earth engaged in a dreadful struggle. Earth would dearly love to change places with heaven. Enveloped in black thunder-clouds, pregnant with misfortune, the gods in Olympus wage a desperate war for their very survival. The group is conceived in a masterly fashion, and worthy of a far more serious subject than the one the mocking artist has chosen. Mars, Apollo and Neptune form the divine triad. Despite certain secret reservations, as is the case in all alliances, they stand united, bound together by common danger. At the centre of this trinity, Phoebus Apollo emerges from the golden gates of Olympus (the Treasury, we read in the inscription), the sun's rays forming his diadem. Using his favourite weapons, he fights off the hulking assailants to defend his throne in the clouds – that is, in Downing Street, where the Minister's official residence is to be found. To his right, Mars brandishes his golden weapons, a lance and a shield. To his left, Neptune is enthroned with his golden trident. Readers who have often strolled with us through our picture gallery will not need to be told that in this masquerade Addington, the Chancellor of the Exchequer, takes the character of Apollo, surrounded by the rays of the sun; that Mars, armed to the teeth, is really the Secretary of State for Foreign Affairs, Lord Hawkesbury; and that Neptune brandishing his trident is the First Lord of the Admiralty, Earl St Vincent. But let us look at the combatants and their means of defence and attack in the great conflict. Poor Phoebus-Addington, your weapons of defence are wholly unfit! Instead of the all-destroying

[15] Readers of Evariste D. de Forges de Parny's mischievous poem *La Guerre des Dieux* (Paris: 1799) will find more than one parallel here. But Gillray had in mind the famous battle in Milton's Paradise, between Satan's traitorous crew and the loyal heavenly hosts, from which he takes the line: 'Not to destroy, but root them out of heaven'.

[*Paradise Lost*, Book VI, line 855.]

[16] [Homer, *Iliad*, Book XXI.]

bow, you hold a clyster-pipe.[17] As you pump it violently, you fail to notice that your immortal arrows are falling quite unused from the upturned quiver on your back! Indeed, they may soon be used against you by the more skilful archers below! Given such poor weapons, is it any wonder that the Sun-god, who hears and sees everything,[18] has already had one of his eyes shot out? Poor, blinded, one-eyed sun-and-clyster-god! And surrounded by such helpers and comrades too! As for Mars-Hawkesbury there on his right, he's only pretending to be fighting back seriously! Just look how the only bullet on target bounces off the centre of his defensive shield! To the amazement and vexation of all learned students of mythology, the terrifying snake-haired Medusa head that is usually found on this shield, complete with tongue hanging out, has been transformed into a murmuring screech owl, Minerva's wise night-bird.[19] This owl has charmed and bewitched all the weaponry, so that it can neither stab nor shoot. Look at this cunning old screech owl, who appears to be more powerful even than Pallas Athene in the real battle of the giants. Perhaps it hides the secret influence of a higher power which the cunning caricaturist is alluding to in cryptic fashion?[20] Earl

[17] Here one has to admire both Gillray's malice and his erudition. Everyone knows that Phoebus Apollo was worshipped at his principal shrine at Delphi under three titles: bowman, cithara player and physician-prophet (conjuror or shaman). The Greek language brings together all these attributes of his in a monstrous compound epithet, 'TOXIATROMANTIS'. Addington followed his father into the medical profession, and throughout his administration was mockingly nicknamed 'the doctor'. This is why he has to put up with being represented as Apollo here. The cithara and the precarious quiver serve as a *sauvegarde* to the characteristic hair bag, in which the long hair of the unshorn (*intonsus*) God is tied by way of a change. They allude to his two attributes of citharist and bowman; attributes which in *this* Apollo at least have long since been pensioned off. But he works all the harder in his third capacity as a doctor or quack, with his clyster syringe; and of course he is shooting through this pipe. We have all heard of the famous duel between the doctor and the surgeon, where the pistols were filled with bullets and the clyster pipes with *asafoetida*.

[18] This apostrophe to Helios or the sun-god occurs in *Iliad*, III, 277, whence Virgil took his famous 'Sol qui terrarum flammis opera omnia lustras!'

[19] [In fact George thinks that Hawkesbury is represented as Minerva, not Mars.]

[20] This is actually the case. Those who are familiar with the secret workings of the English cabinet will know of the all-powerful influence of the old Earl of Liverpool, father of the *ci-devant* Mr Jenkinson, now Lord Hawkesbury. In attacking Addington's group, Pitt and his friends knew only too well that the father's influence rendered the son invulnerable. The protective screech owl is therefore the Earl of Liverpool.

St Vincent, playing Neptune on Addington's left, is the most ridiculous figure of all. In order to point up the incongruity, one need only recall the famous and greatly admired description of the Water King in Virgil's *Aeneid*, and in Rubens's masterpiece. He arrives majestically in his royal chariot, taming hurricanes and tidal waves with a single, omnipotent word.[21] This poor, gouty pseudo-Neptune will probably leave the almighty *quos ego* for ever unspoken, and the crabs in the brackish waters of the overturned chamber pot, symbolising the unbounded waters of the ocean, will be impaled like flies on the forest of lances below. One might ask why the caricaturist chose these vermin in particular to throw into the pot of the god in the sea-green mantle. A joker such as Gillray never draws a single line without good reason, so another malicious idea may easily be hiding there. Actually, no further artistic interpretation is required. Repulsive vermin have indeed crawled out of his pot. These are *his* creatures. Need we say more? Those who would like a more detailed explanation should refer to the pamphlets which were published shortly after Pitt's attack on the administration of the Navy by Lord St Vincent (in the House of Commons on 16 March).[22]

The giants have piled up jagged blocks of granite to form a pyramid, a

[21] This famous painting is a jewel of the Dresden picture gallery, and has been engraved more than once. Connoisseurs know it as the *Quos Ego*, from the famous passage in Virgil's *Aeneid*, Book 1, 135.

[Rubens's *Quos Ego! Neptune Calming the Waves* in the Gemäldegalerie, Dresden, was painted as part of a decorative scheme for the triumphal entry of the Cardinal Infante Ferdinand into Antwerp in 1635, commemorated in the engravings of the *Pompa Introitus Ferdinandi* (1642).]

[22] St Vincent ruined his chances with the English 'monied interest' through the unyielding severity with which he exposed large-scale embezzlement in the Navy, and the iron rod he wielded in dealing with any misappropriations that came to light. It was a simple matter for Pitt, to whom St Vincent had always been opposed, to denounce his whole administration in the famous philippic of 16 March. A friend of Lord St Vincent published a pamphlet: *An Answer to Mr Pitt's Attack upon Earl St. Vincent, and the Admiralty, in his Motion for an Enquiry into the State of the Naval Defence of the Country, on the 15th of March, 1804* (London: 1804). A riposte soon appeared: *Audi Alteram Partem, or the Real Situation of the Navy of Great Britain at the Period of Lord St. Vincent's Resignation, Being a Reply to the Misstatements of 'An Answer' . . . etc. By an Officer of His Majesty's Navy* (London: Budd, 1804). Here there was certainly no lack of powerful accusation, but it is coloured too deeply by party prejudice.

ladder for the stormers of heaven. They can be most conveniently divided into three troops or battle formations. Closest to heaven, and therefore with the greatest chance of success, Pitt and Dundas stand supreme, inseparable brothers-in-arms as ever. Instead of the huge stones with which ancient legend arms the giants, Pitt is launching three bundles of papers at the terrified pseudo-Olympians.[23] Dundas, meanwhile, protects his Achates[24] with an immense shield, brandishing a flaming battle sword, with the true steel mark engraved on its blade. Should Pitt ever exhaust his supply of paper ammunition and end up in dire straits, his brother combatants would be able to commandeer plenty of fresh supplies. They are Canning[25] with his Indian apron, and the two under-secretaries: Rose on Canning's right and Long on his left – as is clear from the pun. A diminutive monster, or ugly little dwarf, has found a fire hose of his own, which he will use if the thunderbolts from above should burst into flames. The book under his arm tells us that this is pious Wilberforce. Every animal makes use of the weapons which Nature has bestowed. This skunk, Gillray is saying, cannot deny its instinct, even here.[26]

[23] The bundles of papers contain the attacks and accusations against Addington. There is a significant ascending scale or rhetorical gradation in these attacks. The first bale which Pitt is in the process of flinging bears the inscription 'Knock-down Arguments'. Then comes the second at his feet: 'Coup de Grace'. The third marks the end: 'Death and Eternal Sleep'. The whole thing may therefore be taken as a figurative version of an expression used by the comic poet Plautus, *lapides loqueris*. Pitt's eloquent attacks wound like mighty stone missiles.

[24] Achates was the faithful friend of Aeneas. Virgil, *Aeneid*, Book 1, 312.

[25] George Canning is usually cast as the Patroclus of Pitt-Achilles, or as his only-begotten, cherished political son. Both inside and outside Parliament, Canning has always been Pitt's champion, mouthpiece, henchman and publicist. When Pitt still gave the appearance of being on Addington's side, Canning had long since removed the mask. Here, too, he offers his faithful services. He is supplying 'Killing Detections'. The two half-figures in the shadows behind Canning are George Rose, Master of the Rolls in Pitt's first administration, and Charles Long. Both 'Right Honourable Gentlemen' proffer 'charges': Long's are 'Long Charges', like his name.

[Canning had represented Pitt's interests in negotiations with Gillray in the 1790s, and arranged the artist's secret pension. Josceline Bagot (ed.), *George Canning and His Friends*, 2 vols. (London: John Murray, 1909), vol. 1, pp. 58f. Hill (1965), pp. 56f. Donald (1996), pp. 31, 165–6, 175f.]

[26] The conepatl or skunk (*viverra putorius*) in Virginia and in Canada etc. is noted for spraying a liquid with an intolerable odour when provoked. Poor Wilberforce has found a declared enemy

Let us now turn to the second main group on our left. The attacking formation is three men high – the vanguard stands just as the citizens of a small imperial city once did, according to a well-known legend.[27] The bristle-headed fat monster, with the enormous blunderbuss spitting fire and death, is Fox. He has found a platform on the stomachs and arms of the two supporting giants. The Marquis of Buckingham with the blue ribbon, and his brother, Lord Grenville, are trying their hardest to lift Fox. One cannot fail to notice at first glance that this group is one of the most disgusting and abhorrent in the caricature. This was altogether Gillray's intention. He must view the unnatural coalition between the noble Buckinghams and the hated Fox with real loathing.[28] Look, he is saying, the desire for political power drives men to such lengths that these proud Lords are now acting as henchmen to this fox. It is well known that Grenville's party refused to join the ministry without Fox; and so, after long and fruitless negotiations, Pitt, who would gladly have joined with the Grenvilles, was forced to try and form a ministry from the ruins of the previous one. Far below this trio, which is in desperate need of a fig-leaf to cover its nakedness, we see a wild and noisy rabble. The Duke of Norfolk beats a kettle-drum. Since time began, anger has forged all kinds of objects into arms and weapons! In his battle against the living Satan, Luther the reformer turned his ink-well into a hand grenade.[29] So incensed was the *kapellmeister* when he heard the first

in Gillray. This is why, despite the fact that he is Pitt's faithful supporter, he is treated so harshly here. The English Prayer Book bears the title 'The Whole Duty of Man'. Since Wilberforce is well known as a pious Swedenborgian and evangelical Christian, Gillray allows him to cover the fountain with this book, and we just see the water spouting from behind it. At the same time it means: look how he gives himself away!

[Gillray perhaps refers ironically to Gulliver's expedient, when he extinguished the palace fire in Lilliput by urinating on it. Jonathan Swift, *Gulliver's Travels* (1726), ch. 5.]

[27] The commandant had ordered that the Civic Guard should be marshalled at the city gates 'three men deep'. The men did their best to climb on top of each other in threes. Finally they sent to the commandant: could he let them stand just two men deep? That would be hard enough: but three men deep was absolutely impossible! See Michael Denis, *Lesefrüchte*, 2 vols. (Vienna: F. Rötzel, 1797), vol. I, p. 55.

[28] [Yet there is some slight documentary evidence that the Grenvilles may have been pleased with the print. Cf. *Diaries and Correspondence of James Harris, First Earl of Malmesbury*, 4 vols. (London: Bentley, 1844), vol. IV, p. 299.]

[29] We all know the legend of the ink blot in Doctor Luther's room in the Wartburg. An ingenious

violin adorning the composer's simple adagio with flourishes of his own, that he used his periwig to silence him.[30] Likewise, for our Duke of Norfolk, as for Virgil's great assembly, it is true to say that *furor arma ministrat*. Instead of using sticks, he beats the battle drum with two full bottles of claret, which are the famous 'inseparables' of this Duke; his extreme antipathy towards empty bottles will be familiar to our readers from earlier caricatures. An instrument of this kind is a very suitable accompaniment to the butcher's harmonica being played behind the bottle-drumming Norfolk by the Earl of Carlisle. For the mocking artist has turned the patriotic Earl into a gigantic butcher's boy, advertising his skills by beating a marrow-bone and cleaver, thus completing the concert.[31] One need hardly point out that the standard-bearer behind Carlisle is the infamous Baronet Francis Burdett, who has earned a reputation as a turbulent demagogue. His attack on the Coldbath Fields prison and the investigation into the behaviour of Aris, the jailer, made Burdett thoroughly unpopular with the ruling aristocratic party in England, as did the huge sums he wasted two years running on his election campaign in Middlesex (ultimately a failure), and the unruly behaviour of the London mob on that occasion. In allusion to the Coldbath Fields episode, the ribbon on his hat bears the inscription 'No Bastile'. For in his

Footnote 29 (*cont.*)

allegorist might say that Luther's ink-well was his most formidable weapon against the devil and all his works. Ink like this will soon have to be prescribed in a great neighbouring country on the other side of the Rhine.

[Martin Luther, who reported often hearing or seeing manifestations of Satan, is said once to have hurled his ink-well at what he thought was the devil. An allegorist might say that he used ink, in the form of his writings, to ward off the devil in this way.]

[30] During the performance of one of his oratorios, Handel grew so angry with the first violinist (who, in the adagio, only wanted to listen to his own playing), that he tore the tie-wig from his head and threw it at the violinist's most sensitive spot – his bow. See *The Wits of Westminster*, p. 70.

[31] The London butchers' concert with marrowbones and cleavers is featured twice in Hogarth's *Industry and Idleness* (1747). Lichtenberg has explained this tradition with great wit in his *Ausführliche Erklärung der Hogarthischen Kupferstiche*. This was his swan song: a few days after he wrote this commentary, death overturned his ink-well.

[G. C. Lichtenberg, *Gesammelte Werke*, edited by Wilhelm Grenzmann, 2 vols. (Frankfurt am Main: Holle, 1949), vol. II, pp. 1173–5. Ronald Paulson, *Hogarth's Graphic Works*, 2 vols. (New Haven and London: Yale University Press, 1970), vol. I, pp. 197–8.]

parliamentary speeches he often refers to the royal prison, where the Minister has sent many a troublemaker, including Despard and company,[32] as the Bastille. This is what the flag topped by the Jacobin cap refers to. How many flags of this kind were flourished by the drunken, riotous crowd marching to Brentford, where the last election of the member for Middlesex was celebrated![33] The remaining cohorts of trumpeters, halberdiers and archers are suggested here by their weapons and missiles, *sine nomine vulgus*.

More significant still, however, are the *velites*, volunteers and flanking bowmen who form the advance guard in the middle of the print. Immediately behind the large group with Fox at its centre, skinny Lord Stanhope fires an arrow, aimed with mathematical precision.[34] At Stanhope's side we see the former director of the Italian Opera, Michael Angelo Taylor, and next to him the hero in the sky-blue breeches, Grey. The fat-cheeked, misshapen little pygmy is the Earl of Derby. These men comprise the entire company of archers. But instead of the Balearic sling-throwers, who were always found in ancient Roman battle-formations, this is a ragged, fantastic little crowd in Lilliputian duodecimo format. The giants' little brothers (*fraterculi gigantum*) are firing clay pellets from blow pipes. Let us hope that the heavenly powers above have prepared a good supply of Theban woundwort. Think of the contusions and amputations we shall soon witness here!

No one could fail to recognise ex-War Minister Windham in the almost

[32] [E. P. Thompson, *The Making of the English Working Class* (Harmondsworth: Penguin, 1968), pp. 521–8.]

[33] Recent incidents in the outlying districts of London and in the capital itself, occasioned by Burdett's renewed parliamentary campaign, were quite satisfactorily reported in the English newspapers. The younger Mainwaring's defeat of Burdett by five votes was generally regarded in higher circles as a triumph over the English Jacobins. For more exact information about all the accusations against Burdett, we recommend a pamphlet published in March of this year: Edward Hankin, *A Letter to Sir Francis Burdett on the Folly, Indecency and Dangerous Tendency of his Public Conduct. Printed for the Author, sold by Rivington* (London: 1804).

[34] Despite his eccentric ideas and contradictions, Earl Stanhope is still one of the best mechanics and mathematicians in England. At the same time he is a true 'patriot' in the Whig Club's sense of the word. In the recent debate on the Corn Bill in the House of Lords he put forward the most considered criticism of the minister's plan.

skeletal fighter. In one hand he holds a terrible lance, which appears to be launching an entire heavenly artillery of flashes and thunderbolts.[35] In the other he has a huge shield, with the most repulsive gaping Medusa's head. Windham's sharp tongue often launches accurate and stinging blows in St Stephen's Chapel, or the House of Commons. He has inherited something of Burke's spirit and eloquence, and his remarks on the feebleness and half-measures of Addington's administration have always hit the nail squarely on the head. Behind him, with a somewhat smaller shield, complete with yet more Gorgon terrors, storms the legal scholar Dr Laurence (shown by his black official robes), and above him, on the edge of the print, the former First Lord of the Admiralty, Earl Spencer. A black bulldog with an angry bark stands out amongst the auxiliary troops on this wing. He is p***ing on a paper on which the words 'the doctor' (Addington) can be clearly read. Underneath is a journal, 'the *Weekly* (*Register*)'. Having deciphered these symbols, we scarcely need the collar to reveal his name. We could have guessed that this barking Cerberus is none other than the rabid, vociferous weekly journalist Cobbett. He is also commonly called the hedgehog or porcupine by his colleagues. He frequently indulged in the most snarling invective against Addington's administration in his *Weekly Register*, a hellfire journal which overflows with gall and corrosive, poisonous spite. The caricaturist has devised an apt metaphor for him: for the beast acts according to its canine instinct and, as dogs always do, sprays its filth wherever other dogs have previously p***ed and left their calling cards.

Every tragedy on the London stage is followed by an 'entertainment' — a light-hearted farce or something of that kind. Gillray has observed this custom in his equally serious satire, by including a most peculiar Jacob's ladder at the back, that stretches between heaven and earth. Tierney as Mercury has secretly thrown a rope-ladder down to his former loyal colleagues and cronies, behind the backs of the trinity enthroned in the heavens. These long-tailed monkeys or guenons are now attempting a stealthy and swift ascent to heaven through the window, which has been so invitingly left open for them. Sheridan marches at the front, then comes

[35] 'With Heaven's Artillery fraught'. Milton, *Paradise Lost*, Book II, line 715.

Erskine, and then Jones with his little bag of camphor.[36] One has to admit that the transformation of the scaling-ladder, which we might have expected to see here, into a mischievous rope-ladder, is one of our artist's wittiest inventions. Mercury, traditionally the patron saint of scoundrels and jokers, was shown in an ancient caricature with a thieves' ladder. The situation is thus portrayed here in classical guise. Everyone knows that Tierney was one of the most effective wranglers of the old Foxite Opposition. Under Addington he sighted the golden ministerial heaven, and was made Paymaster of the Navy. This is why he has not forgotten his purse here. Rumour has it that he also acted as a go-between, trying to win over for the ministry various prominent members of the old Opposition. Among these was the greatly feared barrister and orator, Erskine; and Sheridan, who has run with the hare and hunted with the hounds for a long time now. In this respect, too, the mask of Mercury suits Tierney very well: for this god always busied himself as chief negotiator in all declarations of eternal peace, secret pacts, political marriages, coalitions and alliances of every kind, right back to the grey mists of antiquity. And now look at this clambering group, the 'climbing boys' themselves! A tribe of cunning monkeys trying to *ape* the giants' storming of heaven – through the back window! The idea is quite priceless and worthy of Hogarth.

But the whole composition of the picture proclaims the talent of an artist who would have been capable of something far better than simply wasting his intelligence on caricatures in the service of a political faction. The crowning feature of the whole composition, for example, at the very summit of the pictorial pyramid, is splendid. It shows the impartial presiding eagle with a

[36] We recall here a drawing on an old Greek vase, which is well known from Giovanni Winckelmann's *Monumenti antichi inediti spiegati ed illustrati*, 2 vols. (Rome: for the author, 1767–79), vol. I, pl. 190, and which was also engraved for the title page of Falk's *Satirisches Taschenbuch* for 1803. Here Mercury has loaded Jupiter with the thieves' ladder, to enable him to climb up to Alcmene.

[Probably Johann Daniel Falk's *Taschenbuch für Freunde des Scherzes und der Satyre für 1803*, vol. VII. Alcmene refused to consummate her marriage with Amphitrion until he had avenged the deaths of her brothers, who had been murdered by the Taphians. While Amphitrion was away fighting the Taphians, Jupiter visited her in her husband's likeness to trick her into believing that he had been victorious. The work illustrated by Winckelmann was a semi-pornographic burlesque of the story.]

flaming, radiant thunderbolt in its talons. This is how Zeus is enthroned on Mount Ida. Those we see below are merely his feathered arm-bearers and guards. Zeus awards victory now to the Greeks, now to the Trojans, never exclusively favouring either party. Our gods, who are trying to keep their seats in the clouds with debatable success, will find it hard to seize the thunderbolt from those claws to use in their own defence. French military history tells of the bloody two-day battle of Marignano, where the twenty-one-year-old Franz fell asleep on his cannon in the open air, and 10,000 brave Swiss died on the battlefield.[37] Marshal Trivulzio called this the battle of giants, 'bataille des Géans'. Of course, far fewer men have been killed or wounded in the field in Gillray's battle of the giants. But its outcome will prolong the most passionate and relentless of all wars between nations, a war fought with the bitterest national hatred, that will surely condemn myriads of men to the ocean's wet embraces or dash them to pieces in the cannon's jaws. For victorious Pitt, who yearned for and stormed the palace of heaven, will never sign a second Peace of Amiens!

[37] [Marshal G. G. Trivulzio's army, fighting in the service of Francis I, defeated the Duke of Milan's Swiss mercenaries on 13–14 September 1515.]

17 *L'Assemblée Nationale; – or – Grand Cooperative Meeting at St. Ann's Hill*[1]

13 (1804), 153–80, pl. III

The drift of events means that this caricature is politically somewhat out-of-date, even 'antediluvian', to borrow an expression from the London bucks of New Bond Street. For it was prompted directly by the unnatural coalition formed between the Grenville–Windham party and the so-called Foxites under the patronage of the Prince of Wales, following Addington's resignation from the Ministry early last spring. And we all know how futile those efforts were. For the sick King was later to be restored to health, at least to the extent that he appeared to take over the affairs of government once more.[2] Pitt and Lord Melville resumed their customary positions at the helm of the nation. Fox was given all the leisure he could need to contemplate his (never-written) history of the House of Stuart.[3] The Buckingham family was given ample opportunity to compare its edition of Homer with those of Heyne and Wolf. And, having consumed six ministerial *dîners*, and delivered to his guests all the political addresses penned by Erskine, the Prince of Wales was given all the time in the world to follow his Mrs Fitzherbert to Brighthelmstone.

But even if the main purpose of this political coalition was totally thwarted, Gillray's whimsical imagination, as expressed in the print before us, hits the mark as wittily as ever. Once again, we are reminded of the saying 'materiam superabat opus'.[4] For it is not the subject matter, but the manner in which it is treated which deserves our attention. The print is moreover 'Dedicated to the admirers of a Broad-Bottom'd-Administration'.

[1] [Etching published 18 June 1804. 'Js. Gillray invt. & fect.' *BM* 10253. Broadley, *Napoleon in Caricature*, vol. I, pp. 218–19. George (1959), pp. 75–6. Hill (1965), pp. 119–23. Hill (1976), colour pl. V, p. 127. Donald (1996), p. 37.]

[2] [A recurrence of the King's insanity in the spring of 1804 led to renewed expectations of a Regency.]

[3] [Cf. *Political-Dreamings*, p. 124 above, n. 24.]

[4] ['The work surpassed its subject matter' (Ovid).]

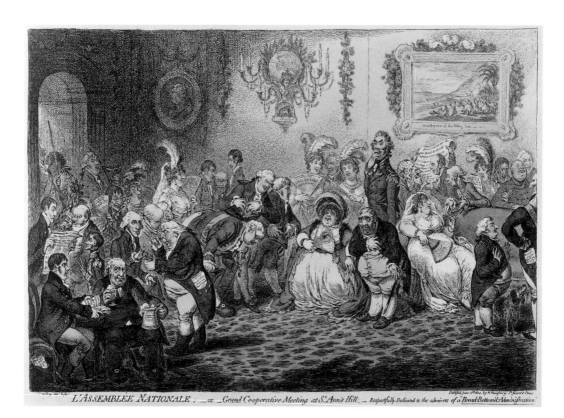

PLATE 29
James Gillray, *L'Assemblée Nationale; – or – Grand Cooperative Meeting at
St. Ann's Hill*, 1804.
Etching, hand coloured.

And we should always keep these gentlemen in mind. Such wicked sinners
could easily give good King George cause for concern. For everyone will
surely agree that the ladies and gentlemen we see gathered here on the occa-
sion of a splendid gala might join forces – perhaps even this winter – with
similar aims in mind, and this time with greater success.

In this print Gillray shows us a gala or fashionable *assemblée* which is
taking place in the drawing room at St Anne's Hill, Mr Fox's country resi-
dence. The tutelary gods of this shrine are the plump, squat little couple at
the centre, doing the *honneurs* to their guests with such studied grace in
facial expression and gesture. They are Mr Fox and his housekeeper, whom

he married at long last on the continent. We had the pleasure of reporting further information about her in this gallery of manners on the occasion of her presentation to Bonaparte.[5] The political tea party can be divided into two halves. Whenever human society forms an object of study for those prophets who enjoy the benefit of hindsight – historians in other words – it is always thus divided: there are those who have already arrived and those who are arriving. Let us first turn our attention to those who have arrived, and who are already deep in conversation.

For the enjoyment of the reader and observer, the old Opposition's corner has been augmented with a number of fresh characters. At the front, we see the Dukes of Bedford and Norfolk, chatting at a round table. Readers will know that the present Duke of Bedford, a true chip off the old block of the House of Russell, is treading in the political and agricultural footsteps of his brother Francis, who died suddenly two years ago. So even at this early stage in his career, he is forced to endure Gillray's malicious sneers.[6] The caricaturist shows him reading a book containing all sorts of schemes, which are in fact political creeds under the guise of suggestions for agricultural improvements. 'Scheme', we read, 'for Improving of the Old English Breed' (of sheep). On the first line of the opposite page we can just about make out the words 'French Rams'. Under the farming Duke's chair is a hat containing a whole package of agricultural projects. The top one bears the inscription: 'Plan for Sheering the British Bull'! This year, of course, the Duke of Bedford once again held the great sheep-shearing at his estate at Woburn Abbey. Over four days the richest and shrewdest sheep- and bull-breeders took advice on the finest sheep and horned cattle in Great Britain, casting an expert eye over various parts of Bedford's great estate and his agricultural experiments. The English newspapers always devote several columns to the programme of this wonderful farmers' gathering. One day is given over solely to sheep-shearing, and the freshly shorn fleeces are weighed, judged and inspected in a building specially equipped for the purpose. Another session is dedicated to a discussion of the latest attempts

[5] [Gillray's *Introduction of Citizen Volpone and his Suite, at Paris* was in *LuP* 10 (1802), 244–73. *BM* 9892.]

[6] [The former Duke, a prominent Foxite, had been frequently satirised by loyalist writers and Gillray. Cf. *Search-Night*, pp. 51–2 and n. 6 above.]

to cross South with North Downs sheep. On another day still, special plough races are held, with inspections of the finest draught animals and fattened cattle.[7] Now everyone will be able to grasp Gillray's joke. The democratic Duke, who is of the French way of thinking, wants to improve the Old English breed by introducing French breeding sheep. This would be an impossible task, even for Lasteyrie.[8] For even the standard French herds at Rambouillet, Croissi etc. can only be improved by using Spanish stock. How on earth could they be used to improve English herds, which were pure-bred at a much earlier stage anyway? It is not hard to grasp that the 'French ram' refers to French principles and opinions. And just imagine the British bull being shorn! What fine wool we would get; an excellent counterpart to the greatly admired *lana caprina*! But what if Bedford's friends were to become ministers, and well and truly fleece John Bull! Wouldn't this be as good as the best sheep-shearing at Woburn or Holkham?

Next to Bedford the Duke of Norfolk is enjoying his splendid 'Whitbread's Entire'. We have encountered his noble passion for 'the joys of the bottle' in a number of earlier caricatures. Whether justified or not, Gillray always portrays him with wine as his symbol. The fact that he is merely drinking 'English Burgundy', or foaming porter, in this print may simply be to enable Gillray to introduce a 'quibble' or pun: not only is Whitbread the largest brewer in London, but he is also a staunch supporter of the Opposition. The best porter is called 'Whitbread Entire', as we read here on the frothing silver tankard. But taken in another sense, this can also mean something like 'Whitbread as he lives and breathes', i.e. a passionate democrat and opponent of the Minister. And then of course we are not just talking about the beer, but about the beer-drinker himself. Incidentally, the port has

[7] The best excerpts from the English newspapers on the subject of this sheep-shearing can be found in the 'Englische Miscellen' in the *Allgemeine Zeitung* of 4 August. The latest issue of *The Farmer's Magazine*, which is superbly edited and published in Edinburgh, also contains interesting remarks on the subject.

[8] Lasteyrie's excellent work on the attempts to improve sheep-breeding in various European countries, through which the esteemed author had himself travelled, has been translated into almost every European language.

[Charles Philibert de Lasteyrie du Saillant, *Histoire de l'Introduction des Moutons à Laine Fine d'Espagne dans les Divers Etats de l'Europe, et au Cap de Bonne-Espérance*, 2 parts (Paris: 1802).]

not been forgotten either. Just as everything else in the print is either flowing in or out, the port bottle too has been overturned, and has come to rest on an empty one.[9] The entire smiling physiognomy of the ducal reveller verges on bacchanalian raptures, the bliss which the Englishman describes so accurately when he says someone is 'half seas over'.

Directly above the ducal farmer is a trio whose relationship to each other could be very cleverly described by the three verbal forms: *activum, passivum* and *reciprocum*. The active, the tall gaunt figure who is reading to the other two from the *Morning Chronicle*, is a living demonstration of this grammatical terminology, as successfully Germanized by Campe.[10] Campe suggests that the *verbum activum* should be translated by 'tätiges Aussagewort' ('active verb'). We need only a brief glance at this smug reader to convince ourselves that he is the very personification and embodiment of an 'active verb'. This reader is none other than the infamous Opposition malcontent who writes in the *Morning Chronicle*, Robert Adair, usually called Bob Adair. He is doubtless reading out his latest paean of praise and homage to the leader of the coalition. The other side of the newspaper facing us is also the true *revers* of the praises being sung here. 'Verses upon the Death of ye Doctor', it says, referring to the resignation of the state quack Addington. We can almost hear the creature which, in Pfeffel's witty fable, once crept into Lady Fama's trumpet and refused to come out again.[11] The article Mr Adair is reading out must be extremely pungent; for

[9] It is not going too far to suggest that, in Gillray's hunt for witty ideas, game lurks behind every bush. The port bottle emptying its contents in our direction beneath a chair whose occupant quaffs so valiantly might remind us of the famous little *Bacchus* by Guido Reni in the Dresden gallery. While the boy pours a full bottle into his upper orifice, excess liquid drains off from his lower orifice. Surely making water is also hinted at here, albeit in a veiled way.

[Reni's painting of the infant Bacchus or a putto (1620s or 1630s) in the Gemäldegalerie, Dresden, shows him drinking and urinating, while wine spurts from a cask. D. Stephen Pepper, *Guido Reni, a Complete Catalogue of His Works, with an Introductory Text* (Oxford: Phaidon, 1984), p. 279, pl. 195.]

[10] See *Versuch einer genauern Bestimmung und Verteutschung der für unsere Sprachlehre gehörigen Kunstwörter* (Brunswick, Schulbuchhandlung, 1804), pp. 84f.

[11] One day Fama's speaking trumpet was lying near her in the grass, when a snake crawled inside. It hissed and was soon gossiped about. 'Shall I kill it?' said Fama, 'No! It will be useful!' See Gottlieb Konrad Pfeffel's poem in his journal *Taschenbuch für Damen auf das Jahr 1805*, 12.

delight animates every fingertip of the small military gentleman standing opposite him. It is General Walpole, here the true image of a *passivum* or 'passive verb' In the middle is the *verbum reciprocum* or 'reflexive verb'. This is Jones, the hero of the Opposition, sniffing his little camphor bottle, which enables him to neutralise the incense rising from the *Morning Chronicle* in the most bearable manner possible.[12]

As we pass by, let us also make the acquaintance of a beautiful lady whose head is lolling right behind Mr Jones's bald pate. It is not altogether clear whether she is just arriving, or whether she is one of those who have already arrived. She is the famous Scottish Duchess of Gordon, the Duke of Bedford's mother-in-law, who has only recently become an enthusiastic supporter of the Opposition.[13] She used to be very popular at court, and enjoyed the favour of the Queen. But since she made the fatal 'trip to Paris' with her beautiful daughter Georgina, the Queen has been very cool towards her. However, she has compensated for this coolness by closer association with the Opposition. Her voyage across the Channel is also alluded to in the inscription on her fan: 'Over the Water with Charley'. This 'Charley' is none other than the tall and handsome Lord Cholmondeley (pronounced Chumley), at whom the Duchess is gazing longingly.[14] Those familiar with London gossip will spot more poisoned shafts

[12] There is also a personal allusion to Jones in this bottle of camphor. Travellers recently returned from England assure us that camphor bottles have recently come to be used by London fops as elegant containers for smelling-salts.

[13] It is said that the Duchess of Gordon has the usual maternal instinct in being an eminent matchmaker for her daughters. She had already cast her net to catch the late Duke of Bedford. When Death foiled her, she set about capturing his successor in title and property, the present Duke of Bedford, who was at first terribly shy, and fled to the country.

[14] *The Oracle of Fashion*, or London scandal sheet, speaks of a tryst between Lord Cholmondeley and the Duchess of Gordon on a pleasure jaunt to Paris. Incidentally, the words on the lady's fan, 'Over the Water with Charley', are the opening of a ballad which was sung all over Scotland in 1745 and 1746, when the Pretender Charles Edward set out from Edinburgh to attempt his famous invasion of England. If we remember rightly, Andrew Henderson refers to it in his *Edinburgh History of the Late Rebellion* (London: for the author, 1752).

[While *LuP* identifies 'Charley' as Lord Cholmondeley, whose names were actually George James, the name would more likely have suggested an association with Charles James Fox's politics, and his much-criticised visit to Napoleon in Paris in 1802. The reference to a Jacobite song confirms this insinuation of disloyalty to the King.]

of wit hidden in this part of the print. Even my Lady's headdress is not without significance. She is wearing a spray of thistles. Only the wife of a Scottish peer who is also a Knight of the Scottish Order of the Thistle may do this. Our readers will remember handsome Lord Cholmondeley from the Pic Nic orgies of last year's gallery, where he was dressed as a gigantic Cupid.[15]

Above the Duke of Norfolk's head we see that vigilant observer and apologist of the war, Windham, the former War Minister. He is taking a pinch of snuff from the tin offered him by Sheridan. The famous ancient symbol of alliance and coalition which we have seen so often on coins and stone carvings, two clasped hands, may henceforth be rendered by the moderns as two hands taking snuff from a box! But neither man really has his heart in this coalition gesture. Both faces are set in a grim smile at the sight of the farce of unity and equality being enacted here. Peeping superfluously from Sheridan's pocket is an announcement of a 'bran new' pantomime 'in the press', called *The Coalition*; the roguish look on his face provides the best commentary on it. The director of Drury Lane, who is always on the lookout for theatrical novelties, knows only too well what profits a pantomime of this kind could bring in! He won't let such grateful material escape him. Poor Carlo, who filled the house last winter, has now expired.[16] Under the disguise of Sheridan's pocket announcement Gillray is actually saying: watch this performance of a brand new pantomime of political lies and deceit!

Let us now turn our attention to the opposite side of the room, and see what is happening there, round about the huge red sofa. The artist has deliberately concentrated the strongest light on this part of the print. For it is only right and proper that the illustrious actors performing on this side should be illuminated most brightly by the radiance of their own splendour. The sun at the centre of these revolving planets and satellites is itself in

[15] [In *Dilettanti-Theatricals*; see p. 151 above.]

[16] In a great spectacle of procession and noise, called *The Caravans*, a Newfoundland dog comes on stage and pulls a drowning child from the water, right in front of the audience. The dog was called Carlo, but was lamed last summer. He is so famous that he has even been honoured with his own biography: *The Life of Carlo* (London: Tabart, 1806) is now a novelty of the English book trade.

semi-darkness; but despite this partial eclipse, he can be clearly recognised, even from behind. For the man who has been cut almost in two at the far edge of the print, with his back turned towards us and arms akimbo, is none other than the heir to the English throne, the Prince of Wales himself! He is perfectly characterised by his stance and position, but even more so by the quotation from Shakespeare's *Henry IV* peeping from his pocket. Indeed, the caricaturist should be commended for solving so cleverly the rather delicate problem of placing the heir to the throne himself on the stage. Of course, the bitterest caricatures have often been directed at him before, but it is said that he has shown rather less forbearance and goodwill in these matters than his father did.[17] Gillray must be aware of this. Naturally, every Briton knows his Shakespeare by heart. And so he will immediately construe the single phrase in the prince's pocket ('I know you all, and will a while uphold / The unyok'd humour of your idleness'), not only as the most glorious apologia for the Prince, but also as the most cutting criticism

[17] The present writer has two caricatures in front of him: both aimed at the Prince of Wales alone, and both by Gillray. In one the Prince is shown between Fitzherbert and his wife, both of whom are tugging at him. The royal parents intervene, but certainly not to give their blessing. In the other we see the Prince all alone, and, as here, *a posteriori*. But the greatest malice is hidden in this very pose; and for that reason he finds the portrayal extremely distasteful. King George III regularly sends over, via the quarterly courier, new works of art and literature for the library of his beloved Georgia Augusta University (Göttingen). Several years ago he started including a whole collection of the most recent London caricatures, on the subject of the King himself! We should hardly expect the Prince of Wales to do the same. Not everyone is like good King George, or can so confidently apply to himself the great 'nil conscire sibi, nulla pallescere culpa'.

['To have nothing on our conscience, no guilt to make us turn pale'. Horace, *Epistles*, I. i. 60. Hill (1965), pp. 120–1, notes that *LuP*'s description of the first print of the Prince is the only evidence of it that survives: it was apparently suppressed with near total success. The second is assumed to be the untitled print published on 10 March 1802, portraying the Prince as an overweight middle-aged dandy (Plate 30). *BM* 9846. Hill (1965), p. 119. George (1959) and Hill both cite evidence of an attempt to suppress *L'Assemblée Nationale* itself, but evidently after the date when *LuP*'s London correspondent bought the print; or did Gillray himself slip copies of suppressed prints to him? George III's greater tolerance of caricature is also vouched for by Henry Angelo in *Reminiscences*, 2 vols. (London: Kegan Paul, 1904), vol. I, pp. 282–3, 297. There is no record or trace at the University of Göttingen of the prints that the King, on *LuP*'s evidence, sent there. We are grateful to Karsten Otte of the Niedersächsische Staats- und Universitätsbibliothek Göttingen, for the search he undertook. Cf. Timothy Clayton, *The English Print, 1688–1802* (New Haven and London: Yale University Press, 1997), pp. 261–2, 308 n. 5.]

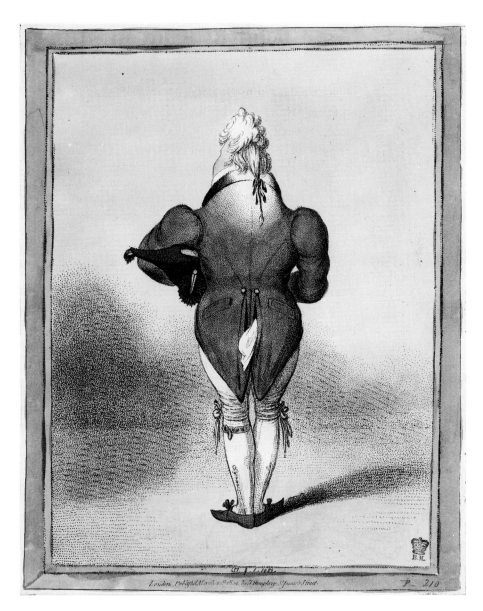

PLATE 30
James Gillray, untitled caricature of the Prince of Wales, 1802.
Etching, hand coloured.

of this entire right honourable national assembly.[18] Perform to your hearts'
content, says the Prince, and think of me as one of your fellow thespians if
you like. But you are all unmasked; I know your knavish tricks inside out,
and a better self, the sun in me, will soon break through these foul vapours.

Indeed, foul vapours and offensive smells surround the good Prince on
every side. One of these is the charming little plump figure with ten
exclamation or amazement marks at the end of his arms, his face filled with
delight at the honeyed words which fall from the lips of the Prince. The
gentleman is mirrored by the dog at his side, and this witty juxtaposition also
reminds us of a coarse Roman peasant's phrase, in which the idea of flattery
was expressed by a word that normally denoted only a fawning dog.[19] This
short fat man is Tyrwhitt, the Prince's secretary, known in higher circles by
the nickname Tommy Tattle. which is inscribed on the dog's collar.[20]
Opposite the Prince on the sofa sits the well-known Mrs Fitzherbert, the
Prince's *chère amie* of old, who commands and indeed deserves the greatest
respect in this society, by virtue of her constancy.[21] Over the back of the sofa
the Earl of Carlisle is handing her a ticket to the Coalition Masquerade,
which may even take place tonight – perhaps in a moment's time in this very
room! The homely figure buttoned up to his neck, his little eyes glittering
approval between his fat cheeks and brow (where Gall's cranioscopy would
be hard put to discover a single organ[22]) is the Duke of Clarence; he is the

[18] We may confidently assume that our cultivated readers who know their Shakespeare can place
this passage. It is from *Henry IV Part I*, Act I, at the end of scene 2. Falstaff and Poins have
persuaded the Prince to act as a highwayman, and to lie in wait for a caravan of pilgrims and
rich traders on the London high road. The Prince has agreed, but as soon as his companions
have left he begins his famous monologue.

[19] The word 'adulari' was, like thousands of others, transferred from Roman demotic speech into
the common language. The word 'adulter' is related to it; meaning literally a strange dog
which slips into someone else's house to pursue a love affair.

[20] [George in *BM* and Hill (1976) both identify this figure as M. A. Taylor, and only the dog as
Tyrwhitt.]

[21] People are generally of the opinion that Fitzherbert, through her influence on the Prince, has
moderated many outbursts of his political impetuosity, and restrained him from various follies.

[22] [The phrenological theories of Franz Josef Gall (1758–1828) and Johann Kaspar Spurzheim
(1776–1832) were based on the detailed analysis and measurement of the size and contours of
the human skull, in order to ascertain character and the relative size of the 'powers and organs
of the mind'. The term 'cranioscopy' was later taken over by the Romantic psychologist Carl

Prince of Wales's favourite brother, and the only member of the royal family who will stand by him in public. We are assured that he is a fat, good-natured bucolic soul,[23] always the first to laugh at his brother's sallies. He has had six children by the high-plumed lady who is clasping his arm so loyally. This lady is none other than Mrs Jordan, the popular actress from Drury Lane Theatre, who has been the inseparable companion of the Duke of Clarence for seven years. To quote London's theatrical annalists, he has anchored 'the little frigate' forever.[24] Her forte, as we know, is in playing the part of a naive country girl, and in low comic roles, which are called 'characters of the romp kind' on the English stage.[25] We read in the current English press that, at the re-opening of the Drury Lane Theatre in early October, she played Mrs Sullen in the *Beaux' Stratagem* as excellently as ever. Malicious Gillray places a ballad in her hand entitled 'Jobson and Nell, with the Farce of Equality';[26] for Mrs Jordan, without being at all musical, can sing a cheerful little ditty very pleasantly on stage. The popular song alluded to here does not denote the best society; but there is absolutely no doubt that, wherever actresses appear with princes of the blood and duchesses, the 'farce of equality' really is acted out. Behind the Duke of Clarence and his Thalia, to the Duke's left, peeps General Fitzherbert,[27] who has decided, with good reason, to assume the role of a male concubine with his

Gustav Carus (1789–1869) to describe his own craniological theories. The term 'phrenology' had not yet been coined in 1804, when this commentary was written.]

[23] The Duke of Clarence likes best to spend time on his country estate, occupying himself with agricultural experiments.

[24] 'The little Frigate', writes the author of *The Secret History of the Green Room*, 2 vols. (London: J. Owen, 1795), vol. I, p. 83, 'has *grappled* with a strength more sure than it was supposed she possessed'. Of her singing talents, he adds (p. 85), 'She sings a few plain songs with effects that confound all musical ideas; without science, she distances its power; and a ballad from JORDAN, unaccompanied, needs only to be once heard, never to be forgotten.' It is only her frequent pregnancies of which the public disapproves.

[25] [On these 'romp' parts, see Claire Tomalin, *Mrs Jordan's Profession: the Story of a Great Actress and a Future King* (London: Penguin Viking, 1994), pp. 53, 82, 115.]

[26] [She had often played Nell in Charles Coffey's *The Devil to Pay*, written in 1731. Cf. Gillray's *The Devil to Pay; – The Wife Metamorphos'd* (1791). BM 7908. Tomalin, *Mrs Jordan's Profession*, pp. 90, 149.]

[27] [Probably General Richard Fitzpatrick is meant (although, according to George, Miss Banks erroneously identified one of the other figures as Fitzpatrick).]

own wife. To the Duke's right we see the Irishman McMahon. Neither man is known as a mirror of virtue on the crooked path of life. Furthermore, Grey, the most fervent Opposition speaker after Fox, is holding out the new operational plan for the coalition, so that Erskine can peruse it avidly through his eye-glass. In addition to Citizen Volpone (as we have discussed before, this is a nickname for Fox, from a famous comedy by Ben Jonson), the new broad-bottomed administration also contains a number of other actors; the list of names will include some cunning moves and some surprises for the two men reading the plan.[28] The tall man in the red uniform with a pensive air directly above Fox is the present *Generalissimo* of the British army in Scotland, valiant Earl Moira. One would probably not be too far off the mark if one were to read in his features and gestures a degree of embarrassment at finding himself in such company. At least his moral sense of smell is somewhat offended at this odd *mixtus compositus*. Immediately behind him, above plump Mrs Fox, is a trio from the famous Pic Nic Society from Tottenham Court.[29] The two near angles of this triangular group are formed by Lady Hamilton and the Duchess of Devonshire. The far angle is formed by Colonel Greville, who is eavesdropping with a sly expression of intentness.[30] We have met him before in earlier prints in our gallery of manners, and we know him to be an excellent impresario. An expert such as this must derive a great deal of entertainment from the illustrious farce being played out here! After the sacrifice to Thalia, Terpsichore, the Muse of Dance, will have her turn. At least the musical fan belonging to the Duchess of Devonshire bears the name of a quite new dance: 'The Devonshire Delight, or the new Coalition Reel'.[31] The widowed turtle-dove

[28] It is well known that the eloquent barrister Erskine (the oracle and bellows of the Prince of Wales) is always *most* eloquent on the subject of his own dear self. This is why his eye-glass has come to rest, with good reason, over the word 'Ego' in the Administration list, where the Office of Lord High (Chancellor) is inscribed. 'Mr Greyhound' immediately below this on the list refers to Mr Grey himself.

[29] [*LuP* writes 'Twickenham-Court', an obvious mistake.]

[30] [George identifies the two figures accompanying the Duchess of Devonshire as her sister, Lady Bessborough, and brother, Lord Spencer, but gives no reasons for this. The locket of Nelson supports *LuP*'s assumption that its wearer is meant for Lady Hamilton.]

[31] The popular 'reel' is, of course, just a very fast *Ecossaise*. We have no word in our language which approximates to this.

beside her, Lady Hamilton, does not wear the portrait of her late husband in her locket, but that of Admiral Nelson. Our *Didone abbandonata* will never be able to forget her Aeneas. Just as Virgil's Dido kisses the carpets on which her lover once stood, this one lives at the country houses of her one-armed swain.[32]

Another group of those who have already arrived deserves our attention. The artist has placed this group directly above the three people bowing deeply as they come in. The former are all old friends, and our readers will recognise every one of them. The bushy Titus-head is Sir Francis Burdett. Opposite him is Tierney. The little hyphen between them is the ex-clergyman, the Reverend Horne Tooke. Good Sir Francis does not yet suspect that he will soon suffer the same fate as his loyal mentor, Horne Tooke, and will lose his hard-earned seat in the House of Commons.

This completes the description of those who have already arrived. But we must also remember to cast an attentive eye over those just arriving, and still in the doorway. The centre of attention and the prime target of Gillray's shafts of wit are the three leaders of the illustrious Buckingham family. They are in every sense new arrivals in this ill-assorted, motley coalition circle. At the front, and bowing deeper than all the others, is the head of the family, the Marquis of Buckingham, with his gouty feet. Next to him is his brother, Lord Grenville, and next to Grenville, Lord Temple, Buckingham's son. One hardly needs much insight to discern that the entire picture was composed purely for the sake of this group. As a ministerialist, Gillray cannot get over the fact that these three noblemen have joined the coalition; the fair-minded admit that the middle one in particular, Lord Grenville, is a man of strict principles and unsullied reputation. This is why Gillray makes their bows so obsequious. Look, he cries, even these distinguished men bow down before the idols of the day! The world is turned upside down! Full sheaves of wheat bow down to thorn bushes![33]

[32] [Flora Fraser, *Beloved Emma: the Life of Emma Lady Hamilton* (London: Macmillan, 1994), pp. 302f. Gillray had caricatured Lady Hamilton as *Dido, in Despair!* (1801). *BM* 9752. Hill (1976), pl. 70, p. 121.]

[33] But isn't that very alliance of the Grenville Party with Fox an unambiguous proof that this time Pitt was playing totally false? Lord Grenville's remarkable letter to the Governor General of Bengal, Wellesley, shows him to be a man of honour. It was taken as booty by the French

Behind the three gentlemen bowing with a more-than-European respect and ceremony comes a charming couple; little Lord Derby, led, or rather dragged, by his slender wife. If we didn't know it already, the words on her fan would reveal her identity: the lady is fanning to hide her self-consciousness in these surroundings: and the inscription, 'Strolling Players in a Barn' is full of venomous wit. Before her marriage, of course, Lady Derby[34] was a popular actress at the leading London theatre, Drury Lane, where she inherited all the roles previously played by the famous Mrs Abington. Her conduct on the slippery path of life was always so exemplary, so unblemished, that when Lord Derby offered her both a countess's coronet and his hand in marriage following the death of his first wife, no one considered it a misalliance.[35] She was favoured even by the Court, and attended the present Duchess of Württemberg to the altar at her marriage. But no one is spared in this print, and Lady Derby, too, must brook the caricaturist's malice. The two-edged inscription on her fan not only recalls her own former position, but also signifies that the entire gathering is just a band of strolling players. Every Englishman knows Hogarth's piquant caricature of a troupe of this kind, which bears the same title, and we Germans will also recall the informative commentary on it by our compatriot Lichtenberg.[36] Be thou as pure as snow, says Hamlet, thou shalt not escape calumny.[37] Poor Lord Derby must put up with being portrayed as a cuckold, in a gesture which the caricaturist has devised with real malice.[38] It is true that he

Footnote 33 (cont.)

from the East Indiaman *Aplin* and published in the *Moniteur*, together with the other intercepted letters. Cf. the remarks on the subject in the *Morning Chronicle* of 5 October 1804.

[The paper contrasts Grenville's political principle with Pitt's 'one continued scene of varying; and . . . duplicity from the termination of his Administration to its renewal.']

[34] See the biography of the Countess of Derby in *Public Characters of 1799–1800*, pp. 465–73.

[35] [This conflicts with *LuP*'s assertion in *Dilettanti-Theatricals*, p. 147 above, that the marriage was frowned on.]

[36] [Hogarth's *Strolling Actresses Dressing in a Barn* (1738) had already been invoked in *Dilettanti-Theatricals*, p. 139 and pl. 25 above. These vulgar and meretricious actresses grotesquely aspiring to grand classic roles provided an apt analogy with the underlying theme of *L'Assemblée Nationale*.]

[37] [*Hamlet*, Act III, scene I.]

[38] The index finger of the hand clutching his wife points to that part of his swollen forehead where those people who have not studied with Dr Gall usually place the organ of cuckoldry.

received the beautiful lady from the hands of his friend Fox, and it is this very Fox whom they are visiting today. But why should one always think the worst of people?

More and more people crowd in behind this charming couple. Directly behind Lady Derby follows Lady Buckinghamshire, and next to her, a little lower down, one-eyed Nicholls can be seen, with a face like that of a leering satyr. We have already discussed the Duchess of Gordon and handsome Lord Cholmondeley parading behind them. Right in the doorway, on the threshold, stands Lord Salisbury with his wife, who is wearing an Amazon's helmet. Both figures are familiar to us from earlier caricatures. We encountered the mannish Salisbury and her love of Amazonian pursuits in the Pic Nic Society, and we saw Lord Salisbury standing behind the King as a loyal chamberlain.[39] The broken chamberlain's staff is very sinister. Those who enter here, Gillray is saying, deserve to be dismissed from the service of the court by the good old King (referring to the breaking of a discharged officer's sword).

The individual groups of those who have arrived and those arriving have now all passed before our eyes. Now we are better placed to view this national assembly as a whole. The composition and poses, as we have come to expect from Gillray, are truly masterly. Nowhere is confusion to be found in this lively throng, and Schiller's famous verse on the dance might well be applied to it:

For aye destroy'd – for aye renew'd, whirls on that fair creation
And yet one peaceful law can still pervade in each mutation.[40]

Look at the brilliant way in which the main and subsidiary groups are organised in relation to each other! Fox and his fat other half (who has

The authors of *The Secret History of the Green Room*, vol. I, p. 23, say of the *ci-devant* Miss Farren's affair with Fox: 'The British Demosthenes paid her particular attention, and frequently dangled whole evenings behind the scenes, for the sake of her company.'

[39] [*Dilettanti-Theatricals* (see p. 143 above) and *The King of Brobdingnag and Gulliver (Plate 2d)* (1804) in *LuP* 12 (1803), actually published in 1804, 341–56, pls. XXII–XXIII. *BM* 10227.]

[40] [Friedrich von Schiller, 'Der Tanz', *Schillers Werke. Nationalausgabe*, edited by J. Petersen, G. Fricke et al., 42 vols. (Weimar: Böhlau, 1943–93), vol. I, p. 228. The translation is that of Sir Edward Bulwer Lytton in *The Poems and Ballads of Schiller* (Leipzig: Bernhard Tauschnitz, 1844), p. 24.]

Bonaparte in the medallion on her fan and 'French brandy' in her pocket)
are the most brightly lit, and are thus distinguished as the main protagonists.
Look at the rays of light surrounding the Prince of Wales! It must be so, for
he is the new Rising Sun, who alone is worshipped here. We need only look
at the picture hung in the full glare of the light, which is entitled 'Worship-
ers of the Rising Sun'.[41] Our readers will recall the marvellous and pro-
found fable by our noble Pfeffel. The adoring Indians find a perfect
counterpart in the effusive coalition clan. They all realise, as young Pompey
once realised, thinking of the declining Cinna and himself (Plutarch's life
of Pompey, Chapter v), that many more people worship the rising than the
setting sun. At any rate this can also be translated into the language of the
ancient Greek poet, Timotheus of Miletus:[42]

I sing young songs, not old.
Young Zeus rules youthfully!
Long ago Cronos was king,
Now old age is no longer respected
Therefore, old Muse, you push off too!

The contrast between this brightly-lit morning worship and the picture of
the old King George, with 'Pater patriae' written around it, hanging in deep
shadow on the other side, is very significant.[43] What a solar eclipse! Poor

[41] The worship of the rising sun, which occurs amongst all fire-worshipping votaries of Mithras,
also features in another caricature on the coalition which Gillray here makes the butt of his
satire. In this other caricature, Persians and Greeks are shown worshipping the *Auspicium solis
orientis*. The Persians – Lord Grenville, the Marquis of Buckingham etc. – are kneeling. The
Greeks, who scorned kneeling, are standing; they include Norfolk, Windham, Fox and
Sheridan. Right at the end stands old Lord Thurlow, who has been given the honourable name
of Ahithophel, because he is the constant and confidential adviser to the Prince of Wales.
Above the rising sun are the Prince's feathers.
 [James Sayers's *Achitophel, an Old Jew Scribe Lately Turned Greek . . .* (1804). *BM* 10258.]
[42] We find this inspired little song in *Athenäus Tischreden*, Book III, ch. 34 or vol. I, p. 473 in the
new Schweighäuser edition. To feel its full force, one should remember that the Greeks spoke
of 'Cronos' or 'Saturn' as a euphemism for a discarded, decrepit and retired old man.
 [I.e. Athenaeus, *Deipnosophistarum Libri Quindecim*, edited by Johannes Schweighäuser, 14
 vols. (Strasbourg: Biponti, 1801–7).]
[43] [Darkness evokes the King's insanity, as in Gillray's *Wierd-Sisters* (1791). *BM* 7937. Hill
(1966), pl. 2, p. 138.]

father of the fatherland! No invitation for you! Take care that you aren't cast into outer darkness: for your sun has already set here.

So as to leave absolutely no doubt as to who is meant by the rising sun, the plumes above the Prince of Wales's coat-of-arms not only appear on the picture of the sun-worshippers, but also on the fans held by Lady Fitzherbert and Lady Derby. Nor should we overlook the moon-candelabra attached to the wall in the middle. The deformed Lilliputian Atlas supporting the globe is none other than the world-conquering ruler of France.[44] And since the entire lighting of this print emanates from this single candelabra, the artist's meaning is quite clear: Look! The newly-risen pseudo-sun and all his satellites really draw their light from this source alone!

The caricaturist's happiest inspiration, the achievement which entitles him to the highest regard as an artist, is the arrangement of the persons, and the ordering of complete groups to give the impression of a single whole. In his famous speech on the new administration in the House of Lords, Lord Grenville used the expression: it must be 'a broad-bottomed administration'. This expression has been greatly derided and ridiculed. Fox and several other members of the Opposition, old and new, are of a very solid, broad-shouldered build, well stuffed with roast beef and pudding. At the sight of Fox's stocky physique in particular, we recall Homer's description of Odysseus (*Iliad*, III, 238–40):

Yes, he looks to me like a thick-fleeced bellwether ram
making his way through a big mass of sheep-flocks,
shining silver-gray.[45]

Compare him with Pitt, the thin 'rush-light', and you will divine that Grenville's expression, which referred to Fox and the coalition, also lends itself very well to a physical interpretation. Gillray has portrayed this very wittily both in the massing of all the groups in the foreground *and* in the placing of the individuals. Even the comical alternative meaning of one of the words is not forgotten here. Everything in this colourful national

[44] [Napoleon had been proclaimed Emperor only a month earlier, but is shown already crowned.]

[45] [Homer, *The Iliad*, translated by Robert Fagles (Harmondsworth: Penguin, 1990), p. 135, lines 237–9.]

assembly is broad-bottomed in every sense of the word. Only now do we understand why fat Fitzherbert has been placed next to funny little plump Tyrwhitt, and to the bulging main couple, Fox and his well-fed darling, with the stout Dukes of Bedford and Norfolk, and plump Sheridan completing the front line on the other side. Only now is it clear why the tall beanpole Lord Moira was planted on top of Fox, why the slender *ci-devant* Miss Farren is above Sheridan, and why Lord Cholmondeley, with his tender glances, tops the Duchess of Gordon. This, too, explains the almost indecent circumference of a certain part of the body, well upholstered to form a comfortable seat, and so luxuriantly delineated in the Marquis of Buckingham's bow of respect, that one is tempted to think of a Venus Callipyge.[46] Look! says Gillray, laughing behind the scenes, look at this broad-bottomed administration! The good of all England is supposed to be built and founded on lumps of flesh like these! The caption below: 'Respectfully Dedicated to the admirers of a *Broad-Bottom'd Administration*', leaves us in no doubt whatsoever that this really is what he meant!

[46] Those familiar with the English language will not need to be told that 'bottom' also denotes that part of the body which a certain lady fancied she was touching, when she actually touched the face of the historian Gibbon; and which our miners are careful to cover with a double layer of leather.

[Madame du Deffand, who was blind, asked to touch Gibbon's features, and, on feeling his puffy cheeks, believed she had been tricked by being presented with a baby's bottom. Patricia B. Craddock, *Edward Gibbon, Luminous Historian 1772–1794* (Baltimore: Johns Hopkins University Press, 1989), p. 93. It is not clear how this anecdote had already gained international currency.]

14 (1804), 3–6. Signed 'Horstig'

When a foreigner listens to Englishmen speaking at public and private gatherings on the subject of politics, or indeed on any issue which attracts the attention of the vulgar herd, he is struck by their total lack of restraint; they far exceed the bounds of generous-minded candour, as we Germans would understand it. The Englishman spares no one on these occasions. He talks about his King, his Princes and Princesses just as he might talk about the lowest of his fellow countrymen. In his eyes a Minister of State is no more important than a petty local official. The private affairs of the royal household are discussed with no regard for majesty, just as one might discuss how well or badly a valet runs a household. If a man's actions expose him to the mercy of the public, it doesn't matter whether he is an Esquire or a Lord: he must put up with being discussed in detail and criticised by everyone who has heard the whisper of Fama's hundred tongues. One is most aware of this shameless freedom in the English literary lampoons and caricatures which are published in such numbers. The lampoons are usually somewhat more careful; if the perpetrator is pursued and discovered he can be punished according to the law. But no law prohibits the much more strident expression of public censure in the form of copper plates and pictures.[1] The freedoms which the English allow themselves in this way are as well known to their continental cousins, for whom the sight of an English caricature is no longer an oddity, as they are to Londoners. No rank, no class is spared. The leading statesmen are the very people who are most frequently exhibited in caricatures. Their distorted facial expressions have become common currency. Their portraits are easily recognisable without a title, and leave the observer in no doubt whatsoever as to the interpretation of the piece.

[1] [This was not strictly true. Caricaturists could incur official harrassment or prosecution, especially at times of national crisis. Donald (1996), pp. 2, 15, 99, 147–9, 166, 168, 223 n. 168.]

The engravers Bunbury and Gillray lead the field in this genre. The former could have earned himself a better reputation,[2] for his early works testify to his talent and genius. They confirm the supposition that those artists who take their tone from the depravity of the common people might well have been moralists on a par with Hogarth, might have acted in the service of virtue, had love of profit not stifled any finer feelings within them and suppressed all sensitivity to beauty and decorum.

Surely we need no further evidence of the damage that is done to good taste, and the extent to which art – true art – suffers as a result. Those who feast their eyes on caricatures, and busy their hands with the pictorial representation of vulgar absurdities, probably have nothing better to look at and are not worthy of doing anything more estimable.

We should also take into account how prejudicial caricatures are to the public interest: they encourage an eccentric and distorted judgement of everything which should be precious and important to Englishmen. Then there is the terrible influence of the political factions, which is nowhere expressed more forcibly than here; the denial of self-respect to all those who constantly figure in the caricatures; the common man's happiness in the thought that he may be compensated for some of his privations by treating with scorn what should be venerated; the silent insults to individual families, whose domestic misfortunes are exposed to the mockery of the common crowd; the secret bitterness they cause, even when one is accustomed to them, which sinks the poisoned thorn ever deeper into the soul; the abhorrence and repugnance of all sensitive citizens when they see mis-

[2] [It is surprising to find the amateur caricaturist Henry Bunbury being tarred with the same brush as Gillray. His published caricatures – usually in fact etched by professionals from Bunbury's sketches – were almost all innocuous social satires, showing amusing types rather than individuals. John C. Riely, 'Horace Walpole and "the Second Hogarth"', *Eighteenth-century Studies* 9.1 (1975), 28–44. Donald (1996), pp. 35–6. However, Johann Georg Adam Forster in *Voyage philosophique et pittoresque sur les Rives du Rhin . . . l'Angleterre . . . (etc.) fait en 1790*, translated by Charles Pougens, 2nd edition, 3 vols. (Paris: F. Buisson, C. Pougens, 1799–1800), vol. III, p. 243, had condemned 'L'indécence de ces esquisses grossières d'un Bunbury ou d'un Gillray'. This may be Horstig's source. Bunbury's caricatures had also been picked out for criticism by Archenholz, who thought the monstrous dimensions of his frieze designs such as *The Propagation of a Lie* and *The long Minuet as Danced at Bath* had overextended the sphere of wit. *Annalen der Brittischen Geschichte des Jahrs 1789* 3.viii (1790), 192.]

takes and crimes for which, perhaps, Nature alone is responsible, exposed to mockery; the clear contradiction which arises in this nation, which has higher church attendances than any other, and yet treats those who administer the divine service more scurrilously and spitefully than anyone else.[3] If we consider the effect which all this, in turn, has on morals and behaviour, on attitudes and actions, then it is hard to grasp how an entire nation can take such pleasure in it. This is all the more ironic, given that one rarely escapes being ridiculed oneself sooner or later.

[3] [This refers to the many satires on the wealthy Anglican clergy. M. Dorothy George, *Hogarth to Cruikshank: Social Change in Graphic Satire* (London: Penguin and New York: Viking Penguin, 1967), pp. 85–7. John Miller, *Religion in the Popular Prints 1600–1832* (Cambridge: Chadwyck-Healey, 1986), pp. 31–4, 47–9, pls. 53f.]

19 *The Reconciliation*[1]

14 (1804), 75–88, pl. ix

Great houses are plagued with great troubles! In this print, for example, we see the royal summer residence at Kew. Everything about it is wonderful, splendid and designed for pleasure. Only recently the foremost British architect himself extended and furnished the royal summer palace with the *most up-to-date* early Gothic architecture.[2] From Hudson Bay to Jackson Bay, all corners of the earth vied with each other to send their most interesting shrubs and flowers to their English Majesties, to provide the sweetest feasts for their eyes and noses as they walked around the grounds. What more could this King and Queen possibly want to make them happy? A great deal! The King, who has been assigned the role of the father in the parable of the prodigal son, has had to make do without much in the way of what we would call happiness. He missed his beloved first-born son, who had gone astray and who had heaped sorrow upon his father's venerable head. But now he has found him again. Today, for the first time in several years, he can once again press his first-born to his bosom. This sets the scene.

To aid comprehension we will copy the following information from the *Morning Chronicle* of 13 November last year:[3] 'The public will learn with the most lively interest that his Royal Highness the PRINCE of WALES had yesterday a long and most affectionate interview with his MAJESTY. The

[1] [Etching published 20 November 1804. 'J. Gillray des. & fect.' *BM* 10283. Hill (1965), p. 121.]

[2] [James Wyatt (1746–1813) designed the 'Gothic' or 'Castellated Palace' at Kew, which was under construction between 1801 and 1811. It was widely criticised for its bastille-like effect, huge expense and impracticality, and was never finished, being demolished in 1827–8. Howard M. Colvin, *The History of the King's Works*, 6 vols. (London: Her Majesty's Stationery Office, 1963–73), vol. VI, *1782–1851*, pp. 356–9. John Martin Robinson, *The Wyatts, an Architectural Dynasty* (Oxford University Press, 1979), p. 242.]

[3] [That is, 13 November 1804. *LuP* 14, although dated 1804, did not appear until 1805.]

The RECONCILIATION. ___ [And he arose and came to his Father, and his Father saw him, & had compassion, & ran, & fell on his Neck, & kissed him.
Geo. III P. Wales. Read the Parable. Verse 16th to 24th.

PLATE 31
James Gillray, *The Reconciliation*, 1804.
Etching, hand coloured.

meeting took place at Kew, and we are persuaded that the result of it will be
the perfect re-establishment of that habitual intercourse which is not more
essential to the happiness of the illustrious family itself, than to the welfare
of the Empire at large.'

Say what you like about the King of England's mental capacity or his
ability to rule: friend and foe agree, and the whole of Great Britain speaks
with one voice in declaring that he is the truest and best *paterfamilias*, and
only ever feels really well and happy when he is in the midst of his large and
handsome family. Even the bitter satirist Peter Pindar, or Wolcot, who
habitually fired entire quiverfuls of satirical arrows at the King and the royal
family in his poems, could not deny this fact. In his famous *Lousiad* there

are even some very moving passages, in which Balaam blesses when his intention had been to curse.[4] In order to gain an impression of the domestic bliss at Windsor, it is perhaps appropriate to quote the following article, which was recently printed in several English newspapers.[5] It described how the King lived and took his meals:

The Royal Family. When the whole number is complete, that is those who have always been accustomed to sit at the Royal Table, the party amounts to eleven persons: the King, the Queen, the Princesses Augusta, Elisabeth, Sophia, Mary, and Amelia; the Dukes of Kent, Cumberland, Cambridge and Sussex. At the head of the table sit the King and Queen; on the right of the King, the Princess Augusta; on the left of the Queen, the Princess Elisabeth; then follow the Princes and Princesses, according to their seniority. The King, when he was accustomed to dine with his family, always was the last person who took his chair. It was a common exclamation with his Majesty, when all the family was seated, 'Now I am happy!'

Such true observers are the King and Queen of old English habits, that they will not suffer a made dish to be brought upon the table; their food is always plain roast and boiled; game and venison they are very fond of. To carve for so large a company would be very irksome, although his Majesty has been known to take pleasure in the office. The charge is now entrusted to one of the Pages of the Household. The King fixes on the particular dish he likes best: it is then taken off the table to a side one, and the part he approves is cut off; the Queen next gives her orders. The Princess Augusta next, and then the other branches of the Royal Family. The Queen and the Princesses always drink white wine, considerably diluted with water at table; the Duke of Cumberland the simple beverage of the fountain only; but the Princes drink ale and porter.

The most familiar topics are generally introduced at table; and that which forms the prominent feature in the political occurrences of the day is afterwards discussed. Healths are never drank (*sic*).

[4] This satirical poem in three cantos is to be found in the first part of *The Works of Peter Pindar* (London: J. Walker, 1794–6), which has now grown to four volumes, and is surely known to our readers from a partial adaptation in Falk's *Satyrischer Almanach* for 1801.

 [*The Lousiad* had first been published in 1786. For the Biblical Balaam, see Numbers, chapters 22–24.]

[5] See *St. James Chronicle*, 5–8 January 1805.

 [This reference to an article of 1805 is explained by n. 3 above.]

With all this in mind, it is easy to understand how painful the old King must have found the years of misunderstanding and coolness between himself and the Prince of Wales. However, a dogged persistence, which sometimes verges on stubbornness, is altogether in King George's character. After all that the Prince has done to divide them over the last four years, a rapprochement would probably have been impossible, had the aged father not been encouraged to yield a little by the tender love which he has always felt for the much-neglected Princess of Wales and his granddaughter, Princess Charlotte, and his passionate desire for this granddaughter, who is now coming up to her tenth year, to be always by his side. With the help of a few close friends, he was persuaded to meet the Prince of Wales half-way. For some time now the Prince's sole adviser in all important political and domestic affairs has been Earl Moira, whose unshakeable honesty, bravery and talents are never doubted, even by his opponents. As soon as he was given the nod, he hastened to London from Edinburgh, where he usually resides as the supreme commander of the British troops in Scotland. He held several meetings with Pitt, and then agreed with the Prince of Wales the famous meeting with his father at Kew. In order to get an idea of the rumour and speculation to which this highly unexpected reconciliation gave rise, one has to understand the sympathy which the whole of England feels for the Royal Family and the interest shown in all, even their briefest appearances.[6] According to some, we were to expect nothing less than a regency, upon which, it was said, the aged father would abdicate. Others claimed to know the minutest details of the conditions under which the father had

[6] The rubric 'Royal Family' is a constant feature of most English daily newspapers. Every ride, every hunting party, even every church-going and every private concert of the King and his family is carefully documented. For example, a great deal was written recently about the old eight-seater state coach, painted in pompadour red, which the King discovered in a dusty corner during an inspection of the coach-houses before his departure for the seaside resort of Weymouth. When he found that this was the very coach in which the valiant Duke of Cumberland had hurried to Scotland in 1745, in order to quell the rebellion which had broken out there, he immediately had it brought out and refurbished, saying that henceforth he would not ride in any other carriage. How many carping comments have recently been made about the full-bottomed wig which the King wore at the opening of Parliament, since he usually wears a bag-wig! And about the abolition of the Hanoverian mail coach, which has been replaced by English ones!

forgiven his son, the most important being that he had to renounce all association with Fox and the other leaders of the old Opposition. The *Morning Chronicle*, meanwhile, which really should have been the best-informed source, took pains to expose the tittle-tattle of alehouse politicians for the rubbish it was,[7] yet immediately went on to say that the sole topic of conversation between grandfather and father had been the establishment of a plan for the education of Princess Charlotte. The Prince of Wales not only came to Windsor himself for the three days from 16 to 18 November, but also brought the only brother who is well disposed towards him, the Duke of Clarence. The Prince himself collected the Duke from his residence at Bushy Park, on the way to Windsor. It was a truly joyful and exciting spectacle for the population of the entire area, when they saw the good old King accompanied by the Prince of Wales (whom many people regard as the most handsome man in Great Britain), together with all the other Princes and Princesses, riding out to a hunting party on Ascot Heath; with the Prince and the King deep in conversation all the while. But of course all these events were only brief spells of April sunshine. Lord Moira, who had gone back to Edinburgh, soon had to return to London once more, as mediator and peacemaker. Fresh storm clouds gathered on the horizon. And because a peaceful agreement could not be reached on the limits of the grandfather's and the father's authority over Princess Charlotte, a new rift ensued.[8]

But the first reconciliation which took place at Kew on 13 November[9] was certainly not an empty gesture, not just a charade of affection. The heart of every honest Briton beat for joy at the sight – all except that of our friend Gillray. Even here jaundice tainted his soul, party passions warped his vision; and so he used a meeting which, according to the Gospel, would

[7] 'Nothing', says the *Morning Chronicle* of 15 November 1804, 'but gross indelicacy could imagine . . . that the first moment of paternal and filial reconciliation could be employed in any overtures of the kind which have been alluded to.' Cf. the *Morning Chronicle* of 14 and 16 November.

[8] We ask our readers to refer to what was said about the negotiations concerning Princess Charlotte, in comments on Gillray's *A Morning Ride*, *LuP* 13 (1804) 379–413, pl. VII.
 [*BM* 10230. Hill (1965), p. 119.]

[9] [Actually 12 November.]

gladden the very angels in Heaven for a new outburst of mockery, twice dipped in bile. The caricature we have before us remains psychologically and politically remarkable, but only as a monstrosity, like the grotesquely deformed head of a pig which Blumenbach recently showed us.[10]

Gillray, as the superfluous caption suggests, is parodying the Gospel parable of the prodigal son, who came to his senses while feeding the swine, and threw himself into the arms of his forgiving father. In the truly heavenly and movingly simple story in the Gospel, we read that he arose and went to his father, and his father saw him and had compassion, ran, and fell on his neck, and kissed him. In this caricature the King comes out of a summer house at Kew to meet the Prince in the same way. But Heavens, what a contrast! The first-born, the heir apparent, cannot even cover his nakedness. His stockings and coat sleeves have holes in them, his shoes are worn out, his garters are hanging down,[11] his hair is loose and unkempt. What a humiliation, how miserably low he has sunk! And then comes the sinner's contrition: I have sinned against heaven and in thy sight and am no more worthy to be called thy son! What a humble confession. Certainly all we need now is for an Irish 'link-boy', a ragged street urchin, to shout out the 'last dying speech' of a poor sinner before execution. To appreciate the excessive degree of malice in this travesty of the Prince of Wales, we must remember that for years the Prince has been, and indeed still is, regarded throughout England as the paragon and prime model of all that is most sophisticated and elegant in male attire, riding dress and fine furniture; so much so that his pavilion at Brighthelmstone leaves the once-famous Bagatelle of Prince Artois[12] a hundred miles behind. Indeed, whenever the vendors of fashionable goods in Old and New Bond Street bring out a new

[10] See Johann Friedrich Blumenbach, *Abbildungen Naturhistorischer Gegenstände* (Göttingen: Dieterich, 1796–1810), VII, no. 61. Each issue is truly a little box of choice goodies for natural history fanciers. Let us hope it will appear more often!
 [The illustration in question shows a hideously deformed one-eyed pig.]

[11] A vicious horse-fly has settled here. The garter hanging down to the right (*sic*) foot is the Order of the Garter and its 'honi soit' is said advisedly.

[12] [François-Joseph Bélanger, *premier architecte* of the Comte d'Artois, designed Bagatelle, his luxurious house near Paris, in 1777. Wend Graf Kalnein and Michael Levey, *Art and Architecture of the Eighteenth Century in France* (Harmondsworth: Penguin, 1972), pp. 340–1, 352–3.]

patent invention or elegant convenience,[13] which they do almost monthly, they will give anything to be able to say: the Prince of Wales received it with a gracious nod, bought it, wears it or uses it in his room etc. What a disparagement it is, therefore, to portray this man in the attire of a gypsy or mendicant Jew!

All those artists who have depicted the return of the prodigal son have sought to captivate the spectator and to show their talents by means of well-drawn expressions of pity and joy in the faces and poses of the by-standers.[14] Even Gillray has not neglected this entirely. The Queen emerges with a charming look and, in the manner of the old Roman *histriones*,[15] she acts out the pantomime to the dialogue of the main actors in this *catastrophe* of tearful drama. The two sister princesses and the two gentlemen at their sides form the *chorus*, which is an indispensable feature of any well-composed historical painting. Next to the King stands Lord Moira, with Pitt next to him. Lord Moira's gesture comes close to the famous gesture of the god Sigalion, an erroneous name for Harpocrates, when he puts his finger to his lips enjoining silence.[16] Nothing is more contemptible and more trifling than

[13] Just at present everyone in England who wants to be correctly dressed is once again wearing a buckle set with stones and a state sword. And why has this fashion spread so rapidly? Hüttner gives us the most satisfactory answer in his informative *Englische Miscellen* 1 (1800), 54–7: the Prince of Wales, who is known to set the *ton* in fashion, wore them first.

[14] Thus, to give just a few examples from the Dresden Gallery: Domenico Fetti, in his *Return of the Prodigal Son*, includes a boy clinging to his mother and pointing with great sympathy to the naked feet of the prodigal, which have been lacerated by thorns. In another painting by our worthy Dietrich, the repentant son kneels before his compassionate father, and clasps his knees. Here the artist has even provided animal sympathisers as well as human ones, for a friendly, smiling dog is also welcoming an old friend in his own way.

[Fetti's painting was one of a series illustrating the parables (1618–22). The painting by Christian Wilhelm Ernst Dietrich (1712–74) appears to be no longer at Dresden.]

[15] Horace, *Epistles*, 1. 18. 14, leaves us in no doubt that in Roman theatres the actor's words were expressed by another in dumb show. In the language of dramatic art he was called *secundus alicui agere* . . . See K. A. Böttiger, *Entwickelungen des Ifflandischen Spiels auf dem Weimarischen Hoftheater* (Leipzig: Göschen, 1796) p. 217, note k.

[16] We all know the 'Harpocrates, digito qui significat St!' which supposedly comes from Varro's fragmentary work *De Lingua Latina*, but can't be found there! Ausonius in *Epistles*, xxix, line 27, Tollius's edn, has even made of it a god, Sigalion. The author of this note has shown elsewhere in detail that the whole question of Harpocrates' injunction to silence is based on a misunderstanding of the ancient Egyptian language of signs. Horus or Harpocrates – for they

a minister who cannot keep quiet. But with Moira this mystical gesture might also have a more arcane meaning. As we know, the noble Lord is also the most enthusiastic advocate and supporter of freemasonry in Great Britain. Pitt's attentive sidelong glance expresses the man entirely. The inscriptions on the two scrolls in his hand are also very significant. The lower one says: 'Britain's best Hope', the upper one: 'New Union Act'![17] Gillray's idea of uniting these two in the bonds of friendship is also very witty, since they do not usually enjoy the warmest of relationships. The example of reconciliation comes from above and is doubly infectious for that reason. The good old King embraces his homecoming son, and honest, brave Moira confidently clasps the arm of the statesman, a man who is elusive and slippery as an eel.

One might say of this satirical dish that the sauce is better than the meat. The setting and secondary figures in the print are actually as far removed from malice as possible. But only in England, where freedom often borders on audacity, could the main group be portrayed in this way. The *Morning Chronicle* had this to say shortly after the appearance of this caricature:

A certain caricaturist, who is notoriously in the pay and of course subject to the direction of Ministers, still continues to exhibit a scandalous caricature respecting the late happy reconciliation between his Majesty and his Royal Highness the Prince of Wales. Thus an event which has afforded the most exquisite satisfaction not merely to every loyal subject, but to every man capable of feeling or appreciating the most sacred connections of human life, is made use of to gratify the venom of those few who can be so malignant as to enjoy attempts to depreciate the character of the Prince of Wales. But these attacks from such a person as we allude to, may, we have no doubt, be ascribed rather to the encouragement, derived from the known liberality of his Royal Highness's mind, than from any provocation offered by his conduct. If His Royal Highness were of the same species of

are the same – was symbolised by a new-born infant sucking his finger for lack of his mother's breast. Later love of mystery found in this extremely simple and natural child's gesture a deeply significant hieroglyph, and Greeks and Romans repeated it unthinkingly.

[17] All patriots are convinced that Pitt earned himself undying merit through the union of Ireland with England. Gillray, who lets slip no opportunity to show his devotion to the minister, calls this reconciliation of father and son the 'New Union Act'. For here, too, Pitt acted with rare intelligence and objectivity.

disposition with the abettors of this assailant, if he were forward to originate *vin-dictive prosecutions*, he might pursue whatever course of conduct he pleased, he might become the associate and advocate of the taskmasters and oppressors of his country, and be perfectly secure, not merely of impunity, but praise from such censors.[18]

[18] *Morning Chronicle*, 21 December 1804.

[The form of Gillray's signature suggests that the idea of the caricature was indeed contributed by an 'abettor'.]

20 *The Plumb-pudding in danger; — or — State Epicures taking un Petit Souper*[1]

14 (1804), 244–54, pl. XIV

First, a general observation before we proceed to an explanation of the particular. Both this and the engravings that follow depict people eating. In more than a quarter of all English caricatures the subjects are shown guzzling, or (which amounts to the same thing for true English diners) smacking their lips in pleasure. For the English are a nation of eaters. All travellers describe with amazement the assimilative powers and enormous capacity of the typical English stomach, which the German can seldom match.[2] All the favourite metaphors of English humorous writers are taken from the 'bill of fare', and reflect the nation's love of good food. In Fielding's immortal novel of English life, *Tom Jones, a Foundling*, and in Smollett's *Humphry Clinker* for example, at least a third of all the action takes place in inns or at table. We have all heard of the Roast Beef of Old England! And we have often discussed it in this gallery of manners too! As a man eats, the British maintain, so does he work and fight. Prior understood this only too well when he wrote:

Sallads and eggs and lighter fare
Tune the Italian spark's guitar;
And if I take Don Congreve right
Pudding and beef make Britons fight.[3]

[1] [Etching published 26 February 1805 (*LuP* 14, dated 1804, was issued in 1805). 'Js. Gillray inv. & fect'. *BM* 10371. A. M. Broadley, *Napoleon in Caricature 1795–1821*, 2 vols. (London and New York: John Lane, 1911), vol. I, p. 230. John Ashton, *English Caricature and Satire on Napoleon I* (1888, reissued New York and London: Blom, 1968), pp. 255–6. George (1959), p. 79. Hill (1965), pp. 111–12. Hill (1966), pl. 39, p. 153. Hill (1976), pl. 83, pp. 129–30. Ronald Paulson, *Representations of Revolution 1789–1820* (New Haven and London: Yale University Press, 1983), p. 187.]

[2] E.g. Joachim Heinrich Campe in his *Reise durch England und Frankreich in Briefen*, 2 vols. (Brunswick: Schulbuchhandlung, 1803), vol. I, p. 157.

[3] [Matthew Prior, 'Alma; Or, the Progress of the Mind' (1718), Canto III, lines 1316f.]

215

PLATE 32
James Gillray, *The Plumb-pudding in danger; – or – State Epicures
taking un Petit Souper*, 1805.
Etching, hand coloured.

So let us not waste any more time before examining the two national leaders, as they chomp and munch so valiantly. It goes without saying, I hope, that no reader should take up this joke on an empty stomach, but rather use the perusal of our journal as a light opiate following a substantial breakfast, or in the pleasant digestive hour after a meal. For here, too, old Martial exclaims:

Tunc admitte iocos: gressu timet ire licenti
Ad *matutinum* nostra Thalia Jovem.[4]

[4] This may be roughly translated: 'Admit the joke then! Thalia should mount up even to an unbreakfasted Zeus in the heights of Olympus.'

 [Thalia was the muse of comedy.]

For some time now the English newspapers have been full of tales of pow-erful spherical bombs, 6 feet in diameter, whose hellish entrails would smash and destroy the French invasion fleet at Boulogne. The French have been quick to ridicule the whole idea as a feverish dream (*aegri somnia*),[5] and have proved that such a bomb would be utterly impossible from a pyrotechnic point of view. Our caricature also shows a sphere, but of quite a different kind. The two hostile powers, Napoleon and Pitt, who once threatened each other with death and destruction, have made friends at last, and are now separated only by the width of a table. In neighbourly fashion they are carving a juicy, round, delicious-looking plump raisin dumpling or 'plum pudding'. We have all heard stories of murderers who saw the heads of their victims in every calf's or pike's head they were served. Ambitious men and those hungry for territory have their own visions. Is it any wonder, there-fore, that when the English prime minister and the French emperor see a round pudding, a sphere of quite a different kind, the archetype of all impe-rial orbs, the earth's globe itself, floats before their eyes? As their delusion reaches its height, the raisin marbling on the surface suddenly appears to sketch out the shapes of countries and continents on the globe. Pope thought he saw a Spaniard leafing through books in his reference library. The Leipzig philosopher heard his dead wife Hannchen speak.[6] And, as they cut into their pudding, one on each side, our two leaders genuinely believe they are divid-ing the world in two, and amicably sharing it out between them.

[5] In the *Journal de Paris*, An. XIII, no. 241 (21 May 1805), 1687, we read, 'Nous pensons, que *la représentation des globes* donnera plus d'occupation aux journalistes qu'à notre flottille. Nous affirmons que l'explosion et la dimension des bombes, proportionnée à la peur qui monte en croupe du cheval de M. Pitt, n'interrompra pas *la partie de piquet* que nos braves de Boulogne jouent sur *le gaillard-d'avant.*'

 [Gillray's spelling of 'plumb' is also conceivably a punning reference to the armaments which threatened the globe.]

[6] Amongst the many works inspired by Wezel's story of his wife's apparition included in the last book fair catalogue, the one by the scientist Helmuth in Calvörde stands out. In his *Herrn D. J. K. W. über die wirkliche Erscheinung seiner Gattin nach ihrem Tode* (Brunswick: Schulbuchhandlung, 1805), he explains the delusive play of fantasy using the story of Pope, who around midnight saw the apparition of a Spaniard enter his locked bed-chamber and rummage through his books.

 [In *Meiner Gattin wirkliche Erscheinung nach ihrem Tode* (Chemnitz: Aue in Altona, 1804) J. K. Wötzel (Wezel) described seeing an apparition of his wife some time after her death. The work provoked a number of responses.]

Visionaries or not, these *puissances copartageantes* are acting out an edifying drama, which has grave implications for the other nations of Europe. The caricature expresses everything so clearly and comprehensibly, that no one in possession of all five senses would doubt its meaning for a moment. But if a commentary *were* needed, it has already been supplied by our immortal Schiller in his lyric, 'At the Start of the New Century'. Writing in that characteristic poetic mood which many critics would define as 'angry', he says:

Two mighty nations struggle, and contend
For the sole possession of the world.
And to devour the freedom of all peoples
Is the trident brandished, lightning hurled.

The Frenchman lays his brazen sword – like Brennus,
Barbaric chieftain in the days of old –
To weight the scales in place of justice, forcing
Each country to yield up its store of gold.

Like tentacles of greedy octopus
The Briton's trading fleet is spread afar;
And the whole kingdom of free Amphitrite,
Is as his own house, under lock and bar.

On to the south pole and its unseen stars,
To coasts and islands in earth's farthest zone,
Restless, unchecked, he still expands his power,
Leaves undiscovered Paradise alone.[7]

Once before, on the Quirinal, the Vicar-general of Christ cut the globe in two, to spare two freebooting nations the strife and bloodshed arising from their lust for territory.[8]

[7] [These stanzas are taken from Schiller's 'Am Antritt des neuen Jahrhunderts', first published in 1803 and included in Book IV of his *Gedichte*. See *Schillers Werke. Nationalausgabe*, edited by J. Petersen, G. Fricke et al., 42 vols. (Weimar: Böhlau, 1943–93), vol II. i, pp. 362–3.]

[8] It is well known from history that in 1493, following the Portuguese and Spanish discoveries in America, the Pope drew a meridian line through the poles 360 miles west of the furthest island of the Azores, and assigned everything on this side to the Portuguese and everything on the other side to the Spanish. This cut at least gave the Portuguese the rich country of Brazil.

But for our pudding-eaters it's even easier. They can carve away to their hearts' desire, and whatever they carve they can keep. Pitt is taking the ocean and the West Indies, and thereby assumes dominance over all the seas and coastal lands. Napoleon has skewered Europe – one of the prongs of the fork has just pierced Hanover. His slice includes Holland, France (which seems to be expanding infinitely to the east and south), Spain, Switzerland and Italy. And unless his carving knife suddenly grows blunt, he will soon have Africa below and Heaven only knows what else on his plate! Only Great Britain, Sweden, Russia and a small part of northern Germany have *for the moment* escaped the sharp Napoleonic sword. But no one can know what might happen in the future. Any stomach with room for a snack like this first mouthful will surely want second and third helpings! Woe then to us poor Germans, who have been temporarily spared: we shall be the first to fall under his blade; indeed, we shall probably come to grief very soon. The quotation on the print, taken from ex-minister Windham's 'eccentricities', as reported in Cobbett's *Political Register*, is very appropriate: '"The great Globe itself, and all which it inherit"[9] is too small to satisfy such insatiable appetites'.

Seen through the eyes of a true Englishman, incidentally, the whole caricature contains much that is characteristic of, and at the same time flattering to, Gillray's great hero, Prime Minister Pitt. What a contrast in the behaviour of the two eaters! Look at the composure and self-confidence on the face of the man at the British helm, as he sits comfortably, enjoying his food. His face and gestures say it all: render unto Pitt that which is Pitt's and unto Caesar that which is Caesar's. The god Momus sits upon his pointed nose, and a half-astonished, half-mocking smile plays about the lips of this statesman, who is old in experience if not in years. For on the other side of the table his diminutive companion is indeed behaving in an astonishing manner. Look at the greed twitching and convulsing every muscle, right to the end of his fingertips! If this is not *animus in patinis*, or, as it has been translated, worship of the dish, then what on earth is? His covetous eyes are almost popping out of his head, his mouth gapes like that of a shark. There can be no question of remaining seated when performing a caesarean of this

[9] [Shakespeare, *The Tempest*, Act IV, scene 1.]

kind! Both figures are exquisite, and could take pride of place in Le Brun's drawing book of expressions.[10]

The other allusions in the costumes and weapons are also piquant, and should not be overlooked. Pitt has speared the pudding with a trident, Napoleon cuts it with a sword. It is almost as if each man had Schiller's poem before his eyes. The Frenchman's plumes are curved like a cock's, Pitt wears a high-brimmed Volunteer's hat, in keeping with the latest English fashion. On the back of the imperial chair the legionary eagle builds its eyrie on a Jacobin *bonnet rouge*, craning its omnivorous beak, to the terror of all hares and lily-livered rabbits. A triumphant admiral's flag is waved by the British lion[11] on the back of Pitt's chair. Even the golden dishes have their distinguishing coats-of-arms. But all this is crystal clear for those who have eyes to see.

The moral of the print, and the lesson *we* can learn from it, is well worth our attention. 'You take the continent of Europe', the great English spokesman is saying to his terrible neighbour across the channel, 'And I'll take world trade, and all the coasts washed by the ocean will quake with fear at the roar of the English lion of the seas.' The Briton will merely laugh at this caricature. But for us *Allemannen* or 'men of all the world', it's another matter altogether. The Englishman may be able to borrow Democritus's laughter-muscles, so that, like a good speculative trader, he may laugh 'with a stranger's cheeks',[12] but for us Germans only Heraclitus' lachrymal sacs will do, for our own tear glands and ducts could never cope with the sorrow which may befall us and our children, even sooner than we fear or predict.

I hope that everyone who has honoured this pudding feast with a fleeting

[10] [Charles Le Brun's illustrated lecture on the expression of the passions in the human face was first published in France in 1698, and in England in 1701. It went through numerous editions and adaptations in the eighteenth century. Jennifer Montagu, *The Expression of the Passions: the Origin and Influence of Charles Le Brun's Conférence sur L'Expression Générale et Particulière* (New Haven and London: Yale University Press, 1994).]

[11] [*LuP* calls this a leopard, an evident slip.]

[12] In passing, may I point out with reference to the usual explanation of the expression 'malis ridere alienis', which Horace (*Satires*, Book II, Satire 3, line 72) borrowed from Homer's *Odyssey* XX, 347, that even in Homer it surely means only 'to laugh excessively, immoderately, as if with borrowed cheeks'. This becomes clear if it is compared to a saying based upon it in Thucydides' *History*, Book 1, chapter 70.

glance will now listen to the voices of two great and noble Germans, whose words, like that Asian Sultan's warning 'remember the Athenians!', are repeated to us on a daily basis. The eminent Swiss historian Johannes Müller,[13] a man who stands at the highest vantage point of historical circumspection, looking both backwards and forwards, says: 'Gutenberg and Luther have created a *public* in the *republic* of Europe which will only be silenced if lethargy and selfishness allow an irresistible World Empire to come into being. Then the West could end up like China, with its own Emperor Shih Huang Ti, pompous and triumphant, who hid his misdeeds under cover of a contempt for books.'[14] And this is what noble Klinger calls to us from the banks of the Neva, from the Empire of Plato's 'royal man'. For even there Klinger holds his former country close to his heart:[15] 'Germany beware! On the other side of the great river, which once inspired your forefathers, and now merely forms your border, lives a man who will never tolerate your liberal convictions: convictions which your constitution, strange though it is, and your great hero Luther have allowed you to express openly. In such a man, Charles V and the Ferdinands seem to have been born again!'

Where are you now, spirits of Luther and Ulrich von Hutten?

[13] In the short but important preface to Heinrich Luden's *Christian Thomasius, nach seinen Schicksalen und Schriften dargestellt* (Berlin: Unger, 1805), pp. vi–vii. The whole biography breathes an unfettered spirit, which reveals the author's ability to heed the signs of the times.

[14] [Shih Huang Ti (259–210 BC), Chinese emperor from 246 BC, called himself 'the First Emperor' and built the Great Wall. In 212 he had all historical documents burnt, to maintain himself and his successors in power.]

[15] Friedrich Maximilian von Klinger, *Betrachtungen und Gedanken über verschiedene Gegenstände der Welt und Litteratur*, 3 vols. (Cologne and St Petersburg: Peter Hammer, 1803–5), vol. III, p. 286.

 [The German playwright Klinger moved to St Petersburg in 1780 to take up military office. His initial admiration for Napoleon turned to the disillusionment and hatred expressed here.]

15 (1805), 159–97, pl. III

'It was the ordinary people rather than the princes who demanded and needed the Reformation. Only they were actively involved in it; the princes remained passive. Resistance to the Reformation therefore came from princes and rulers, rather than from the people.' If this statement, recently reiterated by one of the most excellent and unprejudiced scholars of church history in Germany[2] is true, it is all the more striking that there is only one people in Europe that has for two centuries stubbornly opposed the Reformation and a Protestant monarchy: the Irish Catholics. We have all heard of the deplorable crimes and murders carried out by the *people* in order to assert Papism against their Protestant rulers in the seventeenth and eighteenth centuries, outrages which have written many a page of history in letters of blood. But the history of Catholicism in Ireland cannot be compared to that in any other country. Much of the blame must be laid at the door of the ruling Protestants, for they have constantly instilled great bitterness in the Catholic inhabitants of their country, whom they have ruled with the iron yoke of oppression. The most interesting and objective work on the subject is the history of Ireland by an Irish Catholic, Plowden.[3]

Until recently England has treated Irish Catholics in a harsh and uncaring manner, but a gentler attitude towards Ireland, together with the pres-

[1] [Etching published 17 May 1805. 'Js. Gillray inv. & fect.' *BM* 10404. George (1959), pp. 82–3. Hill (1965), p. 121. John Miller, *Religion in the Popular Prints, 1600–1832* (Cambridge: Chadwyck-Healey, 1986), pp. 50–1, pl. 134. Donald (1996), p. 37.]

[2] See Heinrich Philipp Conrad Henke's twelfth treatise accompanying Charles François Dominique de Villers's *Versuch über den Geist und den Einfluß der Reformation Luthers*, translated from the French by K. F. Cramer (Hamburg: Hoffmann, 1805), p. 548. A veritable 'bocca di venta' speaks from all these supplements to one of the most valuable books of our time!

[3] [Francis Plowden, *An Historical Review of the State of Ireland*, 2 vols. (London: T. Egerton, 1803).]

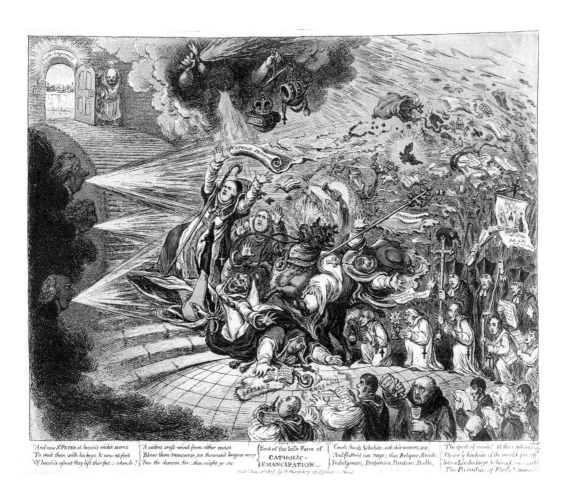

PLATE 33
James Gillray, *End of the Irish Farce of Catholic-Emancipation*, 1805.
Etching, hand coloured.

sure of the times and fear of wicked neighbours, has now caused milder
measures to be taken. An Act of Parliament in 1793 suddenly freed the Irish
Catholics from their most oppressive fetters and, with a few exceptions, has
placed them on a more equal footing with the Protestants. This means that
they are now permitted to vote in parliamentary elections and can be
awarded all kinds of civil and military honours, with the exception of the
very highest honours of all. Indeed, immediately after the most glorious
event in his entire administration, the Union with Ireland, it seemed that

Minister Pitt was about to lift even the few remaining restrictions contained in the above-mentioned Act of Parliament. For the amalgamation of the Irish Parliament with that of Great Britain, and the removal of all other barriers, obviated the fears aroused by the idea of the full equality of Catholics and Protestants under the previous separate Irish constitution. But, as we all know, Pitt's power and his entire prime ministership foundered on this very issue. The King, already jealous of his Protestant right of succession, and even more swayed by the clamour of zealots from the Church of England, refused altogether to approve Pitt's well-intentioned plan. The matter subsequently became the primary and most obvious cause of Pitt's resignation from the ministry. At any rate, the Catholics in Ireland could, and indeed should, have been satisfied with what they had gained in 1793, which was already far more than the rights enjoyed by Protestant dissenters and Presbyterians in England. But Pitt had raised hopes that they might achieve everything. And this alone spurred them on to make new and ever more pressing demands. More than two thirds of the entire population of Ireland were still not represented by their own people in Parliament. This amounted to at least three million people. (Some even speak of more than four million Catholics in Ireland, a country which seems to favour rapid population growth.) For parliamentary seats in the Lords and Commons were amongst the posts from which, under the terms of the 1793 Act, they were still debarred. Only thirty-nine of the highest offices in the state administration were not open to them; but according to the great English constitution, it must be possible for even a butcher's son to become Lord Chancellor. When Lord Grenville submitted the Irish petition to the House of Lords on 10 May, he gave a remarkable speech and quite rightly said: 'I will take the three professions, the law, the navy and the army. Let us look at the incentives which stimulate men to enter into each of those: we shall find they are a thirst for fame, and a praiseworthy ambition to rise to the highest and most eminent stations incident to each. – Is not the rankling of the barbed shaft with which oppression strikes the Catholics to the heart, produced by their not being allowed, however superior their ability, the chance of rising to the top of their several professions?'[4] For no Irish Catholic may become

[4] [Cf. *Parliamentary Debates* vol. IV for 1805 (London: Hansard, 1812), cols. 670–1.]

Viceroy, Keeper of the Privy Seal, Secretary of State, crown advocate, army general or admiral. Hardly had Pitt returned to the ministry last year, than the Irish plucked up their courage once more. After various meetings had been held, a solemn deputation led by the first Catholic Lord in Ireland, Lord Fingall, was sent to London late last winter. The deputation delivered a petition to both Houses of Parliament, asking for the Test Act to be repealed – 'emancipation',[5] in other words: for according to this act no Catholic is allowed to swear the oath of supremacy, and yet it is an oath which every higher state official must swear before taking up office. Anti-ministerial newspapers, such as the *Morning Chronicle* and Cobbett's *Weekly Register*, could barely disguise their glee at the frightful dilemma in which this petition placed Pitt. But Pitt used a fine distinction to extricate himself.[6] I still approve of the freedom and emancipation of the Irish Catholics in principle, he said, but I disapprove of the point in time which they have chosen to demand it. For 'it is not a question of rights, but of expediency'. One hardly needed powers of prophecy to have predicted this outcome with some certainty. After a very serious debate, which continued uninterrupted for several days in both Houses, the petition was rejected in the House of Lords by a majority of 129, and in the House of Commons by a majority of 212.[7] For several months before, a veritable hail of pamphlets had been published for and against the cause. These educated the wider public on the

[5] We know the meaning of the word 'emancipation' in ancient Roman usage: it signified the liberation of a child from paternal authority, which was very harsh in Roman law, leaving every son almost entirely subject to the arbitrary actions of his father. Before 1793 this sense of the word could indeed be applied to the Irish, who were ruled with a more than paternal rod. But for the period since 1793 this expression would be too strong, although artful people used it intentionally, to bring home to the Irish the oppressive nature of their governance and their blatant right to freedom. Pitt himself, however, seems to have had his own reasons for tolerating and retaining it.

[6] The experienced statesman is never stumped for these. Whether the art of making nice distinctions was transferred from the fencing academy to statecraft and diplomacy, or vice versa, may be decided by a new Machiavelli. This much is certain – because he has such talents, the great Pitt stands accused of Jesuitry. The following epigram is often repeated on these occasions:

> Why are the Papists' claims oppos'd by Pitt,
> Who is himself a special Jesuit?

[7] [*Parliamentary Debates*, vol. IV, cols. 843, 1060. For Pitt's words, cf. cols. 1014f.]

importance of the question, whilst the champions and spokesmen from both sides bravely fought it out in the public arena. The general conviction seemed to be that the matter was not yet ripe for a final decision. Fair-minded Catholics themselves remarked that, even if they had not been successful on this occasion, they had at least been listened to with respect. The great majority of their fellow countrymen still had justifiable doubts on the advisability of emancipation; it was therefore only right that they should continue to practise their arts of persuasion, and lay the matter to rest for a time.[8]

And indeed it will continue to be considered carefully. The Catholics maintain that they no longer have any secular connection with the Vicar of Christ in Rome and his hierarchical views. But it is this very point which makes their case seem more ambiguous. It was pointed out that one could not be a *good* Catholic without close association with the Pope, and that intolerance and proselytising are the essence of Catholicism. Many alleged that the Catholic priests in Ireland must have known all the details of the latest atrocities and crimes, having heard them in the confessional. Yet they had given nothing away.[9] It was also said that the much-vaunted tolerance towards ordinary Catholics was just a fashion. And fashion is by its very

[8] 'That the minor part should submit to the major', it says in one of the most widely read newspapers, 'is the law of human society. The Catholics may endeavour to inform the majority better, and it is the duty of the majority to attend carefully to their reasons and arguments, and in this state the important business must some time remain.' This conclusion may seem flawed and ridiculous. But in a state where great value is still attached to the freedom of the ballot box, it is quite logical. The great Napoleon, whose chief aim, according to the kind author of *Der Neue Leviathan* (Tübingen: Cotta, 1805), is to bring about a balanced mixture of the constitutions of Athens and Sparta, would resolve the knotty problems in quite a different way – by chopping through them.

[The author referred to is Paul Ferdinand Friedrich Buchholz.]

[9] This point was minutely discussed in a libel suit brought before the King's Bench on 11 July between the two great lawyers Erskine and Garrow, in front of a large audience. The caustic *Anti-Jacobin Review* severely rebuked the Catholic Titular Archbishop of Dublin, Dr Troy, on the grounds that he must have known all about the late rebellion in Ireland even before it broke out, through hearing Catholics' confessions. Yet he had not informed on them, as was his canonical duty. See *St James Chronicle* no. 7423 (11–13 July 1805).

[*The Anti-Jacobin Review and Magazine* (July 1805), 288f. Troy won an action for libel against the *Anti-Jacobin* over this allegation.]

nature ephemeral. How quickly the opposite principles might return to the general agenda![10] And are not the preparations for this already being made in south-western Europe? Already we hear the cry: 'No Popery, No King'.[11] All these concerns derive from the very nature of Catholicism. But other concerns emerged in England too. For many years the heir to the throne has had as his publicly declared, inseparable lover a fervent Irish Catholic, who has complete power over him. The Prince and the entire Opposition therefore come under suspicion, simply because of their passionate participation in the Irish petition. This secret motive had an incredible influence on even the most tolerant and enlightened part of the nation.

It is these private thoughts that Gillray brings into the open in the caricature before us. If ever a caricature in our gallery was political, it is this one. But it also fairly drips with poisonous mockery, and has been dipped in gall at least three times. In addition to the Bible and the prayer book, Milton and Shakespeare are the two great works of national literature found in every household. Taking both together, some twenty to thirty thousand copies are sold annually at home and in the colonies. Many people from the

[10] Apart from John Mitford, Lord Redesdale's *The Catholic Question. Correspondence between . . . Lord Redesdale . . . and . . . the Earl of Fingall* (Dublin: 1804), the most forceful pamphlets against Catholic emancipation are: *The Roman Catholic Petition Unsanctioned, Therefore an Unsafe and Unconstitutional Ground of Emancipation* (London: Symonds, 1805) and Thomas Le Mesurier's *A Serious Examination of the Roman Catholic Claims, as Set Forth in the Petition, Now Pending Before Parliament* (London: F. C. and J. Rivington et al., 1805). For German readers, there is the detailed essay by Hegewisch in *Minerva* 2 (June 1805) 529–48, 'Ueber die Emancipation der Catholiken in Irland', with Archenholz's thought-provoking introduction. Even the cool-headed, impartial Hegewisch here agrees with the ministerial adjournment of the petition, for reasons which every true Protestant in Germany will also find enlightening. Incidentally, all history lovers will certainly wish the promised *Geschichte der Revolution in Irland* (by Hegewisch) to be published very soon. Even the immortal Schiller at one time thought this subject worth re-working. After the completion of his history of the revolt in the Netherlands, he had in mind a treatment of the Irish insurrection, of which our knowledge is still very one-sided and superficial. For readers who would like to peruse these latest proceedings on emancipation in greater depth . . . a work has just been published by the bookseller Stockdale in London: *The Speeches at Length in Both Houses of Parliament from the 25th March to the 14th May on the Roman Catholic Petition.*

[Hegewisch published his *Uebersicht der Irrländischen Geschichte* in 1806.]

[11] [Presumably a reference to the renewed oppressiveness of the Inquisition and of reactionary Ultramontanes within the Catholic church in Spain, c. 1801–5, and liberal resistance to this.]

class which we would call commoners know both poets almost by heart. Burlesque and parody must therefore allude to them if they are to hit the mark with Britons. On this occasion it was a famous passage from Milton's so-called 'Paradise of Fools' in the third book of his *Paradise Lost* which gave our grateful caricaturist the text for a bitterly satirical commentary on the advocates and supporters of Irish Emancipation. Having fought through the chaos of wind and darkness, Satan is now wandering on the convex outer rim of the universe, where he comes upon a place designated for man's future follies; the limbo of all vanity and fatuity. Milton doubtless had in mind Ariosto's similar poem about the moon in *Orlando Furioso*, when he composed this famous episode.[12] He gives free rein to his satirical leanings, which all great British poets have inherited and which go by the name of humour. The list of things which the poet takes into this little corner of the universe is reminiscent of an auction catalogue in an old junk shop. It is the ornaments, splendours and symbols of the Roman Catholic religion which come off worst of all, for these vain trinkets and the love of ostentation must have been doubly abhorrent to the strict Presbyterian icon-oclast.[13] It is from this passage that Gillray has taken the lines he places under the caricature. But in order to understand the passage in context, it should be expanded a little. Here it is:[14]

[12] *Orlando Furioso* (1516), Canto XXXIV, stanza 70. After Milton, Pope also made use of it in his *Rape of the Lock*.

 [Canto V, lines 113 f.]

[13] It is well known that Milton's riposte to the *Eikon Basilike* (said to have been written by King Charles I himself) gained him a great many transient supporters, but also some bitter, lifelong antagonists. He called this work *Eikonoklastes* (1649). Already on his journey through Italy, the English Jesuits in Rome threatened his life, because of his vehement remarks on papal abuses and ritual. See *The Life of Milton* by William Hayley (London: T. Cadell and W. Davies, 1796), p. 50. In later years he himself wrote a polemical work on the best way to curb the growing power of the papacy. See Dr Johnson's *Lives of the Poets*, as translated by von Blankenburg.

 [I.e. *Johnsons biographische Nachrichten*, translated by Christian Friedrich von Blankenburg, 2 vols. (Altenburg: 1781–3). The reference occurs in the unsympathetic life of Milton, written in 1779. *Lives of the English Poets, by Samuel Johnson*, edited by George Birkbeck Hill, 3 vols. (Oxford: Clarendon Press, 1905), vol. I, p. 148.]

[14] [*Paradise Lost*, Book III, lines 444–7, 474–6, 481–2, 484–96.]

. . . but store hereafter from the earth
Up hither like aëreal vapours flew
Of all things transitory and vain, when Sin
With vanity had filled the works of men:
. . . idiots, eremites and friars
White, black and grey, with all their trumpery.
Here pilgrims roam . . .
They pass the planets seven, and pass the fixed,
And that crystalline sphere whose balance weighs . . .
And now St Peter at heaven's wicket seems
To wait them with his keys, and now at foot
Of heaven's ascent they lift their feet, when lo
A violent cross wind from either coast
Blows them transverse ten thousand leagues awry
Into the devious air: then might ye see
Cawls, hoods and habits with their wearers tossed
And fluttered into rags, then relics, beads,
Indulgences, dispenses, pardons, bulls,
The sport of winds! All these upwhirled aloft
Fly o'er the backside of the world far off
Into a limbo large and broad, since called
The Paradise of Fools . . .

So it is here, in these *intermundia*, the empty spaces above the earth's sphere, that the scene is set, which our mocking artist describes in his caption as 'the end of the Irish farce'. The whole amusing mirage, this vain hallucination, takes place in the limbo of vanity, the Paradise of Fools. All is now clear at a glance. A papal legate (the man riding the bull) thinks he is making a solemn approach, with all the pomp and pageantry of the Catholic rite, to the stairway leading to heaven, where St Peter holds open the gate. The procession is just marching over the globe. The road leads through England and Ireland, for that is the procession's home base. It would not be the first time that papal legates have arrived in lordly splendour, with no regard for the comfort and salvation of Old England.[15] The conquering

[15] More than one papal legate has ominously arrived in London, demanding rather more than just Peter's Pence. We need only recall the entry of Cardinal Pole during the reign of Queen Mary,

procession advances with quickened step and has just gained the foot of the golden stairway to heaven. Indeed, the vanguard has already made a bold attempt to climb the lower steps, when suddenly, the heads of three fat-cheeked children of Aeolus appear from clouds, pregnant with misfortune, and blow their whirlwinds and hurricanes into the teeth of the holy brethren, with such irresistible force that they fall back in utter confusion. To complete the horrific scene: overhead there are thunder-clouds criss-crossed with lightning, from which the guardian of paradise, the angel with the flaming sword, appears and hangs a pair of scales. The sight of the scales must make the rashly encroaching comrades-in-arms below feel themselves totally annihilated. In wild confusion, above the heads of those blown back by wind and lightning, flies the whole apparatus of relics, indulgences and other baggage which the Roman Curia has traditionally used to cushion the consciences and unlock the coffers of the faithful. All this trash has been ripped from the folds of the terrible petition scroll, which fell from the hands of the man on the flank. What a scene of chaos and wild disorder! We must summon all our presence of mind lest we fall into the clutches of dizziness, that powerful giant, whom an inventive modern poet places on the summit of the Swiss Schreckhorn mountain.[16] After all, they are only phantoms and vain apparitions of the *fata morgana* in Gillray's mind. Let us examine with cooler heads the individuals in the procession, and all the sorry consequences and the signs of alarm and flight.

A single attentive glance at the procession itself immediately reveals the malice of the dastardly caricaturist. It is made up of all the members of the old and new Opposition. They have been disguised as passionate defenders of the Irish Catholics' petition, and are assigned a variety of roles in this priestly farce. It is, as we have said, a solemn procession of the latest papal *Legati a latere* in Great Britain and Ireland. Its aim is to reach the holy of

Footnote 15 (*cont.*)
of bloody memory. At the sight of him the Queen, fancying herself pregnant, declared that she felt the child leap in her womb.
 [David Hume, *The History of England, Under the House of Tudor*, 2 vols. (London: A. Millar, 1759), vol. I, p. 372. *LuP* cites Basil's German edition, vol. VI, p. 158.]
[16] Jens Immanuel Baggesen in Canto 7, *Parthenais oder die Alpenreise. Ein idyllisches Epos in 9 Gesängen* (Hamburg: 1804), which has been much too one-sidedly criticised and denigrated.

holies; the gates of papal supremacy and power. We know from church history the extensive power which papal legates like these have exercised as grand pastors of the provinces they have entered.[17] Who is the leading actor of this piece? Whom has the Holy Father vested with the highest ecclesiastical honour? Gillray has deliberately positioned the groups so that our gaze is involuntarily directed towards the main figure. The fat man on the fire-snorting bull is the hero. The cardinal's hat and the whole regalia leave us in no doubt as to His Eminence's political and religious character. His mission is clearly described on the standard fluttering from the triple cross: 'Catholic Emancipation' we read in large letters. Apocalyptically he holds the magnificent Bull of Mercy and Blessing with seven seals in his hand, inscribed: 'Hierarchical Powers of ye Legate Cardinal Volpone'. So this well-known figure, already clearly recognisable, is further identified by name: Volpone, Reynard and Fox are all just different names for the same foul predator, which has always played such a masterly role as apologist, speaker and privy councillor, from Aesop's animal fables down to Casti's *animali parlanti*.[18] And was it not Fox who submitted the petition of the Irish Catholics to the House of Commons, mustering all his eloquence and persuasive arts in their support? But why did the caricaturist place this horned beast under him, when the Neapolitan palfrey or Roman mule would have looked so much better? We need only read the inscription on the collar. It is the 'Bull of Saint Patrick', the patron saint of Ireland. It is appropriate for anyone who carries out such a chivalrous fight for the saint's protégés as Fox does to ride on the saint's animal. But there is also a double entendre or pun in the use of this beast of St Luke and St Patrick.[19] It was a wicked idea to

[17] See the footnote to Hume's *History of England, Under the House of Tudor*.
[vol. I, p. 371.]

[18] [The Italian poet Giovanni Battista Casti published his political satire *Gli animali parlanti* at Paris in 1802.]

[19] The papers and other paraphernalia (which Milton, in the passage below the print, awards a fate similar to that of the famous Sibylline Books – cf. *Aeneid* Book VI, line 75) . . . include papal bulls. But 'bull' also means an ox, or male cattle. Here we see the storm hurling back both a *bull* and a *papal bull* in the hand of the bull-rider. In some parts of Upper Saxony the biting north-east wind is called a 'Ziegenschinder' (goat-flayer). By analogy, the gust of wind here could be called a bull-biter. But there's more. 'Bull' also, of course, denotes a nonsensical, foolish idea, and as such is an Irish national institution. The ingenious Miss Edgeworth

give the bull Bonaparte's medallion as an amulet or pendant; so he is the secret talisman, the saint's saint.

If we take legate Fox to be the real centre, the *punctum saliens* or *desiliens* of the procession, we must now also direct our attention to the vanguard. This consists of four very important personages, splendidly bedizened with ecclesiastical jewels and robes of honour. At the front is a consecrated prelate with his crozier, and all the insignia of a metropolitan bishop. He is the chosen instrument of mercy. It was he who presented the petition in which so many other jewels were carefully concealed. But the power of the aeolian bellows which blast the leader is truly awesome. Despite his size, he falls back, dropping the scroll, which unfurls in mid-air, and all sorts of precious rarities spill out. If you were to ask who it is that Gillray has hidden behind this disguise, we would answer you with another question: who was it that submitted the petition to the House of Lords? He must be the leader. You will recall from the newspapers that it was Lord Grenville who solemnly presented the Catholic petition to the House of Lords on 10 May, in a three-hour speech, which was one of the most eloquent apologies for the Catholic cause ever spoken. And Lord Grenville figures here as the bishop. Similarly, no one conversant with English political physiognomy will fail to recognise in the bespectacled Dominican-General standing behind him the leader of the Grenvilles, the Marquis of Buckingham. The Carmelite monk, falling beneath these two figures, betrays the fact that it is all masquerade. It is the brave Irish Earl Moira, currently *generalissimo* in Scotland, fresh in our memories as a close friend and adviser to the Prince of Wales. There is nothing worse than the condition of a monk who allows himself to be defrocked

Footnote 19 (*cont.*)

published a book dedicated to a defence of the Irish a few years ago, in which she shows that the infamous 'Irish bulls' are at home more or less the world over. However, not only is everything about Gillray's ox-ride thoroughly Irish: he also, for fun, makes it so absurd and preposterous that the double meaning is highly appropriate. . . . Incidentally, Milton did not disdain the pun on the word 'bull' either, in one of his polemical works; for he describes the expression 'Roman Catholic' itself as a 'Roman bull', since it actually means something as contradictory as 'universal schismatic'. See Johnson's *Lives of the Poets*, vol. II, p. 118 in von Blankenburg's edition.

[*Essay on Irish Bulls* by Maria and Richard Lovell Edgeworth was published in London in 1802. *Lives of the English Poets, by . . . Johnson*, edited by Hill, vol. I, p. 148.]

(*moine défroqué*), or lets us peep under his habit. Here his identity is betrayed by the general's uniform we can see under his robes. But the wicked caricaturist has spited our warrior in two further ways;[20] only in an *English* political caricature would they be indulged, instead of being indignantly refuted and avenged. Even more malicious, if that is possible, is the robing and exposure of the lady who completes the forward group. She is dressed as an abbess, and the puffs and blasts of the bellows opposite have landed her in the same equivocal position in which, according to the inspiration of a witty Greek comedian, the fair goddess of youth lost her office as cup-bearer in the banqueting hall of the gods. The open book before her exposes this religious masquerade: 'by the Brighton Abbess, System of Education for the benefit of Protestant Children'. We still have fresh in our minds the ascension to heaven of little Miss Seymour's foster-mother.[21] Who could be meant by this abbess, but the chaste and respectable Mrs Fitzherbert herself? The bulging contours and plump hands and feet shown here are the spitting image of this Irish lady, who enjoys the favour of the Prince of Wales. We all know of convent boarding-schools for girls, run by nuns. Abbesses are also very zealous in this respect. Those who have read Diderot's *Religieuse* will find many similarities between his second abbess and ours.[22] But finally, the scoundrel of a caricaturist was also thinking of a definition of the word 'abbess', which could only have been devised and employed in that sink of iniquity, the capital city on the Seine, where even the most sacred thing is defiled, profaned and vilely perverted.[23] The manner in which our abbess places her right hand on Ireland and her left on England is very ominous, thereby forming the *copula* or hyphen between the two kingdoms.

The rear of the procession is formed by several priests, in whose costume

[20] The strange noose formed by the red reins of Fox's parade bull, dropping straight over Moira's head, could give rise to further ideas. But even more striking is the fact that the general's disastrous somersault leads not to a broken leg, but a broken sword. An officer with a broken sword!

[21] [Gillray's *The Guardian-Angel* (1805), a burlesque on a painting by Matthew Peters, satirising Mrs Fitzherbert's Catholicism, was in *LuP* 15 (1805), 76–94, pl. 1. *BM* 10389.]

[22] 'C'est une petite femme toute ronde, cependant prompte et vive dans ses mouvemens' etc. Denis Diderot, *La Religieuse* (Paris: Buisson, 1796), pp. 208f.
[Written in 1760.]

[23] [A bawd. This sense was also current in England.]

and features we immediately recognise the holy Jesuit fathers. For even as
they take part in such a triumphant church procession, these pious men, aptly
called the janissaries of the Vatican gate, emerge from their cunningly
assumed incognitos. But try as they might to disguise themselves, we recog-
nise them immediately. At the front, looking terrified and appalled, is Tierney,
always so susceptible to every ministerial breeze. A Jacobin cap tops the cross
in his hand, with an altar bell on the tip: quite in the spirit of an order whose
basic maxim it is not only to be all things to all men, but to turn all men into
all things. Behind him fanatical Windham waves his banner with a tremor of
ecstasy. Fire pours from the scroll in his right hand, lighting the pyre painted
on the bloody flag in his left hand. Here Gillray reveals himself as an expert
in pyrotechnics. His witty rockets fire in all directions, lighting everything up
to marvellous effect.[24] Right at the back Erskine, the great lawyer and orator
of the King's Bench, carries quite new 'Instructions for the Advocate of the
Holy Order' (of Loyola). This eloquent lawyer is retained in advance for

[24] The scroll from which the flame shoots out bears the title *Weekly Register*. This is the fire-and-
brimstone-snorting journal published weekly by so-called 'Porcupine' Cobbett . . . It is generally
believed that Windham offers it his Cyclopean services, hurls its political lightning and forges its
thunderbolts. In the sheets which appeared in April and May of this year, at a time when the Irish
petition was pending in both Houses of Parliament, Cobbett zealously championed the Catholic
cause against the minister. This is symbolised by the flames shooting from the *Weekly Register*.
Windham's character is full of political bitterness, and, once this is brought into play, he can
sanction the most violent and bloody measures, even though in private life he is the mildest and
fairest of men. Thus, he once spoke in defence of the barbaric bull-baitings, on the grounds that
they guarded the true British national character against sentimentality and effeminacy. This is
why the caricaturist places the bloody flag of the Inquisition in his hand. It shows an *auto da fé* in
Smithfield at its height. Smithfield, one of the largest open spaces in the City of London, is now
only famous for its great meat market and the diversions of Bartholomew Fair, which even
Hogarth thought worthy of his graver. But there is still a large stone marking the spot where
people were tied to the stake and burned – Protestants under Henry VIII and Bloody Mary, and
Catholics under Elizabeth. See Thomas Pennant's *Some Account of London*, second edition
(London: R. Faulder, 1791), pp. 189–90: 'In *Smithfield* was also held our *Autos de Fé*; but, to the
credit of our *English* monarchs, none were ever known to attend the ceremony . . . The stone
marks the spot, in this area, on which those cruel exhibitions were executed' etc. Gillray is
therefore saying that Windham is a man who, in honour of God and his own opinions, would
revive the old scenes of horror at Smithfield, and have heretics roasted alive, as we see *in effigie*.
The sharpest barb of the satire lies in the fact that the scroll becomes kindling for the pyre. But
the words which are legible above the banner – 'Vigour beyond the Law' – are very appropriate.
[Hogarth actually represented *Southwark Fair* (1733).]

every important case; he is one of those black-and-white moralists, who live their lives according to Ovid's principle: to make 'Candida de nigris et de candentibus atra' (black white and white black), and has often jokingly been compared to the 'devil's advocate' in a papal canonisation. Perhaps the caricaturist had that title in mind when he conceived this figure, and placed these instructions in the talented man's hands. In addition to these three superiors of the order, there are various other sly dogs of similar cut and costume peeping out, whose identities we do not know. Very significantly, one of this group is waving a little banner in honour of 'Purgatory', which seems to be touching the fuse by which the other purgatorial fire is lit.

No such splendid procession in honour of the Church would be complete without choir boys and ministrants. And indeed, five little altar boys, kneeling humbly to make themselves smaller, form the cortège of the procession, carrying all sorts of holy implements. The expectant, fawning and submissive nature of these servile spirits is portrayed with striking veracity. All this is masquerade and carnival farce too. Grattan, the famous Irish parliamentary orator, glides ahead of the others on his knees, holding the censer; its proximity to the hind quarters of the bull reminds us of another *argumentum a posteriori*, as someone once called the burning of incense at the back of the church. Then comes Sheridan with a golden *gloria* or sun, the like of which never shone above a monstrance. (The letter N can clearly be made out under a little crown.[25]) He is followed by Grey, bearing the altar bell, and then Lord Holland, bringing in the holy candle and lantern – a fire lit in Paris. (The title of the placard under his arm, 'Religion à la Paris', reminds us of a certain pilgrimage to the First Consul in Paris, shortly after the signing of the Peace of Amiens.) The son of the recently deceased Marquis of Lansdowne, Lord Henry Petty, brings up the rear. In the absence of any other distinguishing feature, a pun gives him away.[26]

All great processions include a host of attendants, acolytes from other pious brotherhoods, sacristans and vicars. The tireless satirist has made sure

[25] [For Napoleon. Fox's notorious visit to Napoleon's court is also alluded to below.]

[26] In the missals and prayer books of the Roman Catholic liturgy we find the 'Petty prayer of the Fathers', as it is called in English. But Petty is also the name of the nobleman who is portrayed here as an altar boy, singing to the tune of *his* father, a staunch Opposition man . . . Thus, a double pun is hidden in this title.

that he has provided us with a large auxiliary corps. One need only glance at the bottom row, marching in formation. But although the English caricaturist may have permitted himself to mock the papacy and its decrees in a bitter attack impelled by party hatred,[27] it is hardly fitting for us to be the shield-bearers and heralds in this onslaught of malicious glee; nor indeed do we relish the role. We would rather turn our attention to the mercy-seat, the palace of heaven which this overly political, indeed quite mercantile[28] Jesuit pilgrimage is heading for. The road, the *santa scala* (or 'holy stair-

[27] For those readers who would like to pursue this further, the following information about the general character of the protagonists should suffice. The gentleman at the front with the tonsure, and wearing the blue chasuble, is the Duke of Clarence, the ever-loyal brother of the Prince of Wales. It is well known from earlier exhibits in this gallery that his mistress is the fat comic actress, Mistress Jordan. Do the words 'Holy Water from y^e River Jordan' now need any more comment? Clarence is followed by the Duke of Bedford in the red chasuble. He is heir to the estates and agricultural projects of his late elder brother Francis, and carried off first prize at the last great competition for fattened beef and mutton, held every Christmas at Smithfield market. Oil cake feed is of great use to this large-scale feeder and grazier. It is now 'transubstantiated', 'turn'd into real Mutton', making (somewhat greasy) meat. Woburn Abbey is the Duke's most splendid country residence in Bedfordshire. It is famous for its grand annual sheep-shearing, held every June, when around four hundred rich farmers and cattle breeders devote an entire week to weighing and judging the quality of wool and carcasses. (See 'Englische Miscellen' in the *Allgemeine Zeitung*.) Hence the allusion in the second page of the missal held by the abbot and chief shepherd of Woburn: 'with the method of feeding ye flock at Woburn Priory' it reads. The Duke of Norfolk, backing him up, pours good bottled porter from Whitbread's London brewery into the rinsing chalice, in order to transfer it into the living rinsing bowl of his own body. Another team of five sings Vespers; Sir Francis Burdett and the Earl of Derby at the front, then Lord Carlisle, Bob Adair, the author of the political articles in the *Morning Chronicle*, and Lord Spencer right at the back. We all know the meaning of 'chanter vêpres' (to sing Vespers) when it is applied to night revellers.

[28] Pilgrimages and High Mass on holy days have always encouraged trading and dealing, as well as population growth. Karl Dietrich Hüllmann's interesting *Deutsche Finanz-Geschichte des Mittelalters* (Berlin: Frölich, 1805), pp. 185f . . . reminds us how episcopal palaces and abbeys in Germany encouraged commerce to thrive. Amongst the most speculative and profit-hungry people on earth (as the present-day English could be described), it is not hard to imagine that calculation is involved in the promotion of the Catholic petition. Fox, Sheridan, Tierney and other actors in this spiritual farce might well profit from the overthrow of the Protestant Ascendancy in Ireland. Cf. the famous pamphlet *Thoughts on the Protestant Ascendancy in Ireland* (London: J. Harding and Dublin: J. Archer, 1805). At least four refutations, 'strictures' etc., were published against it.

[The pamphlet is attributed to James Mason.]

way'[29]) from which these pilgrims are so violently rebuffed, is clear to see, in its positively Homeric splendour.[30] But where does *this* lead? The radiant gate and gate-keeper appear in all their glory. St Peter, the golden keys of authority in his hand, holds Heaven's gate wide open, and those below gaze upon it longingly.[31] But this is the Papist heaven, open only to believers, and written above it in huge letters is 'Popish Supremacy', the stumbling block for all who must swear the oath of 'Royal Supremacy', according to the Constitution.[32] No explanation is required for the shewdishes and

[29] This, of course, is the name for the flight of twenty-eight marble steps, which Pope Sixtus V ordered to be built into a chapel, constructed by the architect Fontana, and which Christ is said to have climbed to Pilate's judgement seat. One may only touch the steps with one's knees. Anyone who shuffles up them on his knees, and says an Our Father and a Hail Mary on each step, is given indulgence for three years and forty days. See Joseph Jérôme Le Francais de la Lande, *Voyage d'un François en Italie fait dans les Années 1765 et 1766*, 8 vols. (Venice and Paris: Desaint, 1769), vol. III, pp. 393f.; or an even more detailed description in Johann Georg Keyssler's *Neüeste Reise durch Teutschland, Böhmen, Ungarn etc.* (Hanover: Förster, 1740–1), letter XLIX, p. 693. All travel writers, from Volkmann to Stollberg, have borrowed most frequently from this source.

[St Helena (c. 257–c. 336) is said to have brought the marble *Scala santa* to the Lateran in Rome. In 1585–90 it was removed and housed in a separate building. Today it is covered in wood.]

[30] Homer several times refers to the floor of Olympus as a paving of gold. The stairway to heaven here is also covered with sheets of gold. But we might take the yellow for a straw mat, by which the caricaturist would, of course, intend an even more malicious interpretation.

[31] According to Milton's expression 'St Peter at Heaven's *wicket seems* (for it is a mere apparition) to wait'. Wicket, 'guichet' in French, describes a small gate within a larger gateway. As Newton has already remarked in his notes on this passage, it was intentionally chosen by the poet as a 'low phrase', to characterise the worthless riff-raff he had in mind here. The Abbé Jacques Delille, in his recently published translation of *Paradise Lost* (*Paradis perdu, traduit par Jacques Delille*, 3 vols. (Paris: Giguet et Michaud), 1805), has chosen to omit this entire passage, substituting for it the highly political image of fools who wish to devise new constitutions and reform states. 'J'ai eu plus d'une raison de ne pas me charger de la traduction entière de ce morceau', he writes in his 'Remarques', vol. 1, p. 292. The most pressing of these reasons can be guessed without prophetic gifts.

[32] Those familiar with English history will know what bloody executions the King perpetrated in his struggle for 'Supremacy', or supreme power over the church. Anyone who wishes to take his seat in Parliament, or to take up one of the highest offices of state, must recognise the King as primate of the church through swearing the 'Oath of Supremacy'. See Carl Friedrich Stäudlin's *Kirchliche Geographie und Statistik*, 2 vols. (Tübingen: Cotta, 1804), vol. 1, pp. 137f. Anyone who goes over to papal supremacy is therefore a perjurer, unless he is a so-called 'Non juror', as the Jacobites and Tories once were.

shewbreads placed before the worshippers. They glow with holy effulgence on the altar inside. Even the holy fishes have not been forgotten.[33] It has got to the stage where the most important public men and counsellors to the nation, under the convenient pretext of tolerance towards their Catholic brothers in Ireland, are guilty of perjury against the Constitution, and are defecting to the Pope. 'Sic itur ad astra!'

But the path to this *latium* is not as easy as this pious Aeneas and his entourage might think. Wind and storm, thunder and lightning are the dangerous hostile powers which oppose them, more violent even than the storms which beset the Trojan fugitive, and, worst of all, they are far more certain of success. First the terrible three-headed brood of Aeolus blows terror and destruction at him from one side.[34] You will recall the scene in the first book of the *Aeneid*:

The winds formed line, and charged through the outlet which he had made. With tornado blasts they swept the earth. They swooped down on the sea. Winds of the east and the south, and the African wind with squall after squall, came tearing from their depths, and set the long rollers rolling to the shores. Now men were shouting and tackle shrieking. In a moment the clouds had wrested from Trojan eyes the sky and the light of day . . . The thunder cracked in heaven's height, and in the air above a continuous lightning flared.[35]

[33] Students of art and history will know all about the ridiculous hieroglyphs which arose from the abbreviation ICHTHUS used in early Christian times. According to the Greek initials, it means 'Jesus Christ, Son of God, the Redeemer'. But if it is written as a single word, it means 'fish'. There was no end to the allegories and allusions to Peter's miraculous draught of fishes. Hence the Pope's 'fisherman's ring' and a number of Christian emblems in stone carvings in churches etc. See Giovanni Battista Passeri's treatises in his edition of Antonio Francesco Gori's *Thesaurus Gemmarum Antiquarum Astriferarum*, 3 vols. (Florence: 1750), vol. II. These little fishes have frequently been abused. The immortal author (Johann Gottfried Herder) of the *Ideen zur Philosophie der Geschichte der Menschheit*, 4 vols. (Riga and Leipzig: Hartknoch, 1784–91) vol. IV, p. 67, said very aptly that 'for centuries the *pisciculi christiani* swam in a cloudy element'.

[34] Do those with eyes to see still need a name, to remind them of the identity of the chief of the four winds, the *Africus* (who is not only *arbiter Adriae*, as Horace says, but also *arbiter Oceani*)? It is Pitt himself; and beneath him Eurus-Hawkesbury, and lower still Notus-Sidmouth or Addington, are working hard with their rhetorical bellows in the Upper and Lower Houses.

[35] [Book I, lines 81f. Virgil, *The Aeneid*, translated by W. F. Jackson Knight (Harmondsworth: Penguin, 1982), pp. 29–30.]

The last line is literally fulfilled here. Flashes of destructive lightning come from above. It is the avenging angel, whom God placed before the gates of Paradise. Here we should allow Milton (*Paradise Lost*, Book XII, lines 633–6) to speak:

The brandished sword of God before them blazed
Fierce as a comet; which with torrid heat,
And vapour as the Libyan air adust
Began to parch that temperate clime;

But there is more to come. The scales have been associated with the twelve great animal star signs for a good reason. These are the same scales which Homer's Jupiter hung from the clouds, when he weighed the fate of the Greeks and the Trojans, of Hector and Achilles. They are the *libra* which Milton's Eternal takes from the zodiac at Satan's battle with Gabriel, the scales which ordain the archangel's victory,[36] and which our compatriot Gleim uses to determine the victory at Rossbach in the songs of the old grenadier:

Amidst starry chimes God weighed up
The war the armies were fighting;
As He weighed, Prussia's scale fell
And Austria's scale rose.[37]

[36] Compare Homer's *Iliad*, VIII, 69 and XXII, 209, with Virgil's *Aeneid*, XII, 725, and Milton's *Paradise Lost*, IV, 996f. As Newton has already pointed out in his *Remarks*, Milton gave novelty to his image of Jehovah weighing souls by taking the divine Creator's scales, 'wherein all things created first he weighed' (line 999), from the zodiac. It is very likely that Homer's description of the balances of Jupiter came from an ancient astrological image, for the heavenly scales are already to be found in the earliest Egyptian constellations. See Charles François Dupuis, *Origine de Tous les Cultes, ou Religion Universelle*, 7 vols. (Paris: H. Agasse, l'an III, 1795), vol. VI, p. 406. . . . The scales of fate on a Greek vase painting are particularly remarkable: Aubin Louis Millin de Grandmaison has an engraving of them in his *Monumens Antiques, Inédits ou Nouvellement Expliquées*, 2 vols. (Paris: Didot, 1802 and Paris: Imprimerie Royale, 1806), vol. II, Book I, p. 33, and pl. IV.

[37] [Johann Wilhelm Ludewig Gleim, 'Siegeslied nach der Schlacht bei Roßbach, den 5. November 1757' in *Sämmtliche Werke*, 8 vols. (Halberstadt: im Büreau für Literatur und Kunst and Leipzig: F. A. Brockhaus, 1811–41, reprinted Hildesheim and New York: Georg Olms Verlag: 1971), vol. IV, pp. 28–44.]

Here these same scales hang from the thunder-clouds as the lightning breaks forth.[38] And, as in Milton, Satan is dismayed, and flees at the sight of the scales —

> The Fiend looked up and knew
> His mounted scale aloft: nor more; but fled
> Murmuring; and with him fled the shades of Night.[39]

Like Satan, the crowd in our caricature retreats in horror and profound fear at the sight of this sign in heaven and earth.

But we still need to explain the final effect of the storm, which sends everything flying – the colourful mass of sacred bric-a-brac, caught in a whirlwind in the upper regions, flying to the Paradise of Vanity and Fools. Half a dozen of the most garrulous sextons and sacristans would exhaust their stock of pious chatter, and would need to borrow Homer's ten tongues and mouths to boot, if they wanted to describe properly all that has broken free from the Catholic petition: all the flying objects which envelop the procession in the most ridiculous confusion. Somewhat lower down, near the ground, we spy some valuable papers. For centuries these have been as precious to the Roman Curia as all the gold and silver mines in Potosi and Mexico (the profits of which our much-praised, admirable compatriot Alexander von Humboldt was told about so trustingly by the New Spanish Viceroy).[40] At the front flutters the fat book of papal 'Decretals', then a long list of miracles, then the

[38] No explanation is needed for what is rising and falling in the scales. The Bishop's mitre with all its appendages shoots up in the air. The King's crown sinks by its own excessive weight. It rests on a Bible, labelled 'Truth'. This recalls a satirical picture from the time of the Reformation, in which Luther and his Bible translation in one scale make the Pope and his entire clergy in the other scale fly high in the air. A remarkable depiction of this kind can be found in the Gothic House in Wörlitz Park.

[No record of this painting can be found at Wörlitz Palace, Saxony-Anhalt. We are grateful to Dr Reinhold Alex of the Kulturstiftung Dessau-Wörlitz for the search he undertook. The design *LuP* describes seems to be a variation of the kind where Christ in one scale outweighs the Pope and Cardinals in the other. Cf. R. W. Scribner, *For the Sake of Simple Folk: Popular Propaganda for the German Reformation* (Cambridge University Press, 1981), p. 116, fig. 88.]

[39] [*Paradise Lost* Book IV, lines 1013–15.]

[40] [Following a five-year exploration of South America (1799–1804), Baron Friedrich Heinrich Alexander von Humboldt (1769–1859) published his *Essai Politique sur le Royaume de la Nouvelle Espagne*, 2 vols. (1811) in which he drew attention to the immense mineral resources

document of 'Infallibility', sealed by the papal fisherman's ring and finally confirmed by the famous bull *In coena domini*. Then, in order to finish the business lock, stock and barrel, we find a fat bundle of other very lucrative documents from the apostolic chancellery. There are 'Dispensations', 'Anathemas of the Church', 'Indulgences' and 'Absolutions', all tumbling from the packet of papers as it bursts apart. More is hardly needed, yet there is another large volume of penances and mortifications of the flesh above, looking just as if it were fighting in Swift's famous 'battle of the books'.[41] Above these flies a whip for flagellation. A large sack of 'Relicks', or 'Heilthümer' as our forefathers used to call them, sails in an arc overhead. A violent explosion has burst this stuffed sack, and it has already spewed out most of its entrails: 'Virgin's Hair', a bottle of 'Virgin's Milk', models of the 'santa casa' at Loretto being carried off by angels, and many other little things which we will gladly leave to our readers to decipher.[42] After all this seed has

of Mexico, and of the silver mines in particular. The book was immediately translated into English by J. Black (London: 1811), and led to the Mexican mining industry coming under English control after Mexican independence. In 1830 many shareholders were ruined and Humboldt was held responsible in the English press. Cf. Douglas Botting, *Humboldt and the Cosmos* (London: Sphere Books, 1973), pp. 209–10.]

[41] [Jonathan Swift's *A Full and True Account of the Battel Fought last Friday, Between the Antient and the Modern Books in St. James's Library* (1704) had already inspired Hogarth's print *The Battle of the Pictures* (1745), which must in turn have been a source for Gillray. Ronald Paulson, *Hogarth's Graphic Works*, 2 vols. (New Haven and London: Yale University Press, 1970), vol. I, pp. 189–90.]

[42] To help our readers a little, we will copy just one passage from the richest anti-papist armoury, without scouring away the rust of the archaic language. It is the speech of the 'porteurs de rogatons' or relic-pedlars. 'Ils ne se contentoyent en desployant leur belle marchandise, de dire . . . Voilà en ceste phiole du sang du Iesus Christ recueilli sous la croix par la vierge Marie: item, Voilà en cest'autre phiole des larmes de Iesus Christ: item, Voilà des bandelettes dont la vierge Marie emmaillottoit Iesus Christ en Egypte: item, Voilà *du laict de la vierge Marie*; item, Voilà *des cheueux de la vierge Marie* . . . nous lisons d'un prestre de Gennes, qui retournant de Leuant, se vanta d'auoir apporté de Bethlehem ledict souffle de Iesus Christ', (. . . gardé sogneusement par sa mere depuis le temps qu'il estoit petit enfant) . . . 'et du mont Sinai auoir apporté les cornes qu'auoit Moyse descendant d'iceluy.' Henry Estienne, *Apologie pour Hérodote*, new edition, 3 vols. (La Haye: chez Henri Scheurleer, 1735), vol. III, p. 234. Cf. vol. II, p. 367, where you can read an even more ridiculous list from an uncastrated edition of Boccaccio's *Decameron*. The end of that first passage, by the way, is reminiscent of Leopold Friedrich von Göckingk's *Reliquien*: 'The Prior allowed us to go to a cupboard, and showed us a small piece of the ladder which Jacob once saw in a dream.'

been sown, some holy animals are left on the earth. These now crawl forth. First comes the serpent of Paradise, as it is usually presented in the Feast of Corpus Christi processions, and last but not least, Balaam's ass. Higher up we see all sorts of *curiosa* from the wardrobes of the saints; with the undergarments of St Ignatius Loyola distinguished in particular. We will leave it to the likes of Parny to expand upon this in his account of the wars of the gods, and to Casti to describe in his novellas.[43] We deny all responsibility, and are heartily thankful to have escaped finally from this wild chaos and catastrophe.

Let us ignore for the moment all the mockery and sarcasm, inspired by party-political rage, which no reasonable Protestant would ever condone. What deserves our respect in this caricature is the splendidly conceived composition and poses of the figures, which would be worthy of a nobler subject. Look at the energy with which the violent movement of the four principal figures is conceived and executed! Despite the bold placing, everything is in perfect order. The figures emerge clearly, nowhere is there confusion or obscurity. The main figure, Fox himself, on his Irish bull, reminds us almost involuntarily of that much admired masterpiece in the fourth Raphael room at the Vatican Palace, showing Attila, who, at the sight of the apostle in the clouds, is filled with dread and terror of St Leo (Plate 34).[44] All that is necessary is to ignore the intentional exaggeration which is a law of caricature! For those who know how to examine the whole work with the eyes of an artist, there is a rich source of comedy in the grouping of the figures, where the highest become the lowest, and in the contrast between slow sedateness and violent gestures of despair. The clearest evidence that this time the satirist has succeeded brilliantly lies in the fact that one can look at the picture many times, and each time discover something new and

[43] [Evariste Désiré de Forges, Viscount Parny (1753–1814): French poet and author of the epic poem 'La guerre des dieux anciens et modernes' (1799). Giovanni Battista Casti (cf. note 18 above), also wrote the forty-eight *Novelle galanti* (1793).]

[44] See Giorgio Vasari, *Vite de'* . . . *Pittori*, in Giovanni Bottari's edition, 3 vols. (Rome: Niccolò and Marco Pagliarini, 1759–60), vol. II, p. 109, and the programme on this subject by Christian Gottlob Heyne in the *Opuscula Academica*, 6 vols. (Göttingen: 1785–1812), vol. III, p. 135 etc.

[Raphael's fresco *The Repulse of Attila* is in the Stanza d'Eliodoro of the Vatican (c. 1512–14). Luitpold Dussler, *Raphael, a Critical Catalogue of his Pictures, Wall-Paintings and Tapestries* (London and New York: Phaidon, 1971), pp. 81–2.]

PLATE 34
Raphael, *The Repulse of Attila*, c. 1512–14.
Fresco in the Stanza d'Eliodoro, Vatican Palace, Rome.

admirable in it. One of the most splendid church processions in Rome used to take place on the day when the newly-elected Pope took possession of the church of St John Lateran. It was usually called 'il possesso' in the Catholic ritual, or 'taking possession'.[45] Everyone has heard the story of the Franciscan friar who almost despaired at the performance of a Pulcinello

[45] Read the detailed description in the *Voyage en Italie* by Mr de la Lande, vol. v, pp. 106f. etc.
 [Cf. n. 29 above.]

opposite him, as he was trying to preach in Rome. In order to distract people's attention from the clowning, he suddenly pulled a crucifix from under his habit and kissed it, saying 'Eccolo, il vero Pulcinello'. We might parody the saying with reference to this caricature: 'Eccolo, il vero possesso'!

18 (1806), 7–10, signed 'H[üttne]r'
London, 18 July 1806

As our readers know, various artists produce the caricatures published in London, many of which have appeared in this journal. Most of them are by Gillray, Fores, Holland and Rowlandson.[1] The reader hardly needs to be told that Gillray outshines the rest: anyone can see at a glance that the others cannot hold a candle to him. The extraordinary talents united in Gillray's works have not been seen in any other artist since Hogarth. His extensive literary knowledge of every kind; his extremely accurate drawing; his ability to capture the features of any man, even if he has only seen him once; his profound study of allegory; the novelty of his ideas and his unswerving, constant regard for the true essence of caricature: these things make him the foremost living artist in his genre, not only amongst Englishmen, but amongst all European nations. Paris may boast of its talented artists, but our readers know how pointless, dull and feeble all Parisian caricatures are when compared with those of Gillray.[2] Examining the works of his English rivals, we discover at once that in fact they have all learnt their trade from him: they may grind their teeth in envy, but nevertheless they study his prints in detail, and actually borrow a multitude of details which the public has come to associate with Gillray's work. We all

[1] [Samuel Fores and William Holland were principally print publishers and sellers rather than artists. However, recent research on Holland suggests that he did design many plates himself; and both these publishers must have had a strong influence on the work of the artists they employed. Cf. David Alexander, *Richard Newton and English Caricature in the 1790s* (The Whitworth Art Gallery, The University of Manchester, and Manchester University Press, 1998), p. 23. Had the highly original caricaturists Richard Newton and Frederick George Byron still been alive in 1806, *LuP* could not so easily have dismissed Holland's publications as mere imitations of Gillray.]

[2] [Many were, of course, reproduced in *LuP*.]

know the discomfort and embarrassment we feel when we examine an unsuccessful imitation, of whatever kind: we shudder, and turn away in disgust. That is exactly how we feel when comparing the London caricatures of Fores, Holland and their ilk to those of Gillray. But the English, of high and low birth alike, are so enamoured of these satires, that all of them – good or bad – find a buyer. Caricature shops are always besieged by the public, but it is only in Mrs Humphrey's shop, where Gillray's works are sold, that you will find people of high rank, good taste and intelligence. This woman runs a successful business selling her own publications alone.[3] It would be a rare miracle indeed if envy did not make every possible attempt to thwart such success. Fores, who struggles in vain to conjure up works which would stand any kind of comparison with those of Gillray, plagiarises his designs, so that it is possible to buy very poor, usually somewhat reduced, copies of all Gillray's caricatures from him.[4] Many people are ignorant of this theft, and unwittingly buy copies from Fores instead of the originals. And because a caricature is not the kind of thing one would care to go to law about, Gillray puts up with this piracy, without attempting to protect his property.

For a long time Gillray attacked the previous ministry and there are a number of prints from this period which are regarded as unsurpassable in the quality of their invention.[5] But he suddenly switched sides, and began to fire all his arrows at Fox in particular, and the old Opposition in general. What it was that moved him to do so, no one can venture to decide, for Gillray himself rarely gives anything away. Outwardly, indeed, in his manners and conversation, he gives the appearance of such everyday simplicity, such a straightforward, unassuming character, that no one would

[3] [Mrs Humphrey's nearly exclusive contractual relationship with the highly successful Gillray put her business on a different footing from those of most London publishers, who relied on wholesale barter of current prints amongst themselves, and the acquisition of old plates and prints etc., to augment and diversify their stocks. George, introduction to *BM* vol. VI (1938), p. xxxiv; vol. VII (1942), pp. xlvi f. Hill (1965), pp. 38f. Hill (1976), pp. xxi f. Donald (1996), p. 4.]

[4] [George, introduction to *BM* vol. VIII (1947), pp. xxxvi, xxxviii, attributes these copies to Williams.]

[5] [Probably a reference to *Light expelling Darkness* and *Presages of the Millen[n]ium* of 1795, which were hostile to Pitt. Donald (1996), pp. 163–6.]

guess this gaunt, bespectacled figure, this dry man, was a great artist.[6] The ill-disposed say that he received a pension from the previous ministry, but this has never been proved, and Pitt possessed too much courage and pride to lower himself by offering a sop to his enemy in this manner. More likely it was Gillray's patriotic views which occasioned his political *volte-face*. Seeing how influential his caricatures were, he believed that his work could contribute in some way to the maintenance of the anti-Gallican spirit amongst his countrymen.[7] If you study the major targets of Gillray's prints over the last five years, and the wonderful things he has produced on the most recent political events, you will quickly discover the spirit which moves him. But if Gillray was bribed by the previous ministry, why then does he still remain loyal to it, when any such pension (supposing it to have existed) would have come to an end when Pitt died? Why does Pitt still appear to be his idol? Why does he still interest himself on behalf of Lord Melville (Henry Dundas) and the entire present Opposition?[8]

Whatever the truth may be, English art collectors already place Gillray's original prints among the finest pieces in their portfolios, and they will continue to grow in value in the future.

[6] [This impression of a puzzling contrast between Gillray's inscrutable, self-effacing demeanour and exuberant imaginative gifts was shared by other contemporaries. Anon., *The Caricatures of Gillray, with Historical and Political Illustrations, and Compendious Biographical Anecdotes and Notices* (London: Miller, Rodwell and Martin, and Edinburgh: Blackwood, undated. Issued in parts, c. 1818 onwards), p. 5. Henry Angelo, *Reminiscences*, 2 vols. (London: Kegan Paul, 1904), vol. I, pp. 299–304. Donald (1996), pp. 30–1. Cf. the Introduction, p. 35 above.]

[7] [The earliest English commentator on the artist in *The Caricatures of Gillray* (see n. 6 above), pp. 13–14, also stressed his patriotism and its salutary effect on the public by way of justification.]

[8] [Gillray had, of course, received a secret pension from Pitt's government via Canning in 1797. It was probably stopped when Pitt temporarily lost power in 1801, and not resumed thereafter. However, Gillray's friendly association with Canning's group continued, even after the death of Pitt early in 1806. George, introduction to *BM* vol. VIII, pp. xii–xiii. Hill (1965), pp. 104, 111–12. Hill (1976), p. xxiii.]

23 *Visiting the Sick*[1]

18 (1806), 168–86, pl. xv
London, 15 August 1806

Seeing this caricature for the first time, one instinctively shudders. Do the parties in England hate each other so much that they will hound a man even to his death bed? If an enemy (in this case Fox) is dying of an incurable disease, and the most medicine can promise him is a short period of respite;[2] if he is more than likely to renounce all affairs of state of his own accord: surely anyone who even then continues to attack his failings must be impelled by a truly evil malice? This caricature will certainly shock our readers; but we wash our hands of it. Gillray should answer these charges himself![3] The caricature exists after all, and pleases a large number of people in England, who share its political sentiments. Because our journal seeks to present the unvarnished truth about happenings in London, it is our duty not to withhold *Visiting the Sick* from our readers. All we try to do is to interpret Gillray's (that is to say, the *anti-ministerial*) satires as well as we can.

Any unprejudiced person would object to a rage for party which makes men pursue an opponent, even while others are ordering his coffin; but we should not overlook the excuses they give for their conduct. In truth, this is just an exercise in retaliation. For when Pitt was on his death bed, Fox's friends were just as cruel and unfeeling; they filled the newspapers with their rejoicings that the era of bribery, embezzlement, waste, subsidies and taxes would soon be at an end, that Pitt's time was up, that the bottle, Ulm and

[1] [Etching and aquatint, published 28 July 1806. 'Js. Gillray fect.' *BM* 10589. George (1959), p. 94. Hill (1965), pp. 114, 123. Hill (1966), pl. 44, p. 156. Donald (1996), p. 41.]
[2] [Fox actually died on 13 September.]
[3] [In the form of his signature, however, Gillray presents his role as that of a mere executant, and disclaims responsibility for the idea of the print.]

VISITING the SICK.

PLATE 35
James Gillray, *Visiting the Sick*, 1806.
Etching and aquatint, hand coloured.

Austerlitz had finally finished him off, and that happier days now lay ahead. Even supposing that these things were true, no thinking man could condone their being loudly trumpeted at a time when Pitt had already (in fact several weeks earlier) been pronounced incurable. To be fair to Mr Fox, we should note that he himself objected strongly to these remarks, but we all know how such things happen: the great, greedy mob of party followers is blind, and happily abandons itself to a hundred different excesses and improprieties of this kind, all of which are ultimately laid at the feet of their leader.

Secondly, we should take into account the political atmosphere when this picture appeared at the beginning of August. The ministers, Fox's party in particular, had lost the support of the people. The Foxites had taken every

opportunity to condemn, scoff and blacken the unfortunate Pitt's name, his measures and friends – so much so that one almost went down on one's knees to pray that heaven would place the oracle, Britain's only hope, Charles James Fox, at the head of the Cabinet. Yet now that it has gained power, this party has been able to do little more than complain, double existing taxes and tread in the footsteps of Pitt – poor mocked, defamed and misunderstood Pitt! And then there was the Foxites' strange political declaration. I refer here to the notorious pamphlet, reprinted some seven or eight times, entitled *An Inquiry into the State of the Nation* (London: Longman and Co.).[4] Every child in London knows that it was penned by a certain critic from the *Edinburgh Review*, that it was read and expanded by Lord Holland (Fox's nephew), and that finally Mr Fox himself amplified it with the addition of a number of marginal notes. For this reason it caused an extraordinary sensation. Its message, in brief, is as follows: Pitt was wrong from beginning to end; he brought nothing but misery to the country; we must have peace at any price and must abase ourselves in the dust. What most amazed unbiased readers of this gem was the dismissive tone it adopted towards Fox's colleagues, the Grenvillians, who had served with Pitt at the helm. This tone was obviously ill-judged, and was regarded as irrefutable evidence of the 'imprudence' of which Mr Fox has so often been accused.

The pamphlet is very well written, and reveals its author's extensive knowledge of politics. For a time it held the field triumphantly, crowing like a cockerel which has rid the neighbourhood of all its rivals. But then a stronger contender appeared, a more convincing one, more manly and eloquent: this defender of Old England published *An Answer to the Inquiry into the State of the Nation*.[5] Three to four editions of the work, with ever increasing supplements, have already appeared, and I dare say it will be reprinted as many times as the *Inquiry* itself. To a certain extent this polemic is a commentary on our picture. It exposes all the sins and failings of the present ministers, but principally of Fox's party. It urges the nation to

4 [Henry Peter Brougham, Baron Brougham and Vaux, *An Inquiry into the State of the Nation, at the Commencement of the Present Administration* (London: Longman and J. Ridgeway, 1806).]

5 [Joseph Lane, *An Answer to the Inquiry into the State of the Nation, with Strictures on the Conduct of the Present Ministry* (London: John Murray, 1806).]

examine the situation with a cool head, warning against a peace which might prove worse than ten more years of war. Needless to say, the independent-minded Briton would not let himself be swayed by the author of this pamphlet any more than he would by the previous one, but the *Answer* has certainly made a great impression on the English, and has done immeasurable damage to the Foreign Secretary and his supporters (whom we will meet in a moment in tears).

And finally, we should examine this caricature through English eyes, as we must all such caricatures which appear in London, where things that would cause an outcry in Paris, and perhaps any other capital on the Continent, are dismissed with a fleeting smile. Every 'public character' – anyone who appears in the public eye – allows (indeed *must* allow, if he is not to be regarded as a fool) the Gillrays, Peter Pindars, Woodwards and Mathiases[6] of this world to expose him to ridicule, whether in a caricature, a pamphlet, or even in the newspapers, where every day 'public characters' suffer the most lewd and defamatory insults.

Let us not delay visiting the sick any longer, for there is no time to lose. Poor Fox is swollen with dropsy to the size of a kettle-drum, and we can see from his miserable expression that he believes his condition to be hopeless. But notwithstanding all this – if we are to believe the caricature – in the midst of such danger he has been unable to resist his old passion for gambling, the pastime which robbed him of his fortune, his reputation and to some extent even his health. The cup lies on the floor, the dice have spilled out. For Fox, this cup of dice was a veritable Pandora's box. If he had not allowed himself to be carried away by the game, we should have been spared this sorry sight, a situation in which the most important affairs of state are to be conducted by a dropsical invalid! Good Heavens! Peace is being discussed between two of the most powerful nations, whose constant squabblings have disturbed the peace of all Europe. And this great task, which requires unremitting mental effort, is to be undertaken and accomplished by a minister with dropsy!

But there are a number of other remarkable aspects to this sick chamber,

[6] [George M. Woodward produced caricatures and humorous writings. Thomas James Mathias was a loyalist satirical poet, author of *The Pursuits of Literature* (London: 1794–7).]

a room filled with the richest food for thought, for Britons and foreigners alike! Who, for example, would expect to find a Catholic Abbess at the home of a Protestant Minister, a few steps away from St James's, where the entire Anglican clergy might at this moment be assembled at court with the King? Of course, if you look carefully at what her veil is supposed to hide, you discover to your amazement that she has abandoned all decency in her attire, and is dressed more like a creature of the streets than an Abbess: and yet she is, in her own words, and those of her neighbour in blue, an Abbess. 'Bah', you say, 'Don't try to fool us: "Abbess" must mean something else in English!' Yes, true enough. To be frank, the word also denotes the madam of a brothel.[7] But let us discover why she is here. She says to the patient: 'Do confess your Sins Charley, do take Advice from an Old Abbess and receive Absolution! Here is Bishop O'Bother, 'twill be quite snug amongst Friends you know!' Our readers can see for themselves that this exhortation and the whole characterisation of the person fit Mrs Fitzherbert, of whom, indeed, it is a speaking likeness. She is, as is well-known, over sixty years old, of the Catholic faith, and the *chère amie* of a certain married man of the highest rank, and so the title 'mother Abbess' in the sense that the common people use it, suits her quite well. But the old sinner is, in priest's talk, very religious and is probably trying to convert the dropsical Fox to the one and only true Church of salvation, to earn a place in Paradise for herself. But the patient gives her the following, hardly comforting answer: 'I abhor all Communion which debars us the comfort of the Cup! – Will no one give me a Cordial?' That the lay members of the Roman Catholic Church do not receive the chalice at Communion is well known. Equally, we need hardly point out that the patient's abhorrence is not due to a pious man's theological scruple, but may be explained by his own love of a drink. The English language allows this double meaning of the word 'cup'. And the extent to which the patient craves a good, stiff drink is reflected in the ending to his protest. He cries and whimpers like a thirsty child. Fox spent most of his life amongst men who, as is sometimes said in English, 'drink deep'. We know that drinking is the cause of dropsy; but Fox did not drink any more than

[7] [Compare *End of the Irish Farce of Catholic-Emancipation* for this satire on Mrs Fitzherbert's Catholicism, p. 233 above.]

most of his fellow countrymen. We need not assume that he made the same mistake as his great political opponent, since it would seem that he inherited the seed of dropsy; both his father and his brother suffered from this illness for many years before finally dying of it. This imputation, then, is merely a *licentia poetica*.

The stocky, heavily powdered gentleman in the blue coat is saying 'Alas! poor Charley! – do give him a Brimmer of Sack, 'twill do him more good Abbess, than all the Bishop's nostrums'. But we can ascertain nothing more from this advice than that the adviser himself has always found a glass of champagne, or indeed any strong drink, to be the best remedy for any illness or unpleasantness. His red face, of which only a tiny part is visible here, also seems to have acquired its high colour from the frequent use of wines and *aqua vitae*. In a word, it is the Prince of Wales, whom Gillray never spares. And to dispel any doubts we might have as to whether this really is the heir to the throne, the malicious artist has placed a copy of the goldsmith Jefferys's letter to the Prince of Wales in his pocket.[8] Nothing spreads so widely nor so rapidly as news of a scandal. We may therefore assume that the dispute between this goldsmith and the Prince is not entirely unknown to our readers, but we will add a few words on the subject. Jefferys alleges that he has been greatly wronged by His Royal Highness and by Mistress Fitzherbert on the matter of payment for some jewellery he was asked to deliver to the pair. The pamphlet in which these allegations are made has already been reprinted three or four times; the Prince must be particularly displeased by a postscript, in which Jefferys writes about his behaviour towards his wife and towards Fitzherbert. In order to attract even more attention from the public, Jefferys advertises his pamphlet almost daily in the newspapers, and even employs people to walk around with the title printed in huge letters on placards! Not content with this, Jefferys has also issued another letter directed at Madame Fitzherbert, in which he dwells at length on the influence of her improper life and the shocking example she sets.[9] Without wishing to excuse the Prince in any way, we should point out

[8] [Nathaniel Jefferys, *A Review of the Conduct of . . . the Prince of Wales in his Various Transactions with Mr. J.* (London: 1806).]

[9] [Appended to the seventh edition of *A Review* (1806).]

that the general opinion is that Jefferys has also acted falsely, and has little reason to make such a fuss. As one might imagine, the Prince of Wales has not lacked champions. Three or four pamphlets have been published, in which his behaviour is defended. The most widely read of these is called *Diamond Cut Diamond*.[10]

Amongst those who are distressed by Fox's illness we find the Chancellor of the Exchequer, Lord Henry Petty, as is shown by a scroll of taxes under his arm. He has more reason than most to cry, for Fox has protected him at every turn. His new taxes were not only very unsuccessful, but earned him such a bad reputation amongst the people that it is thought he will resign, or be forced to resign his post, if Fox goes the way of all flesh. He is saying: 'Ah poor me! I fear my Dancing Days are over!'

Above him we find Windham, the War Secretary. This man has had an extremely colourful political career. First he was against Pitt, then for him. Afterwards he changed tack again and entered the present administration with Fox's party. If, as appears here, Fox is to leave the stage, Windham would probably have to change his allegiance yet again to remain in the government. But this is not a very pleasant prospect, and the fear that it will end this way causes him to say: 'O Lord! what side can I tack round to Now!' Lord Moira, too, the Commander General of Artillery, seen here above Windham, is in a state of high anxiety and affliction about the dangerous condition of his old political friend, without whose influence he would never have achieved his high office. He exclaims: 'I must go back to Ballynahinch Och! Och!', meaning, 'I must return to my estate in Ireland, oh dear, oh dear!' This is expressed in such a way as to highlight and ridicule his Irishness. For 'Ballynahinch' sounds ridiculous to the English ear, as does the guttural 'och, och!' instead of 'Oh dear'.

But these three gentlemen are only lamenting the patient's sad condition because their own fortunes are inextricably linked with his. The Bishop seems to be less selfish. Hearing the answer which Fox gives to the Abbess, an answer which rouses his theological fervour, he says: 'O Tempora, O

[10] [Philo-Veritas, *pseud.* (Thomas Gilliland), *Diamond Cuts Diamond; or, Observations on a Pamphlet . . . entitled 'A Review of the Conduct of His Royal Highness the Prince of Wales'* (London: C. Chapple, 1806).]

Mores! – Charley! dear Charley! remember your poor Soul! – and if you're
spared this time give us Emancipation – or!!!' The *aposiopesis* means nothing
other than 'or the Devil will get you and roast you as a loathsome heretic'.
At least this threat would fit his proselytising. Take it as you will, this
unusual cleric, this hybrid priest, this anointed Protestant bishop, whose
vestments only partly hide a rosary, deserves closer examination. It is
O'Beirne, the Bishop of Meath. In order to ridicule his name, the Abbess
and Sheridan here call him 'O'Bother'; for 'bother' or 'pother' is a vulgar
word which means noise, spectacle or rumour, and which suits the common
Irishman particularly well; and this travesty of his name clearly refers to the
political behaviour of the Bishop, a fervent supporter of the Foxites.
O'Beirne (you will find this explained in detail in the *Public Characters* of
1799–1800)[11] is a Catholic-born Irishman who was brought up in St Omer
and was intended for the Catholic priesthood. He converted, however, and
now professes the episcopal faith. It was this conversion, but more impor-
tantly his wide knowledge, honesty and social talents, that made him many
friends, and he had the good fortune to become chaplain to the great naval
hero Howe, when he served his country so well in the American War. It was
the powerful Howe family who recommended him to the Opposition. The
Duke of Portland, when Viceroy in Ireland, made him his chaplain and sec-
retary, and as a result, on Portland's recommendation, O'Beirne was given
two fat livings in the north of England, from which he receives 700 pounds
sterling. In gratitude he became one of the most passionate supporters of
Mr Fox, who was, of course, Leader of the Opposition for many years. The
ardour of this attachment can be gauged by the fact that, at the famous elec-
tion of Mr Fox (when the beautiful Duchess of Devonshire offered her
cheek to dirty artisans in return for votes for her protégé), he joined Colonel
North at the back of the coach in which Fox was drawn by the people to the
Duchess's palace, while the Duke of Norfolk sat on the box.[12] O'Beirne
afterwards accompanied Lord Fitzwilliam, who became governor of
Ireland, and who soon promoted him to Bishop of Ossory, and finally to
Bishop of Meath, a position believed to yield him 5,000 pounds annually. It

[11] [*Public Characters of 1799–1800*, pp. 141–52.]
[12] [A reference to the Westminster election of 1784.]

is well known that the so-called emancipation of the Irish Catholics was a subject very close to the honourable Lord Fitzwilliam's heart. Though himself a former Catholic, O'Beirne shows none of the misguided fanaticism of the typical new convert; he honestly believes that the four million of his countrymen who are excluded from public offices and from other advantages, to which only Protestant subjects have access, should no longer be debarred on the grounds of religion alone. He has written a pamphlet on the wisdom and necessity of emancipation,[13] and has also delivered an excellent, still famous speech in the Irish Upper House, in which he defended his patron Fitzwilliam's conduct in the matter of the Irish Catholics. It is to this that he owes the honour of being depicted in our caricature, and this is why he is shown as a hypocrite or a wolf in sheep's clothing. Because it is inconceivable that a Protestant, and a Protestant bishop to boot, could be magnanimous and enlightened enough to desire the removal of odious and shameful political exclusions ('disabilities') from his Catholic fellow countrymen, he is branded a secret Jesuit!

But we must return to the caricature. Because O'Beirne raises the subject of emancipation, Sheridan (our readers have long been familiar with his carbuncled features) is saying 'Emancipation! fudge! why Dr O'Bother, I thought you knew better!' Our caricaturist always depicts Sheridan as a wily old fox, a characterisation that is conspicuous in the whole air of the present portrait. We all like to ascribe our own way of thinking to others, and because Sheridan (in the spirit of this caricature at least) believes emancipation to be a mere pretext, a device to win the good will of the people, the words he whispers to the Bishop mean, 'What emancipation? My colleagues and I think only to throw sand into the eyes of the people, to earn for ourselves the title of the most generous patriots, but we never meant it seriously.' This cunning time-server, who craves the flesh-pots of ministerial life, can already see what is going to happen: he knows that Fox will not last much longer, and already has a 'Scheme for a new Administration' tucked in his pocket. What a fine friend! Behind him we see Lord Howick (famous

[13] [Cf. *Public Characters*, p. 150 and Thomas Lewis O'Beirne, *A Letter to the Rt. Hon. George Canning, on His Proposed Motion in Favour of Catholic Emancipation* (London: J. Hatchard, 1812).]

under his former name, Grey), First Lord of the Admiralty, who is weeping. We cannot hear what he is saying: however, as one of the longest-standing Foxites, he has the sick man to thank for his promotion, and he is naturally fearful; for as soon as Fox closes his eyes, this Lord's ministerial power will probably come to an end.

Madame Fox plays a very interesting part in this sick room. She would indeed have a heart of stone if she did not sincerely grieve over her husband's incurable dropsy! Indeed, she is sitting quite insensible in an arm-chair, and requires smelling salts to revive her. Nevertheless there are a number of remarkable and strange things about her. A loving wife and yet so dressed up at her husband's sick bed, fresh from her toilette, as if she were on her way to Court; with such a beautiful blooming complexion; such plump cheeks! Hm! Is she really pining away because of her husband's sad state of health? And what is that under her chair? It is a bottle of spirits, full of genuine *aqua vitae*, 'True Maidstone',[14] where the best gin in England is distilled. Next to it is a broken glass. And so the secret is out. Madame Fox did not know what to do with herself in her great sadness and turned to the 'comforter' (the English amusingly refer to a Römer glass, of the kind which lies broken on the floor, as a 'comforter'); and afterwards she fell asleep. But Lord Derby does not know that she is suffering the effects of the spirits, and, believing that she has fainted, holds smelling salts under her nose: 'My dear old Flame Bet, don't despair! If Charley is pop'd off – a'nt I left to Comfort you?' A second discovery! Lord Derby himself reveals that Madame Fox, formerly Madame Armistead, who gave herself to the highest bidder as a *femme entretenue*, was once also a friend of his; and as old love never dies, the widow Fox might well throw herself into the arms of this lovable Adonis. For the fact that he is married is never an obstacle for a man of this kind. We need only think of the man opposite him!

An English Foreign Secretary has many friends, particularly a man as famous as Fox. They come and go constantly. The door of the sick room has just been opened and four visitors are leaving. These are men of the greatest importance. The one with the spectacles is the Marquis of Buckingham;

14 ['True Maidstone' also refers wittily to the United Irishman Arthur O'Connor's trial for treason at Maidstone in 1798, when the Foxites supported his (false) plea of innocence.]

immediately next to him is his son, Lord Temple, then Lord Grenville with Addington, now Lord Sidmouth. All these men were, as we know, long-time friends of the late Pitt, and three of them are his cousins. People thought that the sky would fall in before they would join with their sworn enemies, the former Opposition; but Pitt's pride and stubbornness brought them together, and when this inclusive coalition took office, they aroused great interest on all sides by discreetly reconciling their differences and preserving harmony. However, when the great question of the peace arose in Parliament, it soon became clear that men who start from completely different political premises can never be reconciled. Then appeared the Foxites' credo, which was mentioned above (*An Inquiry into the State of the Nation*), in which Fox and Lord Holland, as we have said, gave vent so imprudently to their indignation with the Grenvilles. How, therefore, could the latter conceivably speak well of Fox? Their visit to the sick must be very similar to the kind of visit a cat might pay to the chickens. Just look at their secret gloating as they leave the sick room! Grenville covers his face with his hat, so that no one will observe his *schadenfreude*. With the air of a crafty hypocrite, he pulls Sidmouth close to him, and asks: 'Well Doctor, have you done his business? – shall we have the Coast clear, soon?' It is well known that Grenville and Fox now share power in Parliament. The latter has the strongest party, but it will probably be destroyed along with its leader. And then the 'coast', as Grenville says, would be 'clear', and he and those loyal to him in the ministry could gain the upper hand and exercise power at will. Our readers already know why he calls Lord Sidmouth 'Doctor'. Addington's father was a very rich doctor, and the son himself once applied his medical knowledge advantageously, when the King was dangerously indisposed: in short, during his ministry he was given the nickname 'Doctor'. Gillray has superfluously placed a medicine bottle in his hand, and on its label we read the words 'Composing Draft'. The doctor has high hopes of this, and replies to Grenville's question with 'We'll see!', slyly covering his mouth with his hand. The Marquess of Buckingham believes that victory is already certain and shouts joyfully, 'O! such a Day as This! so renown'd, so Victorious!' His son chimes in, in the same tone, 'Such a Day as This! was never seen!' This is hardly a reassuring proof of political friendship.

One final question might puzzle some of our readers. How does the Prince of Wales come to be here? What would he lose through Fox's death? Are his tears caused by respect and friendship for the great statesman alone? Politically, of course, the Prince has always sided with the Opposition; during the King's first indisposition Pitt took the monarch's part so actively against the Prince of Wales's claims to a regency, that the Prince could never thereafter be very well disposed towards him. While Pitt lay on his sick bed, and hopes of his recovery were becoming fainter by the day, the Prince placed himself publicly at the head of the Opposition, which held a daily meeting at his home. Pitt died; and Lord Grenville, who had long allied himself with Fox, received an order from the King to form a new administration. The Prince worked passionately on this endeavour, for, according to the wishes of the people and of the King, Fox, Erskine, Moira, Sheridan, Grey – the entire Opposition in other words – were to form the core of the new ministry. This was soon brought about, and the Prince had the pleasure of seeing at the helm men who had his best interests at heart. If Fox were to die, his friends would find it hard to stick together for long. As is well known, the Prince makes many demands on Parliament which he could not so easily obtain without the support of Fox's party.

Appendix
Two previously unpublished letters from Gillray to the print publisher Samuel Fores

These letters are among the large collection of Gillray drawings and prints in the New York Public Library.[1] They both relate to Gillray's seated portrait of the Prime Minister William Pitt, published by Fores on 20 February 1789 (Plate 7).[2] This engraving was badly received, and may have been withdrawn by Fores, but in the following month Gillray produced a second portrait of Pitt, set in an oval, with a slightly different pose and reducing the figure to a simple half length. Draper Hill mentions John Harris as the publisher of this second version, but a variant, apparently issued in May 1789, may have been published by Gillray himself (Plate 8). The print by 'Shirwin' which Gillray mentions in the first letter is John Keyes Sherwin's engraving of Pitt from a portrait by Gainsborough, which was to be published on 15 June 1789 (Plate 9). Draper Hill has pointed out to the editors that the dated letter, and probably the undated one, also precede the publication of a print after Copley's portrait of Pitt on 19 January 1789.

The artist's resentment over the perceived failure of his portraits of Pitt surfaces in *London und Paris*'s biographical sketch in a footnote to *Search-Night*,[3] and the episode is discussed in the Introduction.[4] These two letters, written when work on the plate for Fores was still in progress, suggest that it had already raised doubts and criticisms in the publisher's mind. These may have related not only to the unflattering portrayal of Pitt, but to the looseness of Gillray's technique, which lacked the finesse of a professional

[1] Print Collection, Miriam and Ira D. Wallach Division of Art, Prints and Photographs; Astor, Lenox and Tilden Foundation. Original Drawings and Addenda portfolio; classmark 'MEZYRK+'. Other unpublished letters in this collection are Gillray's drafts for, or copies of, two letters to John Hookham Frere and one to the Revd John Sneyd, written in 1800 about the abortive project for an illustrated edition of *The Poetry of the Anti-Jacobin*. Cf. Hill (1965), pp. 88–101.

[2] Hill (1965), pp. 32–3. Donald (1996), p. 31.

[3] See p. 55 above.

[4] See p. 31 above.

PLATES 36–8
James Gillray, letter to Samuel Fores, undated (1789).

reproductive engraver's. The print bears the marks of Gillray's impatience, which the second letter reveals. Aside from the significance of the contents, the letters are also interesting examples of Gillray's handwriting, orthography and powers of self-expression (Plates 36–8), and confirm Hüttner's impression of an educated man.

PLATES 36–8 (*cont.*)

Gillray to Fores; undated postmarked letter

Sir

I would just mention with respect to the Message you left at Chelsea respecting
[crossed out] concerning the *distribution* of yᵉ Proposals for yᵉ Print of Mr Pitt –
that to me it appears yᵉ most unnecessary & impolitic step than can possibly be

PLATES 36–8 (*cont.*)

taken – Unnecessary; as there is not a Man living so infatuated to Mr Pitt as to sub-
scribe for his Portraits without having seen the Picture or knowing whether ye
Print is a likeness or not – & impolitic; as it will be the most effectual way to urge
forward ye publication of ye other Plates of ye same subject, which may be in hand;
& of goading on ye Proprietors of such Plates to injure the reputation of my
Engraving before it appears – for as to shewing a proof of [crossed out] to any

Person till y^e Plate is finish'd I would not upon any account run y^e risk of it – The Plate is very forward & I must decline Etching y^e Caricatures you want – as I have reason to believe that Mr. Pitt portrait will be of more consequence than I at first imagined – as to trying to procure Mr Pitt to give me a sitting (as you proposed) it might be productive of y^e worst consequences; if from whim, or from perswasion, he should *refuse* to sit, it would damn y^e reputation of y^e Plate at once . . . [illegible sentence, heavily crossed out] . . . – as to dedicating it to Lady Chatham the Print I trust will be such, as to support itself, without y^e flimsy assistance of any fool of Quality – with regard to altering y^e Nose, Mouth, Hair, Eyes, Chin &c &c &c which you seemd to think unlike, I must observe, that I have had again two opportunities for examining every particular feature of y^e face of y^e original – and am convincd that my likeness is a striking one therefore, I will not alter an Iota for any Mans Opinion upon Earth – I believe y^e next two G^s will make up y^e Thirty for your Half share of y^e Plate. I shall leave a Rec^t for it in Millmans Row – I have several reasons for thinking that Shirwin is about y^e Plate of Pitt, tho' he has not the Picture, – it would be a satisfaction to know, tho' I am not much concern'd about it, as it cannot be so forward as mine – which neither he nor his friend in Cornhill believe to be yet in hand – when y^e Portrait is finish'd, I shall call upon you with a Proof where I am y^e while, can interest no person whatever.

I am Sir
your very humble Sevt.
Js Gillray

Millmans Row
Chelsea *Thursday Even^g.*

Mr Fores – Printseller N3 Piccadilly near ye Haymarket

Gillray to Fores, 5 January 1789

Mr Fores
having had a proof from off y^e Plate of Mr. Pitt since I saw you last – I find it will be impossible to get the Plate finishd this Month, therefore should imagine the Card which you wish'd engraved & distributed, can be of little use at y^e Club y^e next Meeting (Thursday next) – as I am certain it will be quite time enough to distribute it y^e next meeting after – The quantity of work which I find in y^e Plate almost drives me mad – & I am sure that if I was to undertake y^e Designing & Engraving

the whole of such another Plate for 200 Gs – I must be a looser by it – yet I am determined not to slight ye execution of it by hurrying it – I thought I would just send you my thought about ye Card – as it certainly can do ye Print no good to say Publicly that it will be finishd by such a time & disappoint – I will call the first time I come to Town.

 I am Sir

yours & c J. Gillray

Chelsea Jany. 5th/89

Mr. Fores – Printseller N3 Piccadilly near ye Haymarket.

Index

Note: page numbers in italics refer to illustrations